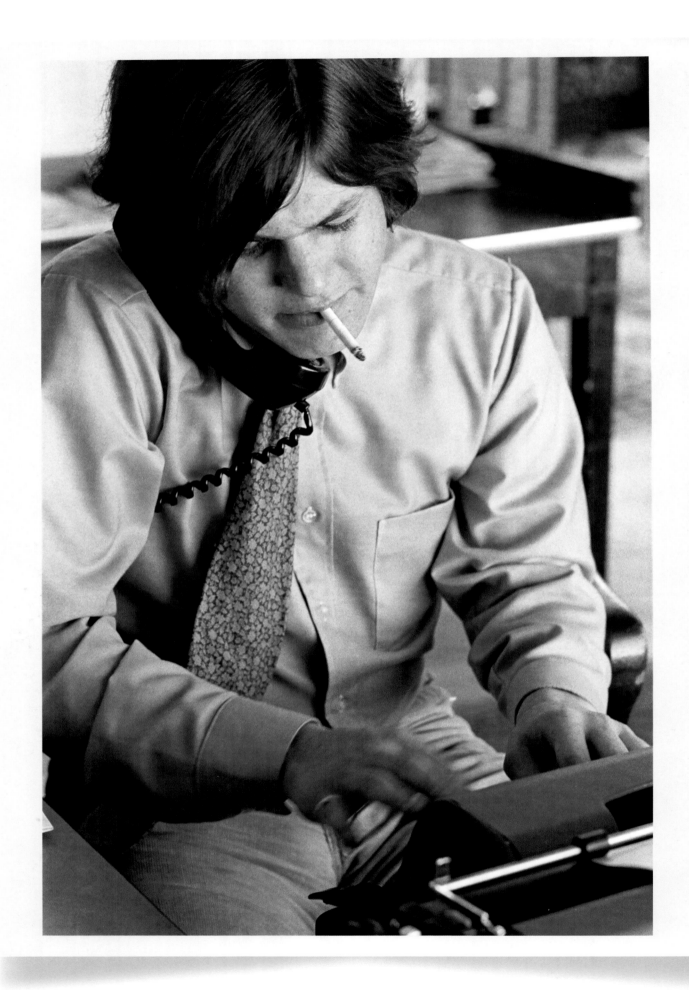

Jann S. Wenner, 1968.

THE MUSIC, POLITICS & PEOPLE THAT SHAPED OUR CULTURE

50 Years *of* Rolling Stone

INTRODUCTION BY
Jann S. Wenner

—

EDITED BY
Jodi Peckman and Joe Levy

—

DESIGN DIRECTOR
Joseph Hutchinson

ABRAMS, NEW YORK

CONTENTS

Introduction

By Jann S. Wenner

THE IDEA FOR STARTING *ROLLING STONE* CAME WHEN I was 21 years old and I couldn't find a full-time job. My brief run as the entertainment editor of a local alternative newspaper, *Sunday Ramparts,* had just ended when the paper folded. That gig had given me a perch in the small world of rock & roll in San Francisco, going to concerts, writing reviews and hanging out with the likes of the Grateful Dead, the Airplane, Janis Joplin and Jim Morrison.

It was 1967, the "Summer of Love." What a time to be 21 and footloose in a beautiful city bursting with music. The counterculture was thriving in neighborhoods all over town, and there was a very liberal attitude toward drugs. I didn't live in, nor much visit, the Haight-Ashbury. But I went to the Monterey Pop festival, heard the Who and Jimi Hendrix for the first time, met great musicians and slept on the floor at the Blue Cheer house. That summer, *Sgt. Pepper's* was released. I got an advance tape and was commissioned to review it by *High Fidelity* magazine. My piece was rejected for being "too hyperbolic." So much for freelancing.

The man who had gotten me the job at *Ramparts,* a terrifically smart and passionate music fan, was the *San Francisco Chronicle's* jazz/pop critic, Ralph J. Gleason. Just turning 50, he was, to me, the voice of wisdom. He had a big droopy mustache, a trenchcoat and a Sherlock Holmes hat, and was always smoking a pipe. He had been my friend and mentor since I was a student at UC Berkeley, so I went to him with some thoughts on what I could do to earn a living.

The idea that clicked was a "rock & roll newspaper."

Ralph had written a long essay for *The American Scholar,* a kind of personal manifesto and philosophical survey of the cultural and popular-music landscape – the beatniks, anti-war politics, Bob Dylan, the Beatles, campus protest – in short, the flowering of what we now call "the Sixties." The piece laid out the intellectual framework for what I was thinking about – it explained the passion I had found in the music and myself, and the kinds of things I was discovering about the world I was growing up in.

Ralph's essay was titled "Like a Rolling Stone," which, of course, came from Dylan's song, and that's how we got the name. And in choosing that name, there was also an explicit nod to the Rolling Stones, who, with Bob and the Beatles, were my heroes.

I thought rock & roll needed a voice – a journalistic voice, a critical voice, an insider's voice, an evangelical voice – to represent how serious and important the music and musical culture had become, in addition to all its

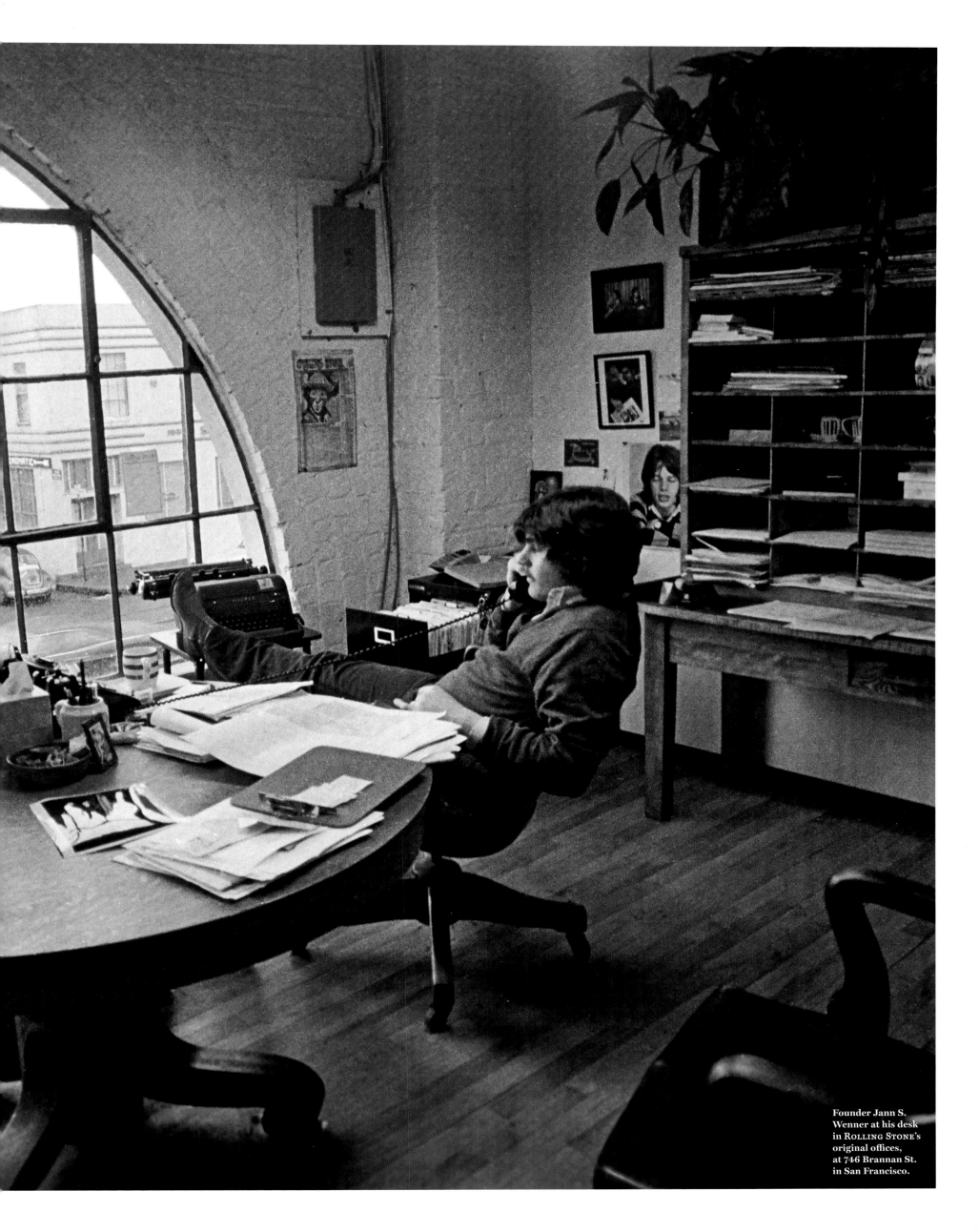

Founder Jann S.
Wenner at his desk
in ROLLING STONE's
original offices,
at 746 Brannan St.
in San Francisco.

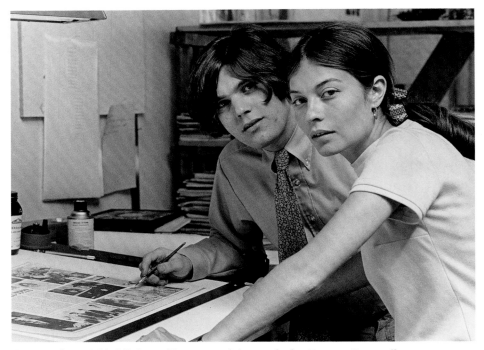

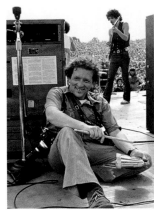

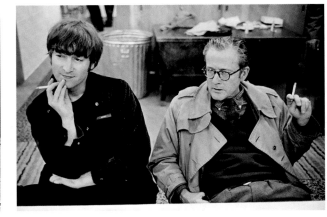

Above left: Former chief photographer Baron Wolman shooting Santana at Woodstock. Right: John Lennon and ROLLING STONE co-founder Ralph Gleason at the Beatles' final show, at Candlestick Park in 1966.

Wenner and Jane Schindelheim working on an early issue at the first ROLLING STONE office in San Francisco. They married less than a year after the magazine was launched.

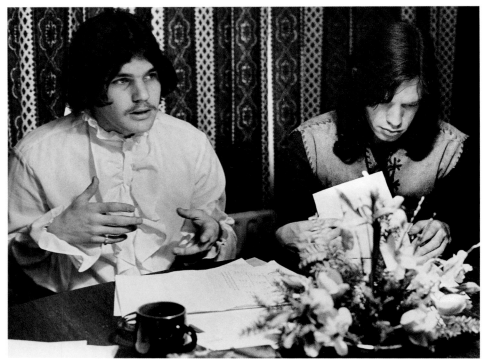

Above: Ben Fong-Torres, senior editor from 1969 to 1981, wrote features on Marvin Gaye, Linda Ronstadt and more. Right: Joe Eszterhas, who wrote landmark investigative pieces before moving on to screenplays, including *Basic Instinct*.

Above: Wenner and Mick Jagger announcing their partnership for the British edition of ROLLING STONE in London, 1969. Jagger was the subject of one of ROLLING STONE's first long-form interviews.

manifest entertainment value; a place where fans and musicians could talk to one another, get praise, advice, feedback; someplace we could shout, "Hail, hail rock & roll, deliver us from the days of old."

Music was the glue holding a new generation together. Rock & roll was the tribal telegraph, and the only places you could get it were on the radio, in a record store or on the jukeboxes. It wasn't just great music, great songs and great singers; rock & roll was also cultural and political upheaval, freedom from drug and sexual and social repression. It was the post-World War II baby boom coming of age – and determined to have its way…and then came ROLLING STONE, the little biweekly newspaper from San Francisco.

In the editor's note for the first issue, I wrote, "We have begun a new publication reflecting what we see are the changes in rock and roll and the changes related to rock and roll.…We hope that we have something here for the artists and the industry and every person who 'believes in the magic that can set you free.' ROLLING STONE is not just about music but also about the things and attitudes that the music embraces."

I got together $7,500 from a few friends, arranged for free office space in the warehouse of our first printer, and scored some used filing cabinets and typewriters. Our logo was hand-drawn by my favorite poster artist, Rick Griffin. And with a few friends from my Berkeley days, and my then-girlfriend, Janie Schindelheim, and her sister – all volunteering – we got that first issue rolling off the tiny rotary press that had once printed *Sunday Ramparts* and *The People's Weekly World*.

We opened champagne as we watched the first issues being printed. The next day, we began sending copies to every musician we could get an address for and to all of Ralph's friends in the music business in hopes of advertising support (Ralph stayed deeply involved with us until he died in 1975). And we got it – $100 for a full-page ad for a Captain Beefheart record. And then came letters of appreciation from musicians – the very first from Rolling Stones drummer Charlie Watts.

Slowly, the magazine began to take off. Within the first year we had long interviews with Mick Jagger and Pete Townshend (by me, at my house one very late night after a Fillmore concert, wherein he first revealed the ideas for *Tommy*). We did a long piece on the wide use of drugs by soldiers in Vietnam. We had Jon Landau and Greil Marcus and Jonathan Cott writing our first generation of record reviews.

We began to get attention for our journalism and our beat – an inside understanding of the generation taking over American culture. We did a cover story about those loving ladies of rock, "The Groupies," which made everyone sit up. Then came Altamont, and Charles Manson.

These were both dark tales. Our reporters who had been to the free Rolling Stones concert at the Altamont Speedway came back to the offices full of stories about bad vibes and bad violence, in contrast to the local coverage of the event, which made it sound like Woodstock West. We produced some 24,000 words of group reporting on tight deadline, laying out in detail the mayhem, the death of several fans and the role of the Hells Angels.

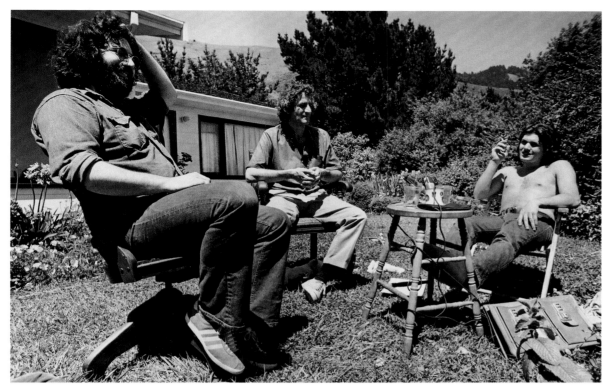

Yale professor Charles Reich and Wenner conducting a five-hour interview with Jerry Garcia at his California home for the magazine's 100th issue, in 1972. Garcia said he was proud that a story about the Dead's 1967 drug bust appeared in the first issue of ROLLING STONE.

Left: Annie Leibovitz joined the magazine in 1970. Her first cover portrait was of Grace Slick. Above: Jon Landau was the first reviews editor before leaving in 1975 to work with Bruce Springsteen.

Cameron Crowe, who as a teenager contributed features on the Eagles, Neil Young, the Allman Brothers Band and more, in the Seventies.

Charles Manson – back then – was a mysterious figure, awaiting a murder trial but seen in some quarters as being persecuted because he came from the hippie underground. We put two reporters on it, one with the Manson Family and the other with the Los Angeles district attorney. And six months after Altamont, we put out yet another defining piece of journalism, which obliterated the fantasy of Manson's "innocence." For publishing these two reports from our side of the generation gap, we won our first National Magazine Award.

* * *

I WAS REACHING OUT for talent high and low, and made some stunning bets. The big three were Annie Leibovitz, Tom Wolfe and Hunter S. Thompson. Wolfe was my hero; I loved his writing, and when I tried to locate him I discovered he was living and working in San Francisco. His first assignment for ROLLING STONE was a series about the astronauts – "The Brotherhood of the Right Stuff." We would publish much of Tom's work through the years, most notably *The Bonfire of the Vanities*.

Tom was the central figure of New Journalism, which powerfully combined fiction-writing techniques with the highest-level reporting skills and an eye for detail. He did it better than anyone else. He was a demon for accuracy and research, he shared my fascination with the oddball byways of American culture, and he has been a pleasure to know and work with over these many years. We let him have freedom and space and a home, and he hit it out of the park.

About the same time I was romancing Tom, I wrote a fateful blind letter to Hunter S. Thompson. I had read Hunter's *Hell's Angels* before starting ROLLING STONE, and asked if he would write a short piece for us on a Hells Angel named Terry the Tramp, who had gone on to his just reward. Hunter wrote back, explaining he was running for sheriff of Aspen, Colorado, and didn't have the time to write the piece but that he loved ROLLING STONE and what we were doing. I then asked him to write about the campaign, which became his first story, "Freak Power in the Rockies: The Battle of Aspen," in October 1970.

Honestly, I didn't see the freight train coming.

Fear & Loathing in Las Vegas became the *Catcher in the Rye* of our times – and then his coverage of the 1972 elections was so brilliant, funny and original that both he and ROLLING STONE became legend.

At first, many people were puzzled by the mix of music, politics, pop culture and journalism. Did they really belong together? In those first three years, there was always the sense that I was on a tightrope trying to manage this odd balance. People didn't understand why a rock & roll newspaper had not only one but two correspondents covering the earliest days of George McGovern's presidential campaign. But I knew why, and Hunter knew why. We shared this sense of purpose and feeling about doing something right, something important and something fun. And the talent that quickly gathered around us shared that too.

Hunter was a dear friend and my soulmate in the deep discussion of what we were doing. I loved him, and it tore my heart apart when he died.

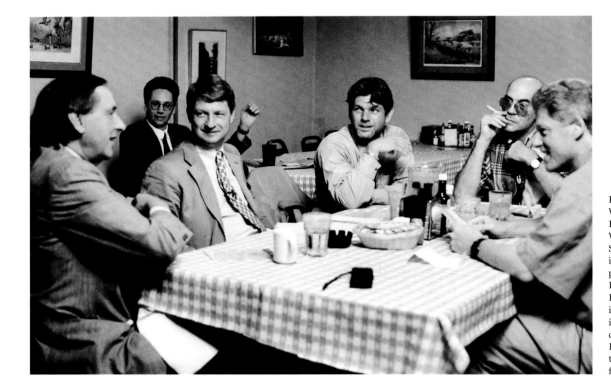

From left:
William Greider,
P. J. O'Rourke,
Wenner and Hunter
S. Thompson
interviewing
presidential hopeful
Bill Clinton in Little
Rock, Arkansas,
in 1992. In the
interview, Clinton
criticized the War on
Drugs and revealed
that Paul was his
favorite Beatle.

I didn't find Annie Leibovitz. She just walked into our offices one day in 1970, a San Francisco Art Institute dropout, and showed some of her student photos to our art director, Bob Kingsbury, formerly a wood sculptor and then my brother-in-law. He used one of those photos and started giving her assignments. Her first cover portrait was Jefferson Airplane's Grace Slick, the voice of "White Rabbit."

I brought Annie with me to New York for my 1971 "Lennon Remembers" interviews, the searing story of the breakup of the Beatles, which made headlines around the world. For the cover, I picked one of her test shots, an unposed, simple portrait that captured John's penetrating eye contact.

I started ROLLING STONE with an understanding that photography was essential to what we were setting out to do. Rock & roll was also an aesthetic: the looks, the style, the sex appeal. I took cues from the great, sensuously designed German magazine *Twen* and the Swiss magazine *Camera*, just as much as I tried to find an editorial voice as powerful as *The New Yorker*'s.

Our first chief photographer (from RS 1, with his photo of the Grateful Dead standing defiantly, arms raised, on the front porch of their house the day after a drug raid) was Baron Wolman. He distinguished himself by making formal portraits – Frank Zappa, Tiny Tim, B.B. King, among many; it was his idea to do the groupies issue, for which he produced a wild portfolio of studio images.

Annie quickly became a very close friend. She was a powerful editorial voice, with as much insight on a story as the best reporters I had. She burned with ambition and a desire to learn. Everyone wanted to be shot by Annie, and she had access everywhere.

Together Annie and I explored the importance of the cover. When ROLLING STONE finally went four-color in 1973, like a real magazine, it totally lifted our game. I focused her on studio work as well as reportage from rock & roll road trips, presidential campaigns and Rolling Stones tours. And I introduced her to Richard Avedon, who was beginning his special issue "The Family" for ROLLING STONE in 1976, so she could learn from the unquestionable master of magazine photography and portraiture.

Tom Wolfe once told me that when Annie arrived on a story, it was like a weather front coming in. She was a force of nature, and went on to become one of the pre-eminent photographers of all time. The power of her 13 years of work with us clearly predicted her greatness. She remains part of the DNA of ROLLING STONE – our look, our sensibilities and karma.

That was how the Seventies began, a confluence of the times and the talent and our search for the truth. The talent came in all sorts of ways; we cobbled together editors, reporters and designers who were young, eager and ready for the chance. Among the many were two former daily-news reporters, Joe Eszterhas and Howard Kohn, who had run afoul of the rules at their papers in Cleveland and Detroit. Joe wrote long, brawling sagas of people on the edge, especially drug-enforcement agents, and became a New Journalism star, then a hot screenwriter. Howard had deep political passions, and that led him to perhaps our two biggest stories of the Seventies: "The Death of Karen Silkwood" and "Patty Hearst: The Inside Story." By a simple twist of fate, the kidnapped newspaper heiress, missing for two years, was captured three days before we released our exclusive account of her time on the run, and ROLLING STONE was featured on front pages and at the top of worldwide network-news coverage for weeks.

At the same time, we were nurturing a kid not yet out of high school, Cameron Crowe, putting him on the road with the Eagles, Led Zeppelin and other rock legends. They all took the irresistible teenager into their innermost circles, and he came through with one cover story after the other. Cameron went on to a career writing and directing movies, and he captured that era of ROLLING STONE so tenderly in *Almost Famous*, in 2000. It was a love letter to what we were and what we believed in, and it earned him an Oscar for Best Original Screenplay.

We developed personal ties with most leading rock & rollers of the time. Mick Jagger and I went into business together to publish a British edition of ROLLING STONE and maintained a long friendship from then on. ROLLING STONE had easy access. We were taken in backstage, on the bus, at home. We could live with a group for a week if we needed to for the story, and we often did.

* * *

IN 1977, we left San Francisco for New York City and set up "World Headquarters" in an office building on Fifth Avenue, across the street from the Plaza Hotel, with grand views overlooking Central Park. Partially the move was aimed at drawing in the editorial talent we wanted and consolidating it with the business side in one place. It was a natural progression for the magazine. The unspoken reality was we were going mainstream. We were joining the "establishment."

Elvis died the week we arrived, so we had to push back our in-the-can transition issue (the cover featured a painting of New York mayoral candidate Bella Abzug by Andy Warhol) and crash a special Elvis edition in four days, one of those round-the-clock runs that gets the adrenaline jumping

in junkie journalists. Just a month later, we published Carl Bernstein's exposé of how the CIA had been secretly using journalists as agents. In the same issue, the Sex Pistols arrived and landed on our cover.

The fact is the establishment was also moving toward us. Instead of Richard Nixon, we now had a Dylan-quoting president, Jimmy Carter, whom Hunter really liked, and whose early campaign had been financed in part by Allman Brothers concerts.

We hit the one-million paid-readers mark. As the average age of our readers – 21 at the start – began inexorably moving up, our interests, our culture and our point of view from the Big Apple grew wider.

We were trying all kinds of new ideas for stories and giving assignments to a broader range of writers, but in my mind and my heart, then and now, I felt we kept our moral center and our editorial credo.

The big watershed was still ahead.

* * *

JOHN LENNON WAS MURDERED. That's how the Seventies closed and the Eighties began. Once again we moved into deadline special-issue mode, this time in a very solemn, purposeful and painful way. It had happened almost on our doorstep. I lived right across the park from the Dakota. The days were dark, dark, dark.

John and Yoko Ono were releasing *Double Fantasy,* so we had conducted what turned out to be his last interview and his last photo session. The picture they staged for Annie the same day he died – John lying curled naked around Yoko – took on extraordinary visual and emotional power. No headlines or words were needed, and that cover would become an inextricable part of the tragedy.

The Eighties were the Reagan years: Money, cocaine and power ruled. Music and culture became fractured, some of it brilliant, some celebrated merely for the fact that it looked pretty, got big crowds and was MTV-friendly. We were dragged along into a lot of that – nice people, good-looking, fun music…but so what? Movie and television coverage got more prominent in our world. ROLLING STONE itself was the center of a shallow movie, *Perfect,* about finding romance in health clubs, starring John Travolta as a ROLLING STONE reporter. I had a lead acting role in it, and somehow or other it spoke, sadly, to the times.

But we also did the first national magazine piece on the mystery of AIDS. It had been an untouchable issue, and we won a National Magazine Award for our reporting. We also delivered exclusive interviews with Johnny Carson and David Letterman. P. J. O'Rourke's long series of reportage and Swiftian essaying was a staple of ROLLING STONE in those years, and Bill Greider, whom I recruited from *The Washington Post* at the advice of Hunter, took over our National Affairs desk in Washington and kept our often lonely progressive political voice alive and well in the sharky waters of trickle-down socioeconomics.

Our triumph was *The Bonfire of the Vanities.* I had asked Tom Wolfe to write something about New York, which had once again become the hot national capital of culture. He came back to me with a 100-page outline for a novel that would portray the city from high life to low society. Tom wanted to write a new chapter on deadline for every issue for a year, and we would work in this rhythm, right on the very edge of possible disaster, just as Charles Dickens had published a century earlier. Tom told me it was not for the faint of heart, but where else could you have so much fun?

* * *

IN 1993, three baby boomers, Bill and Hillary Clinton and Al Gore, moved into the White House, and a kind of renaissance began, restoring the ideas of commitment, fairness, youth and energy. It was reflected in all kinds of ways in our world. Nirvana returned rock to a more personal and meaningful place. The Stones, Dylan, Neil Young were doing work nearly as great as in their first golden eras, but now more reflective, more mature.

We were also focusing on the art of the magazine – how to make it feel and look. The ad pages were coming in big, and we had a lot of space to devote to photography portfolios and design. We were still in the oversize format, rocking out big, thick issues every two weeks, and there was a lot of room to stretch.

I always loved to collaborate with art directors because, after myself, they usually had the broadest understanding of how to frame the editorial voice. Roger Black got it better than anyone, perhaps because he was grounded in a strong journalistic foundation. He solidified RS's classic

look, modernized our funky first logo and commissioned a special typeface, called, at first, ROLLING STONE Roman, now known as Parkinson, after its designer.

And then we discovered a freelance photographer, Mark Seliger, who shot more like Annie than anyone I had seen. He followed in her footsteps as our next chief photographer, establishing his own soulful style. Annie did about 150 RS covers; Mark, as we turn 50, has done nearly 200.

Meanwhile, a lot more media were trying to cover our beat and the stories we used to own – *The New York Times, The New Yorker, 60 Minutes* – heavy hitters with deep pockets, and we thrived on the competition. In addition to the best, most in-depth coverage of music, and with our great ear and eye for pop culture and its excesses and what it was trying to say about society, we plowed ahead. Hunter came back with his last two major pieces, "Fear and Loathing in Elko" (1992) and "Polo Is My Life" (1994), funnier and weirder, and once more at the top of his game. We published an electrifying investigation of Scientology, and our piece "Fast-Food Nation" was a huge hit.

"The Runaway General," another five-bells journalistic coup, made global headlines and prompted President Obama to fire Gen. Stanley McChrystal, his top commanding general in Afghanistan, because of what we uncovered about McChrystal's failing wartime leadership.

Matt Taibbi, who had been running a controversial paper in Moscow, joined us in 2004, bringing us his acid wit and hard, original, pound-the-pavement reporting. He's probably our best political reporter ever, and a journalistic star. His image of the giant investment banks as the "great vampire squid" is a phrase that will live in history.

* * *

WE HAVE GOTTEN OURSELVES in front of a lot of issues and devoted coverage for many years to the failure and insanity of the War on Drugs and the need for criminal-justice reform. Because of John Lennon's murder, we dove into gun control and the despicable role of the NRA, and have been pounding away on this subject ever since.

Probably no single issue has gotten as much space in the magazine in recent years as climate change. We have recruited the best environmental reporters around and have been a home for some of Al Gore's most important reports on the crisis.

And no discussion of modern ROLLING STONE can be had without an understanding of what Bruce Springsteen and Bono have meant to us, and to me personally. They are the rightful heirs of Bob Dylan and the Rolling Stones, as connected to their times and this moment as anyone has ever been. They have been true friends to me, my family and my magazine.

* * *

LOOKING BACK, ROLLING STONE now seems somehow larger than life, a great stage for the legends of modern journalism. There was a supporting cast, of course, a truly motley, sometimes crazy crew – now numbering in the hundreds – people who made substantive, serious contributions to ROLLING STONE. They know who they are; they each shared a special partnership with me personally and with the mission of ROLLING STONE. I could never forget any of it, or any of you.

Our political coverage and advocacy of progressive ideals and a broad definition of human rights are a part of everything we do. We expanded on our 1972 campaign coverage with a commitment to a serious National Affairs piece in practically every issue. Our place in politics and appetite for it, and our voice, grew stronger as our fellow baby boomers and our friends fought in the presidential arena: Bill and Hillary Clinton, Al Gore, John Kerry and Barack Obama, who has been on our cover nine times during his presidency.

So, I think of my generation's presidents and near-presidents much like the musicians and great artists whom I have loved and backed and advocated for. We thought they were of historic importance and we intended to be their voice, both for their fans and for the ages. The Nobel Prize Dylan received in December 2016 validates the significance of his work, those who followed in his footsteps and the support we have given them. I see them all as a great family, sharing, defining and trying to shape their times for the betterment of us all.

ROLLING STONE, as a body of work, is a true and accurate and passionate account of a generation of Americans. And it has been the pleasure and privilege of a lifetime to have also been on that stage.

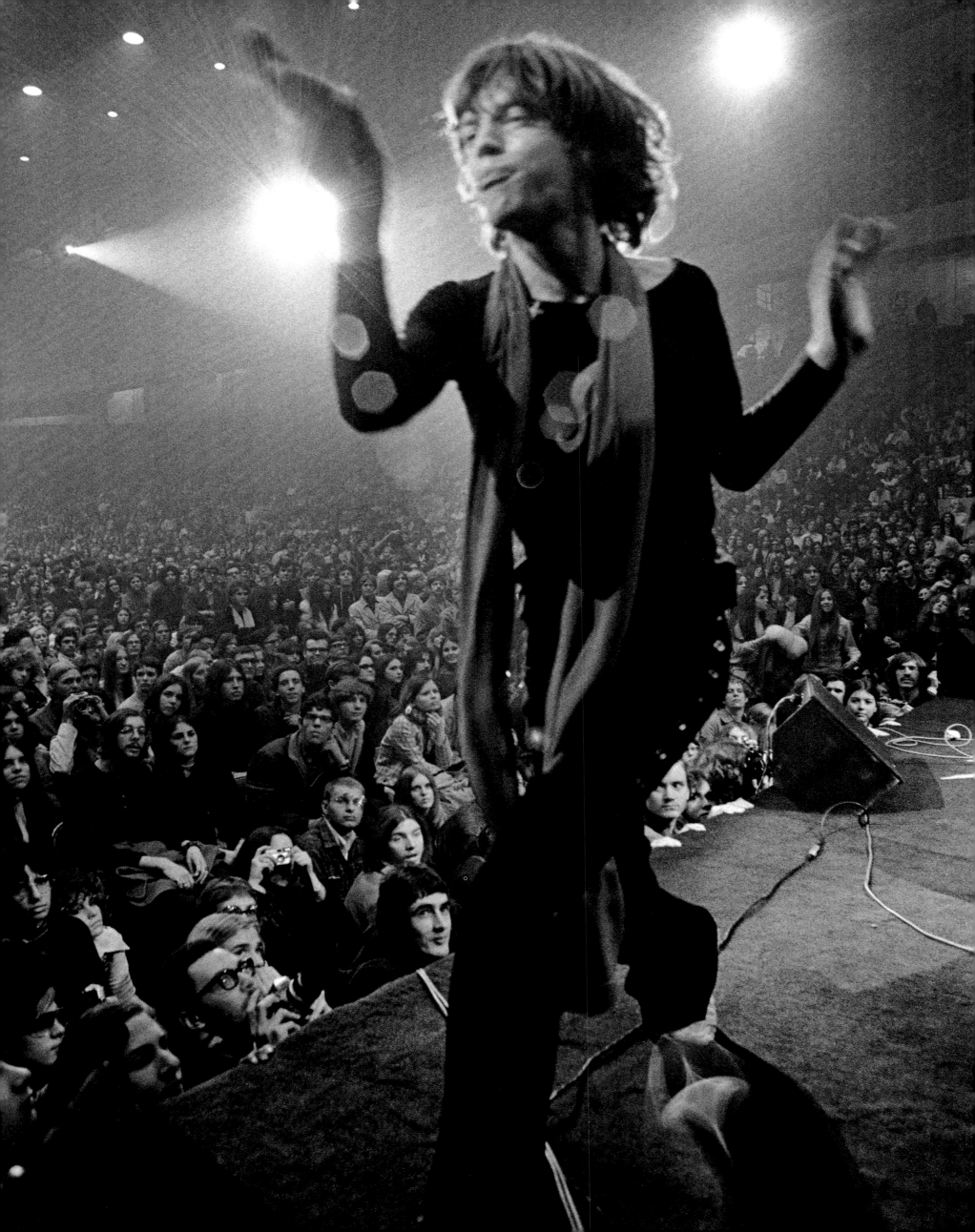

F ROM THE START, *ROLLING STONE* WAS PART MAGAZINE, part newspaper – the first issue, in November 1967, established the rigor of its journalistic intentions with a follow-the-money investigation into the Monterey Pop festival – but it was lit from the inside with the rebellious spirit of the music it covered. The first-anniversary issue featured the nude self-portraits that John Lennon and Yoko Ono had used for the cover of their *Two Virgins* album (hidden in a brown-paper wrapper for the album itself, but set free by ROLLING STONE), and an ad in RS 5 offered a different kind of subscription premium: a roach clip. By RS 16, the sculptor who'd designed that roach clip, Robert Kingsbury, had become the magazine's art director. Yet ROLLING STONE was as serious as it was different, and musicians responded: The ROLLING STONE Interview became the forum where artists such as Lennon, Mick Jagger, Bob Dylan and Pete Townshend delivered the definitive statements on their work and lives. ¶ The magazine was a vital document of a world coming into being. ROLLING STONE's first chief photographer, Baron Wolman, defined the emerging language of rock photography in its pages, and young writers – many of whom would become the key voices of music criticism, such as Greil Marcus, Jon Landau and Lester Bangs – explored rock & roll's meaning and potential. The wide-ranging purview included covers reaching back to rock & roll pioneers such as Elvis Presley and Chuck Berry, along with jazz musicians like Miles Davis and Sun Ra. And there was politics as well – as the cover of one issue in 1969 put it, it was a time of American Revolution.

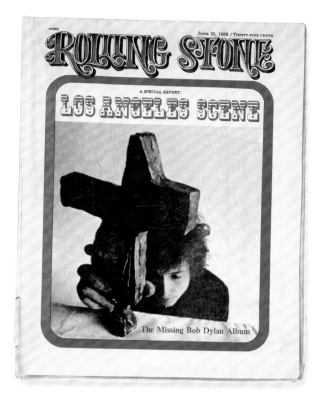

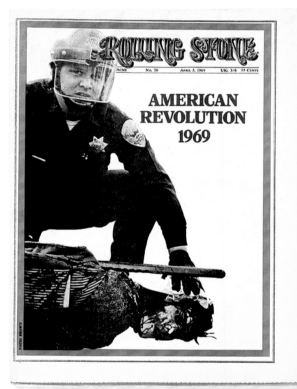

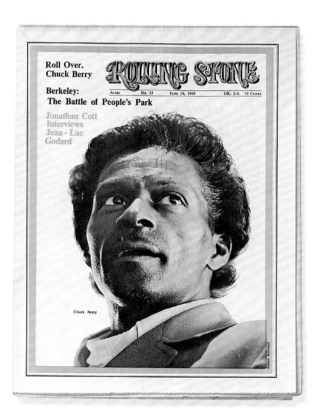

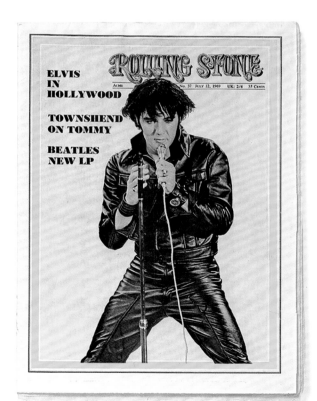

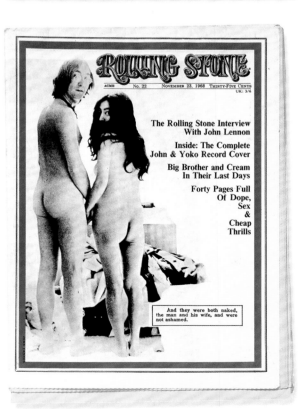

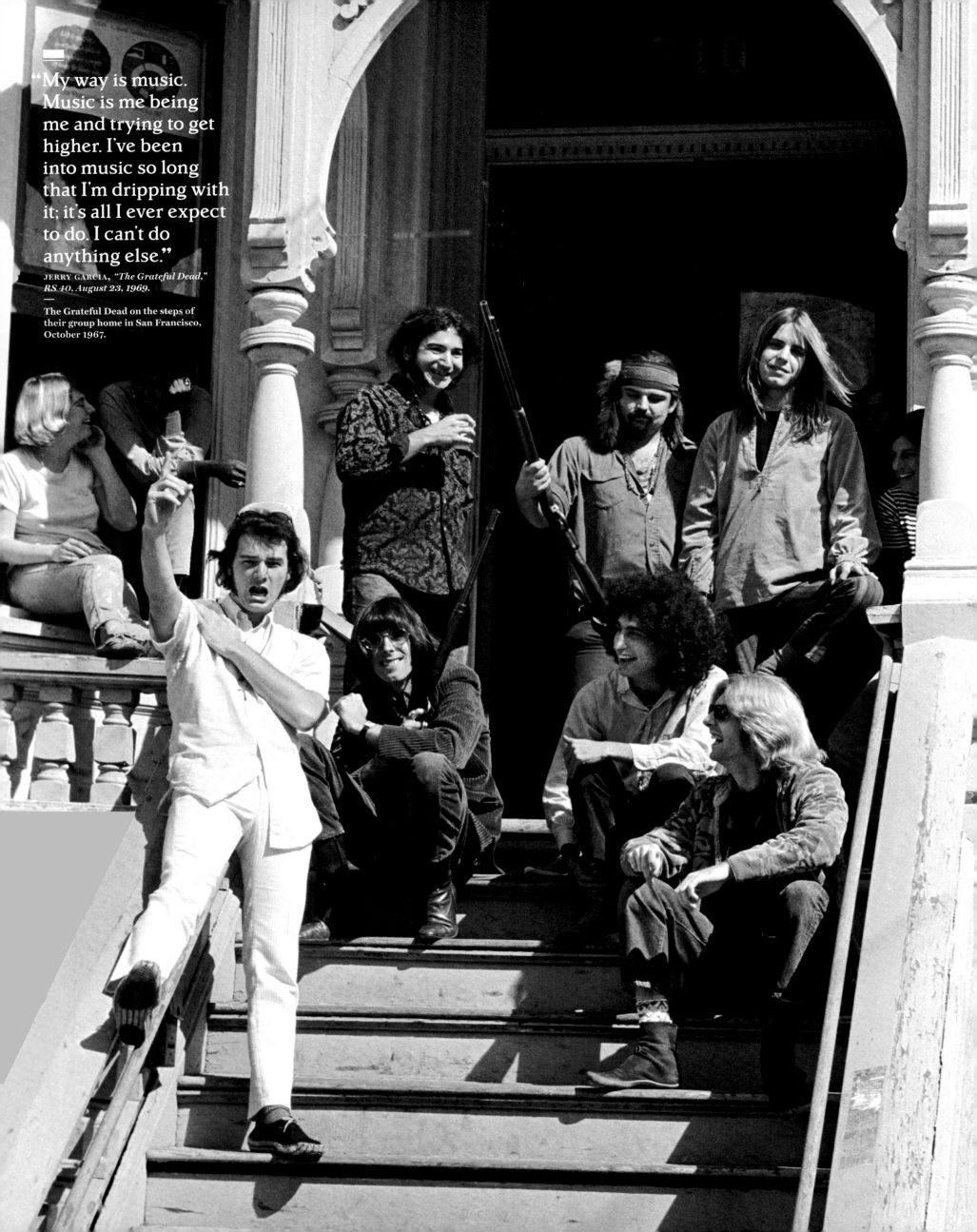

"My way is music. Music is me being me and trying to get higher. I've been into music so long that I'm dripping with it; it's all I ever expect to do. I can't do anything else."

JERRY GARCIA, *"The Grateful Dead,"* *RS 40, August 23, 1969.*
—
The Grateful Dead on the steps of their group home in San Francisco, October 1967.

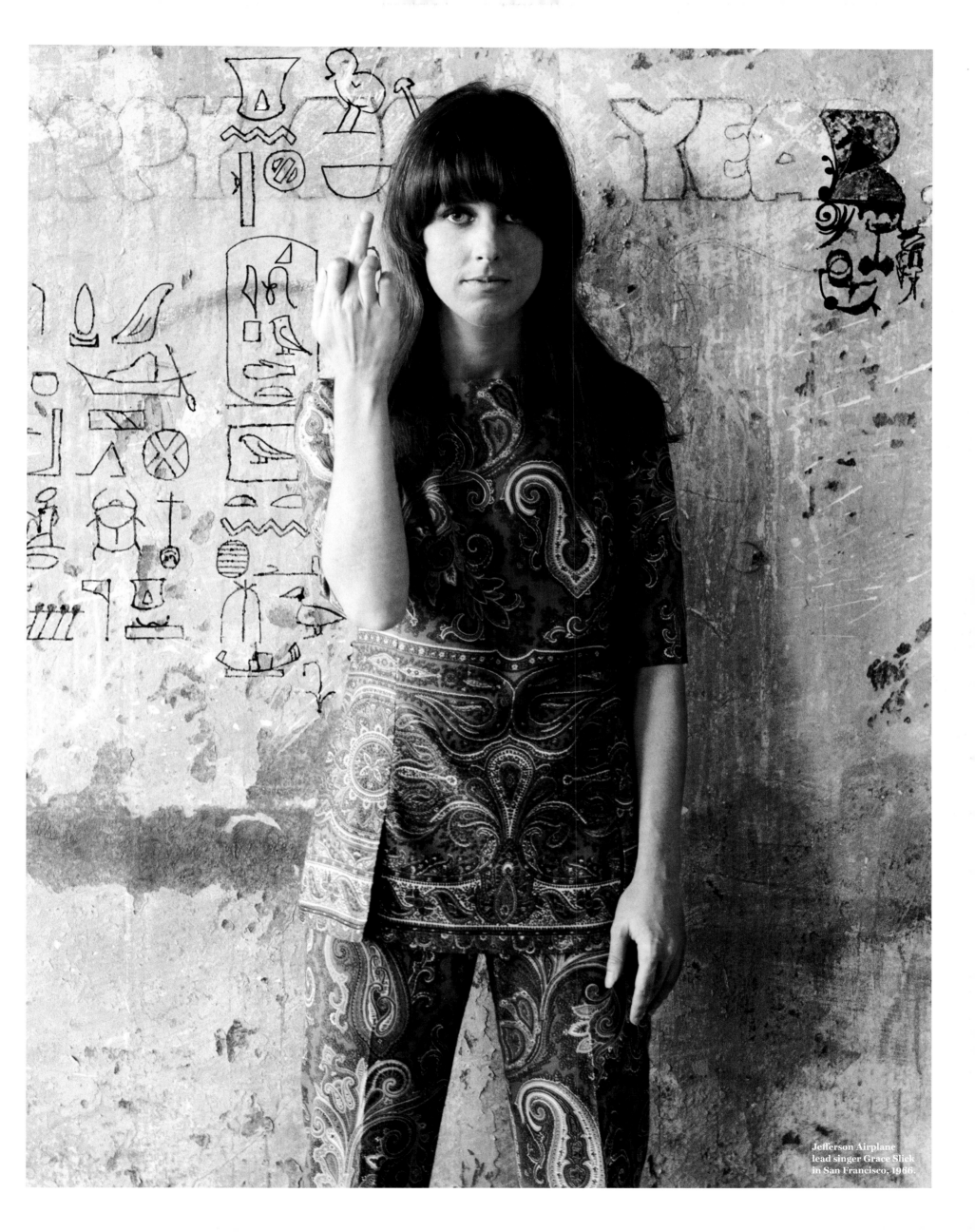

Jefferson Airplane
lead singer Grace Slick
in San Francisco, 1966.

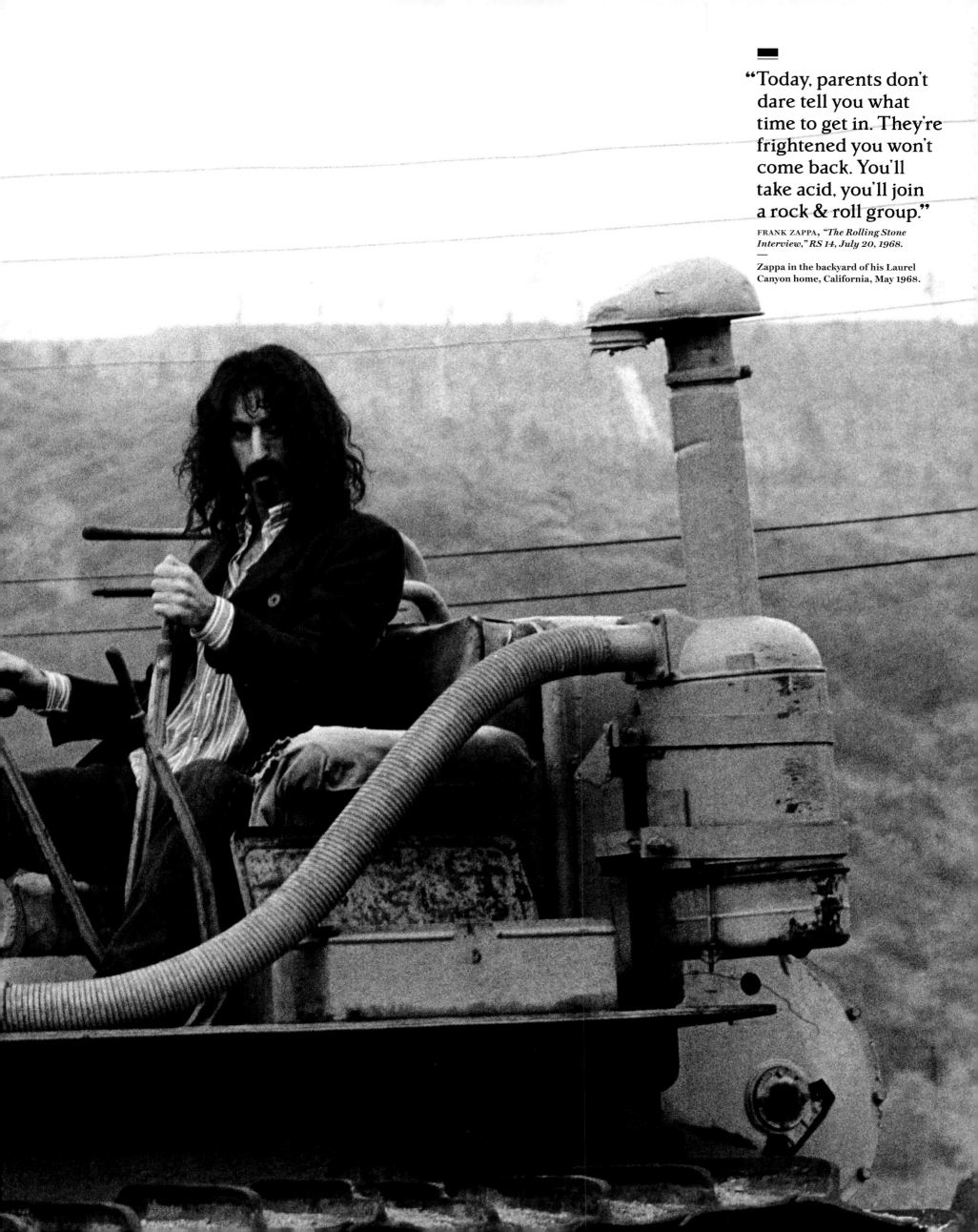

"Today, parents don't
dare tell you what
time to get in. They're
frightened you won't
come back. You'll
take acid, you'll join
a rock & roll group."

FRANK ZAPPA, *"The Rolling Stone
Interview," RS 14, July 20, 1968.*
—
**Zappa in the backyard of his Laurel
Canyon home, California, May 1968.**

Pete Townshend

By Jann S. Wenner

RS 17 & 18 • SEPTEMBER 14 & 28, 1968

ROLLING STONE had run Q&A's since its first issue, but the two-part Pete Townshend interview that ran in 1968 is considered the first fully realized ROLLING STONE Interview. Jann S. Wenner was inspired by the far-ranging interviews in *The Paris Review* and *Playboy*, and applied the same rigorous, in-depth questioning – sometimes over a period of weeks – to rock stars, with startling results. The Townshend interview was so revealing, in fact, at one point Townshend asked if Wenner had spiked his orange juice with LSD. (He hadn't.) Townshend talked about his ambitions and explained the ideas behind the album that the Who would start recording just a month after this interview was conducted: *Tommy.* He'd later say it was the first time he'd ever sketched out that album in full, even to himself.

I *imagine it gets to be a drag talking about why you smash your guitar.*

No, it doesn't get to be a drag to talk about it. Sometimes it gets [to be] a drag to do it. I can explain it, I can justify it, and I can enhance it, and I can do a lot of things, dramatize it and literalize it. Basically it's a gesture which happens on the spur of the moment. I think, with guitar smashing, just like performance itself, it's a performance, it's an act, it's an instant, and it really is meaningless.

When did you start smashing guitars?

It happened by complete accident the first time. We were just kicking around in a club which we played every Tuesday, and I was playing the guitar and it hit the ceiling. It broke and it kind of shocked me 'cause I wasn't ready for it to go. I didn't particularly want it to go, but it went.

And I was expecting an incredible thing, it being so precious to me, and I was expecting everybody to go, "Wow, he's broken his guitar," but nobody did anything, which made me kind of angry in a way, and determined to get this precious event noticed by the audience. I proceeded to make a big thing of breaking the guitar. I pounced all over the stage with it and I threw the bits on the stage and I picked up my spare guitar and carried on as though I really meant to do it.

Were you happy about it?

Deep inside I was very unhappy, because the thing had got broken. It got around and the next week the people came and they came up to me and they said, "Oh, we heard all about it, man; it's 'bout time someone gave it to a guitar" and all this kind of stuff. It kind of grew from there. We'd go to another town and people would say, "Oh, yeah, we heard that you smashed a guitar." It built and built until one day, a very important daily newspaper came to see us and said, "Oh, we hear you're the group that smashes their guitars up. Well, we hope you're going to do it tonight, because we're from the *Daily Mail*. If you do, you'll probably make the front pages."

This was only going to be, like, the second guitar I'd ever broken, seriously. I went to my manager, Kit Lambert, and I said, you know, "Can we afford it, can we afford it, it's for publicity."

He said, "Yes, we can afford it, if we can get the *Daily Mail*." I did it and of course the *Daily Mail* didn't buy the photograph and didn't want to know about the story. After that I was into it up to my neck and have been doing it since.

Was it inevitable that you were going to start smashing guitars?

It was due to happen because I was getting to the point where I'd play and I'd play and, I mean, I still can't play how I'd like to play. *Then* it was worse. I couldn't play the guitar; I'd listen to great music, I'd listen to all the people I dug, time and time again.... I couldn't get it out. I knew what I had to play, it was in my head. I could hear the notes in my head, but I couldn't get them out on the guitar.... It used to frustrate

> "My visual thing was more my music than the actual guitar. I got to jump about, and the guitar became unimportant."

me incredibly. I used to try and make up visually for what I couldn't play as a musician. I used to get into very incredible visual things where in order just to make one chord more lethal, I'd make it a really lethal-looking thing, whereas really it's just going to be picked normally. I'd hold my arm up in the air and bring it down so it really looked lethal, even if it didn't sound too lethal. Anyway, this got bigger and bigger and bigger and bigger until eventually I was setting myself incredible tasks.

How did this affect your guitar playing?

Instead I said, "All right, you're not capable of doing it musically, you've got to do it visually." I[t] became a huge, visual thing. In fact, I forgot all about the guitar because my visual thing was more my music than the actual guitar. I got to jump about, and the guitar became unimportant. I banged it and I let it feed back and scraped it and rubbed it up against the microphone, did

anything, it wasn't part of my act, even. It didn't deserve any credit or any respect. I used to bang it and hit it against walls and throw it on the floor at the end of the act.

And one day it broke.

I forget if I read this or whether it is something [engineer and producer] Glyn Johns told me. You and the group came out of this rough, tough area, were very restless and had this thing: You were going to show everybody – you were a kid with a big nose and you were going to make all these people love it, love your big nose.

That was probably a mixture of what Glyn told you and an article I wrote.... When I was in school, the geezers that were snappy dressers and got chicks like years before I ever even thought they existed, would always like to talk about my nose. This seemed to be the biggest thing in my life: my fucking nose, man. Whenever my dad got drunk, he'd come up to me and say, "Look, son, you know looks aren't everything" and shit like this. He's getting drunk and he's ashamed of me because I've got a huge nose and he's trying to make me feel good. I know it's huge and of course it became incredible and I became an enemy of society. I had to get over this thing. I've done it, and I never believe it to this day, but I do not think about my nose anymore. And if I had said this when I was a kid, if I ever said to myself, "One of these days you'll go through a whole day without once thinking that your nose is the biggest in the world, man" – I'd have laughed.

It was huge. At that time, it was the reason I did everything. It's the reason I played the guitar – because of my nose. The reason I wrote songs was because of my nose, everything, so much. I eventually admitted something in an article where I said that what I wanted to do was distract attention from my nose to my body and make people look at my body, instead of at my face – turn my body into a machine. But by the time I was into visual things like that anyway, I'd forgotten all about my nose and a big ego trip and I thought, "Well, if I've got a big nose, it's a groove and it's the greatest thing that can happen because, I don't know, it's like a lighthouse or something." The whole trip had changed by then anyway.

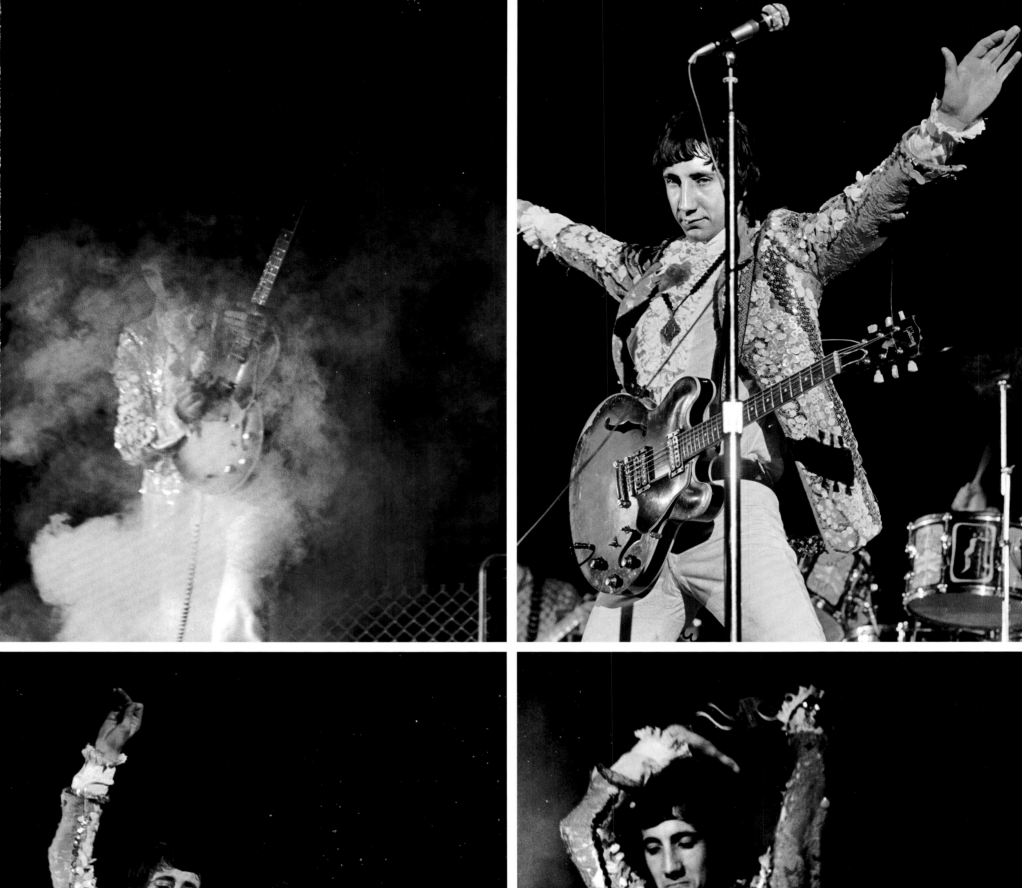

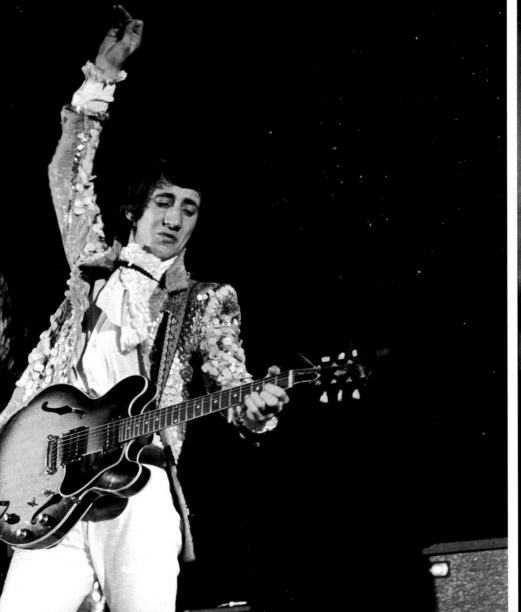

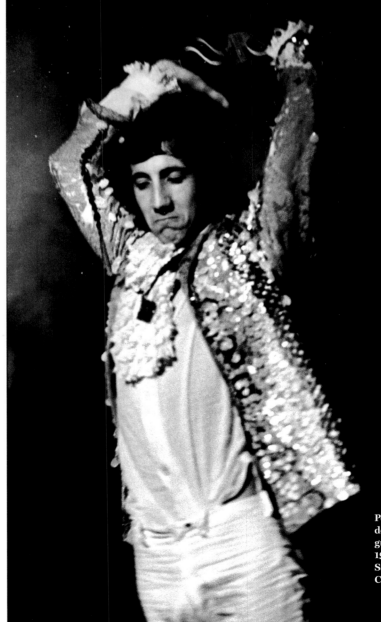

Pete Townshend
destroys his
guitar during a
1967 concert at
San Francisco's
Cow Palace.

Taj Mahal at his home in Topanga Canyon, California, December 1968.

"I'd produce Bob Dylan. You see, he's never been produced. He's always gone into the studio on the strength of his lyrics, and they have sold enough records to cover up everything – all the honesty of his records. But he's never really made a production. He doesn't really have to."

PHIL SPECTOR, *"The Rolling Stone Interview," RS 45, November 1, 1969.*

—

Spector at home in Beverly Hills, 1969.

The Woodstock Festival

By Greil Marcus

RS 42 • SEPTEMBER 20, 1969

Three ROLLING STONE staffers – chief photographer Baron Wolman, reviews editor Greil Marcus and Jan Hodenfield, the magazine's New York bureau chief – departed New York City for Woodstock early on Friday, August 15th, 1969. Less than 10 miles from the site, they encountered the flood of cars that caused a traffic snarl of mythic proportion. "Automotive casualties looked like the skeletons of horses that died on the Oregon Trail," wrote Marcus. Woodstock was a moment when the mainstream media – or the straight press, as it was known in the Sixties – intersected with the world of ROLLING STONE. As Hodenfield noted in his reporting on the festival's mechanics (full of details like an estimated 500,000 long-distance calls through the area's main switchboard on Friday night, with a local operator telling him, "Every kid said thank you"), *The New York Times* had run an editorial denouncing the festival as an "outrageous episode," then followed it with another acknowledging it as "essentially a phenomenon of innocence." Marcus wrote about the festival itself: the rain and mud, the way the crowd "turned calamity into celebration," and the music. One highlight was Crosby, Stills, Nash and Young, in the hours before sunrise on Monday morning.

Thirty-two acts played, including Jimi Hendrix and the Who, but ROLLING STONE's cover featured Woodstock Nation itself.

SOMETIME AROUND FOUR IN THE MORNING THE STAGE CREW BEGAN TO assemble the apparatus for the festival's most unknown quantity, Crosby, Stills, Nash and Young. This was not exactly their debut – they'd played once or twice before, but this was a national audience, both in terms of the factual composition of the crowd and the press and because of the amazing musical competition with which they were faced.

It took a very long time to get everything ready, and the people onstage crowded around the amplifiers and the nine or 10 guitars and the chairs and mics and the organ, more excited in anticipation than they'd been for any other group that night. A large semicircle of equipment protected the musicians from the rest of the people. The band was very nervous – Neil Young stalking around, kissing his wife, trying to tune his guitar off in a corner, kissing his wife again, staring off away from the crowd. [Stephen] Stills and [Graham] Nash paced and tested the organ and the mics, and drummer Dallas Taylor fiddled with his kit and kept trying to make it more than perfect. Finally they went on.

Crosby, Stills and Nash opened with "Judy Blue Eyes," stretching it out for a long time, exploring the figures of the song for the crowd, making their quiet music and flashing grimaces when something went wrong. They strummed and picked their way through other numbers, and then began to shift around, [David] Crosby singing with Stills, then Nash and Crosby, back and forth. They had the crowd all the way. Many have remarked that their music is perfect, but sterile; that night it wasn't quite perfect and it was anything but sterile. They seemed like several bands rather than one.

After perhaps half an hour Neil Young made his way into the band and sat down with Stills, and the two of them combined for an extraordinary acoustic version of "Mr. Soul." Stills pushed stinging blues out of his guitar and Young's singing was as disturbing and compelling as ever. From that point they just took off. They switched to rock & roll and a grateful electricity. At one point, Crosby nearly fell off the stage in his excitement.

Deep into the New York night they were, early [Monday] morning in the dark after three days of chaos and order, and it seemed like the last of a thousand and one American nights. Two hundred thousand people covered the hills of a great natural amphitheater, campfires burning in the distance, the lights shining down from the enormous towers onto the faces of the band. Crosby, Stills, Nash and Young were just one of the many at this festival, and perhaps they wouldn't top the bill if paired with Hendrix or the Airplane or Creedence Clearwater or the Who or the Band, but this was their night, and I don't believe it could have happened with such power anywhere else. This was a festival that had triumphed over itself.

* * *

AT THE FESTIVAL, thousands were able to do things that would ordinarily be considered rebellious. Selling and using all kinds of dope, balling here, there and everywhere, running around naked, and, believe it or not, *staying up all night* – one could do all of these things simply because they were fun to do, not because such acts represented scoring points against parents or Richard Nixon or *Reader's Digest.*

The now-famous Dope Supermarket is a case in point. Off in the woods, on the crossroads of "Groovy Way" and "Gentle Path," right next to an overpriced bead shop, a dozen dope dealers called out for their wares. "Hash? Acid? *Really* good mescaline?" "Who's got opium?" "He does, he does, the cat in the red jacket." "Who's got grass?"

A photographer came by. "Hey," yelled the guy with the opium, "take *my* picture." There was no sense of cheating the cops out of a bust. Kids who had their first taste of dope or sex or nudity at Woodstock might remember later that these were acts that at least *somebody* thought were wrong, but at the festival it was as natural as cruising Main Street or catching a subway.

This is not to say that repression has vanished overnight, or vanished at all, but rather that the festival created and provided a place of freedom. The promoters laid the roads and brought in the music and built a Babylonian hanging garden sound system, and the kids did the rest.

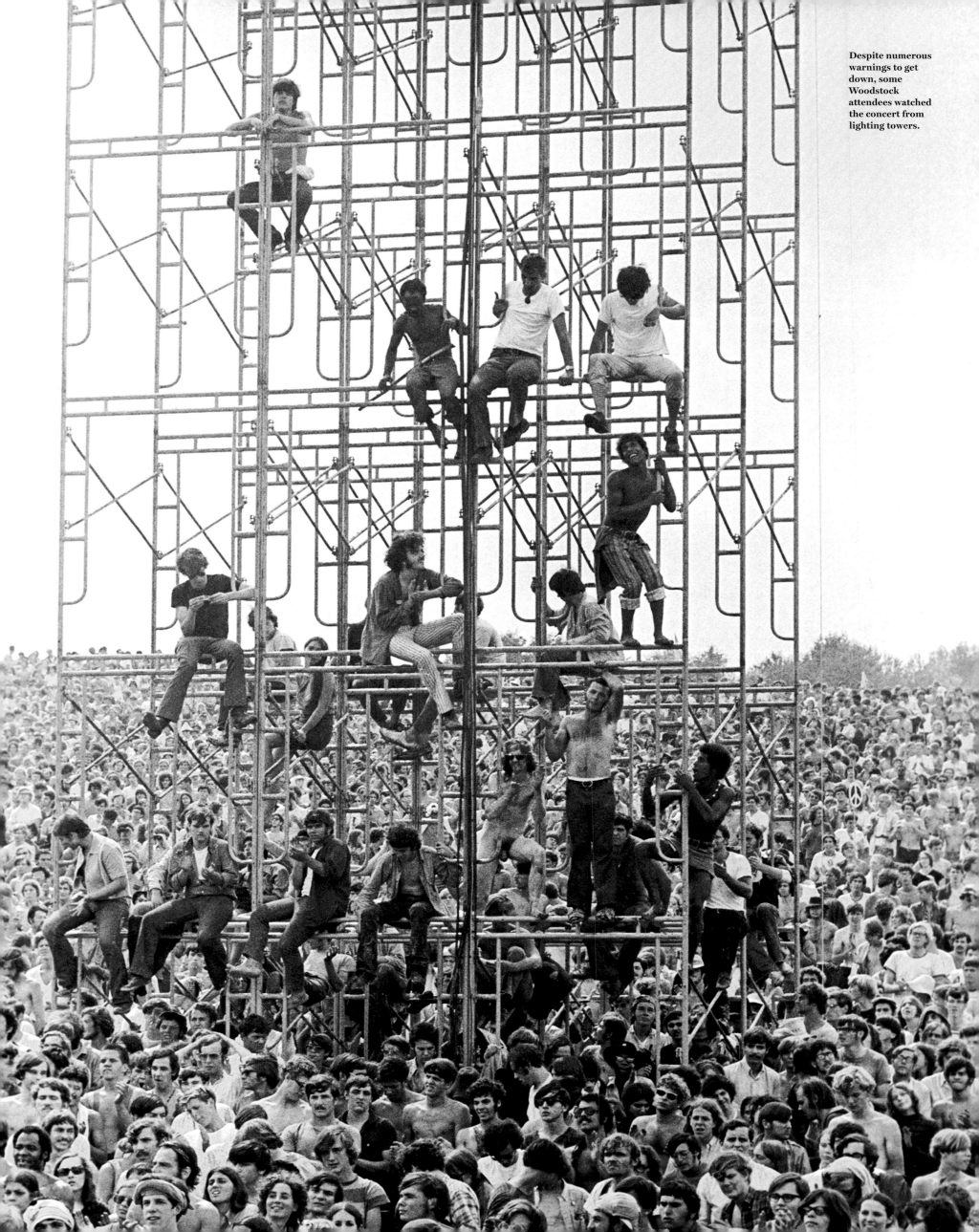

Despite numerous warnings to get down, some Woodstock attendees watched the concert from lighting towers.

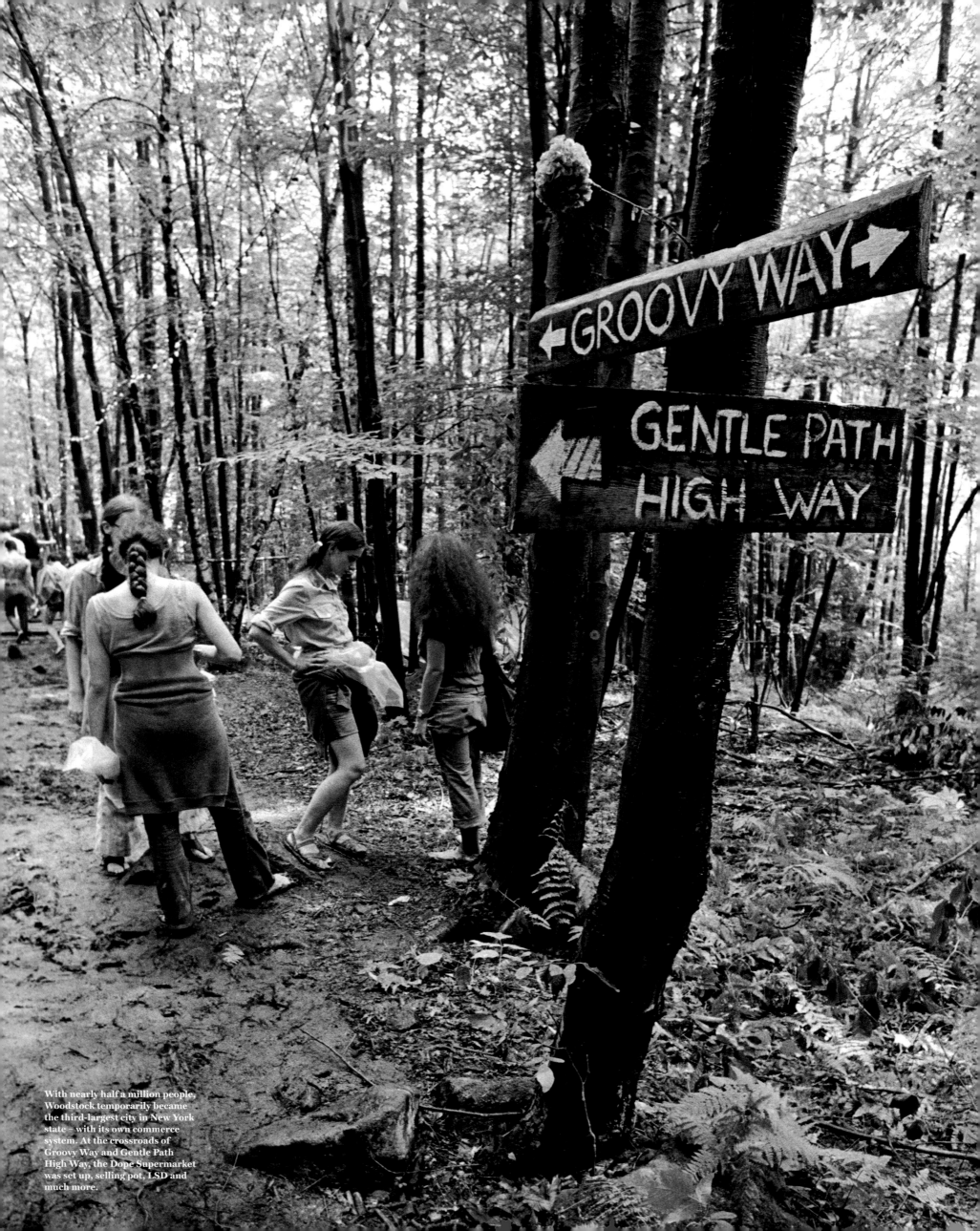

With nearly half a million people, Woodstock temporarily became the third-largest city in New York state – with its own commerce system. At the crossroads of Groovy Way and Gentle Path High Way, the Dope Supermarket was set up, selling pot, LSD and much more.

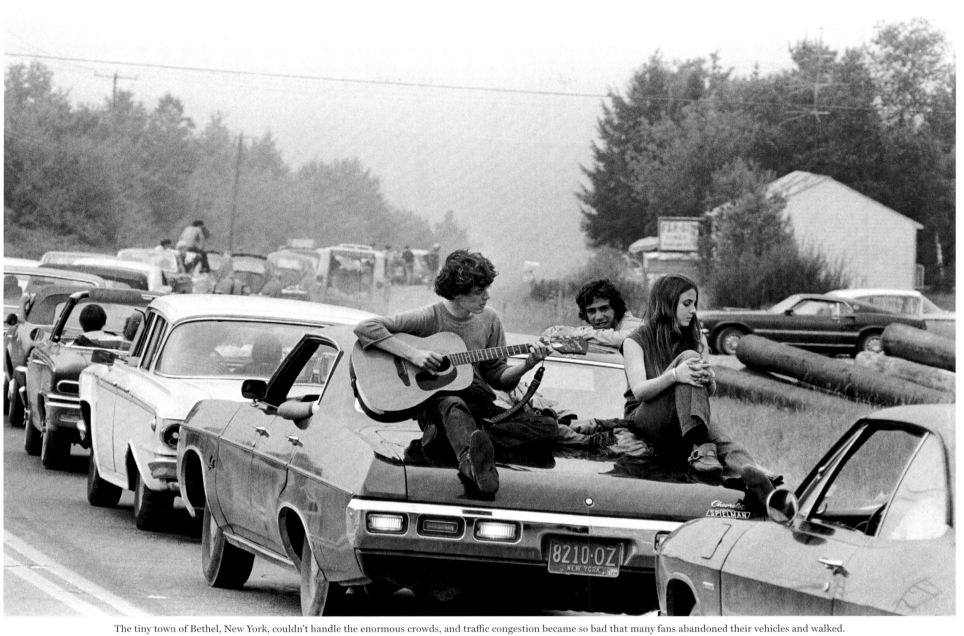

The tiny town of Bethel, New York, couldn't handle the enormous crowds, and traffic congestion became so bad that many fans abandoned their vehicles and walked.

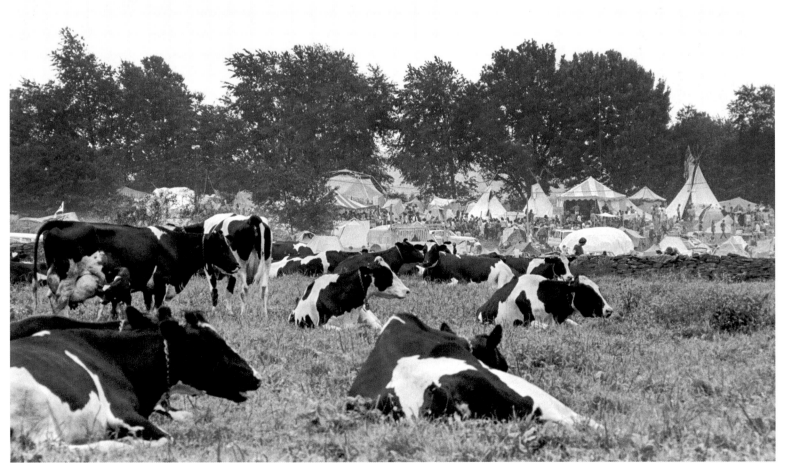

Dairy farmer Max Yasgur allowed the Woodstock organizers to completely take over his farm, and for that very memorable weekend more than 400,000 hippies peacefully shared the land with his cows.

Joni Mitchell at
her Laurel Canyon
home, 1968.

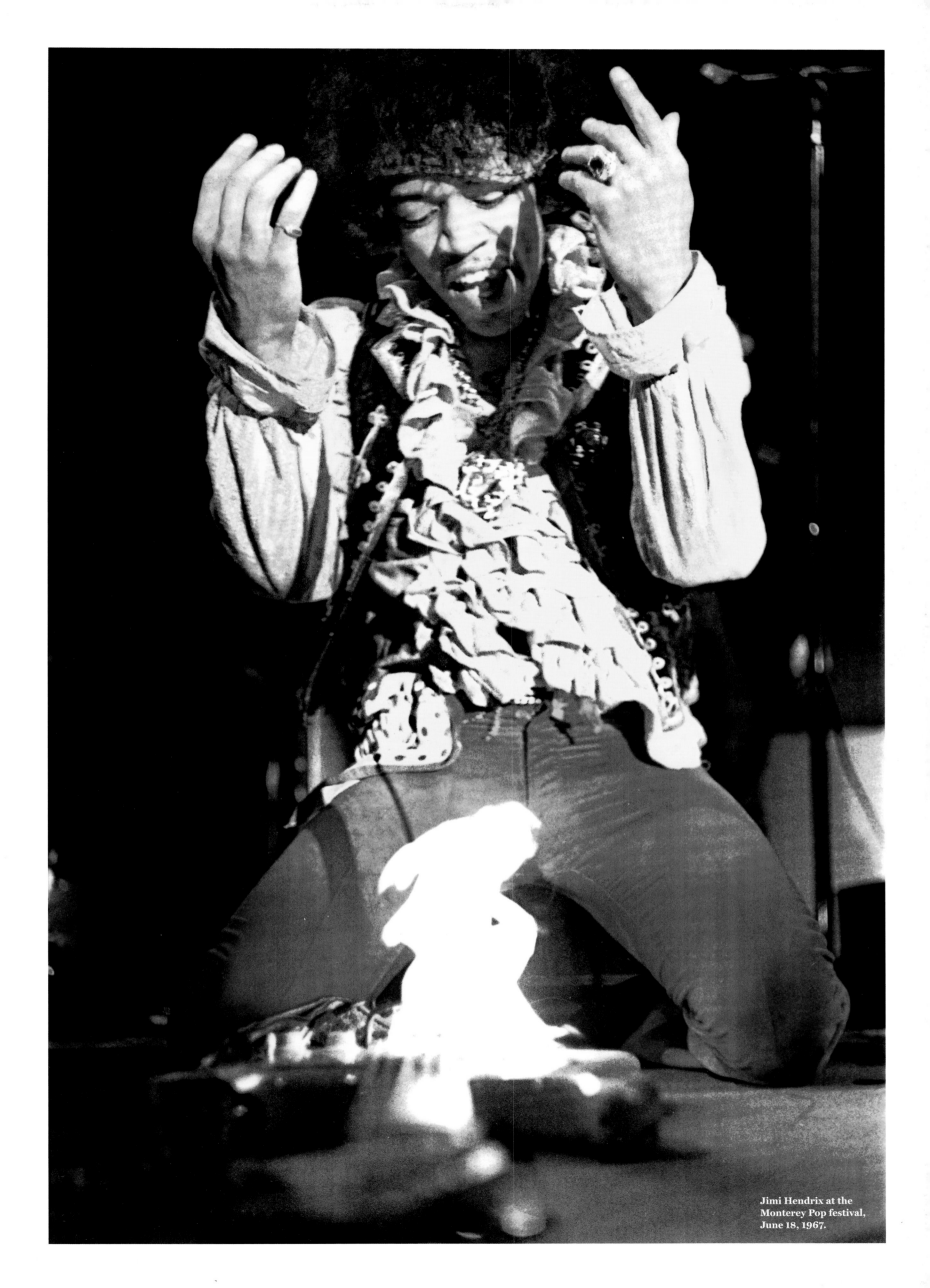

Jimi Hendrix at the
Monterey Pop festival,
June 18, 1967.

The Groupies and Other Girls

A cover story that opened the backstage door to a new subculture

RS 27 • FEBRUARY 15, 1969

"I T'S A LIFE WITH A LOT OF PAIN, BEING A GROUPIE," SALLY MANN told ROLLING STONE. "People just leave you, always leaving you." At 20, Mann had already retired from four years on the scene that ROLLING STONE chronicled in an issue timed to Valentine's Day in 1969 – though she was still intimately connected to the rock & roll life. She lived with the Jefferson Airplane in a San Francisco mansion, which wasn't as glamorous as it sounded. She cooked, cleaned, answered the phone and did "a host of other chores, for which she is paid nothing except the gratitude of the Airplane," the magazine explained. Her mom lived in a small San Francisco apartment with Mann's baby son. Rock & roll was, Mann said, "one of the most important things happening anywhere, and I just want to be part of it."

"The Groupies and Other Girls" was a team report by John Burks, Jerry Hopkins and Paul Nelson, with striking pictures from Baron Wolman, the magazine's first chief photographer, that were by turns joyous and poignant. In 15 pages and more than 20,000 words, the cover-story package opened the backstage door to a world few knew even existed. So few, in fact, that ROLLING STONE took the unusual step of placing a full-page ad in *The New York Times* announcing the special issue. "When we tell you what a groupie is, will you really understand?" the ad read.

The groupie lifestyle offered freedom, Mann explained. "In plastic terms – in sensual terms – where can you get more sensations?" she said. "You get to ball, smoke dope, dress weird, be groovy, be around nothing but groovy people – all at once."

At the center of the cover package were stories like Mann's and those of other young women who were "freedom fighters at the avant-garde of the Sexual Revolution that is sweeping Western Civilization." That's how Frank Zappa saw them. "It's amazing what you run into on the road," he said. "I think pop music has done more for oral intercourse than anything else that ever happened, and vice versa."

Zappa was one of many musicians ROLLING STONE talked to – including Jimmy Page, Jimi Hendrix, Jeff Beck and Steve Miller – and he had become something of an impresario in

Karen Seltenrich in San Francisco, 1968.

the groupie subculture. The story featured the Plaster Casters of Chicago, two women who made casts of rock stars' phalluses. (Hendrix was an early subject.) "Some people condemn you for seeking friendship with someone famous and they call you a groupie," said Cynthia Plaster Caster. "Most of my friends are groupies." Zappa had taken the Plaster Casters under his wing. "I'm their adviser to see that they're not mistreated," he said, adding that he saw their work as something like public statuary honoring war heroes. Also featured was Girls Together Outrageously, a faux girl group that Zappa had organized around six Los Angeles women. The GTOs were about to release their first single, featuring Miss Pamela, later known as Pamela Des Barres. "Pamela has kept a diary reflecting her interest in groups," the article noted – a diary that would later form the backbone of her 1987 book, *I'm With the Band*.

Some women objected to being labeled groupies. "We're beyond the groupie things," Karen Seltenrich, who had gone from being a waitress at San Francisco rock club the Matrix to booking bands there, told ROLLING STONE. She preferred to think of herself and her friends as "band aids" – a term that would turn up 31 years later in Cameron Crowe's movie about a young ROLLING STONE reporter, *Almost Famous*.

The groupies cover story was full of the details and secrets of backstage life: the hotels where groupies found rock stars, the clinics where they went to treat VD, the difference between the scenes in San Francisco (where "open balling" wasn't a thing) and Los Angeles and New York (where it was).

And as with any revolution, there were casualties. "It's so phony, so plastic," said one of the women Wolman photographed – identified only as Lacy – of the groupie grind. She'd left Seattle for San Francisco, traveled with a band to London, then gone "skipping off into new things" in Paris, and now sounded tired of the whole scene. There weren't as many good bands, and her values had changed as she'd gotten a little older. "Going home with one cat after a gig," she said. "I found it really depressing after a while. It's at such a low level. It's not knowing anybody. It spoils any chance of making something deeper."

American Revolution 1969

Coverage of the protest movement swiftly turned into covering street fighting and police violence

RS 30 • APRIL 6, 1969

FROM ITS VERY FIRST ISSUE, *ROLLING STONE* HAD DEFINED ITS coverage as being "not just about music, but also about the things and attitudes that the music embraces." Of course, that meant politics as well, and in April 1969 the magazine devoted a special issue to "something hopefully titled 'The American Revolution – 1969,'" as an introductory editorial put it.

The focus of the coverage was the student protests then sweeping the country, with a history tracing their roots back to the Free Speech Movement at the University of California Berkeley in 1964, and a lead piece by one of the FSM leaders, Michael Rossman, along with an essay by George Mason Murray, the minister of education of the Black Panther Party. Murray's suspension from a teaching position at San Francisco State College in 1968 had prompted a student strike and clashes with the police the previous November. The cover photo (seen below) of a demonstrator beaten into bloody submission came from those protests.

The unrest was captured in the headline of Rossman's piece, taken from a lyric in the Rolling Stones' "Street Fighting Man": "The Sound of Marching, Charging Feet." Rossman's story was part report – as an observer and organizer, he had visited campuses across the country – and part manifesto. "America's 2,700 colleges form a great youth ghetto with 7,000,000 inhabitants," Rossman wrote. "Schools everywhere are alive with growth and tense with dread," and college campuses were "now coming alive with violence and change."

Rossman noted that rhetoric and action had "gone hard" in the circles he traveled in – "during pleasant nights in communes in San Francisco and Colorado, I watch friends oiling guns and learning how to load magazines; they offer to teach me to shoot" – and warned "the violence will increase."

He was right. On May 15th, just a month after Rossman's story, a protest over People's Park – a student- and community-constructed space near the Berkeley campus – turned deadly. "The Battle of People's Park" was a report from inside the chaos that resulted when then-governor of California Ronald Reagan called in the National Guard, after local

police had already used tear gas and buckshot, resulting in one death. "In many ways it followed the pattern of street fighting and police violence which has now become an American tradition," wrote Langdon Winner. "What was new about the Battle of People's Park was that for the first time in recent history the police gunned down white students in the streets."

But not the last. A year later, four students were shot dead at Kent State during protests following the escalation of the Vietnam War into Cambodia. ROLLING STONE took a phrase from President Richard Nixon's speech announcing the Cambodian action and turned it on its head, publishing a June 11th cover story called "On America 1970: A Pitiful Helpless Giant." Dispatches from around the country (as well as Saigon) formed a portrait of a nation collapsing in on itself: Two black students had been shot to death at Jackson State College in Jackson, Mississippi; there were riots in New Haven, Connecticut; and around 4 a.m. on May 9th, in the predawn hours, Nixon had made a visit to the Lincoln Memorial and had a strange encounter with protesters there. "He was mumbling at his feet," one of the protesters told John Morthland afterward. "He had makeup on all over, it was in his eyelashes."

"He looked very tired; he was hunched over, had his hands in his pockets, and was looking at the ground," another of the protesters told Morthland. "Nothing he was saying was coherent, or even in complete sentences. Nothing led in to the next thing he said."

Nixon's behavior was odd enough that ROLLING STONE reporter Jon Carroll called the White House to ask if the president had been using tranquilizers "or anything else." The official response: "The president was very tired" but was not under the influence.

At the center of the coverage, though, was John Lombardi's reconstruction of the events on the Kent State campus, which was full of heartbreaking details – 19-year-old Bill Schroeder had died wearing the orange pants he called his "'Brian Jones' bellbottoms" – and ended wondering if there was a way of bringing any real meaning to the deaths of four students. But in 19 pages of far-ranging reporting, ROLLING STONE was trying to do just that.

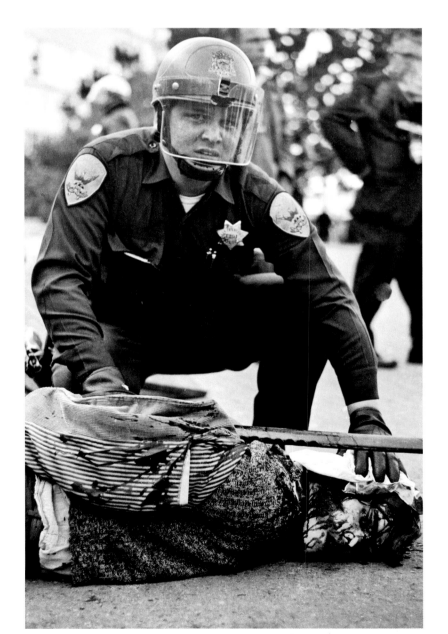

A protester beaten into submission at San Francisco State College, 1968.

Bob Dylan in New York's
Greenwich Village, 1963.

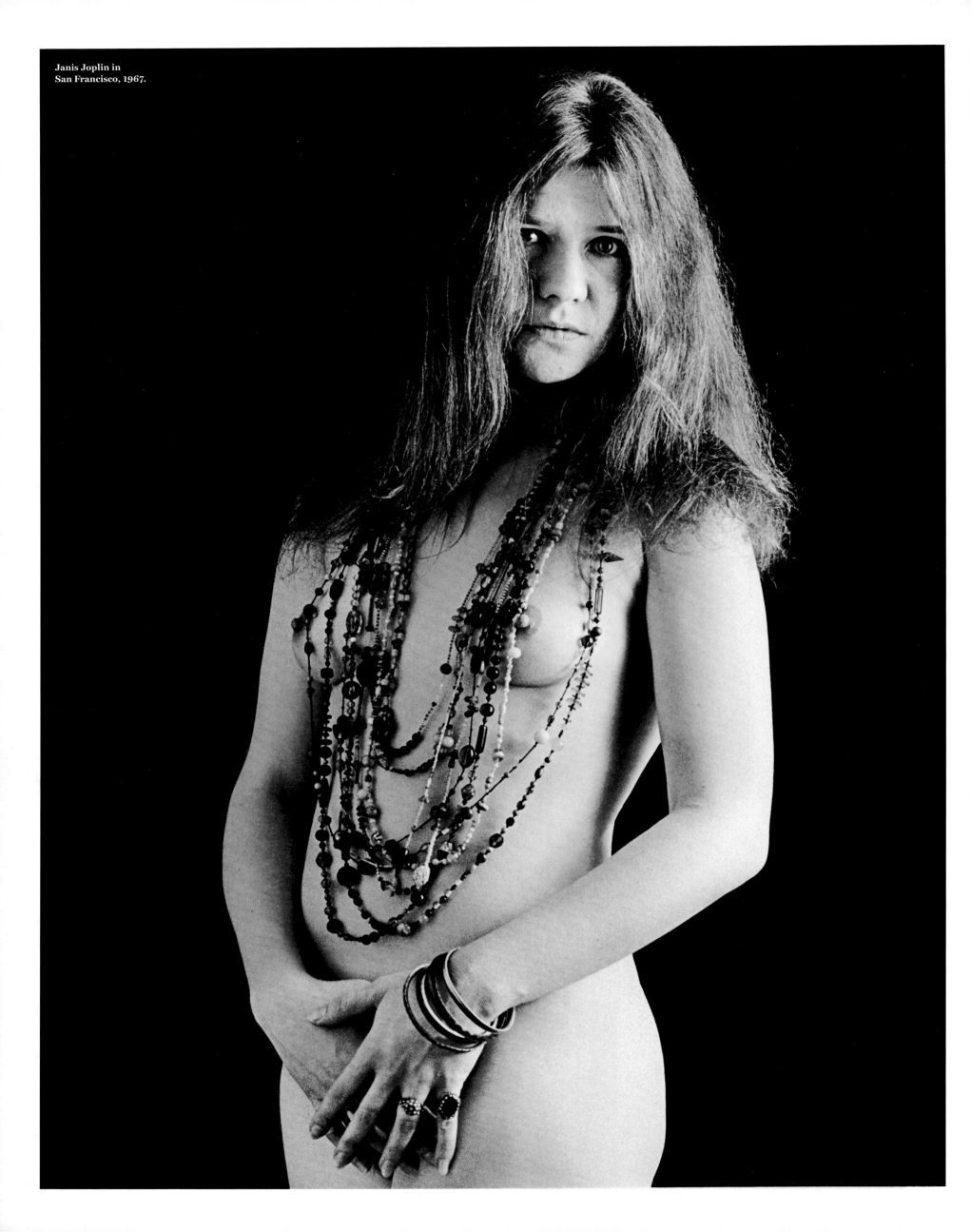

Janis Joplin in
San Francisco, 1967.

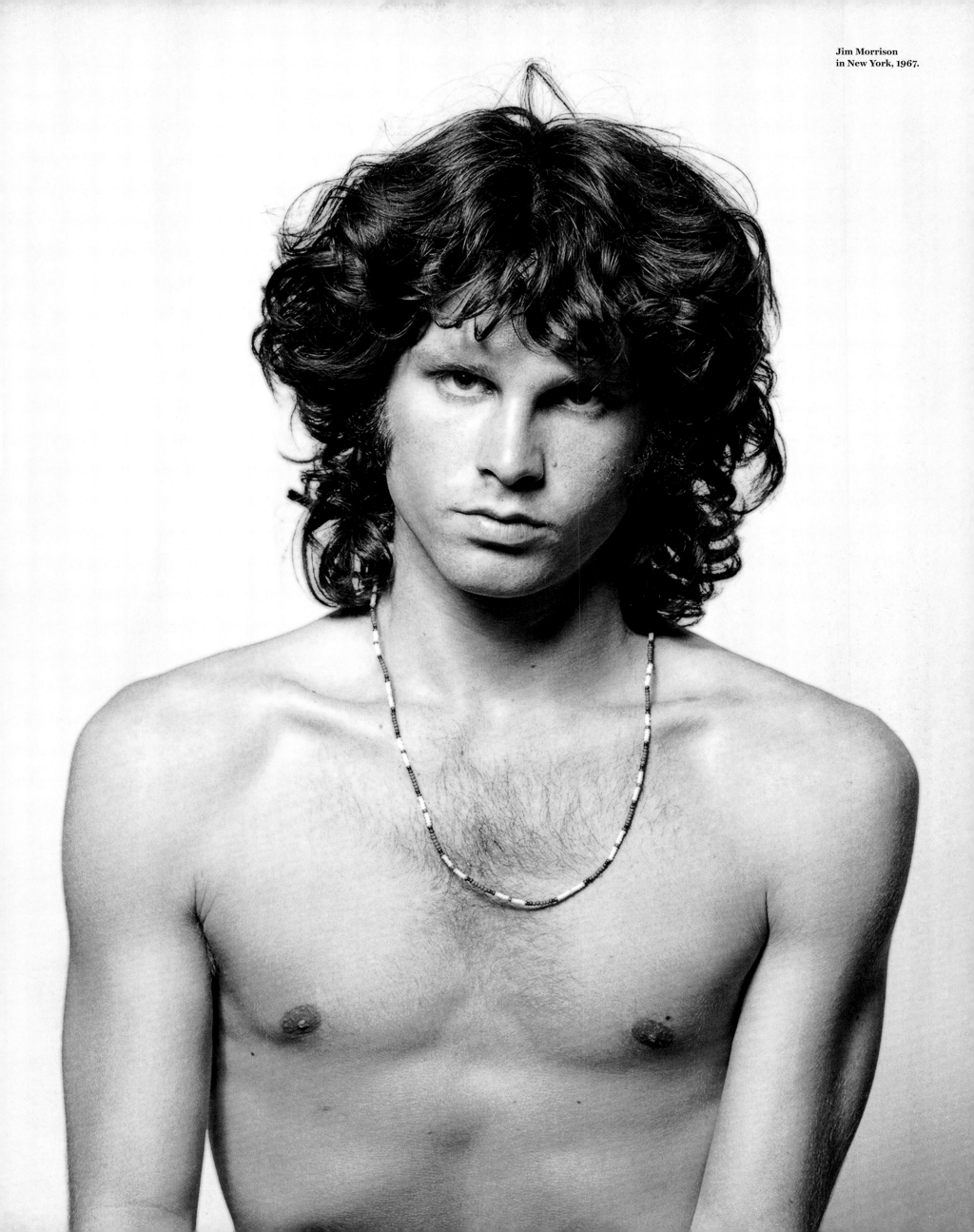

ROLLING STONE STARTED AS THE VOICE OF THE counterculture, but in the 1970s it became the voice of American culture. The magazine had unique access and insight from the start, and it began now to turn that into authoritative stories on events that defined not just rock & roll but the country itself: the Charles Manson murders, the kidnapping of Patty Hearst, the mysterious death of Karen Silkwood and its ties to the dangers of the nuclear-power industry. But ROLLING STONE set the pace with more than groundbreaking journalism as it began long associations with unique talents who changed the way people saw and thought about the world around them. Annie Leibovitz was a 20-year-old art student with a passion for photojournalism when she came to ROLLING STONE in 1970, the same year that saw the magazine publish its first story from Hunter S. Thompson. Over the next 13 years – 10 of them as the magazine's chief photographer – Leibovitz shot 142 covers. Many were startlingly direct encounters with the subjects, others were conceptual and wildly imaginative, and all became defining works in the art of celebrity portraiture. ¶ Thompson's contributions – including the unprecedented "Fear and Loathing in Las Vegas" – continued for the next 34 years, with his iconoclastic voice (to say nothing of the wild behavior it described) inspiring several generations. And the magazine itself grew: adding readers in leaps and bounds, shifting to a full-color cover and, finally – in 1977, as it marked its first decade – moving from San Francisco to New York, where it has been headquartered ever since.

Previous spread: Bob Dylan, Los Angeles, 1977.

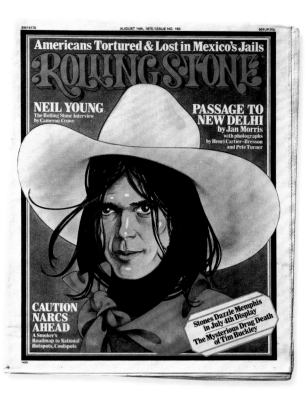

AUGUST 14th, 1975/ISSUE NO. 193

ROLLING STONE

Americans Tortured & Lost in Mexico's Jails

NEIL YOUNG
The Rolling Stone Interview
by Cameron Crowe

PASSAGE TO NEW DELHI
by Jan Morris
with photographs
by Henri Cartier-Bresson
and Pete Turner

CAUTION NARCS AHEAD
A Smoker's
Roadmap to National
Hotspots, Coolspots

Stones Dazzle Memphis
In July 4th Display
The Mysterious Drug Death
of Tim Buckley

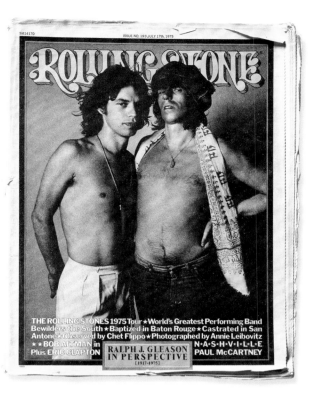

ISSUE NO. 192/JULY 17th, 1975

ROLLING STONE

**THE ROLLING STONES 1975 Tour ★ World's Greatest Performing Band
Bewilders the South ★ Baptized in Baton Rouge ★ Castrated in San
Antone ★ Observed by Chet Flippo ★ Photographed by Annie Leibovitz
★ BOB ALTMAN in
Plus ERIC CLAPTON**

RALPH J. GLEASON
IN PERSPECTIVE
[1917-1975]

N·A·S·H·V·I·L·L·E
PAUL McCARTNEY

FEBRUARY 22nd, 1979/ISSUE NO. 283

CHARLES MINGUS: 1922-1979

Rolling Stone

**BLUES BROTHERS:
SATURDAY NIGHT
CONFIDENTIAL**

DAN AYKROYD
Messin' with the Kid
By Timothy White

AEROSMITH
Bares Its Battle Scars
By Daisann McLane

FREDERICK EXLEY
Last Notes from Home · Part III

SONIC BOOM '79

ROLLING STONE

October 29, 1970
No. 69
UK: 3/-
50¢

Janis Joplin
1943-1970

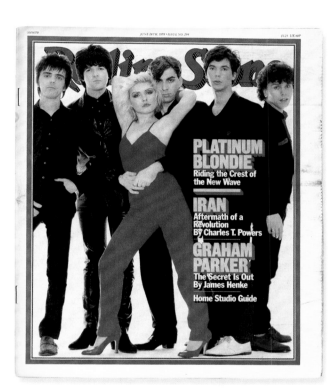

Rolling Stone

JUNE 28TH, 1979/ISSUE NO. 294
$1.25 UK 60P

PLATINUM BLONDIE
Riding the Crest of
the New Wave

IRAN
Aftermath of a
Revolution
By Charles T. Powers

GRAHAM PARKER
The Secret Is Out
By James Henke

Home Studio Guide

Rolling Stone

May 11, 1972 60¢
Issue No. 106 UK 20p

**Naked
Lunch Box:
The
Business of
David Cassidy**

**Rolling Stone
Interview:
William
Burroughs**

**Tammy
Wynette**

**True Dope Tales:
The Promoter
was a Narc**

ROLLING STONE

AUGUST 25th, 1977 ★ ISSUE NO. 246
$1.00 UK 50p

**FLEETWOOD MAC
Rocks Madison Garden**

**The Wizard of
STAR WARS**
An
Interview
with
George
Lucas
By Paul
Scanlon

DOLLY PARTON
By Chet Flippo

TED NUGENT's
Bloodlust Rock
By Charles
Young

Plus:
Dolly Meets Mr. Universe
By Annie Leibovitz

Rolling Stone

No. 63 July 23, 1970 UK: 3/- 50¢

**Rolling Stone Interview:
David Crosby**
The
New
Bob
Dylan
Album

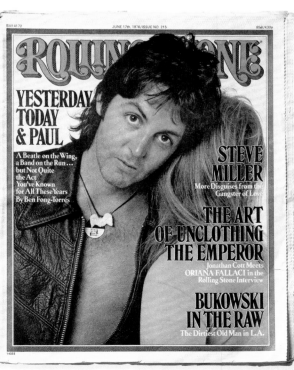

ROLLING STONE

JUNE 17th, 1976/ISSUE NO. 215
85¢ UK 30p

**YESTERDAY
TODAY
& PAUL**
A Beatle on the Wing,
a Band on the Run...
but Not Quite
the Act
You've Known
for All These Years
By Ben Fong-Torres

STEVE MILLER
More Disguises from the
Gangster of Love

THE ART OF UNCLOTHING THE EMPEROR
Jonathan Cott Meets
ORIANA FALLACI in the
Rolling Stone Interview

BUKOWSKI IN THE RAW
The Dirtiest Old Man in L.A.

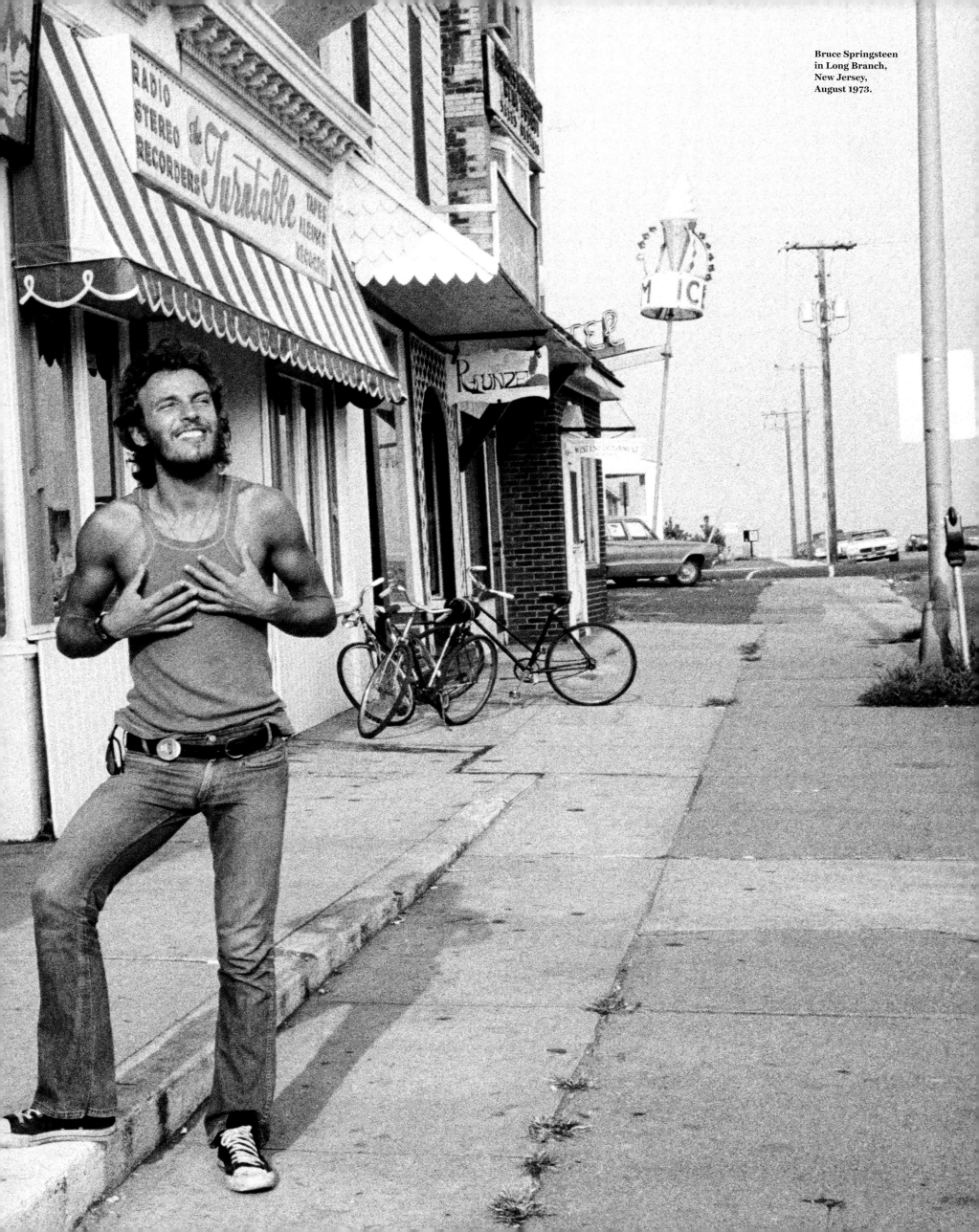

Bruce Springsteen
in Long Branch,
New Jersey,
August 1973.

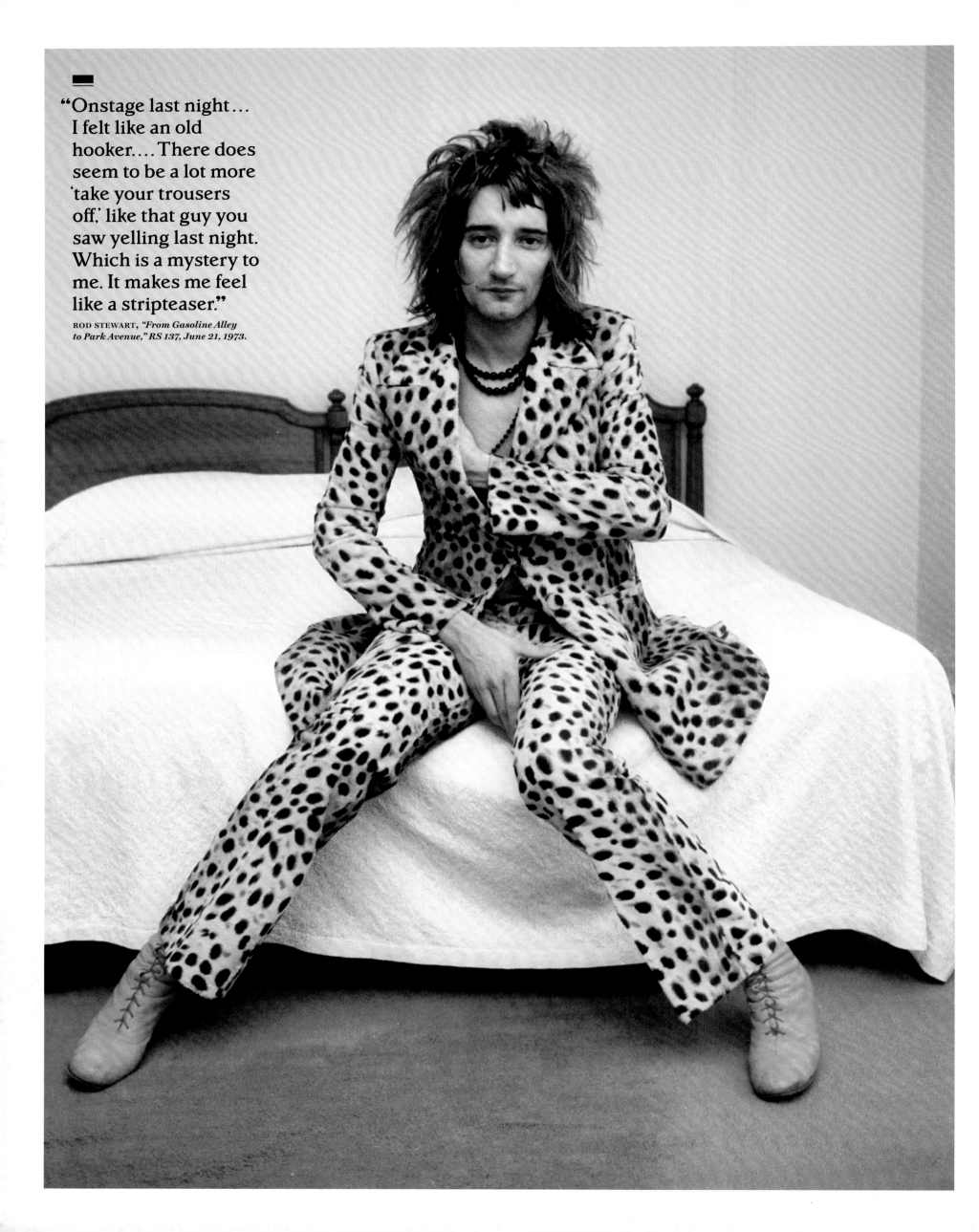

"Onstage last night…
I felt like an old
hooker…. There does
seem to be a lot more
'take your trousers
off,' like that guy you
saw yelling last night.
Which is a mystery to
me. It makes me feel
like a stripteaser."

ROD STEWART, *"From Gasoline Alley
to Park Avenue," RS 137, June 21, 1973.*

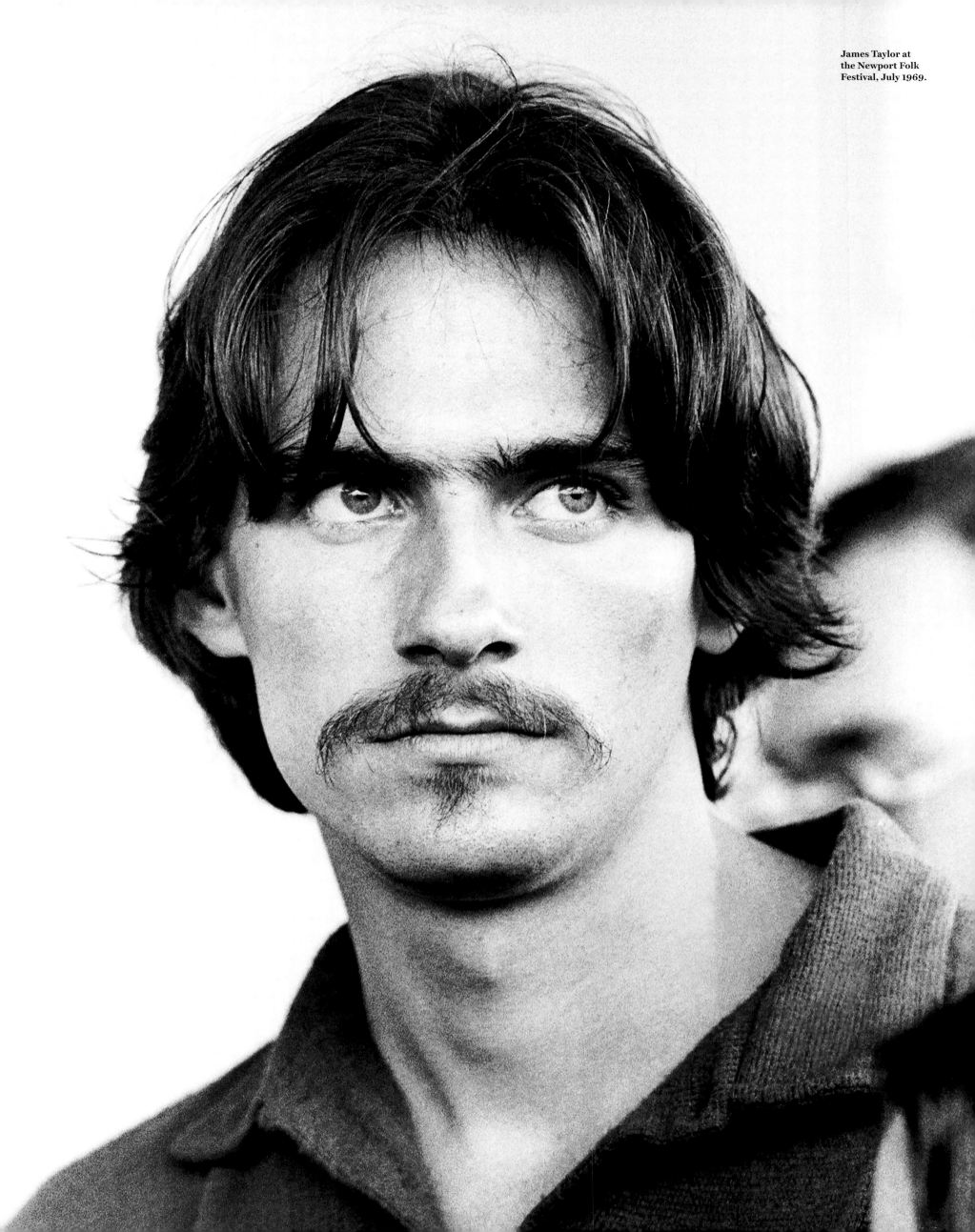

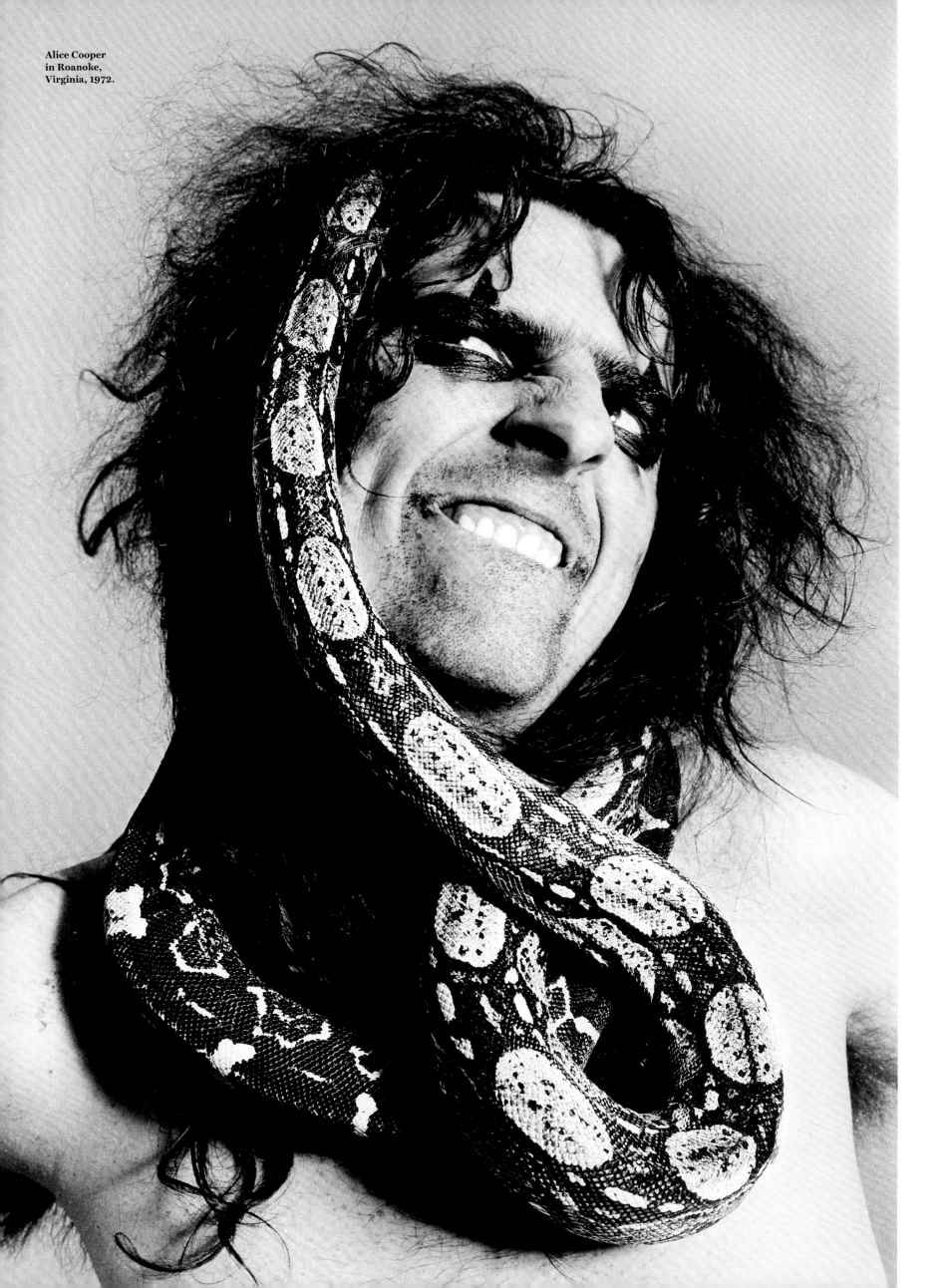

Alice Cooper
in Roanoke,
Virginia, 1972.

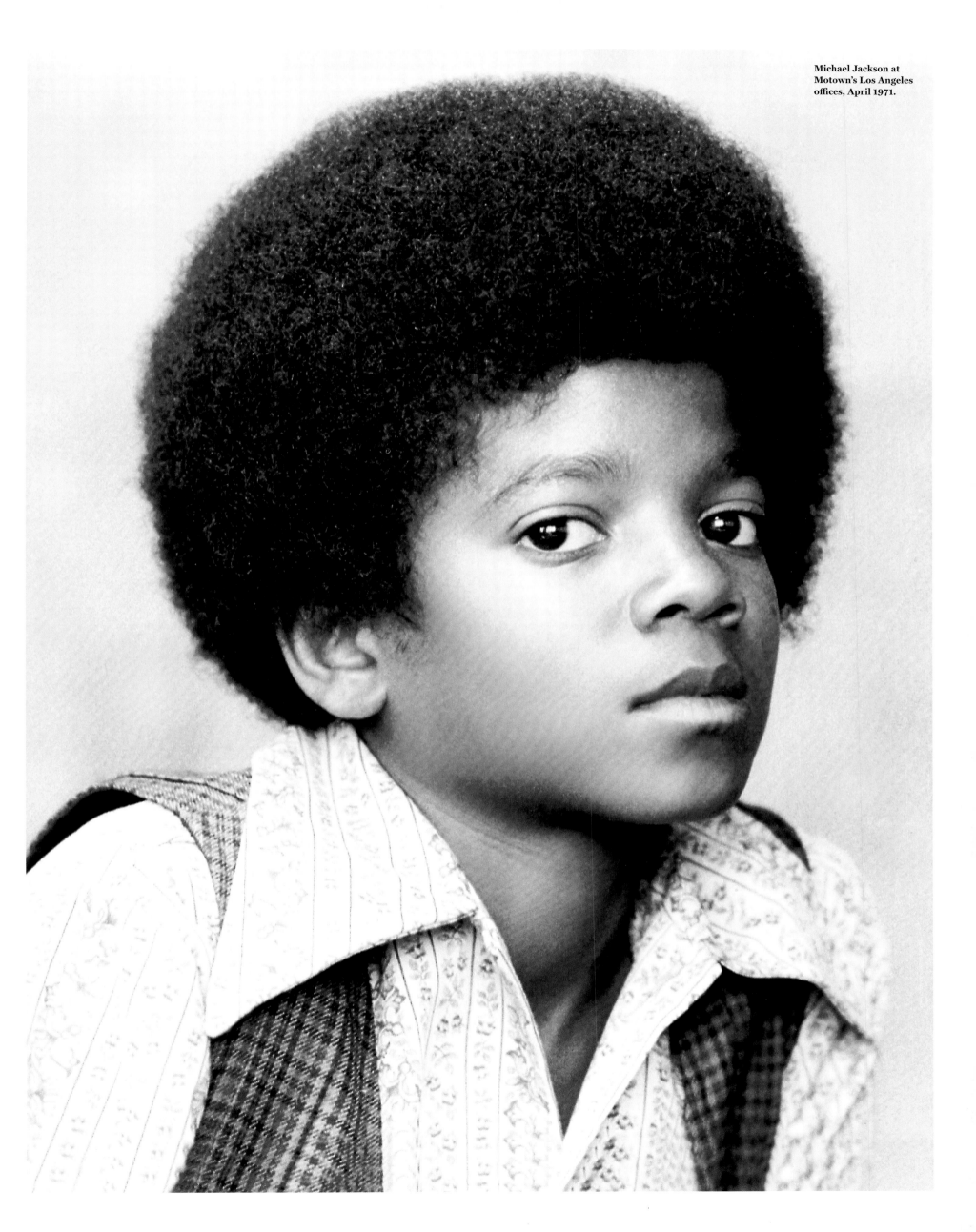

Patty Hearst: The Inside Story

How ROLLING STONE landed one of the biggest scoops of the 1970s

RS 198 • OCTOBER 23, 1975

AT AROUND 9 P.M. ON FEBRUARY 4TH, 1974, 19-YEAR-OLD Patty Hearst heard a knock on the door of her apartment in Berkeley. When her boyfriend answered, several people rushed in, grabbed her and threw her into the trunk of a stolen Chevrolet Impala.

Patty Hearst was an heiress to the Hearst newspaper fortune – her grandfather, William Randolph Hearst, was a principal model for *Citizen Kane* – and her kidnappers were members of a radical revolutionary group calling itself the Symbionese Liberation Army. Within months of her abduction, Patty was issuing statements saying she had joined the SLA, and was calling herself Tania. On April 15th, surveillance cameras caught her brandishing a gun and taking part in a San Francisco bank robbery. A month later, the country watched live footage of a shoot-out in Los Angeles between the police and the SLA, which ended with a house burned to the ground. Six SLA members were dead.

Patty Hearst was not one of them. She and two remaining members of the SLA, Bill and Emily Harris, went underground, traveling across the country and back. Before her capture on September 18th, 1975, the FBI checked nearly 50,000 tips, interviewed or spot-checked 30,000 people in the Bay Area and employed 8,500 agents. They had tracked her movements but knew almost none of the details of her travels. Those they learned in the October 23rd, 1975, issue of ROLLING STONE.

"The Inside Story" had been prepared in secret, after a four-month investigation by associate editor Howard Kohn and freelance writer David Weir. The two reporters had been approached by an attorney representing Jack Scott, a sports activist (he loved sports but criticized authoritarian coaches and advocated for black athletes) with ties to underground politics who had been implicated in the Hearst saga. Scott told them an amazing story: He'd driven Hearst, and then Bill Harris, to the East Coast, where they met up with Emily Harris and hid out in an isolated farmhouse on 87 acres in Pennsylvania that he had rented to protect them. Hearst had spent the summer of 1974 picking wild blackberries, swimming – and also reading Marx and taking part in paramilitary drills run by Bill Harris, a former Marine. Even more amazing: The story checked out. Kohn and Weir visited the farmhouse and found the spent rifle shells from target practice.

The Patty Hearst kidnapping, and her participation in SLA actions, was the biggest story in America, and Kohn and Weir told it with a combination of rigorous reporting and novelistic detail.

The first time Scott met the SLA fugitives – at a house in Berkeley fortified against a police invasion with mattresses piled by the doors and windows, and grenades stacked in the corners – they were too paranoid to let him leave: "He was told to sleep sandwiched between Emily and Patty. Positioned at the head of their bed was an arsenal of guns and grenades," Kohn wrote. "Bill turned out the lights and Jack lay back, staring at the ceiling. He couldn't sleep. Thirty minutes passed. It seemed like decades. Then a loud crash jarred everyone upright. Patty rolled over and grabbed a gun in a single motion that she had practiced many times in the dark. 'It's the pigs,' she whispered....Nobody said a word as the three fugitives trained their guns on the entrances. Slowly Bill pulled back a curtain and peered out. He turned to the rest and grinned. 'It's only a cat.'"

Kohn and Weir spelled out how deeply committed Hearst had been to the SLA (though her story would change over time, and she eventually maintained she was brainwashed) and made clear that she'd had the opportunity to walk away from her kidnappers – Scott had asked if she wanted to leave before their cross-country drive. But she was eager to join Bill and Emily Harris, though she was jumpy the whole trip to Pennsylvania, repeatedly thinking gas-station attendants were "pigs" out to stop her.

Kohn and Weir's story ran in two issues. The first part told Hearst's story, and a cover illustration in the manner of Andrew Wyeth's "Christina's World" showed a lonely, revolutionary Patty Hearst clutching a rifle. The second installment traced the muddled history of the investigation (Sara Jane Moore, who later tried to assassinate President Gerald Ford, was one of the FBI's informants) and of the SLA itself.

But as Kohn and Weir were finishing the first installment, Hearst and the Harrises were captured in San Francisco by the FBI. Publication needed to be accelerated. "The last part was a total frenzy," says then-senior editor Paul Scanlon, who slept at the office on the final night of editing. To protect the scoop, when the piece went to press, guards at the printing plant searched employees coming and going.

And to maintain secrecy on their end, the ROLLING STONE staff themselves had decamped to Big Sur, California, where they celebrated. "We drank a lot of expensive champagne," says Scanlon. When they returned to work that Monday, the office was besieged by reporters, and the magazine's Hearst revelations were the top story on all three TV networks. "It solidified ROLLING STONE as a national magazine," says Scanlon. "We weren't just a little rock & roll magazine anymore."

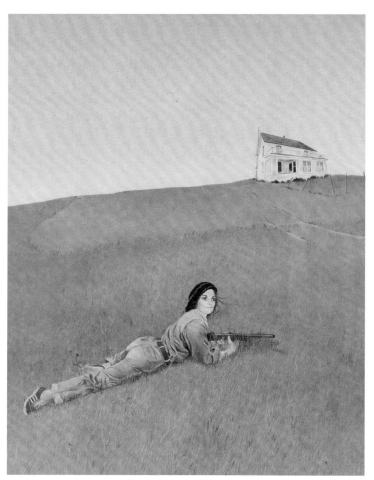

Patty Hearst was depicted in the style of Andrew Wyeth's "Christina's World" for an illustration that ran on the cover of the magazine.

The Death of Karen Silkwood

An investigation into the fate of a whistle-blower uncovered the dangers of the nuclear-power industry

RS 183 • MARCH 27, 1975

'SHE WAS 28, A SLIGHT WOMAN, DARK HAIR PUSHING PAST slender shoulders, haunting beauty nurtured in a small-child look. She was alone that chilly autumn night, driving her tiny three-door Honda through long stretches of prairie." So began "Malignant Giant," a story that would garner more mail to ROLLING STONE than any other had up to that point.

The woman in the Honda was Karen Silkwood, a lab analyst at Kerr-McGee, which ran one of 10 plutonium plants in the country, in Crescent, Oklahoma. She was on her way to meet a newspaper reporter at a nearby Holiday Inn to present evidence of fraud at Kerr-McGee when her car skidded 270 feet off Highway 74 and hit a concrete culvert. Police initially ruled she'd fallen asleep at the wheel, though she'd gotten a good night's rest.

Howard Kohn was on his honeymoon when he read about Silkwood's death. He cut the trip short to chase the story. Kohn devoted months to his investigation, interviewing Silkwood's ex-boyfriend and co-workers, and traveling to Nederland, Texas, to talk with her parents. He constructed a portrait of an intrepid young woman set on breaking out of the constraints around her. "I thought she should be in something like home economics," her mother told Kohn of learning that Karen had enrolled in advanced chemistry in high school. "But [her chemistry teacher] finally made me change my mind. He said she was a better student than the boys."

During her time at Kerr-McGee, Silkwood became involved in the union movement at the plant, winning election to the steering committee of the local chapter of the Oil, Chemical and Atomic Workers Union (OCAW). She gathered evidence of Kerr-McGee's unsafe management – unreported spills and leaks, employees sent into production without safety training, a radioactive storage container being left in the open for three days – and flew with two co-workers to Washington, D.C., to present it to OCAW, which asked Silkwood to work undercover.

In November 1974, days before her death, during a routine safety check on herself, Silkwood discovered she was contaminated with plutonium. She knew how highly toxic plutonium was – a millionth of a gram of the radioactive chemical could induce cancer in lab animals – and was terrified.

Kerr-McGee inspectors turned up nothing at the plant, and at Silkwood's insistence they tested her apartment. "There the alpha counters commenced eerie gibberings," wrote Kohn. "Plutonium, in small quantities, was everywhere." Enough that all her belongings would have to be buried at a disposal site. A package of bologna

Karen Silkwood was the victim of plutonium contamination – but no one could explain how plutonium had gotten into the food in her refrigerator.

and another of cheese were the two most contaminated items in the apartment, and apparently the plutonium had spread through the apartment from the refrigerator. What wasn't clear was how the food had become contaminated in the first place.

Silkwood suspected it was an attempt by Kerr-McGee to intimidate her. The night she died, she was in possession of a manila folder whose contents she planned to present to *New York Times* reporter David Burnham. Those documents, she believed, would expose negligence in the manufacturing of fuel rods. Though a state trooper who was at the crash site of Silkwood's Honda mentioned seeing dozens of loose papers scattered in the mud (which, he said, he put back in the car), no folder or papers were ever recovered. What's more, an independent investigator found a fresh dent in the rear bumper of Silkwood's car that could have come from another automobile, raising the possibility that she'd been forced off the road. Whatever the truth was, the official explanation certainly didn't seem to hold up to scrutiny.

Kohn had put all this together despite not-so-subtle intimidation from Kerr-McGee. Employees had been ordered not to speak to him, and the company made rumblings about its libel lawyers when he started digging in the archives of the Atomic Energy Commission in Washington, D.C. "I had no idea how serious a threat this might be or how intimidated Jann [Wenner] might be," Kohn later wrote. "He listened and then said excitedly, 'Start writing. Sounds like you're onto a hell of a story. I love it!'"

Kohn returned repeatedly to Oklahoma to write a dozen articles about the subject (and a 1981 book), uncovering falsified record-keeping, missing plutonium and industry-wide safety hazards. His reporting helped set the stage for the 1979 No Nukes concerts, held over five nights at Madison Square Garden. (The story was also told in *Silkwood*, a 1983 movie directed by Mike Nichols and starring Meryl Streep.) Silkwood's father soon filed a civil suit against the plant for negligence relating to his daughter's contamination. Wenner donated $10,000 toward the lawsuit and offered to match contributions from ROLLING STONE readers. In 1979, after the longest trial in Oklahoma history, Kerr-McGee was ordered to pay Silkwood's family punitive damages. (The decision would later be reversed, and the case was finally settled out of court.) Wrote Kohn, "Though it was never determined whether Karen Silkwood's death was the result of foul play, the public's confidence in nuclear power would be so undermined that the industry ultimately would become a shadow of its former self."

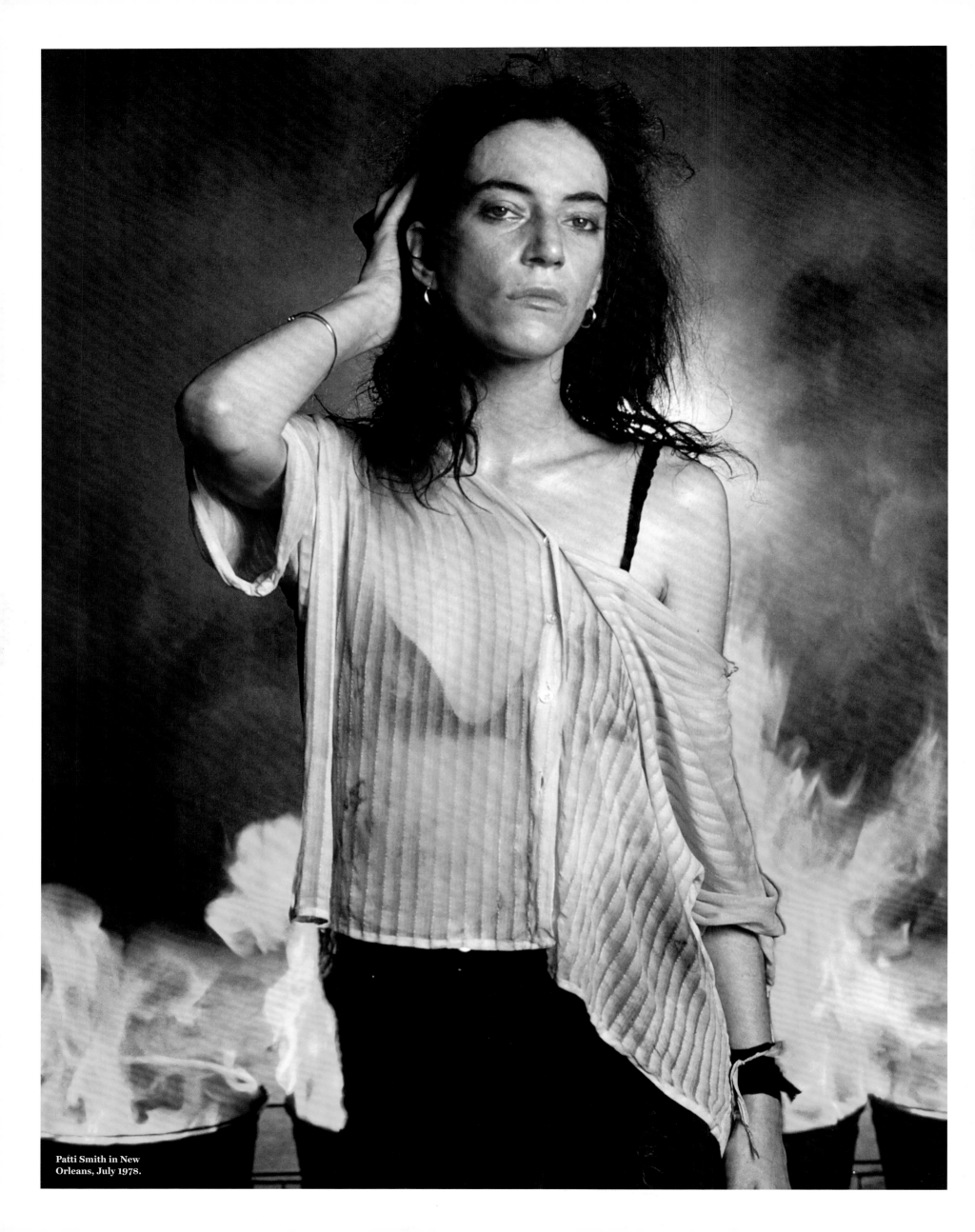

Patti Smith in New
Orleans, July 1978.

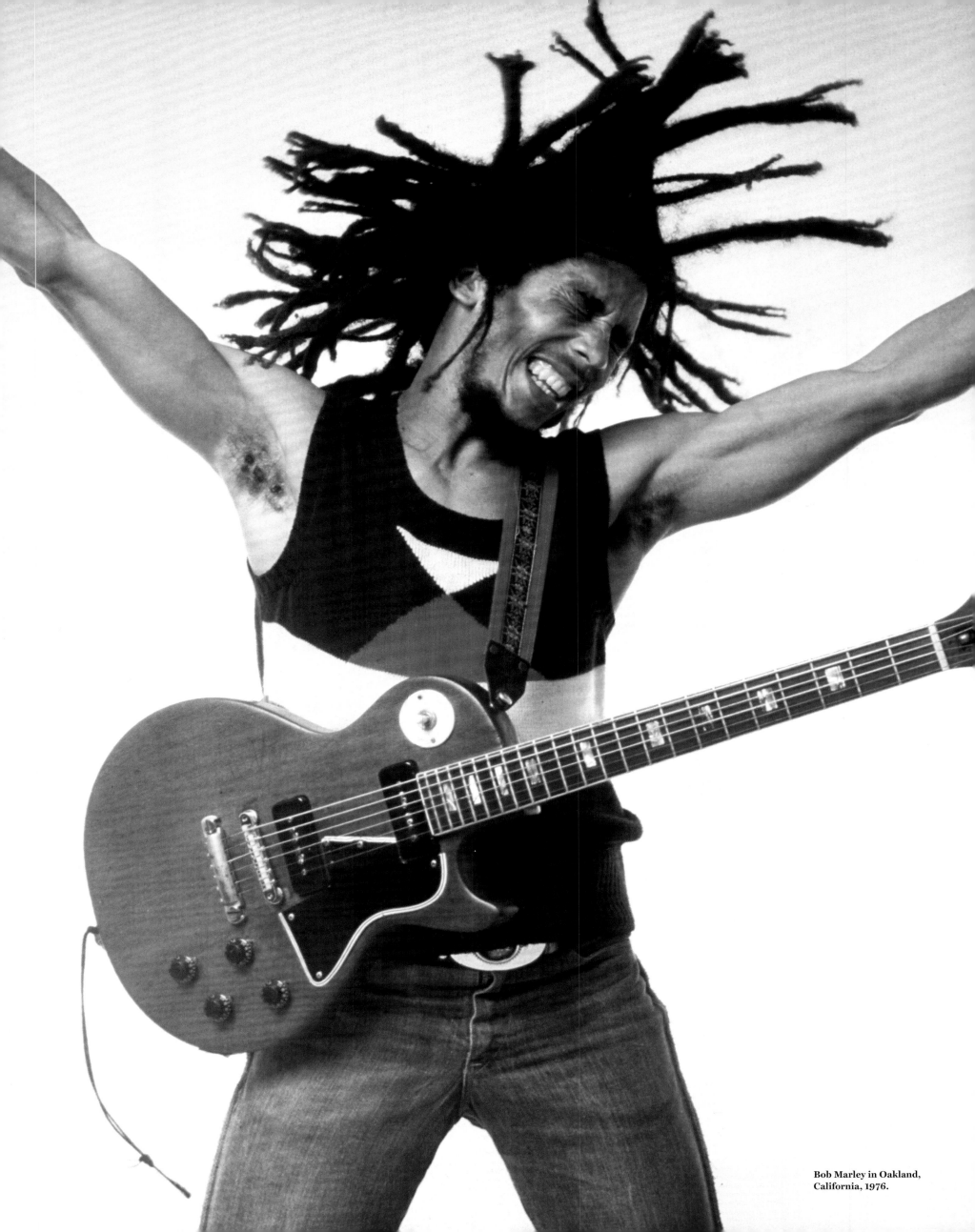

Bob Marley in Oakland,
California, 1976.

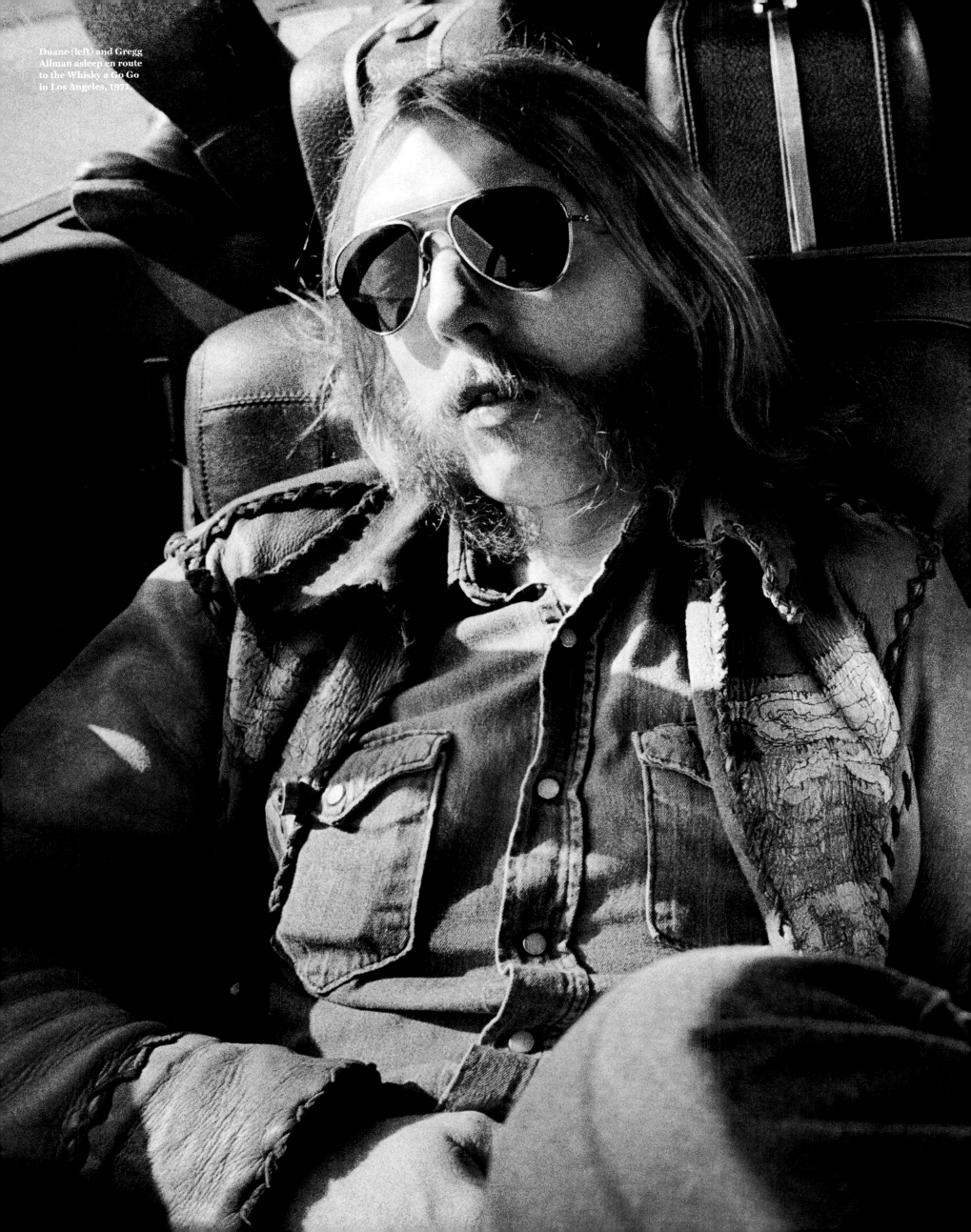

Duane (left) and Gregg
Allman asleep en route
to the Whisky a Go Go
in Los Angeles, 1971.

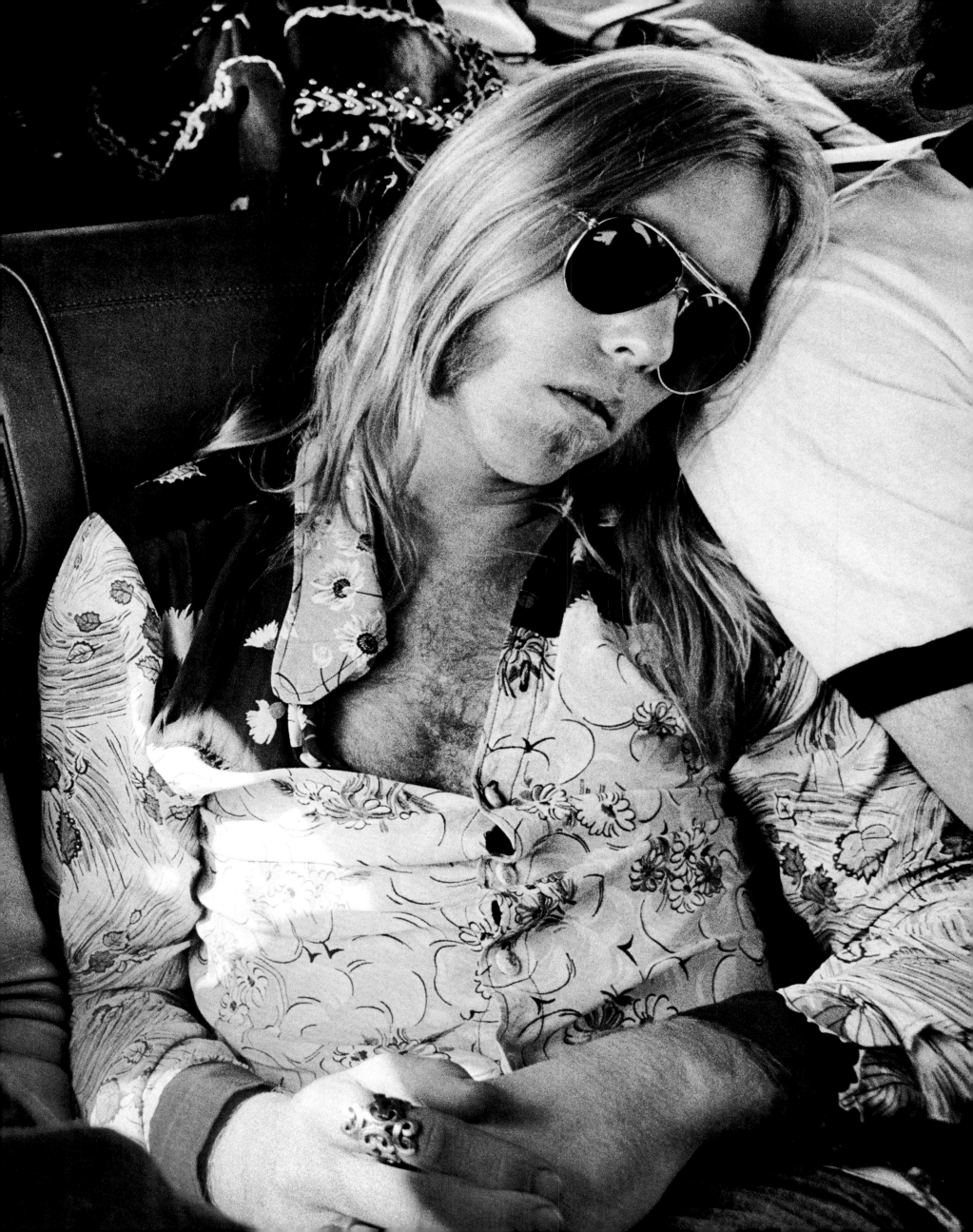

Joni Mitchell at her
Los Angeles home, 1975.

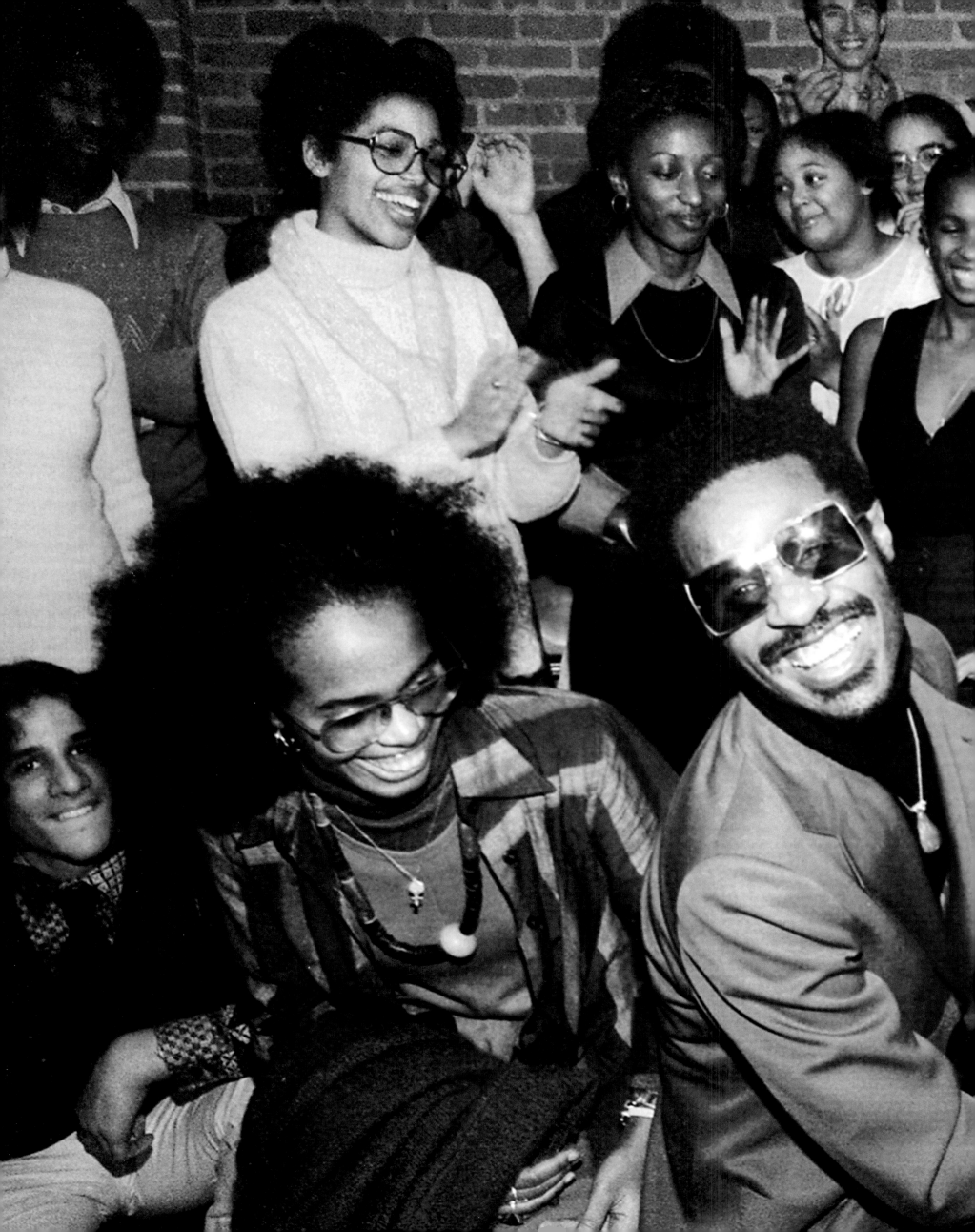

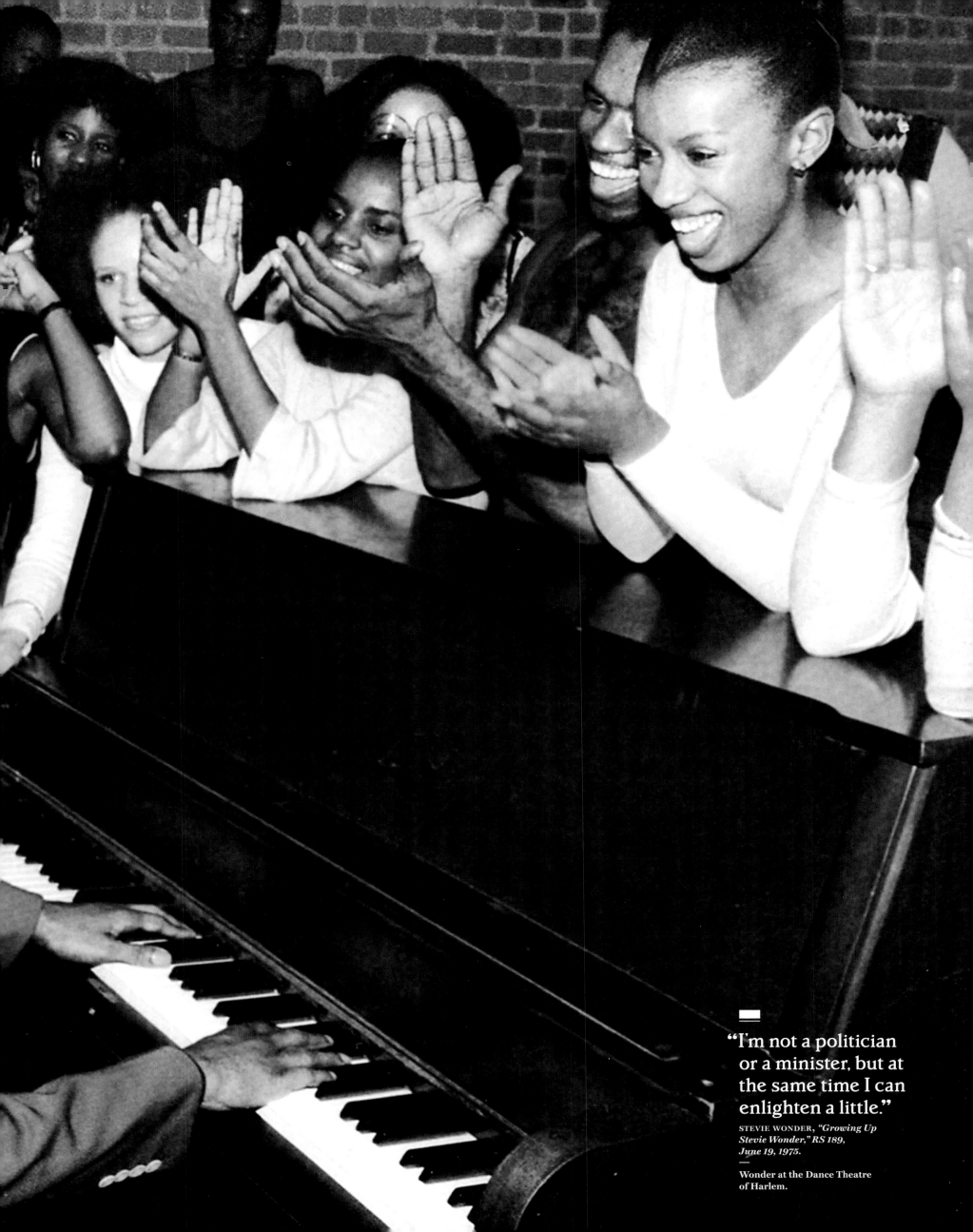

> "I'm not a politician
> or a minister, but at
> the same time I can
> enlighten a little."

STEVIE WONDER, *"Growing Up
Stevie Wonder," RS 189,
June 19, 1975.*

—

Wonder at the Dance Theatre
of Harlem.

The Family 1976

Portfolio by Richard Avedon

RS 224 • OCTOBER 21, 1976

I N 1976, *ROLLING STONE* ASKED RICHARD AVEDON – ONE OF THE most famous and well-regarded photographers in America – to cover the presidential election in the bicentennial year. The original idea was to document the campaign from beginning to end: the candidates, the primaries, the conventions. Avedon proposed another approach. Rather than focus on just the election, he wanted to capture the power structure of America itself – not just political figures, but journalists, bankers, heads of unions and more – and create what he called "a composite portrait of the power elite."

Working for about six months, Avedon produced 69 photographs, shooting his subjects in the stark style that had become his signature. "I didn't want to pit Democrats against Republicans, or good versus bad," Avedon explained. "It's too easy for a photographer to do that. In a way, these pictures were almost taken by the people in the pictures. I didn't tell them what to wear. I didn't tell them how to pose. However they presented themselves, I recorded with very little manipulation."

Decades of history – past, present and future – were summed up in the pictures, which ran across 46 pages in the October 21st, 1976, issue,

almost two weeks before Election Day. The two presidential candidates, Jimmy Carter and Gerald Ford, were part of the portfolio, as were future presidents Ronald Reagan (who'd lost the Republican nomination to Ford) and George H.W. Bush (then director of the CIA). Also included were Sen. Ted Kennedy; his mother, Rose; *Washington Post* publisher Katharine Graham and Vice President Nelson Rockefeller. Almost no one had refused to sit for Avedon, save former President Richard Nixon, who was represented instead by his longtime personal secretary, Rose Mary Woods.

"The Family 1976" – which went on to win a National Magazine Award – marked the start of Avedon's relationship with ROLLING STONE, which would see him shooting covers with everyone from Bob Hope to Prince. The photos were presented without comment – the only text was a brief biography of each subject, in the clipped style of a Who's Who, and it ran apart from the pictures. Avedon wanted the viewer to interact directly with the photos, which he felt were "a Rorschach test…they're seen in very different ways by different people, according to the way they feel about the subject."

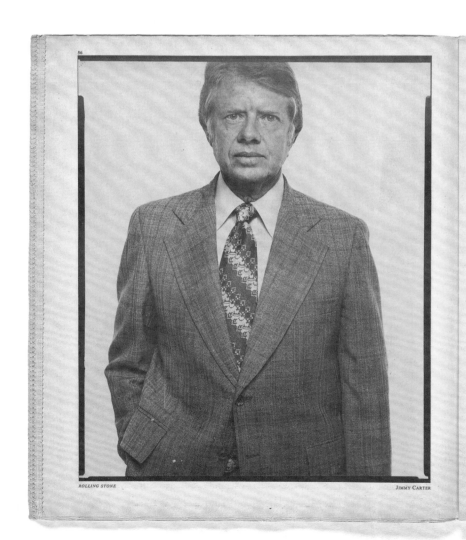

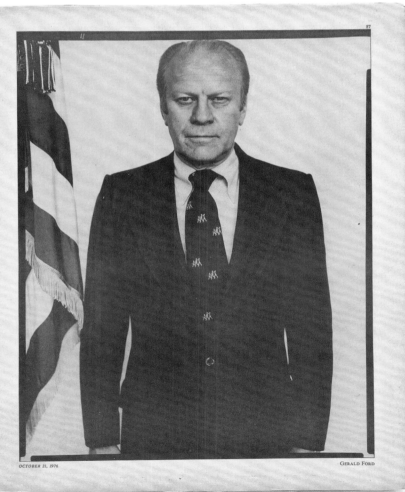

JIMMY CARTER

GERALD FORD

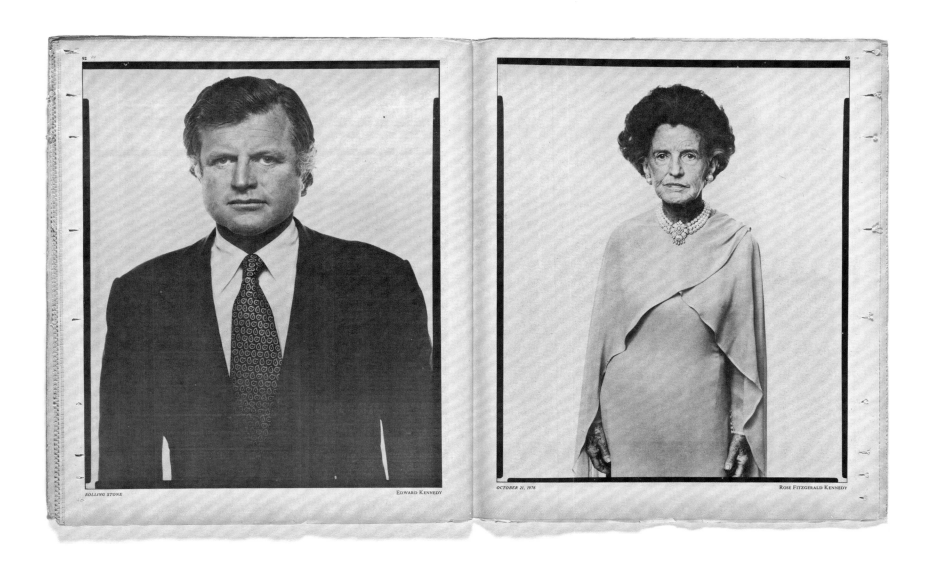

ROLLING STONE EDWARD KENNEDY

OCTOBER 21, 1976 ROSE FITZGERALD KENNEDY

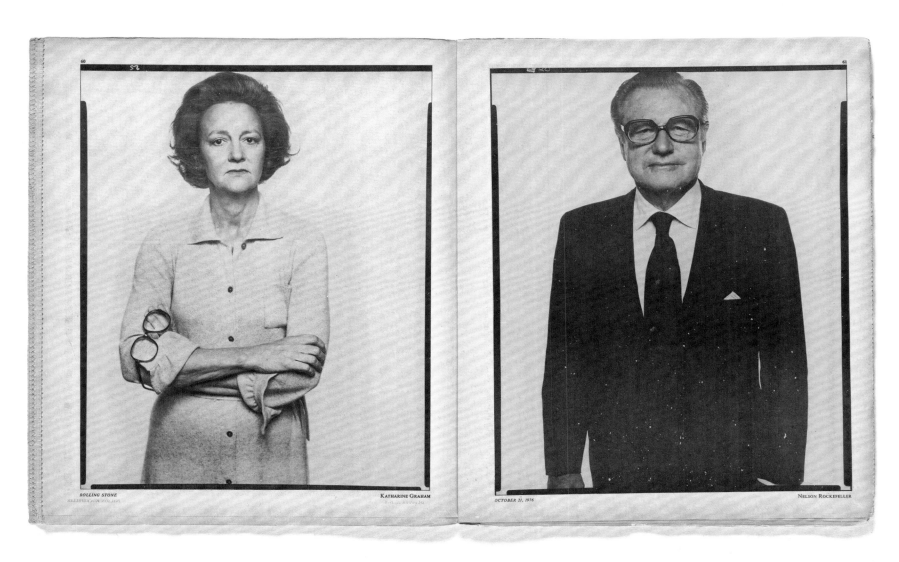

ROLLING STONE KATHARINE GRAHAM

OCTOBER 21, 1976 NELSON ROCKEFELLER

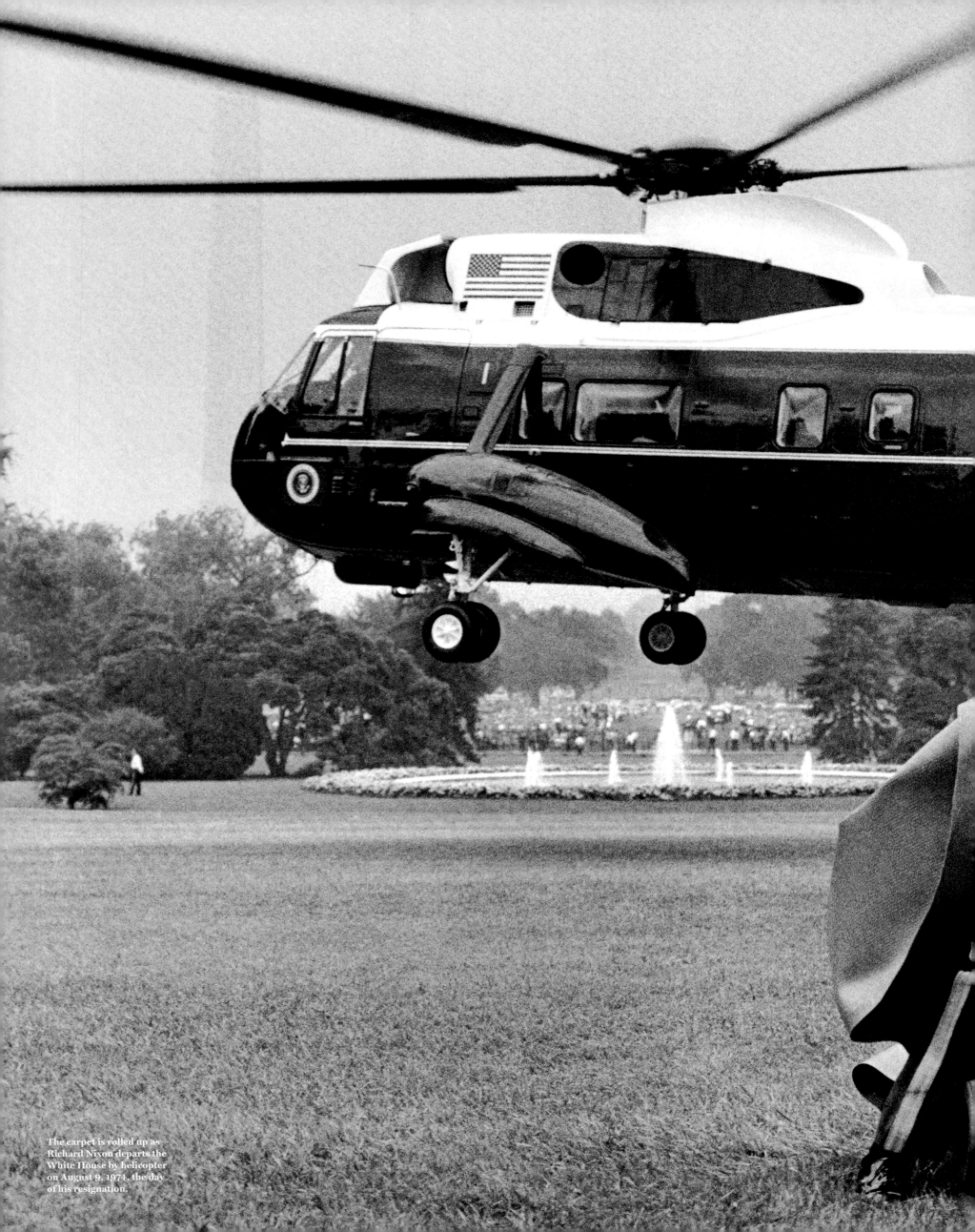

The carpet is rolled up as
Richard Nixon departs the
White House by helicopter
on August 9, 1974, the day
of his resignation.

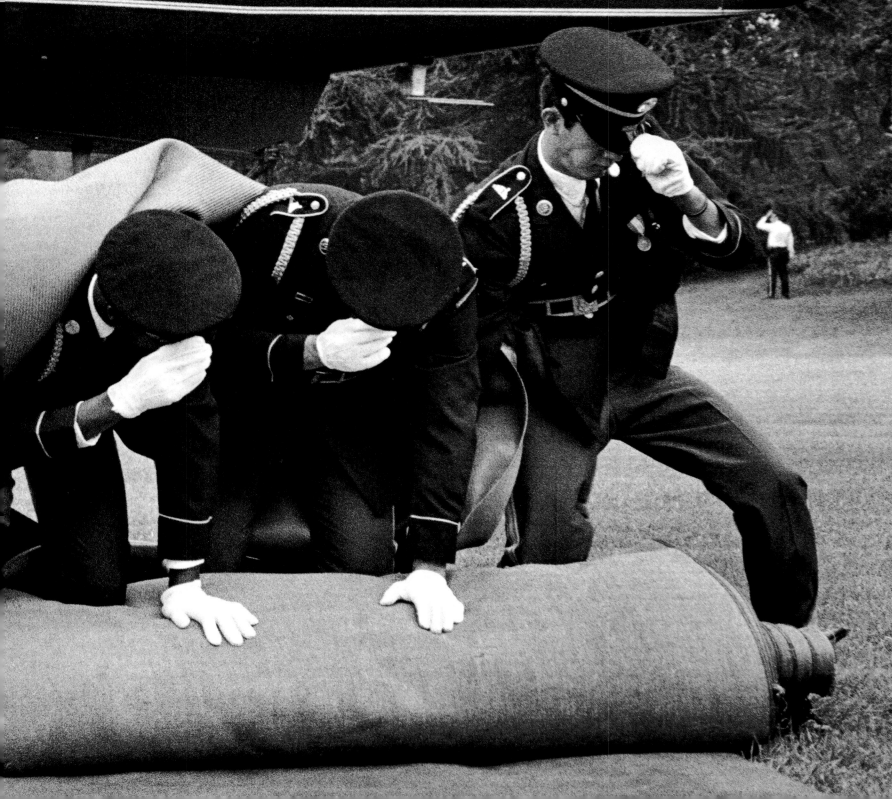

"My mother used to tell me about vibrations.... To think invisible feelings, invisible vibrations existed, scared me to death."

BRIAN WILSON, *"The Healing of Brother Brian," RS 225, November 4, 1976.*
—
Wilson on the beach in Malibu.

Norman Mailer, Bar Harbor, Maine, 1974.

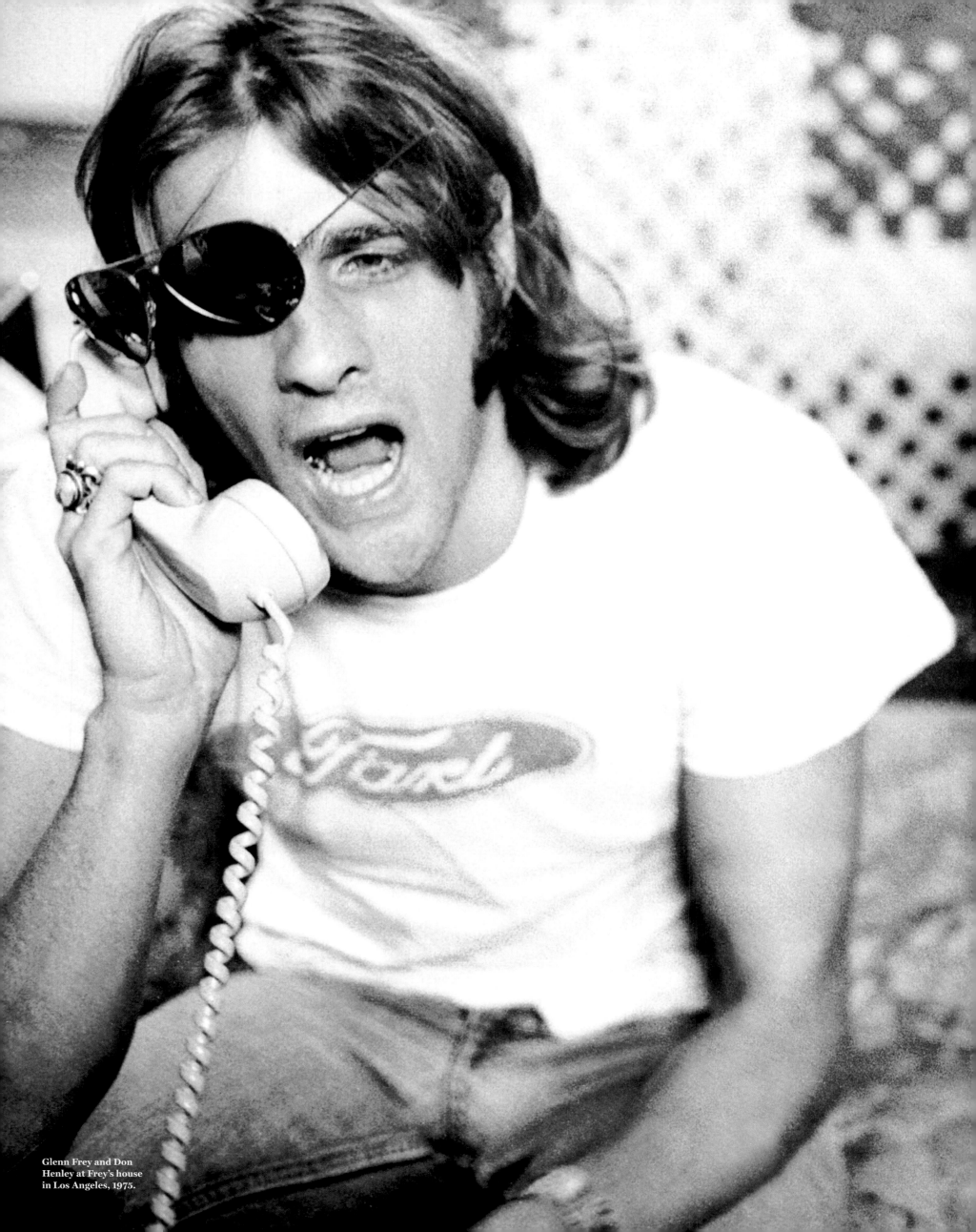

Glenn Frey and Don Henley at Frey's house in Los Angeles, 1975.

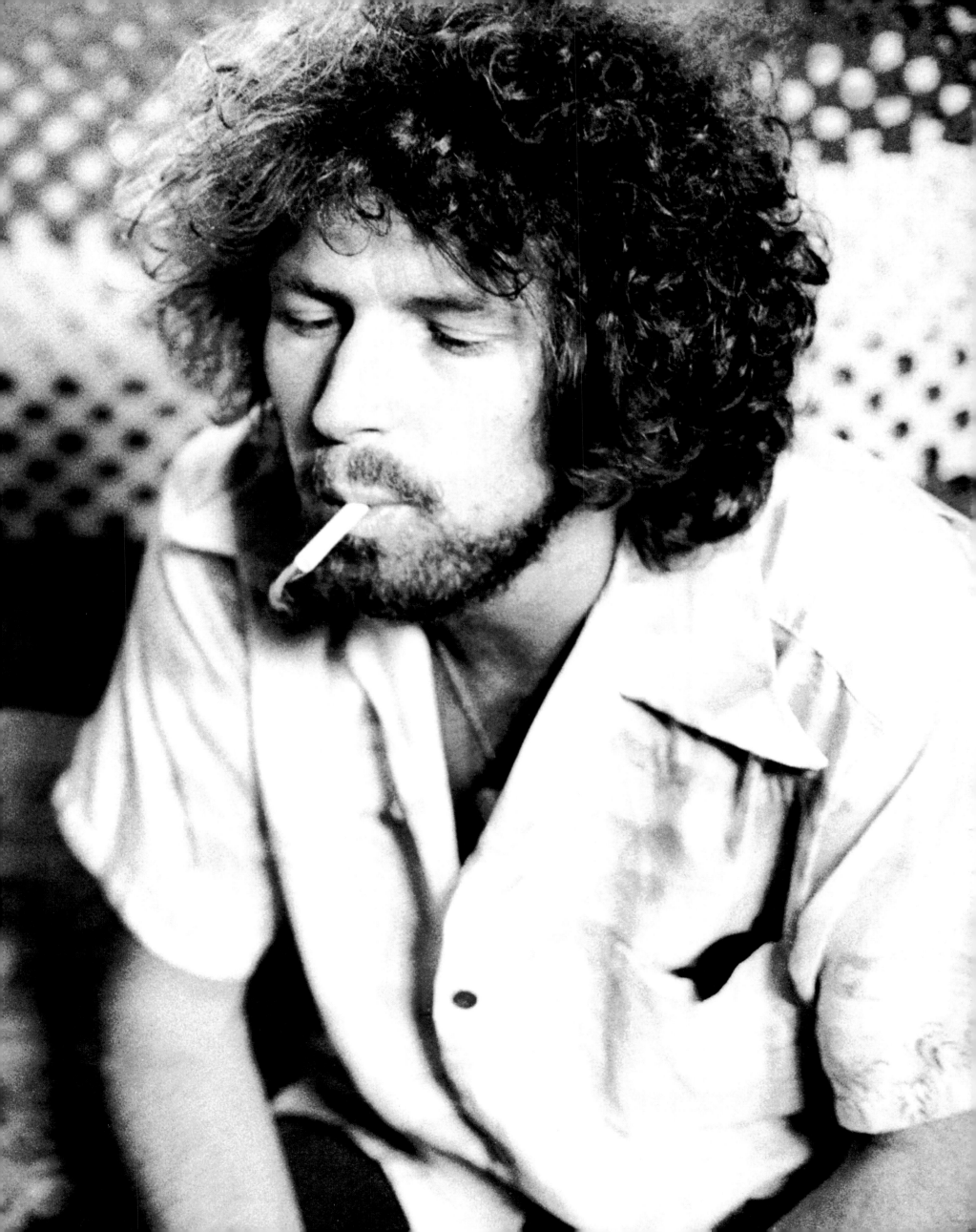

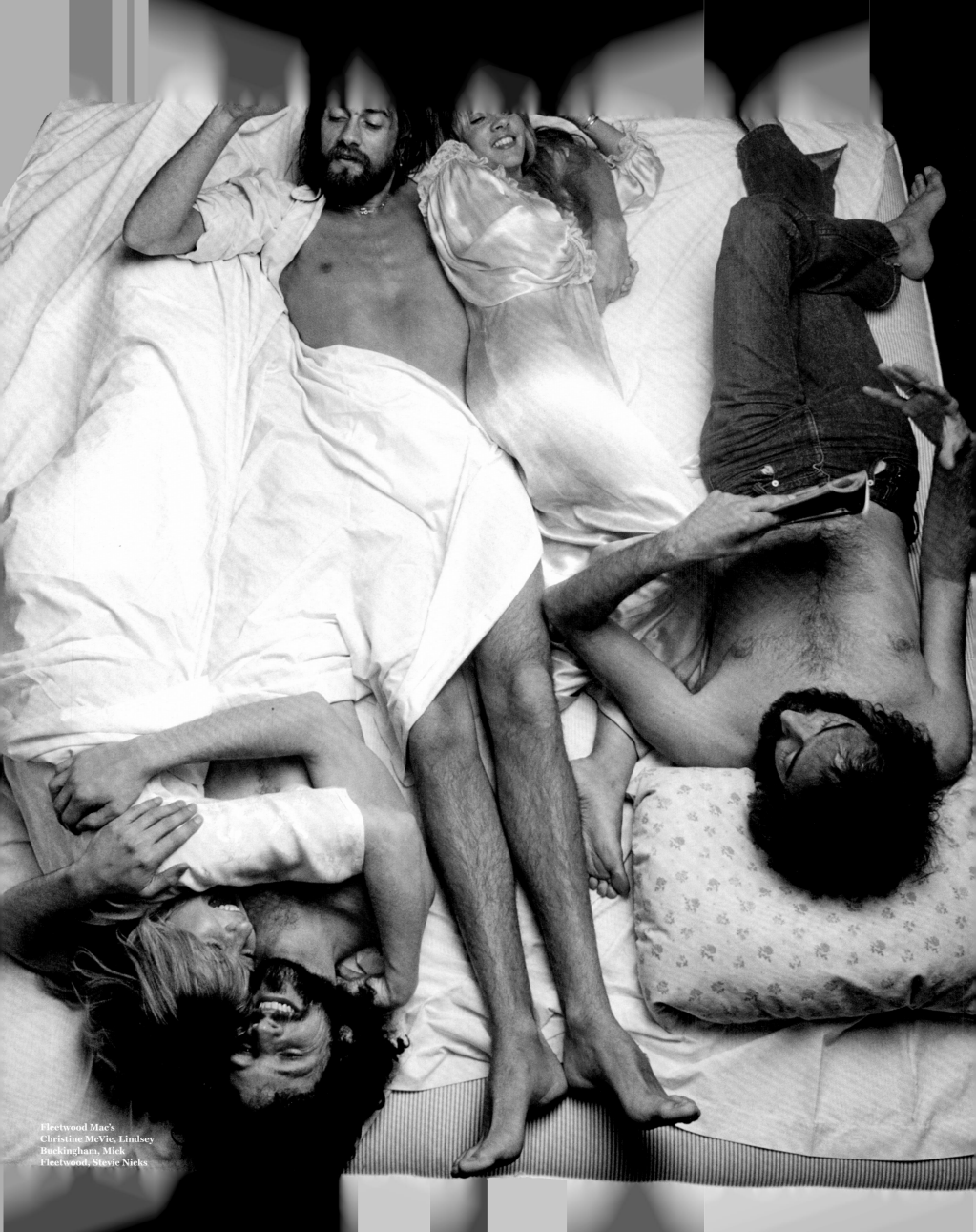

Fleetwood Mac's
Christine McVie, Lindsey
Buckingham, Mick
Fleetwood, Stevie Nicks

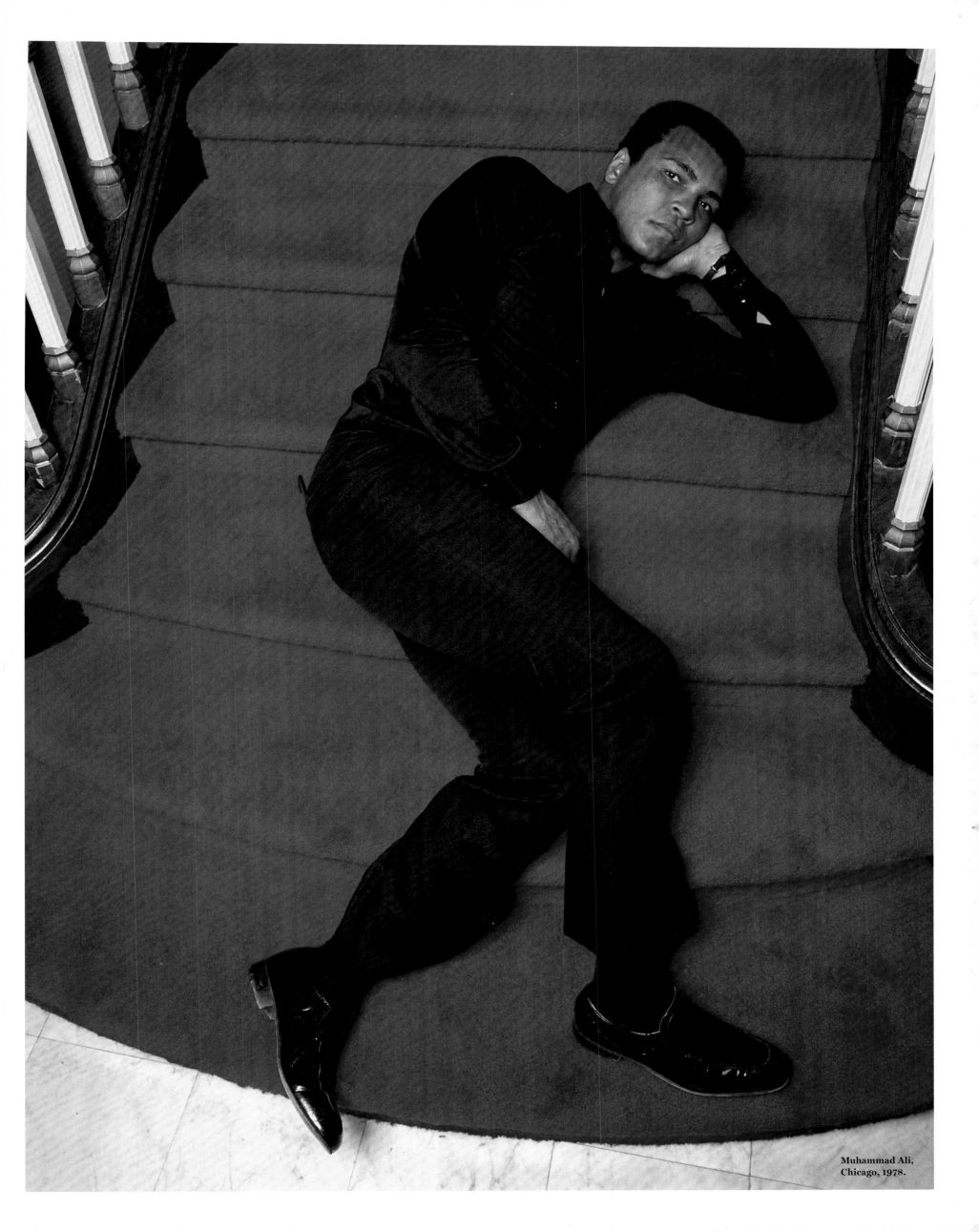

Muhammad Ali,
Chicago, 1978.

John Lennon

By Jann S. Wenner

RS 74 & 75 • JANUARY 21 & FEBRUARY 4, 1971

In December 1970, John Lennon released his first solo album, *Plastic Ono Band*. It was rock & roll reduced to its very essence, shocking in both its simplicity and its contents. In the song "God," Lennon listed all the things that he no longer believed in: Elvis, Zimmerman (meaning Bob Dylan, who'd been born Robert Zimmerman) and the Beatles. "The dream is over," he sang. ❖ The breakup of the Beatles had become worldwide news in the spring of 1970, but none of the group had spoken publicly about it – until Jann S. Wenner sat down with Lennon and his wife, Yoko Ono, to conduct the ROLLING STONE Interview, published in two parts in the magazine's first two issues of 1971. Running more than 36,000 words, it was Lennon as the world had never heard him before, raw and completely unfiltered. Even if the Beatles were no longer the fresh-faced Fab Four introduced to America on *The Ed Sullivan Show* in 1964, they had been hermetically sealed off from the public for years. This interview broke that seal. It was candid, often painful, and startling at every turn. Lennon lifted the curtain on the Beatles' orgies on tour and on their drug use ("'Help' was where we turned on to pot and we dropped drink, simple as that"), and scoffed at the all-you-need-is-love image that the world had of the Beatles. "Fuckin' big bastards, that's what the Beatles were," he said bluntly. "You have to be a bastard to make it, that's a fact, and the Beatles are the biggest bastards on Earth." ❖ Explaining the stripped-down sound of *Plastic Ono Band*, Lennon said, "I always liked simple rock and nothing else," later adding, "The best stuff is primitive enough and has no bullshit." As this excerpt shows, it was a description that also fit this interview.

What *do you think of your album?*

I think it's the best thing I've ever done. I think it's realistic and it's true to the me that has been developing over the years from my life. "I'm a Loser," "Help," "Strawberry Fields," they are all personal records. I always wrote about me when I could. I didn't really enjoy writing third-person songs about people who lived in concrete flats and things like that. I like first-person music. But because of my hang-ups and many other things, I would only now and then specifically write about me. Now I wrote all about me, and that's why I like it. It's me! And nobody else. That's why I like it. It's real, that's all.

On this album, there is practically no imagery at all.

Because there was none in my head. There were no hallucinations in my head.

There are no "newspaper taxis."

Actually, that's Paul's line. I was consciously writing poetry, and that's self-conscious poetry. But the poetry on this album is superior to anything I've done because it's not self-conscious in that way. I had the least trouble writing the songs of all time.

ONO: There's no bullshit.

LENNON: There's no bullshit.

The arrangements are also simple and very sparse.

I always liked simple rock and nothing else. I was influenced by acid and got psychedelic, like the whole generation, but really, I like rock & roll, and I express myself best in rock.

How did you put together that litany in "God"? What's "litany"?

"I don't believe in magic," that series of statements.

Well, like a lot of the words, it just came out of me mouth. "God" was put together from three songs almost. I had the idea that "God is the concept by which we measure pain," so that when you have a word like that, you just sit down and sing the first tune that comes into your head and the tune is simple, because I like that kind of music, and then I just rolled into it. It was just going on in my head, and I got by the first three or four, the rest just came out. Whatever came out.

When did you know that you were going to be working toward "I don't believe in Beatles"?

I don't know when I realized that I was put-

"We believed the Beatles myth too. I don't know whether the others still believe it."

ting down all these things I didn't believe in. So I could have gone on, it was like a Christmas card list: Where do I end? Churchill? Hoover? I thought I had to stop.

ONO: He was going to have a do-it-yourself type of thing.

LENNON: Yes, I was going to leave a gap, and just fill in your own words: whoever you don't believe in. It had just got out of hand, and Beatles was the final thing because I no longer believe in myth, and Beatles is another myth.

I don't believe in it. The dream is over. I'm not just talking about the Beatles, I'm talking about the generation thing. It's over, and we gotta – I have to personally – get down to so-called reality.

Why did you choose [to] refer to Zimmerman, not Dylan?

Because Dylan is bullshit. Zimmerman is his name. You see, I don't believe in Dylan, and I don't believe in Tom Jones either in that way. Zimmerman is his name. My name isn't John Beatle. It's John Lennon. Just like that.

Always the Beatles were talked about – and the Beatles talked about themselves – as being four parts of the same person. What's happened to those four parts?

They remembered that they were four individuals. You see, we believed the Beatles myth too. I don't know whether the others still believe it. We were four guys.... I met Paul and said, "You want to join me band?" Then George joined, and then Ringo joined. We were just a band that made it very, very big, that's all. Our best work was never recorded.

Why?

Because we were performers...in Liverpool, Hamburg and other dance halls. What we generated was fantastic, when we played straight rock, and there was nobody to touch us in Britain. As soon as we made it, we made it, but the edges were knocked off.

You know Brian [Epstein, the Beatles' first manager] put us in suits and all that, and we made it very, very big. But we sold out, you know. The music was dead before we even went on the theater tour of Britain. We were feeling shit already, because we had to reduce an hour or two hours' playing, which we were glad about in one way, to 20 minutes, and we would go on and repeat the same 20 minutes every night.

The Beatles music died then, as musicians. That's why we never improved as musicians; we killed ourselves then to make it. And that was the end of it. George and I are more inclined to say that; we always missed the club dates because that's when we were playing music, and then later on we became technically efficient

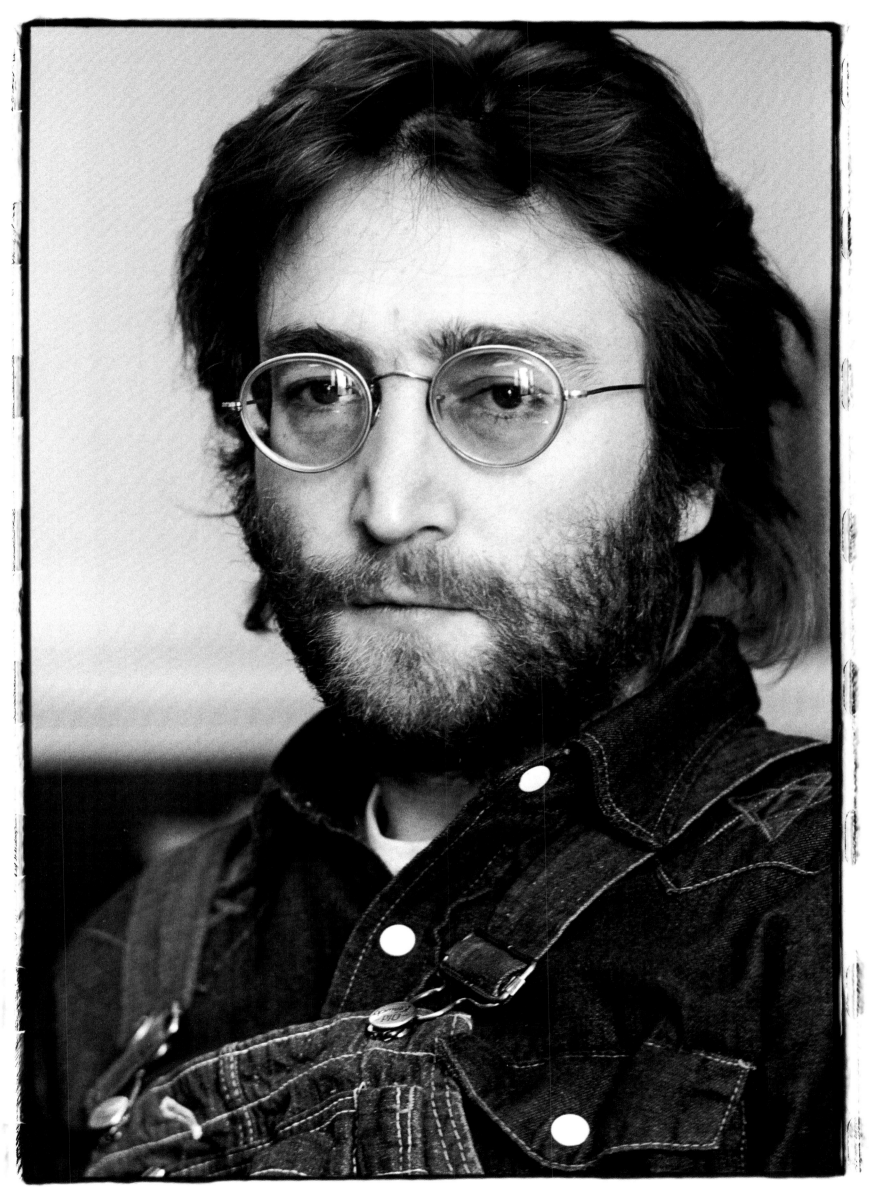

John Lennon in New York in 1970.

"Started on pills when I was 17. I've always needed a drug to survive. The others, too, but I've always had more, more pills, more of everything because I'm more crazy, probably."

recording artists – which was another thing – because we were competent people and whatever media you put us in, we can produce something worthwhile.

At some point, right between "Help" and "Hard Day's Night," you got into drugs and got into doing drug songs.

"A Hard Day's Night," I was on pills, that's drugs, that's bigger drugs than pot. Started on pills when I was 15, no, since I was 17, since I became a musician. The only way to survive in Hamburg, to play eight hours a night, was to take pills. The waiters gave you them – the pills and drink. I was a fucking dropped-down drunk in art school. "Help" was where we turned on to pot and we dropped drink, simple as that. I've always needed a drug to survive. The others, too, but I always had more, more pills, more of everything because I'm more crazy, probably.

There's a lot of obvious LSD things you did in the music.

Yes.

How do you think that affected your conception of the music? In general.

It was only another mirror. It wasn't a miracle. It was more of a visual thing and a therapy, looking at yourself a bit. It did all that. You know, I don't quite remember. But it didn't write the music, neither did Janov or Maharishi in the

same terms. I write the music in the circumstances in which I'm in, whether it's on acid or in the water.

The Hunter Davies book, the "authorized biography," says...

It was written in the [London] *Sunday Times* sort of fab form. And no home truths was written. My auntie knocked out all the truth bits from my childhood, and my mother and I allowed it, which was my cop-out, et cetera. There was nothing about orgies and the shit that happened on tour. I wanted a real book to come out, but we all had wives and didn't want to hurt their feelings. End of that one.

The Beatles tours were like the Fellini film *Satyricon*.

Would you go to a town... a hotel...

Wherever we went, there was always a whole scene going, we had our four separate bedrooms. We tried to keep them out of our room. Derek [Taylor]'s [the Beatles' press officer] and Neil [Aspinall]'s [the Beatles' aide-de-camp and Apple Corps manager] rooms were always full of junk and whores and who-the-fuck-knows-what, and policemen with it. *Satyricon*! We had to do something. What do you do when the pill doesn't wear off and it's time to go? I used to be up all night with Derek, whether there was anybody there or not, I could never sleep. They

didn't call them groupies then, they called it something else, and if we couldn't get groupies, we would have whores and everything, whatever was going....

When we hit town, we hit it. There was no pissing about. There's photographs of me crawling about in Amsterdam on my knees coming out of whorehouses and things like that. The police escorted me to the places because they never wanted a big scandal, you see.

What else was left out of the Hunter Davies book?

That I don't know, because I can't remember it. There is a better book on the Beatles by Michael Braun, *Love Me Do*. That was a true book. He wrote how we were, which was bastards. You can't be anything else in such a pressurized situation, and we took it out on people like Neil, Derek and Mal [Evans, the Beatles' road manager]. That's why underneath their facade, they resent us, but they can never show it, and they won't believe it when they read it. They took a lot of shit from us because we were in such a shitty position. It was hard work, and somebody had to take it. Those things are left out by Davies, about what bastards we were. Fuckin' big bastards, that's what the Beatles were. You have to be a bastard to make it, that's a fact, and the Beatles are the biggest bastards on Earth.

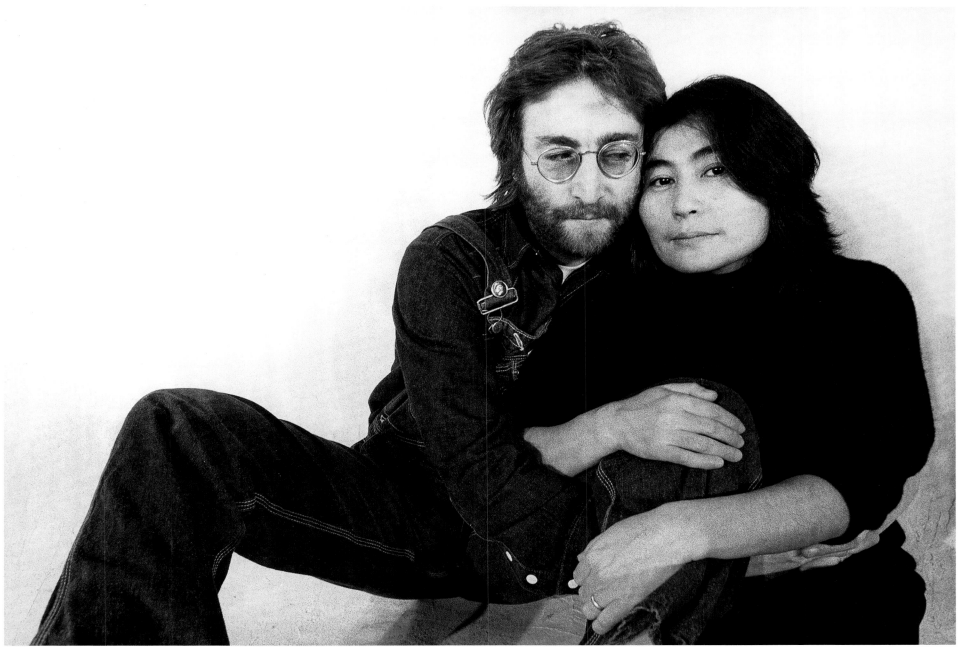

John Lennon and Yoko Ono in New York, 1970.

Do you think you're a genius?

Yes, if there is such a thing as one, I am one.

When did you first realize that?

When I was about 12. I used to think I must be a genius, but nobody's noticed. I used to wonder whether I'm a genius or I'm not, which is it? I used to think, well, I can't be mad, because nobody's put me away, therefore, I'm a genius. A genius is a form of madness, and we're all that way, you know.... I didn't become something when the Beatles made it or when you heard about me, I've been like this all me life. Genius is pain, too.

What do you think are your best songs that you have written?

Ever? The one best song?

Have you ever thought of that?

I don't know.... That kind of decision-making I can't do. I always liked "Walrus," "Strawberry Fields," "Help," "In My Life," those are some favorites.

Why "Help"?

Because I meant it – it's real. The lyric is as good now as it was then.... It was just me singing "Help," and I meant it.

I don't like the recording that much; we did it too fast trying to be commercial. I like "I Want to Hold Your Hand." We wrote that together, it's a beautiful melody. I might do "I Want to Hold Your Hand" and "Help" again, because I like them and I can sing them. "Strawberry Fields" because it's real, real for then, and I think it's like talking, "You know, I sometimes think no…" It's like he talks to himself, sort of singing, which I thought was nice.

I like "Across the Universe," too. It's one of the best lyrics I've written. In fact, it could be the best. It's good poetry, or whatever you call it, without chewin' it. See, the ones I like are the ones that stand as words, without melody. They don't have to have any melody, like a poem, you can read them.

What part did you ever play in the songs that are heavily identified with Paul, like "Yesterday"?

"Yesterday" I had nothing to do with.

"Eleanor Rigby"?

"Eleanor Rigby" I wrote a good half of the lyrics or more.

Who wrote "Nowhere Man"?

Me, me.

Did you write that about anybody in particular?

Probably about myself. I remember I was just going through this paranoia, trying to write something and nothing would come out, so I just lay down and tried to not write, and then this came out, the whole thing came out in one gulp.

What songs really stick in your mind as being Lennon-McCartney songs?

"I Want to Hold Your Hand," "From Me to You," "She Loves You" – I'd have to have the list, there's so many, trillions of 'em. Those are the ones. In a rock band you have to make singles, you have to keep writing them. Plenty more. We both had our fingers in each other's pies.

I remember the simplicity on the new album was evident on the Beatles double album. It was evident in "She's So Heavy," in fact a reviewer wrote of "She's So Heavy": "He seems to have lost his talent for lyrics, it's so simple and boring." "She's So Heavy" was about Yoko. Like she said, when you're drowning, you don't say, "I would be incredibly pleased if someone would have the foresight to notice me drowning and come and help me," you just scream. In "She's So Heavy," I just sang "I want you, I want you so bad, she's so heavy, I want you," like that. I started simplifying my lyrics then, on the double album.

Do you see a time when you'll retire?

No. I couldn't, you know.

ONO: He'll probably work until he's 80 or until he dies.

Do you have a picture of "when I'm 64"?

No, no. I hope we're a nice old couple living off the coast of Ireland or something like that – looking at our scrapbook of madness.

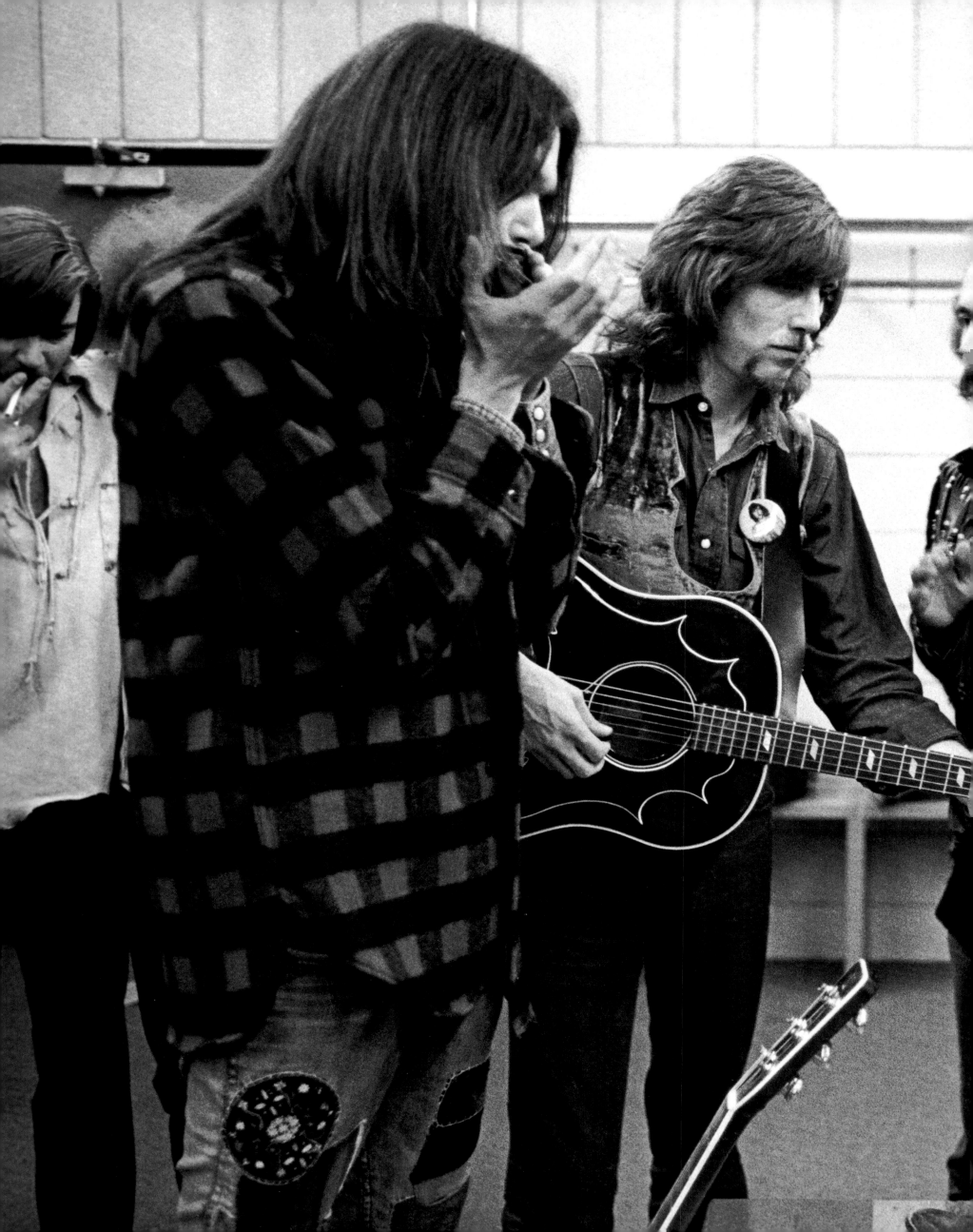

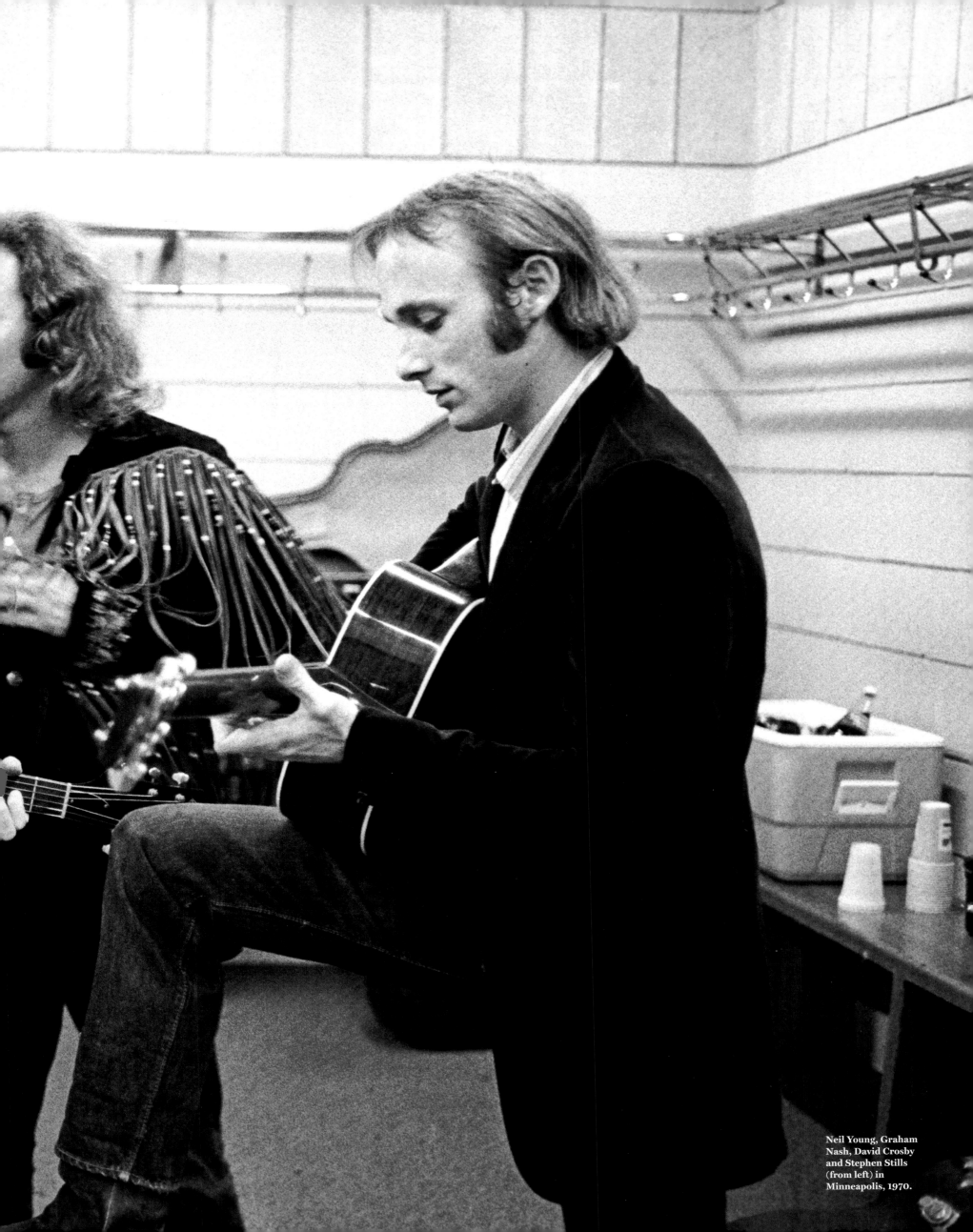

Neil Young, Graham Nash, David Crosby and Stephen Stills (from left) in Minneapolis, 1970.

Charles Manson

Coming face-to-face with the most dangerous man alive

RS 61 · JUNE 25, 1970

IN EARLY 1970, TWO LONGHAIRED *ROLLING STONE* REPORTERS entered Los Angeles County Jail for a sit-down with the most notorious murderer on the planet. Charles Manson had been awaiting trial since the previous August. His followers had committed a series of horrifying slaughters across Los Angeles, but he maintained his innocence. And David Dalton, one of the writers, believed him. "He was a fellow hippie, and I thought he'd been railroaded," Dalton says today. "I was spouting this stupid hippie bullshit, like, 'Which side are you on, man? The fucking government is corrupt!'"

Dalton's and David Felton's areas of expertise complemented each other perfectly: Felton had spent seven years at the *Los Angeles Times* before coming to ROLLING STONE, and Dalton was a music expert with roots in the hippie culture and close ties to Dennis Wilson of the Beach Boys, who had helped Manson record some of his songs (among other things, Manson was an aspiring musician). "We came from different worlds," says Felton of Dalton. "He knew the counterculture in a much more intimate way than I did."

It was ROLLING STONE's connection to the counterculture that brought the magazine deeper into a story that had gripped the media and shaken the country. Manson agreed to a jailhouse interview because he wanted to talk about the album he'd released, *Lie: The Love and Terror Cult.* Dalton and Felton had to pose as material witnesses to get into the jail.

They found themselves sitting at a Formica table, across from a man who'd recently carved an X into his forehead. "He kept clicking his nails on the table to make a point," says Felton. "I could see how he'd have command over people."

Dalton felt he was connecting with a fellow hippie and meant to say, "You're a Scorpio, aren't you?" But he slipped and said something else instead: "You're a scorpion." "Ten different emotions flashed across his face," says Dalton. "Anger, shock, confusion. It was like someone flashing a strobe light. And he could suddenly swing from pure vicious racism to environmentalism to statements like 'I am God.'"

In an effort to tell the story from the inside, Dalton and his wife had spent the past week living with members of the Manson Family – including Lynette "Squeaky" Fromme, who years later would try to assassinate President Gerald Ford – on a commune at the Spahn Ranch, on the outskirts of Los Angeles. "It was like any other hippie commune," Dalton says. "We'd raid dumpsters and make a kind of stew. Everybody would take it out of a big bowl. We'd ride horses at night. It was totally pleasant."

But following the Manson jailhouse meeting, when Felton and Dalton interviewed Los Angeles prosecutor Aaron Stovitz, that pleasantness – and Dalton's theories about Manson's innocence – vanished. "He took out this tray of color photographs of the scene of the LaBianca murders," says Dalton. "Immediately I see 'Piggies' and 'Helter Skelter' written in blood on the walls and refrigerator. At that instant I knew they did it. The L.A. Police Department would have had to be geniuses to plant that."

He raced back to the Spahn Ranch to rescue his wife. "We felt perfectly safe when we believed he was innocent," Dalton says. "Now they looked like children of the damned. Their eyes were dilated, and they all seemed to be tuned in to the same harmonic vibe." Not wanting to arouse suspicion by leaving, they staged a fight and then stormed off and hitchhiked into town. "It was a moment of pure terror," Dalton says. "It was a living horror movie.…The paranoia in L.A. at the time was like a loose power line writhing on the Pacific Coast Highway. It was palpable."

The couple moved into Felton's house in Pasadena, where the two writers spent six weeks threading their notes and transcripts into a 30,000-word feature, roughly the size of a short book. They divided it into six chapters, referencing everything from Dostoevsky's *Crime and Punishment* to the Phil Ochs song "Crucifixion." It was a painstaking look at the entire event: the murders, the media circus, the legal proceedings, the world of the Manson Family. And it accomplished something no other coverage had been able to: It brought the reader face-to-face with Manson himself.

Manson spoke in pronouncements that seemed profound – until you tried to parse what it all actually meant. Dalton and Felton described his patter as a "super acid rap – symbols, parables, gestures, nothing literal, everything enigmatic." "Paranoia is just a kind of awareness, and awareness is just another form of love," Manson said at one point. "Once you give in to paranoia, it ceases to exist. That's why I say submission is a gift, just give in to it, don't resist. It's like saying, 'Tie me on the cross!'"

The story ran across 21 pages of the magazine just before Manson's trial started, and the coup of landing the Manson interview put the journalism world on notice that the rules had changed, helping win ROLLING STONE the first of its 15 National Magazine Awards. (The citation praised the magazine's "formula-free group journalism as reflected in its exhaustive reports on the Charles Manson case and the tragedy of the Altamont rock festival.") "I really have a deep feeling about it even today," says Felton. "And I'm glad Manson is still in jail, and I hope he never gets out."

Manson wrote a letter to the editor from prison after the cover story, offering to talk further: "If you would be so kind and send me a subscription to your paper, I will be happy to answer any questions you may have."

Rock Is Sick and Living in London

'This band hates you,' the Sex Pistols' manager told a ROLLING STONE writer who wouldn't give up

RS 250 • OCTOBER 20, 1977

THERE AREN'T MANY BANDS WHO LAND ON THE COVER OF ROLLING STONE after releasing no more than three singles, and fewer still who refuse to be photographed once they've done so. But the world had never heard – or seen – anything like the Sex Pistols before. If there were any rules in rock & roll, or in life for that matter, the Pistols were dead set on breaking them. It was a story that needed telling.

Charles M. Young – who'd won the first ROLLING STONE national college writing competition in 1975 and come to work for the magazine in 1976 – lobbied his editors to send him to London. A trans-Atlantic flight to write about a band that hadn't finished recording its debut album – and didn't even have a label at the time – was a hard sell. "I know this is important!" Young told his editors. "It doesn't matter if the music is any good!"

When he got there, he found the Pistols had no more respect for the press than they did for anything else. "This band hates you," the group's manager, Malcolm McLaren, told him. "It hates your culture." Young had to camp out in McLaren's office to gain any access to the band – but he did, eventually finding himself in the studio as the Pistols recorded *Never Mind the Bollocks* (with Freddie Mercury and Queen recording right next door). Sid Vicious, the bassist, had bright-red scars on his chest, having recently indulged in some self-mutilation. "One night nobody was payin' any attention to me, so I thought I'd commit suicide," said the bassist, who would be dead from a heroin overdose within 18 months. "So I went in the bathroom, broke a glass and slashed my chest with it. It's a really good way to get attention."

Later, Young shared a car with singer Johnny Rotten, film critic Roger Ebert and B-movie kingpin Russ Meyer (the latter two had been hired to write and direct a movie about the Pistols). The car pulled over so Rotten could buy the following day's groceries: two six-packs and a can of beans. Elvis Presley had died the day before. Young asked Rotten about his passing. "Fuckin' good riddance to bad rubbish," he snarled.

Some of the outrageous bits in the story seemed to have been manufactured for Young's benefit – as when McLaren tore into record-label presidents like Clive Davis ("bullshit artist number one, this guy") even while he negotiated with them. "I or my representatives have had about 20 conversations with him," Davis told Young. "My reaction is amusement."

The Pistols had been effectively banned from playing live. So Young followed them to Wolverhampton, a suburb of Birmingham, where they appeared as the Spots (an acronym for "Sex Pistols on Tour Secretly") in the first show of a "guerrilla tour" of Britain.

At midnight, the Sex Pistols emerged and Rotten unleashed the demonic laugh that began "Anarchy in the U.K." "Some kid has put his fist through one of the speakers and a few more have escaped the security men to step on wires and knock over electronic equipment," Young wrote of what he'd later tell the band was the most amazing show he'd ever seen. "The song is barely intelligible over the explosions and spitting noises from shorts, just the way anarchy ought to sound. The crowd pogos frantically.... 'Pretty Vacant,' their current hit single, draws an unholy reaction – the crowd shouting the chorus at the top of their lungs: 'We're so pretty/Oh so pretty/Va-cant/And we don't care!'.... For the first time, I see Johnny Rotten crack a smile – only a brief one, but unmistakably a smile. Grasping a profusely bleeding nose, a kid collapses at my feet. Another pogos with his pants down. The 'God Save the Queen' chorus – 'No future, no future, no future for you' – sparks a similar explosion and closes the set. 'No Fun' is the encore and, true to its title, blows out the entire PA."

Young returned to New York a changed man, with spiked hair and clothes so tattered that the receptionist at first refused to let him into the ROLLING STONE offices. Once inside, he began a campaign to get his story on the cover – he was so convinced that the phenomenon he had witnessed would translate to America that he bet associate editor Peter Herbst $20 that *Never Mind the Bollocks* would break the Top 10 in the States. He would end up losing that bet, but he was successful in his cover campaign.

"We were pretty mainstream, and punk was upsetting what we felt was the natural order of pop music," says Herbst. "But to Jann [Wenner]'s credit, he decided to go for it." And stuck with it even when the band refused to sit for a cover photo. Roger Black, then the art director, tore two photos of Johnny Rotten in half and assembled something that looked like the Sex Pistols' ransom-note graphic style.

Young wrote about much more than punk rock, including cover stories and features on Carly Simon, Kiss and the Eagles. He became passionate about politics as he got older, writing features on philosopher-activist Noam Chomsky and Howard Zinn (author of *A People's History of the United States*) in the 1990s, but kept his hand in profiling rock & roll wild men like Jerry Lee Lewis as well. On August 18th, 2014, at age 63, Young passed away after a year-and-a-half battle with a stage-four brain tumor. His humor, grace and passion live on in his writing.

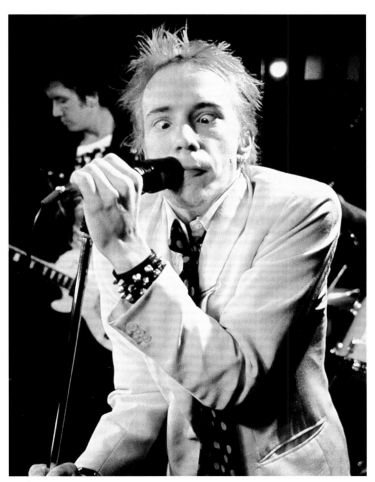

Johnny Rotten performing in Sweden, July 1977. "England was never free," Rotten told ROLLING STONE. "I'm surprised we aren't in jail for treason."

"Unrequited love is a subject very near and dear to my heart. I have a whole well of inspiration when it comes to that."

BETTE MIDLER, *"The Homecoming," RS 306, December 13, 1979.*

Midler in New York.

Linda Ronstadt
at her beach house,
Malibu, 1976.

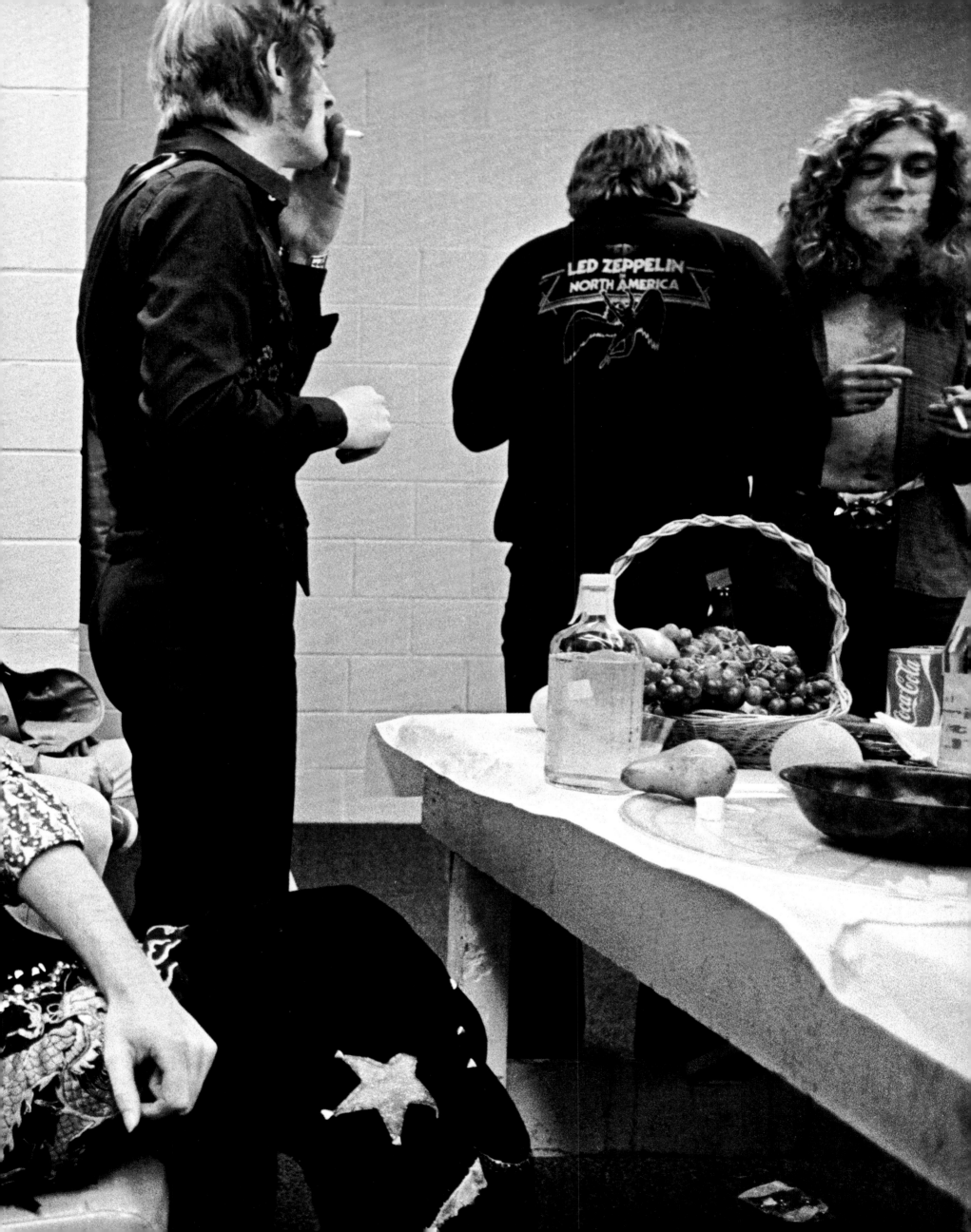

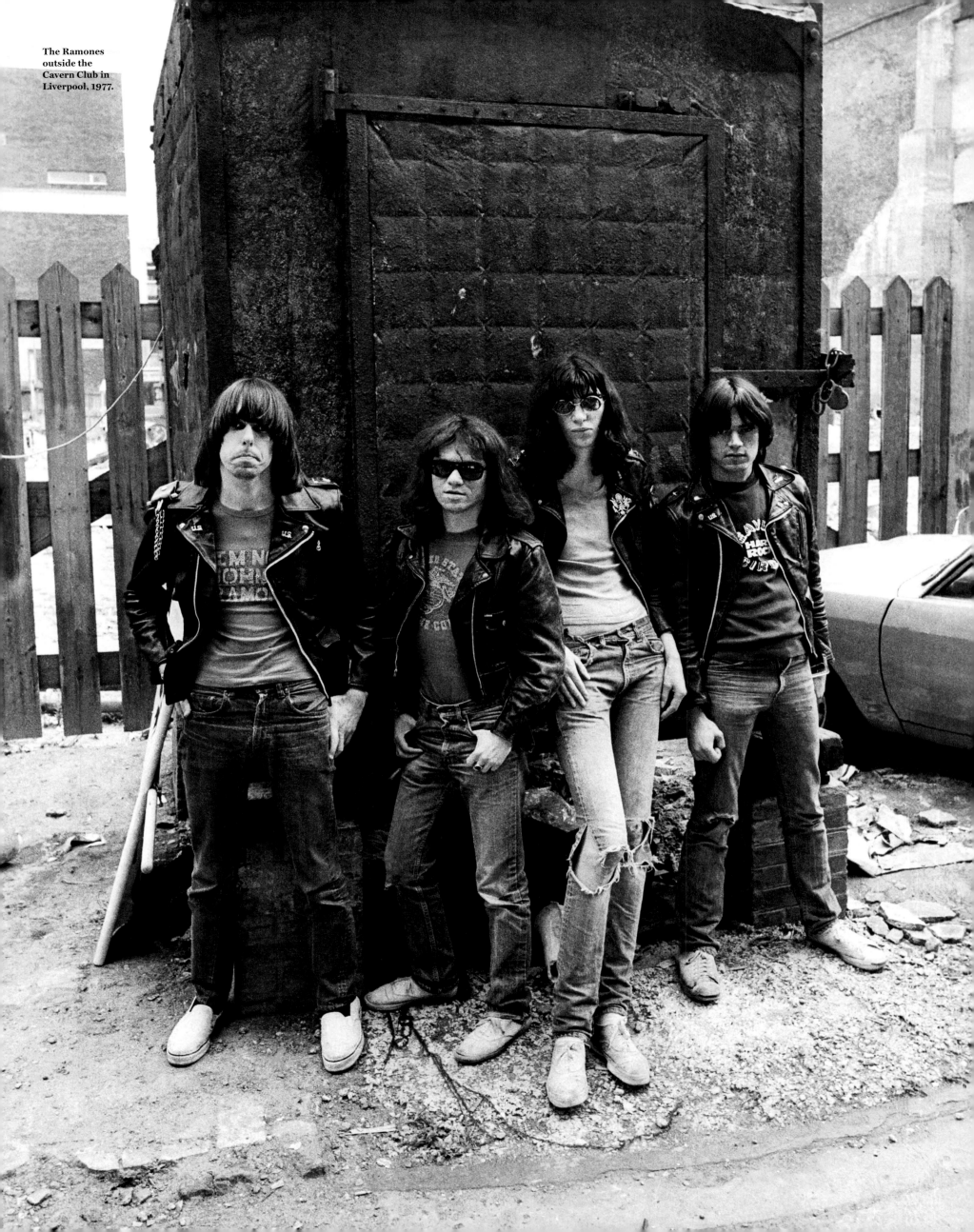

The Ramones
outside the
Cavern Club in
Liverpool, 1977.

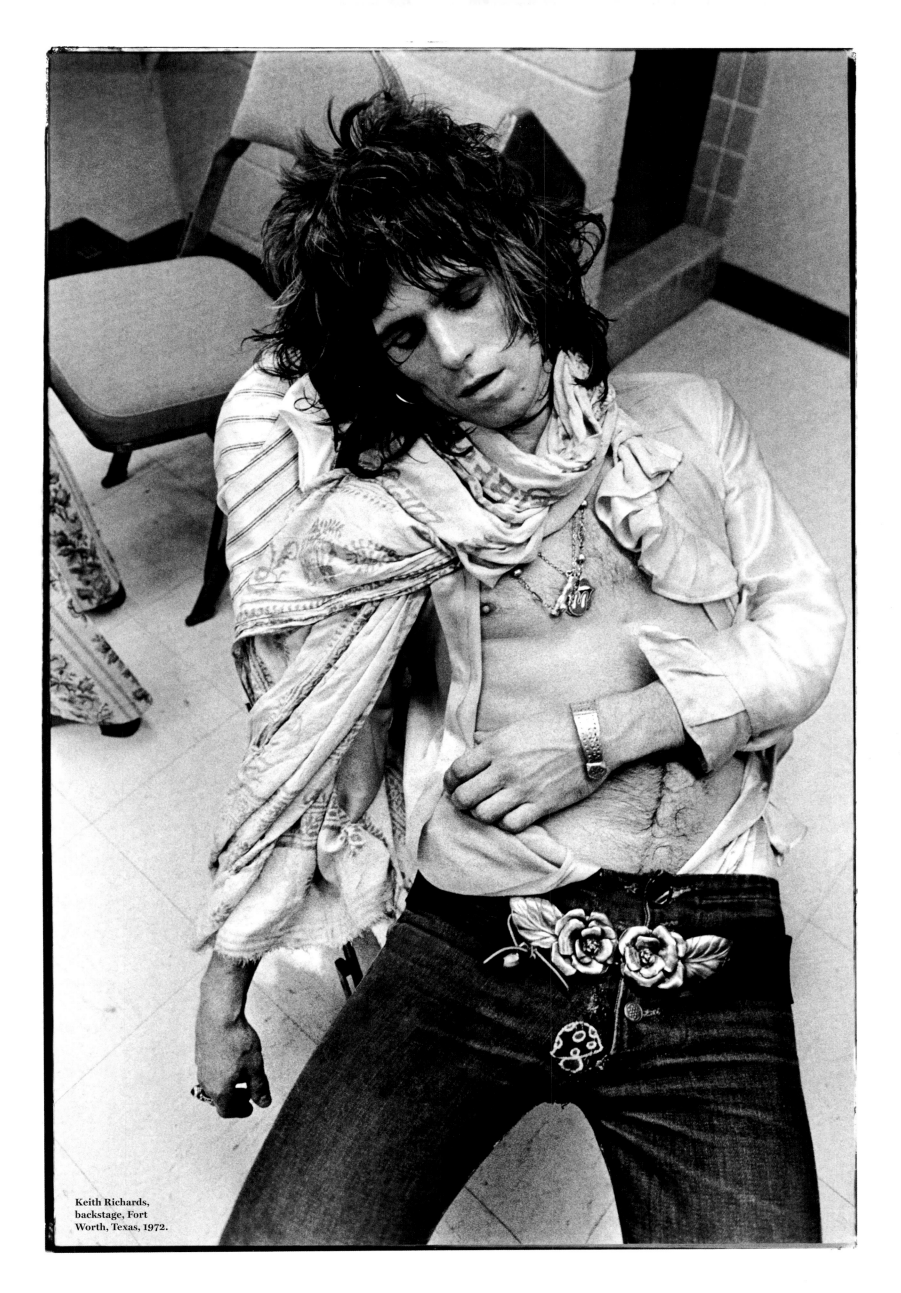

Keith Richards,
backstage, Fort
Worth, Texas, 1972.

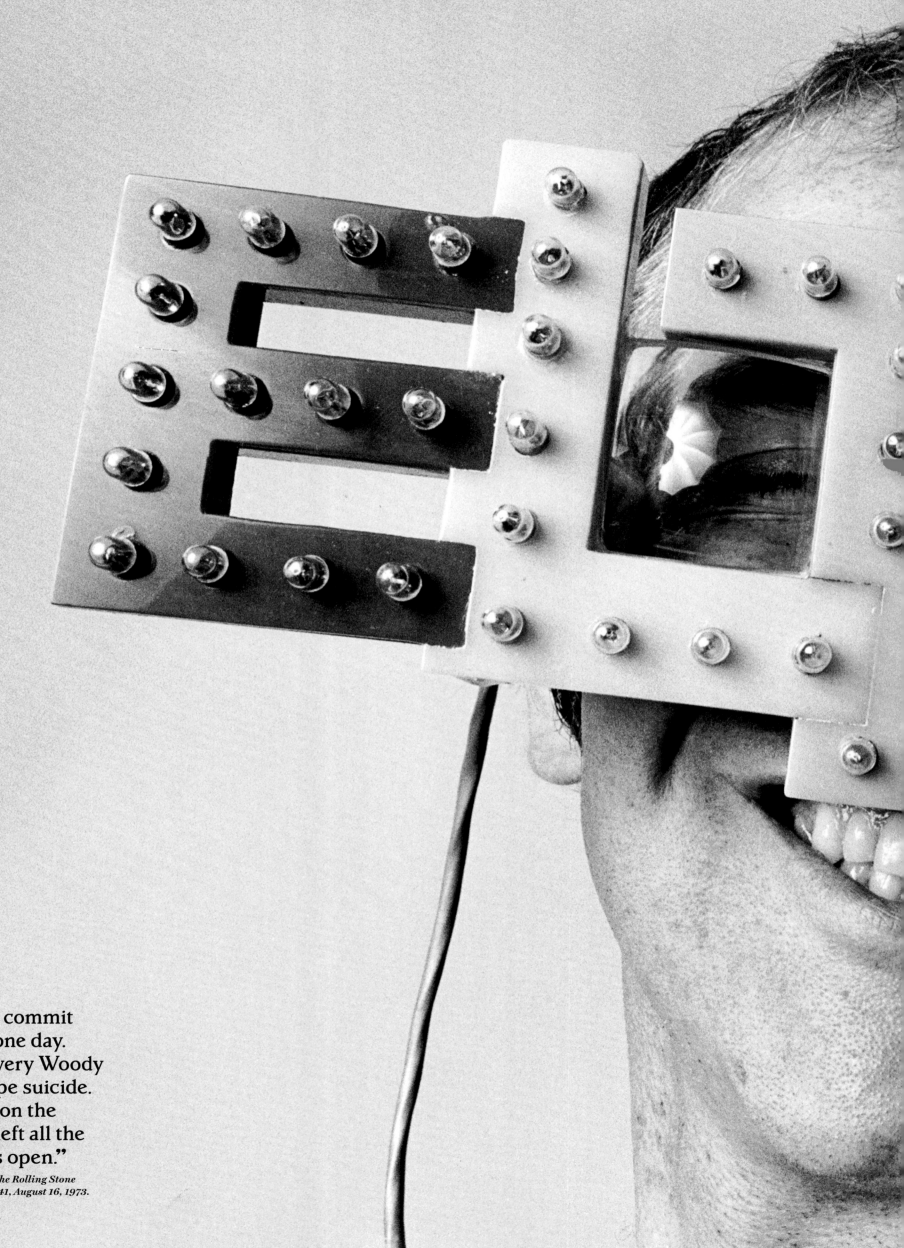

"I tried to commit
suicide one day.
It was a very Woody
Allen-type suicide.
I turned on the
gas and left all the
windows open."

ELTON JOHN, *"The Rolling Stone*
Interview," RS 141, August 16, 1973.
—
John in London.

Hunter S. Thompson

The undisputed master of gonzo journalism exposed the world's fear and loathing in more than 40 articles for ROLLING STONE

IN JANUARY 1970, HUNTER S. THOMPSON WROTE JANN S. WENNER to praise ROLLING STONE's definitive coverage of the disastrous Altamont festival. "[Print's] a hell of a good medium by any standard, from Hemingway to the Airplane," Thompson said. "Don't fuck it up with pompous bullshit; the demise of RS would leave a nasty hole." A bond was formed, and over the next 30 years, Thompson would do much to redefine journalism in the pages of the magazine. He lived and wrote on the edge in a style that would come to be called gonzo journalism, a term that captured his lifestyle but didn't really do justice to Thompson's absolute command of language, his fearless reporting or his fearsome intellect.

Thompson was born in Louisville, Kentucky, and had served in the Air Force and worked as a journalist in the Caribbean before moving to San Francisco, where an article about the Hells Angels turned into a book project. He spent almost a year living and riding with the outlaw motorcycle gang, and in 1966 he published a bestseller that took readers deep inside a subculture completely inaccessible to the outside world.

In that sense, Thompson and ROLLING STONE were kindred spirits. After he wrote to the magazine, Wenner invited him to the office to discuss a piece that would be called "The Battle of Aspen," about Thompson's effort to unseat the sheriff of Pitkin County, Colorado. "He stood six-three," Wenner remembered years later, "shaved bald, dark glasses, smoking, carrying two six-packs of beer; he sat down, slowly unpacked a leather satchel full of 'travel necessities' onto my desk – mainly hardware, like flashlights, a siren, knives, boxes of cigarettes and filters, whiskey, corkscrews, flares – and didn't leave for three hours. By the end, I was suddenly deep into his campaign."

For both men, politics had begun to emerge as a gripping fascination. Thompson had seen a cultural shift in the Bay Area and had moved to Woody Creek, Colorado, in 1967, once he felt San Francisco had been overrun by "the narcs and the psychedelic hustlers." Now, three years later, he described how that same shift played out in "The Battle of Aspen": "Somewhere in the nightmare of failure that gripped America between 1965 and 1970, the old Berkeley-born notion of beating The System by fighting it gave way to a sort of numb conviction that it made more sense in the long run to Flee, or even to simply hide, than to fight the bastards on anything even vaguely resembling their own terms."

This he meant to change by serving as the de facto campaign manager for Joe Edwards, a 29-year-old pot-smoking lawyer who was running for mayor. Edwards lost by just six votes, but Thompson was pressing forward in "The Battle of Aspen" with his own run for sheriff, on the "freak power" platform: "The Old Guard was doomed, the liberals were terrorized, and the Underground had emerged, with terrible suddenness, on a very serious power trip." Among his proposals: protecting Aspen from the "greedheads, land-rapers, and other human jackals" by changing Aspen's name to Fat City and tearing up all the streets and creating a huge parking facility on the outskirts of town. He lost, but his fate as a self-described "political junkie" was sealed.

A year later, Thompson sent ROLLING STONE the first section of a new piece he was working on. "We were somewhere around Barstow on the edge of the desert when the drugs began to take hold," it began. "I remember saying something like, 'I feel a bit lightheaded; maybe you should drive….' And suddenly there was a terrible roar all around us and the sky was full of what looked like huge bats, all swooping and screeching and diving around the car, which was going about 100 miles an hour with the top down to Las Vegas."

"Fear and Loathing in Las Vegas" would become – for better or worse – Thompson's defining piece, and a defining literary experience for several generations of readers. It had begun as an assignment from *Sports Illustrated*. Thompson had been asked to go to Las Vegas to write a 250-word photo caption for a motorcycle race, the Mint 400. He agreed, in part because he wanted to get out of Los Angeles, where he was working on a piece for ROLLING STONE about the death of journalist Ruben Salazar, killed by law enforcement during a Vietnam protest. Thompson and attorney-activist Oscar Zeta Acosta went to Las Vegas with the notion of discussing the story in a less-charged atmosphere than L.A.

But Thompson brought his own charge with him: "two bags of grass, 75 pellets of mescaline, five sheets of high-powered blotter acid, a salt shaker half full of cocaine, and a whole galaxy of multicolored uppers, downers, screamers, laughers…and also a quart of tequila, a quart of rum, a case of Budweiser, a pint of raw ether and two dozen amyls…. Not that we *needed* all that for the trip, but once you get locked into a serious drug collection, the tendency is to push it as far as you can."

The trip became less about covering "the richest off-the-road race for motorcycles and dune-buggies in the history of organized sport" and more of "a savage journey into the heart of the American dream." When Thompson submitted 2,500 words to *Sports Illustrated*, it was rejected outright, along with his expenses. But when Wenner read it, he wanted more, and he wanted it scheduled for publication.

This classic Ralph Steadman illustration of Thompson ran in the first part of "Fear and Loathing in Las Vegas" in November 1971.

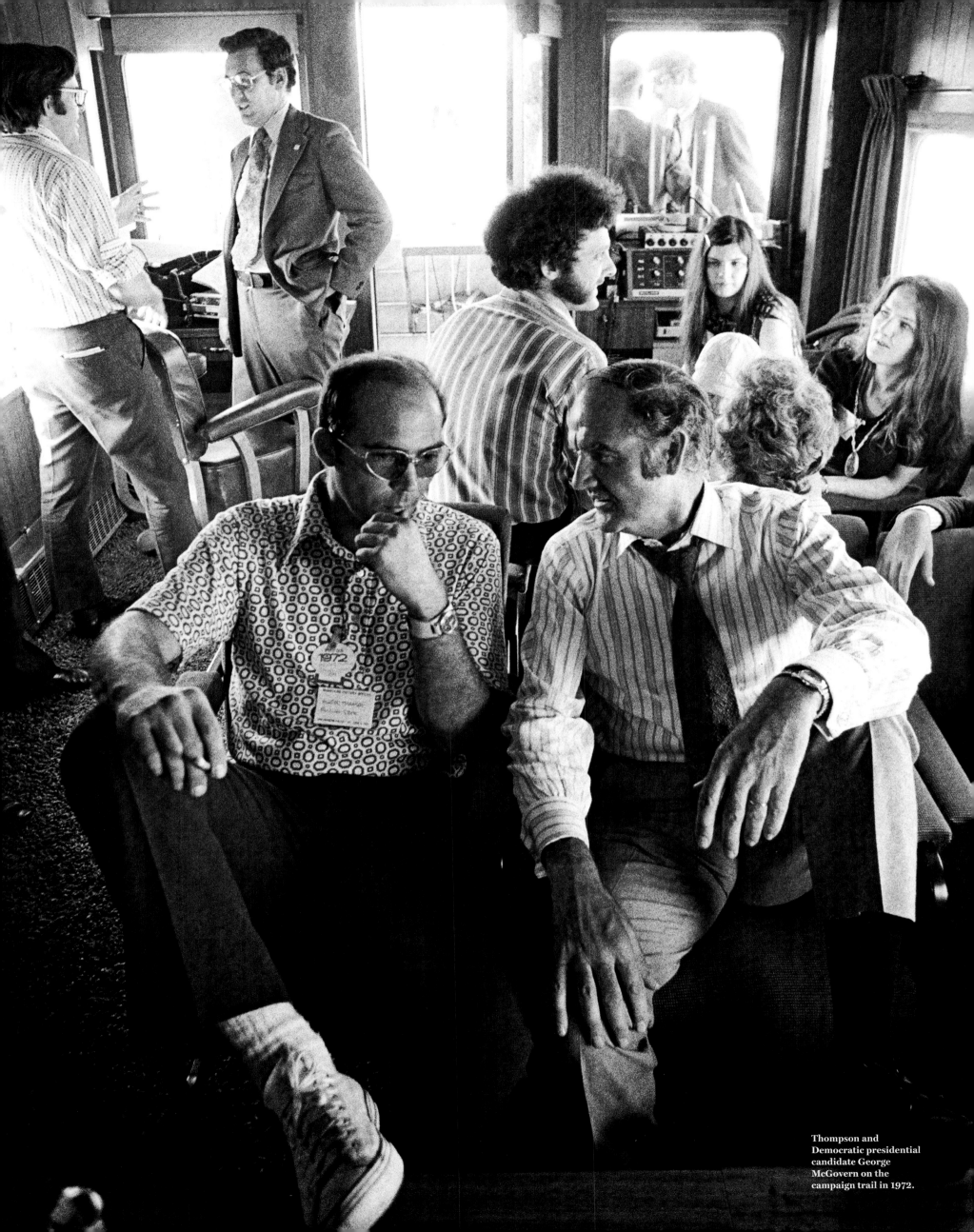

Thompson and Democratic presidential candidate George McGovern on the campaign trail in 1972.

Thompson takes a sobriety test during a ROLLING STONE editorial conference in Big Sur, 1971.

"We were flat knocked out," recalls then-managing editor Paul Scanlon. "Between fits of laughter we ran our favorite lines back and forth to one another: 'One toke? You poor fool. Wait until you see those goddamned bats!'"

ROLLING STONE sent Thompson back to Las Vegas to expand the piece with reporting on the National District Attorneys Association's Conference on Narcotics and Dangerous Drugs. The results were hilarious, frightening and electrifying in equal measure. "Fear and Loathing in Las Vegas" ran in two parts, in the issues of November 11th and 25th, 1971, with illustrations by Ralph Steadman, and was published in book form in July 1972.

By that point, Thompson was well into the 14 dispatches he filed for ROLLING STONE from the 1972 presidential campaign trail. He alternated biting and precise political analysis with gonzo narratives of life on the road. No one had ever covered politics more colorfully, or truthfully. He lacerated the "waterheads," the "swine" and "fatcats" of D.C. culture, and lifted the curtain on the mechanics of political press coverage. Timothy Crouse was also writing campaign coverage – his classic behind-the-scenes book on the press corps, *The Boys on the Bus*, began as a ROLLING STONE piece. He and Thompson exposed "pack journalism," puff pieces born out of late-night schmoozing sessions between journalists and campaign aides. It was a groundbreaking look inside the machinery of both the political system and the media.

Many of Thompson's observations still ring true today: "How low do you have to stoop in this country to be President?" he asked. Another time he wrote, "The whole framework of the presidency is getting out of hand. It's

> "You can't run unless you can cause people to salivate and whip on each other with big sticks," Thompson wrote of presidential politics in 1972.

come to the point where you almost can't run unless you can cause people to salivate and whip on each other with big sticks. You almost have to be a rock star to get the kind of fever you need to survive in American politics." Thompson's coverage made ROLLING STONE a political force, so highly regarded that in 1974 Wenner and Thompson convened in Elko, Nevada, with top policy experts of the Democratic Party to work on a strategy that they hoped could win the 1976 presidential race.

But getting the work out of Thompson was difficult and would become increasingly so. The magazine put him up at hotels in San Francisco or Florida, and stocked his room with booze, grapefruit and speed. A primitive fax machine, which Thompson called his "Mojo Wire," was installed in the ROLLING STONE offices, and he'd transmit his copy a few pages at a time at odd hours, adding the transitions and endings ("The Wisdom") later. (Describing his work ethic, Thompson compared himself to a jack rabbit that likes to wait until the last second to leap away from a speeding car.) He would often call Wenner at 2 a.m. to discuss the pieces. "It was a bit like being a cornerman for Ali," said Wenner. "Editing Hunter required stamina, but I was young and this was once in a lifetime, and we were both clear on that.... We used to read aloud what he had just written, get to certain phrases or sentences, and just exclaim to each other, 'Hot fucking damn.' It was scorching, original, and it was fun. He was my brother-in-arms."

In correspondences between Thompson and Wenner, Thompson demands albums, speed and access to a music club in D.C.; Wenner chastises him for blowing deadlines, keeping the staff late and even stealing

Thompson in a hotel room while on the campaign trail, 1972.

cassettes from his house. ("I did a lot of rotten things out there but I didn't steal your fucking cassettes," Thompson writes.) Sometimes they clashed. "The central problem here," Thompson wrote Wenner early on, "is that you're working overtime to treat this thing as straight or at least responsible journalism…whereas in truth we are dealing with a classic of irresponsible gibberish. I can't work up much enthusiasm for treating 'Fear & Loathing' like a news story."

When Thompson visited the ROLLING STONE offices, it was an event. Loud shrieks, siren blasts or duck calls might signal his arrival. Once, Thompson played animal recordings through the company intercom. Another time he showed up to Wenner's office and blasted him with a fire extinguisher. One night at Wenner's house, he pretended to inject a syringe full of 151-proof rum into his navel; a staffer almost fainted. "It was an adrenaline rush to be with him," Wenner said. "Walking with him, you knew you were likely to come near the edge of the cliff, to sense danger, to get as close to the edge as most of us get in our lives."

Thompson was also a mentor to the staff, holding court about New Journalism or sportswriters such as Jimmy Cannon. He was a stickler for grammar and wasn't afraid to lecture staffers about clean copy. "He had a gift to inspire, and he lifted everybody's game," said Scanlon.

In the mid-Seventies, Thompson hit the college speaking circuit and wrote less frequently. In one memo from around that time, Wenner checks in on seven features, none of which ever came to fruition. In 1975, Thompson traveled to a failing Saigon for a planned epic Vietnam piece, but he spent most of his time there drinking in the hotel courtyard with other correspondents. The piece was never written. He conducted several interviews with Jimmy Carter that the former president remembered as lengthy and revealing, but Thompson lost the tapes.

Still, he could churn out classic material, including a 1978 cover on Muhammad Ali (when Ali had just fought Leon Spinks for the first time and was preparing for a second fight) in which he finally convinced the champion to sit down for a two-hour interview by turning up with what he called "the ultimate cure for Muhammad's privacy problem": a red devil mask. (Ali put it on and pranked his bodyguard, Pat Patterson. Having had some fun, he agreed to get serious the next day.) A few years later, covering the 1982 Pulitzer divorce trial in Palm Beach, Florida – which was full of accusations of drug binges and sexual escapades – Thompson summed up the Eighties culture of greed as it was still taking form, and offered a trenchant look at a media world that was already becoming addicted to scandal. And in 1994, Nixon's death – and his subsequent canonization by Bill Clinton, George McGovern and others at his funeral – inspired some of Thompson's most viciously focused writing in years: "It was Richard Nixon who got me into politics, and now that he's gone, I feel lonely. He was a giant in his way. As long as Nixon was politically alive – and he was, all the way to the end – we could always be sure of finding the enemy on the Low Road. There was no need to look anywhere else for the evil bastard…. If the right people had been in charge of Nixon's funeral, his casket would have been launched into one of those open-sewage canals that empty into the ocean just south of Los Angeles. He was a swine of a man and a jabbering dupe of a president. Nixon was so crooked that he needed servants to help him screw his pants on every morning."

Thompson's final piece for ROLLING STONE was written just before the 2004 election. To Thompson, the Bush presidency was far more frightening than Nixon's. In an uncharacteristically humble and nostalgic piece, Thompson makes an emotional plea to readers to vote, and recalls meeting John Kerry in 1972. "He was yelling into a bullhorn, and I was trying to throw a dead, bleeding rat over a black-spike fence and onto the President's lawn. We were angry and righteous in those days, and there were millions of us…. It was fun. We were warriors then, and our tribe was strong like a river." Three months later, Thompson was dead.

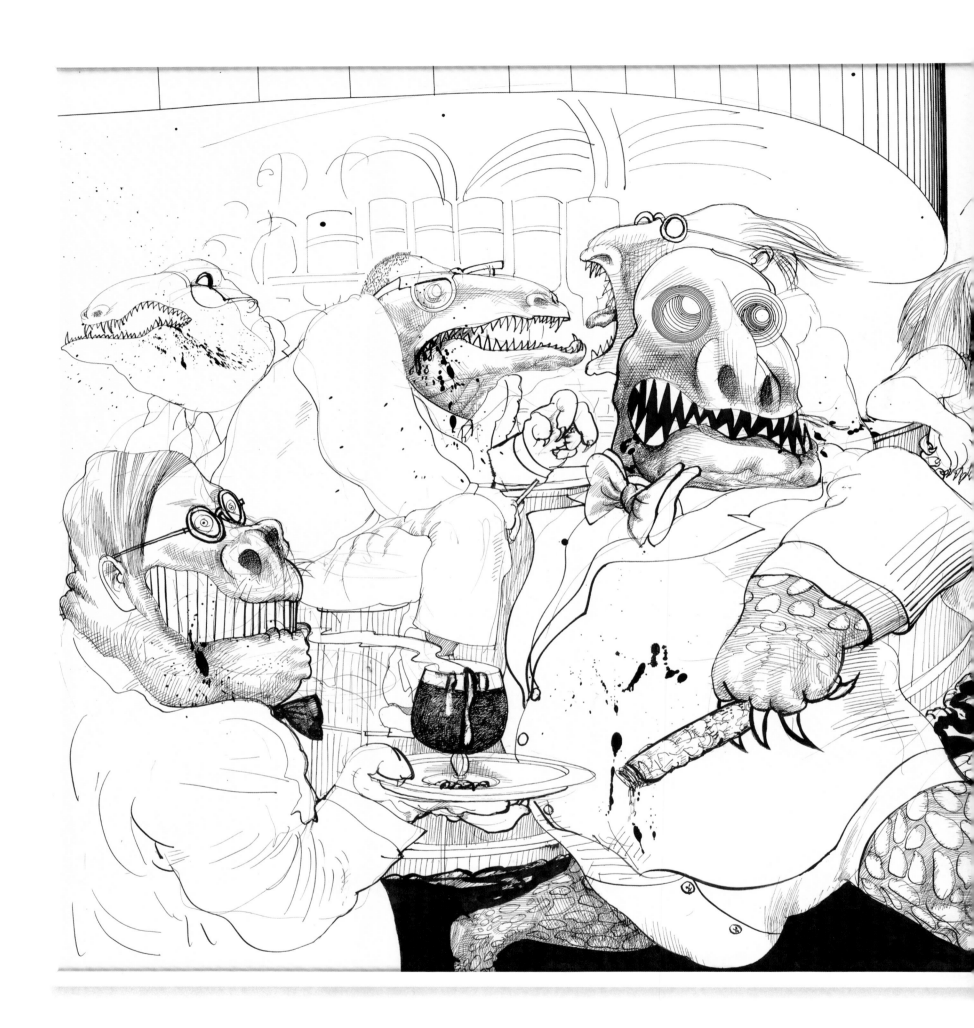

Lizards in a hotel lounge from "Fear and Loathing in Las Vegas." Steadman gave visual form to Hunter S. Thompson's prose. "He had a devil in him, and it excited the devil in me," says Steadman.

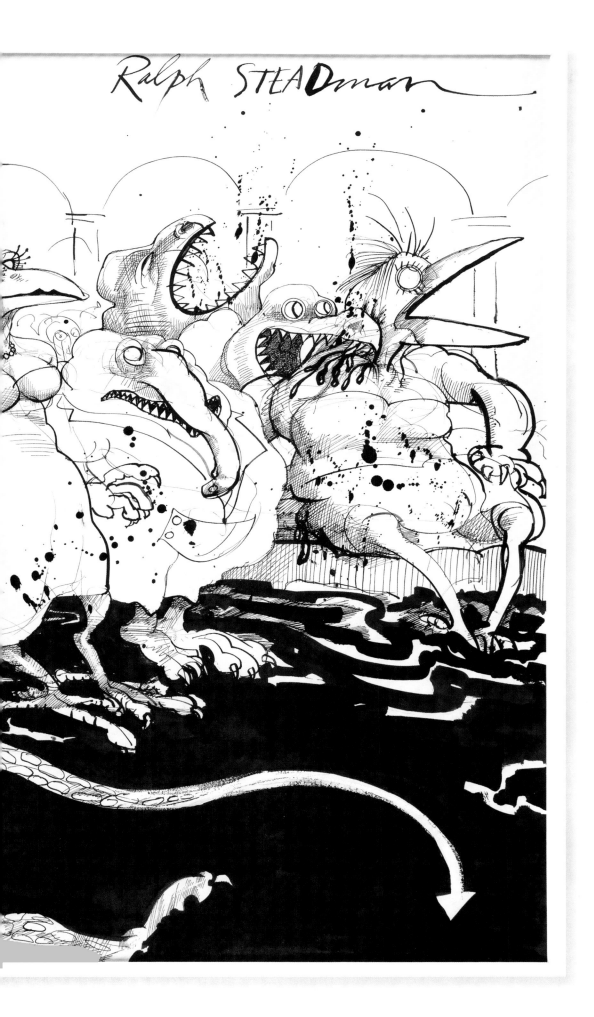

Ralph Steadman

For more than three decades, he illustrated Hunter S. Thompson's wild tales in the pages of ROLLING STONE

RALPH STEADMAN WASN'T ALONG for the ride when Hunter S. Thompson made the two trips to Nevada in 1971 that resulted in "Fear and Loathing in Las Vegas." "With you, I'd get into trouble," Thompson told him. Instead, Thompson chose attorney-activist Oscar Zeta Acosta as his traveling companion. "At least with a lawyer," he said, "I have some sporting chance."

Thompson and the London cartoonist had already worked together twice by then, first covering the Kentucky Derby in May 1970 for *Scanlan's Monthly,* then reteaming at the America's Cup yacht race in Rhode Island, where Thompson kept popping pills. "They're good for when you're on a boat," he told Steadman, who suffered from seasickness.

"It was the only pill I ever took in my life, and it was psilocybin," Steadman says. "By six or seven that night, I was jumping." The two ended up on a rowboat, with a plan to spray-paint a nearby yacht. "He said to me, 'Well, what are you going to write on them?' And I said, 'How about *Fuck the Pope*?' And he asked, 'Are you religious, Ralph?'"

Several months later, Thompson sent Steadman the manuscript for "Fear and Loathing." Steadman set to capturing Thompson's wild visions in twisted images soaked in pen splatters. "He had a devil in him, and it excited the devil in me," Steadman says.

Steadman went on to produce some of the funniest and most disturbing art of the 20th century, full of unflinching political commentary, in the pages of ROLLING STONE – depicting a politically doomed George McGovern being circled by alligators at the 1972 Democratic Convention, for "Fear and Loathing in Miami"; Nixon facing execution by hanging from a Watergate-tapes noose; and Henry Kissinger spinning a web of lies.

For more than three decades, Steadman illustrated Thompson pieces for the magazine. The work would become iconic, but Steadman shrugs it off. "I just did them, and that was it," he says of his drawings. "I'd do them to the best and worst of my ability. We were at an age when it was all good fun and we were doing it for a magazine, you know? But a crazy magazine."

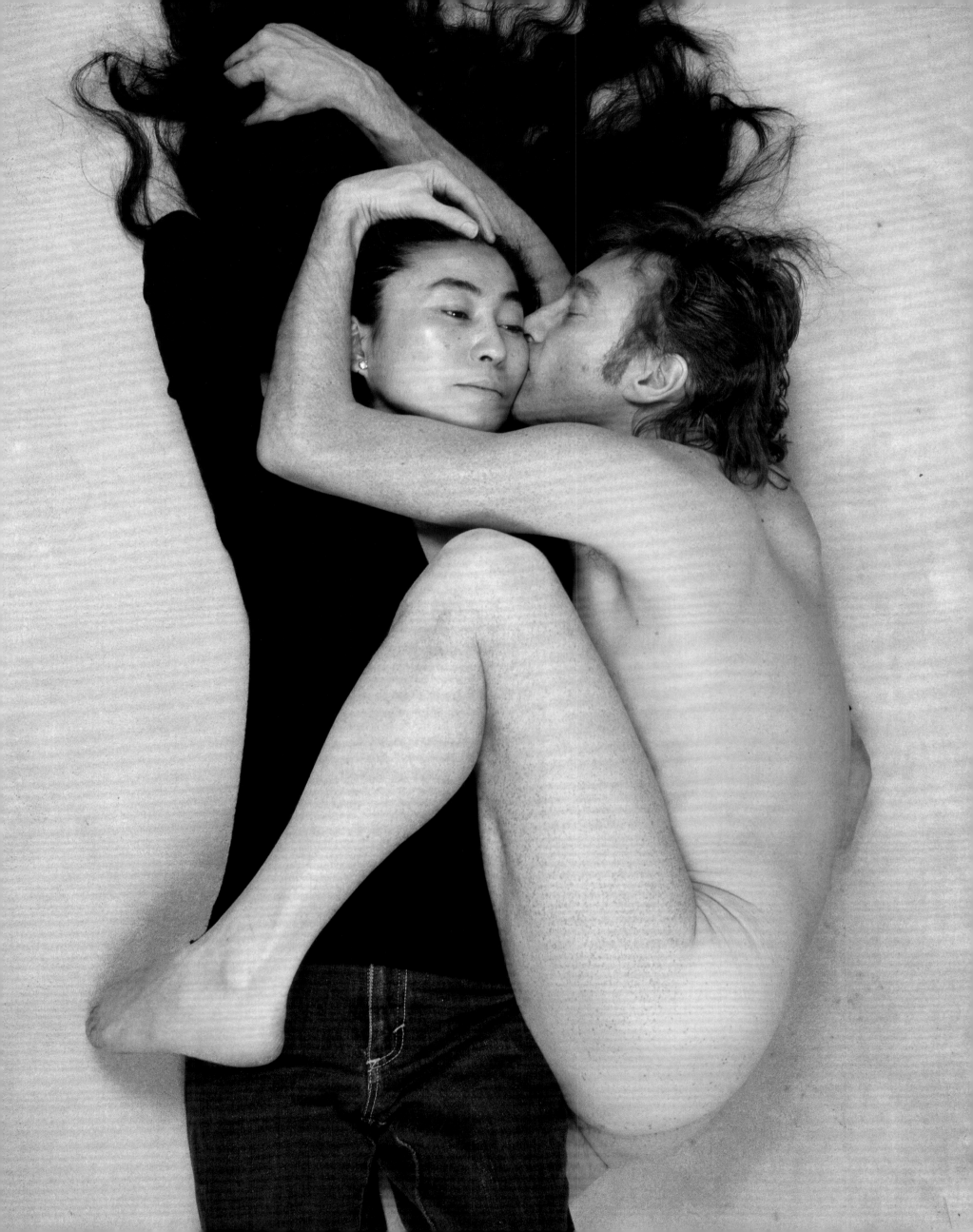

IN THE 1980s, THE REACH AND INFLUENCE OF *ROLLING STONE* continued to expand, as did the music and social change that the magazine was rooted in, from the global pop of Michael Jackson and Madonna to the global politics of U2 and Live Aid. Stories that had started in the magazine, like Tom Wolfe's "The Right Stuff," became movies, and the world of rock & roll began to take over television as well. There were triumphs, but it was also a time of generational tragedy that saw one of the magazine's most heartbreaking moments: a loving and almost impossibly intimate cover portrait of John Lennon and Yoko Ono, taken by Annie Leibovitz just hours before Lennon would be assassinated. ¶ In 1983, after 10 years as ROLLING STONE's chief photographer, Leibovitz departed, and the magazine called on a stable of the world's greatest photographers, among them Herb Ritts (whose shots of David Bowie for a 1987 Style Issue and Madonna on the beach in 1989 typified the warm classicism of his work), as well as Richard Avedon and Albert Watson. ¶ In 1984, Wolfe and ROLLING STONE embarked on an unusual project: The magazine published his first novel, *The Bonfire of the Vanities,* in serial form, with a new chapter appearing every two weeks for an entire year. It was a time that saw ROLLING STONE deepening its coverage of comedy – its first annual Comedy Issue featured Johnny Carson and David Letterman together on the cover – and politics as well, with P. J. O'Rourke and William Greider both beginning their long associations with the magazine. And ROLLING STONE's award-winning journalism continued to break new ground with a yearlong investigation of a then-new disease called AIDS.

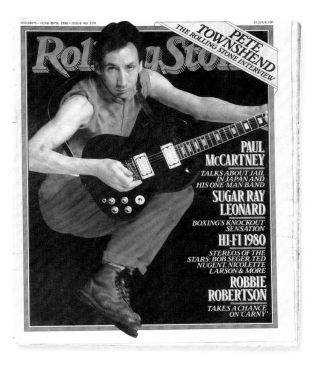

PETE TOWNSHEND
THE ROLLING STONE INTERVIEW

Rolling Stone

PAUL McCARTNEY
TALKS ABOUT JAIL IN JAPAN AND HIS ONE MAN BAND

SUGAR RAY LEONARD
BOXING'S KNOCKOUT SENSATION

HI-FI 1980
STEREOS OF THE STARS: BOB SEGER, TED NUGENT, NICOLETTE LARSON & MORE

ROBBIE ROBERTSON
TAKES A CHANCE ON 'CARNY'

JAMES CAAN ■ SLAM DANCING IN L.A. ■ THE WHO

Rolling Stone

INSIDE THE
GUN
LOBBY

THE NATIONAL RIFLE ASSOCIATION
BY HOWARD KOHN

Back to the Barricades : inside the Environmental Movement

Rolling Stone

KEITH RICHARDS
No Regrets
The Rolling Stone Interview
By Kurt Loder

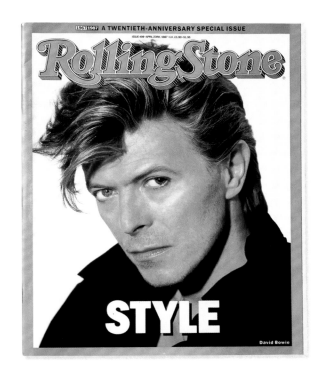

A TWENTIETH-ANNIVERSARY SPECIAL ISSUE

Rolling Stone

STYLE

David Bowie

Rock & Roll Photo Album

Rolling Stone

A SPECIAL ISSUE

LIVING BLUES MASTERS
THE NEW WOMEN OF ROCK
MUSICIANS AND THEIR FANTASTIC FANS

THE TWENTIETH ANNIVERSARY

Rolling Stone

INTERVIEWS with Bob Dylan, Bruce Springsteen, Paul McCartney, Mick Jagger, George Harrison, Keith Richards, Stevie Wonder, Pete Townshend, Bono, Sting, Tom Wolfe, Hunter Thompson, Edward Kennedy, Walter Cronkite, Jack Nicholson and more

XX

Harry Chapin: 1942-1981 ■ Moody Blues ■ Drinks with Lee Marvin

Rolling Stone

OUT THERE WITH STEVIE NICKS
The Reigning Queen of Rock & Roll and Her Magic Kingdom

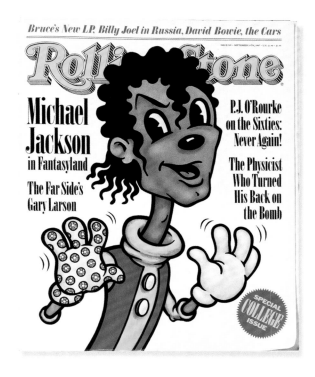

Bruce's New LP, Billy Joel in Russia, David Bowie, the Cars

Rolling Stone

Michael Jackson in Fantasyland

The Far Side's Gary Larson

P.J. O'Rourke on the Sixties: Never Again!

The Physicist Who Turned His Back on the Bomb

SPECIAL COLLEGE ISSUE

End of an Era : Why the Sixties Generation Has Quit Smoking Pot

Rolling Stone

ELVIS COSTELLO REPENTS
The Rolling Stone Interview by Greil Marcus

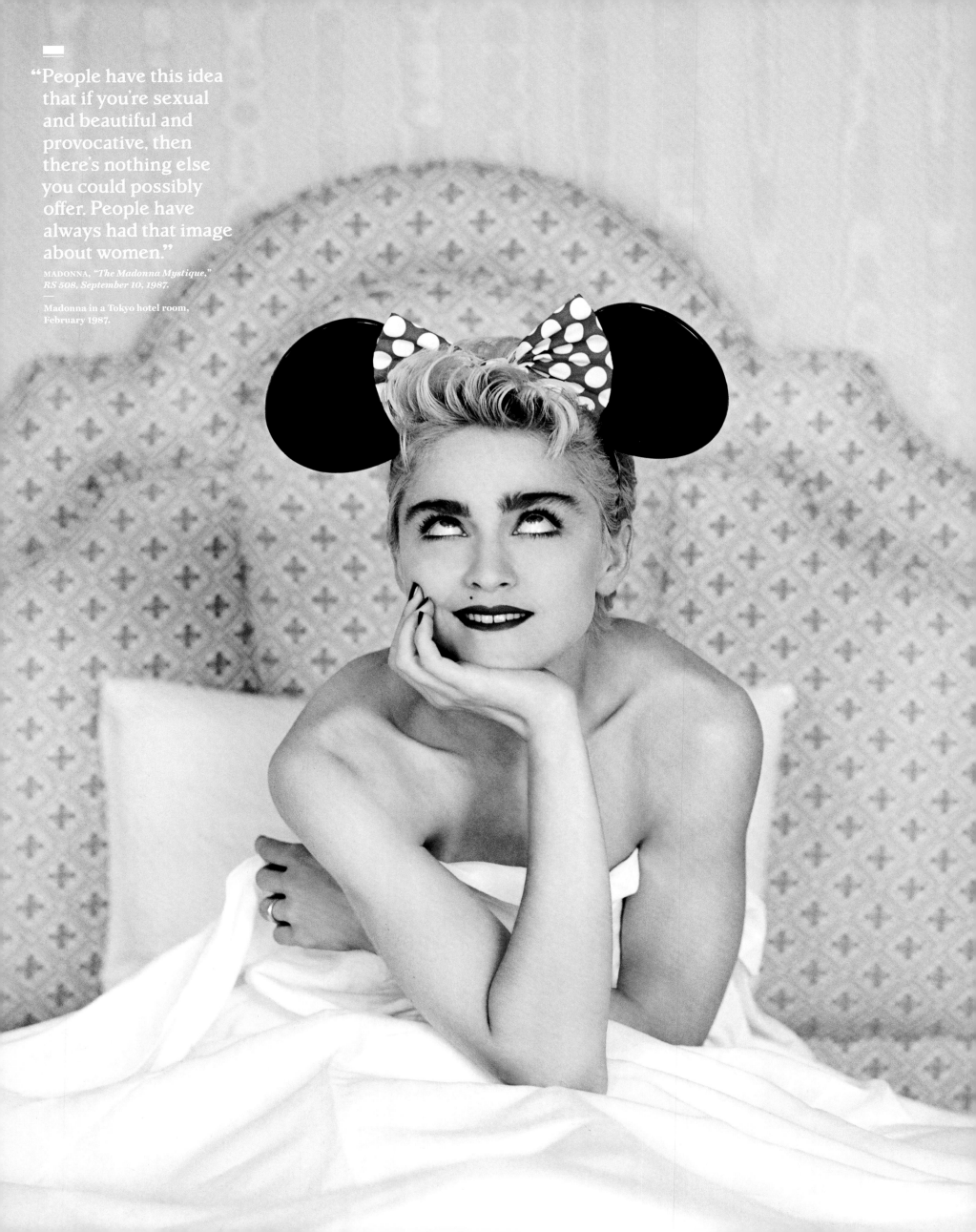

"People have this idea that if you're sexual and beautiful and provocative, then there's nothing else you could possibly offer. People have always had that image about women."

MADONNA, *"The Madonna Mystique,"*
RS 508, September 10, 1987.

Madonna in a Tokyo hotel room,
February 1987.

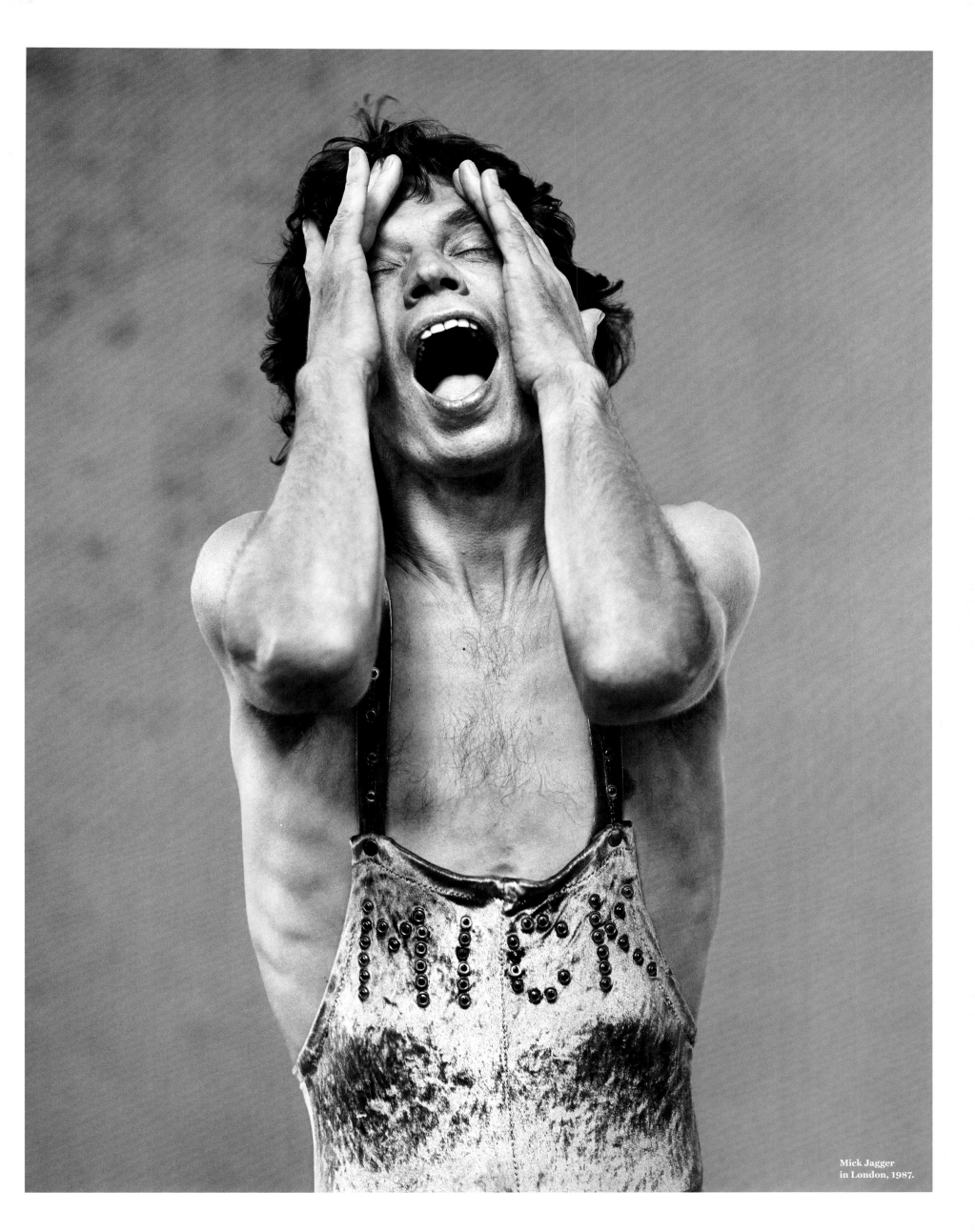

Mick Jagger
in London, 1987.

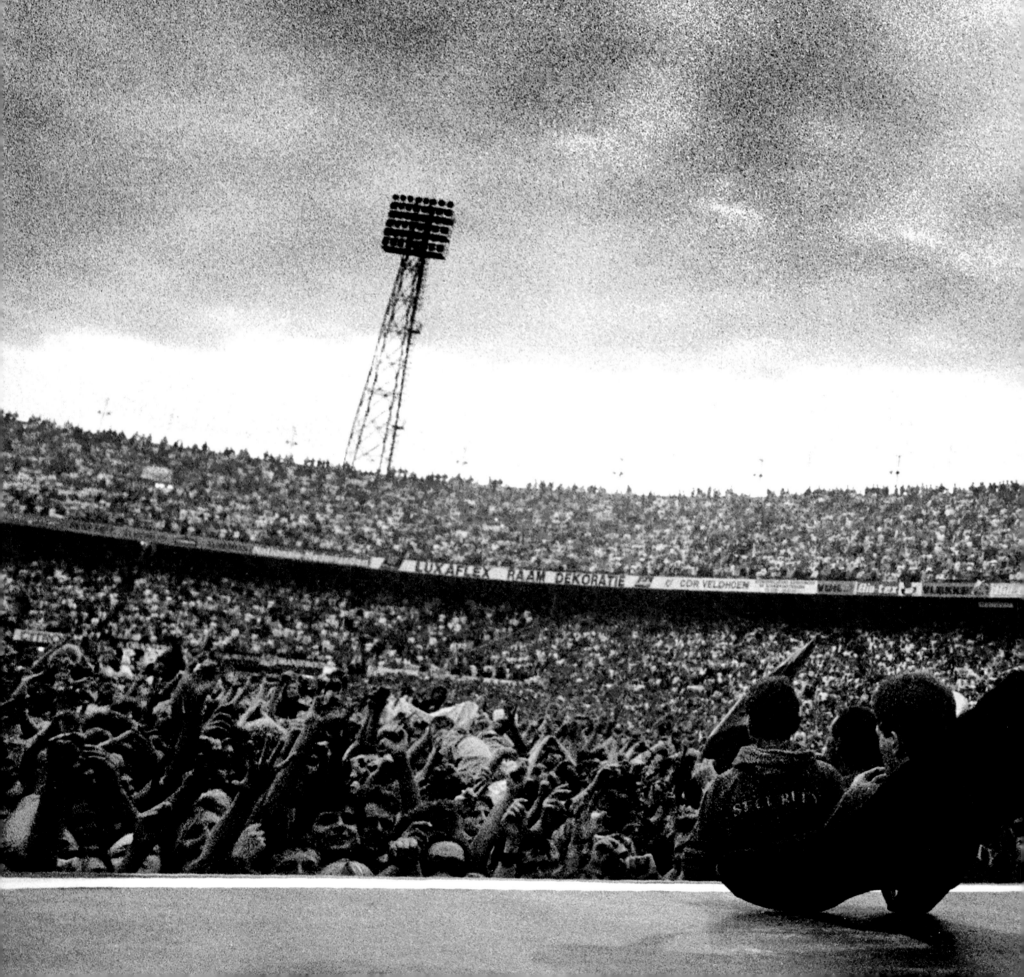

"The young-punk idea is nonsense. I prefer to spend a day with Johnny Cash than a week with some up-and-coming pop star."

BONO, *"Now What?" RS 547,*
March 9, 1989.

Bono in Holland during the
Joshua Tree tour, July 1987.

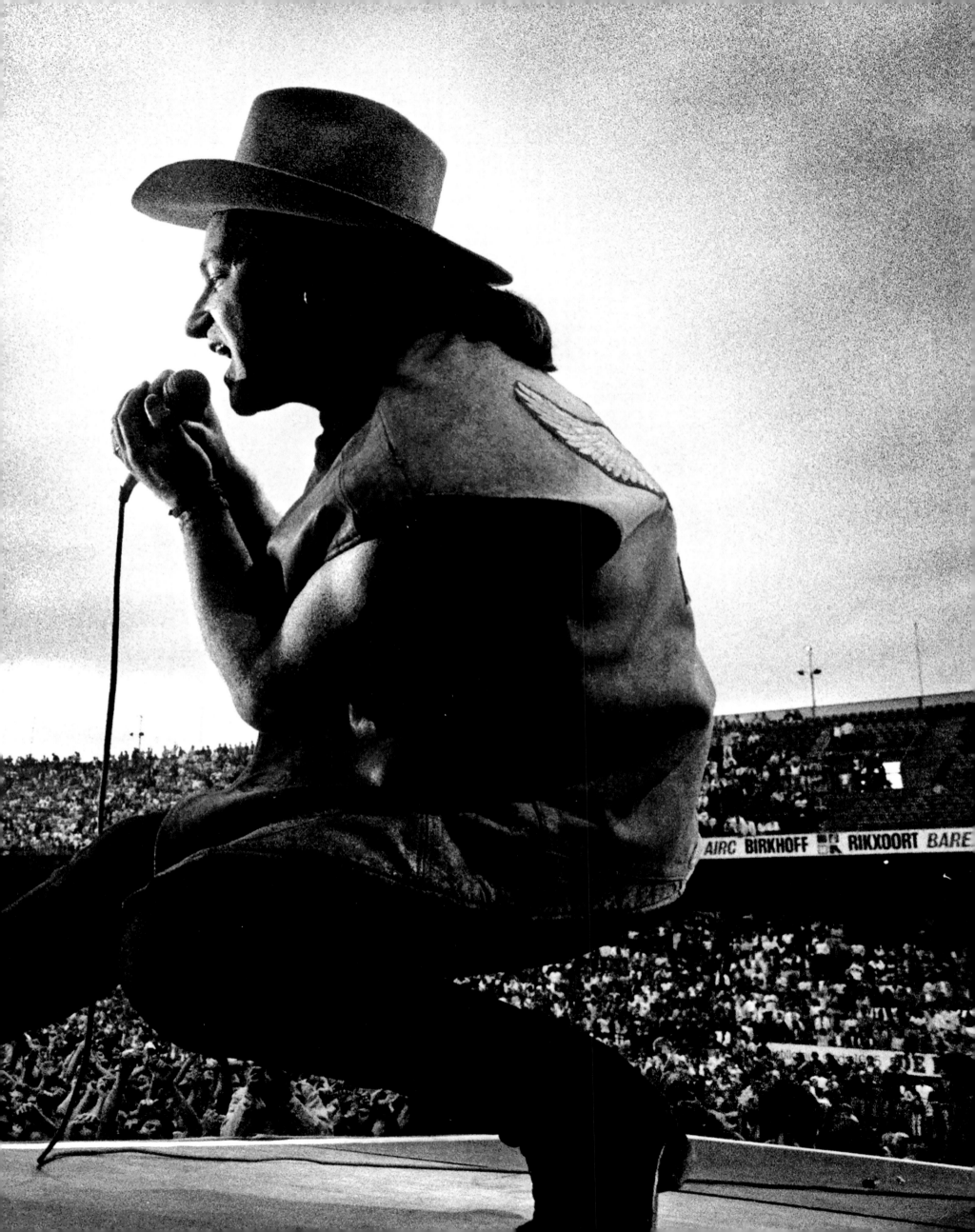

The Hard Truth About Guns N' Roses

Bottles crashed and secrets were revealed. Just another day in the life of Axl Rose

RS 539 • NOVEMBER 17, 1988

When Rob Tannenbaum arrived at the Pine Knob Music Theatre outside Detroit in August 1988 to report a cover story on Guns N' Roses, the band had been on tour for almost a full year. "Every week that summer they just got more and more popular," says Tannenbaum, who spent three days on the road with GNR. "By the time I met up with them, they were the biggest fucking band in the world." The story celebrated their rock & roll ascent, though singer Axl Rose and the band were still upset by it. "But if you're Guns N' Roses and someone writes a big story about it, you have to hate it, don't you?" says Tannenbaum. "It turned out that I was the first of many, many people that Axl felt didn't completely understand him."

* * *

NAME A CITY on their tour itinerary, and Guns N' Roses probably have a story to go with it.

In Atlanta, Axl jumped from the stage to grab a security guard who, Axl says, shoved a friend of his without provocation. The police held Axl backstage while the rest of the band played "Communication Breakdown" and "Honky Tonk Women" with a roadie singing. To avoid a trial, Axl pleaded guilty to assaulting the police and paid a fine.

In Philadelphia, just minutes before a concert, Axl got into a fight with a parking-lot attendant who, Axl says, shoved Stuart, Axl's younger brother and personal assistant. Doug Goldstein, the group's tough but temperate and shrewd tour manager, persuaded the police to release Axl in time for the show.

In Saratoga Springs, New York, a local paper reported, "Police and security guards are calling it a night they won't soon forget." "There was nearly a riot," says rhythm guitarist Izzy Stradlin, who's known Axl for 13 years. "I get off on that kind of vibe, where everything's just about ready to crack. When there's 25,000 people and they have, like, three security guys. God, it was intense, man. It was just on that fucking edge of 25,000 people coming down to the stage." When fans began sprinting onstage, the band bailed. Three nights later, in Weedsport, New York, the Gunners topped that with a show Axl describes as "just, like, psycho."

In Hamburg, Germany, Izzy and bassist Duff McKagan beat up the drummer in Faster Pussycat, bound him with duct tape and tossed him in an elevator.

Although trouble seems to follow Guns N' Roses, they say they don't instigate the conflicts, they merely refuse to back away from them.

Axl Rose in Asbury Park, New Jersey, 1988.

"A lot of bands in L.A. lay down, 'cause they think they have to," Axl says. "But it's harder to live with your conscience of going, 'Man, I just kissed ass.' You can't live with that. Everybody in this band just goes, 'Man, I can't let this person just fuck me like that.' We fight."

Axl is so sensitive and so erratic that even the other members of the band are awed by – and maybe tired of – his "mood swings." He travels on a separate tour bus, not only because he stays up at night and sleeps during the day but also to reduce friction with the band. "Axl's a real temperamental guy," says Slash, the lead guitarist. "He's hard to get along with."

Izzy says the singer used to be far more troublesome. "If it wasn't for the band," Izzy says, "I just hate to think what he might've done."

Onstage, releasing years of anger, he's a remarkably charismatic figure. He sings savagely, abusing his vocal cords and working the crowd with an unequaled ferocity. Offstage, his pale skin and strawberry-blond hair make him appear fragile, almost angelic.

"A lot of the things about my mood swings are, like, I have a temper," Axl says, "and I take things out on myself. Not physically, but I'll smash my TV, knowing I have to pay for it, rather than go down the hallway and smash the person I'm pissed at." Becoming a star so quickly has only worsened matters. "With all the pressure," Axl says, "it's like I'll explode. And so where other people would go, 'Oh, well, we just got fucked,' Axl's going, 'Goddamn it!' and breaking everything around him. That's how I release my frustration. It's why I'm, like, pounding and kicking all over the stage."

As an example, Axl cites Geffen's decision to cut "Sweet Child" from almost six minutes to under four. "When something gets edited," he says, "and you didn't know about it, you lose your mind, and it's like, 'Axl's having a mood swing.' 'Mood swing' my ass. This is my first single, and it's chopped to shit."

A psychiatrist has diagnosed Axl's problem as manic-depressive disorder, a condition that can cause people to swing from impulsive, reckless and argumentative fits to catatonic and suicidal periods. "I can be happier than anybody I know," Axl says. "I can get so happy I'll cry. I can get completely opposite, upset-wise." Many manic-depressives turn to drugs or alcohol to lessen the pain of their illness.

Although Axl takes lithium to combat the disorder, he thinks it's ineffective and claims to be in control of his moods. "Did you ever see that movie – I think it was *Frances*?" Frances Farmer, an actress, was institutionalized because of her emotional outbursts. "I always wonder if, like, somebody's gonna slide the knife underneath my eye and give me the lobotomy. I think about that a lot."

The Indestructible Keith Richards

Nothing could stop Richards – the same couldn't be said for a blacked-out Kurt Loder

RS 356 • NOVEMBER 12, 1981

In September 1981, when Kurt Loder traveled to Long View Farm in rural Massachusetts to interview Keith Richards, no topic was off limits, from hard drugs to his tumultuous relationship with old flame Anita Pallenberg to the death of original Stones guitarist Brian Jones. Richards began the interview drinking from a bottle of Jack Daniel's and then switched to vodka and orange soda. After four hours of conversation, Loder wrapped things up by offering Richards some coke he'd scrounged from co-workers at the magazine. The guitarist countered with his own higher-quality stash, which was hidden in a shark-tooth necklace. "It was really, really good coke, back in the days when every single person took cocaine all of the time," says Loder. "When I was done, I just blacked out. I have no idea what happened after that."

* * *

Did heroin affect your music, for better or worse?

Thinking about it, I would say yeah, I'd probably have played better off of it. Sometimes I still have to play what I played then. "Right, I've gotta play this goddamn *junkie* music? Me? Now? I've *been* through it." The thing about smack is that you don't have any say in it. It's not your decision anymore. You need the dope, that's the only thing. "Why? I like it." You'll go through all those incredible hassles to get it, and think nothing of it. Because that is the number-one priority: first the dope, then you can get home and do anything else that needs doing, like living. If you can.

Did you know you were addicted?

Oh, totally, yeah. I accepted that. It took me about two years to get addicted. The first two years, I played around with it. It's the greatest seduction in the world. Then: "What do you mean I'm hooked? I've taken it for two days and I feel all right. I haven't had any for…all day." It draws you in, you know.

How do you get off junk?

You just have to want to reach that point. I mean, I kicked it *loads* of times. The problem is not how to get off of it, it's how to *stay* off of it. Yep, that's the one.

Rock has an awfully high death rate, it seems. Among your contemporaries, John Lennon, Keith Moon, John Bonham – when you see them go, does it worry you?

There are risks in doing anything. In this business, people tend to think it'll never happen to them. But what a way to make a living, you know? Looking at the record over the last 20-odd years, it goes without saying, I should think, that there is a very high fatality rate in the rock & roll music business. Look at the list, man, look at who's been scythed down: Hank Williams, Buddy Holly, Elvis, Gene Vincent,

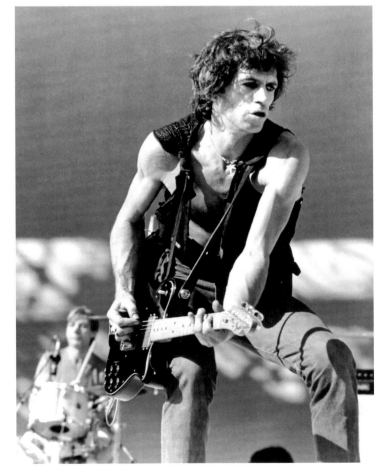

Keith Richards onstage at Candlestick Park in San Francisco, 1981.

Eddie Cochran. The list is endless. And the *greats*, a lot of the greats have gone down. Otis, man. I mean, that one killed soul music.

Did you find anything worthwhile in punk rock?

Yeah, there was a certain spirit there. But I don't think there was anything new musically, or even from the PR point of view, imagewise. There was too much image, and none of the bands were given enough chance to put their music together, if they had any. It seemed to be the least important thing. It was more important if you puked over somebody, you know? But that's a legacy from us also. After all, we're still the only rock & roll band arrested for peeing on a wall.

Apparently, the punks weren't impressed. They really seemed to hate bands like the Stones.

That's what we used to say about everything that went before us. But you need a bit more than just putting down people to keep things together. There's always somebody better at puttin' you down. So don't put me down, just do what I did, you know? Do me something better. Turn me on.

I gather you don't take the music business very seriously.

There's nothing *to* be taken seriously. No way. If you look at the music business over a long period of time, it's always put out mostly shit.

Is that why people aren't buying as much music as they used to? Is it a combination of shitty music and a bad economy?

Music is a luxury, as far as people are concerned. I'm not sayin' *I* believe that, but to people who haven't got work, and haven't got money, music will seem a luxury. In actual *fact*, music is a necessity, because it's the one thing that will maybe bring you up and give you just that little bit extra to keep on going, or…who *knows* what music does?

Do you ever feel you've become too rich to relate to your audience?

I just feel there's an audience out there, and as long as they want to hear it, we'll go on making it.

How do rich people have the blues?

I don't know. I've never met a rich person yet who's *felt* rich. Because from my own experience, the bigger things get and the more money you make, the more it takes to run the whole show. Especially tax attorneys. And therefore, the more you have to go out and make more money to pay them to give you…it's a diminishing return, you know? I've never felt rich. All I'm worried about is having enough to keep the show on the road. As long as that's there, then it's all right. The rest of it – what am I gonna do with it anyway? I spend half my life in the studio, and when I'm not there, I'm hustling to get on the road again. So, I mean, I can spend it, but I don't know where it goes.

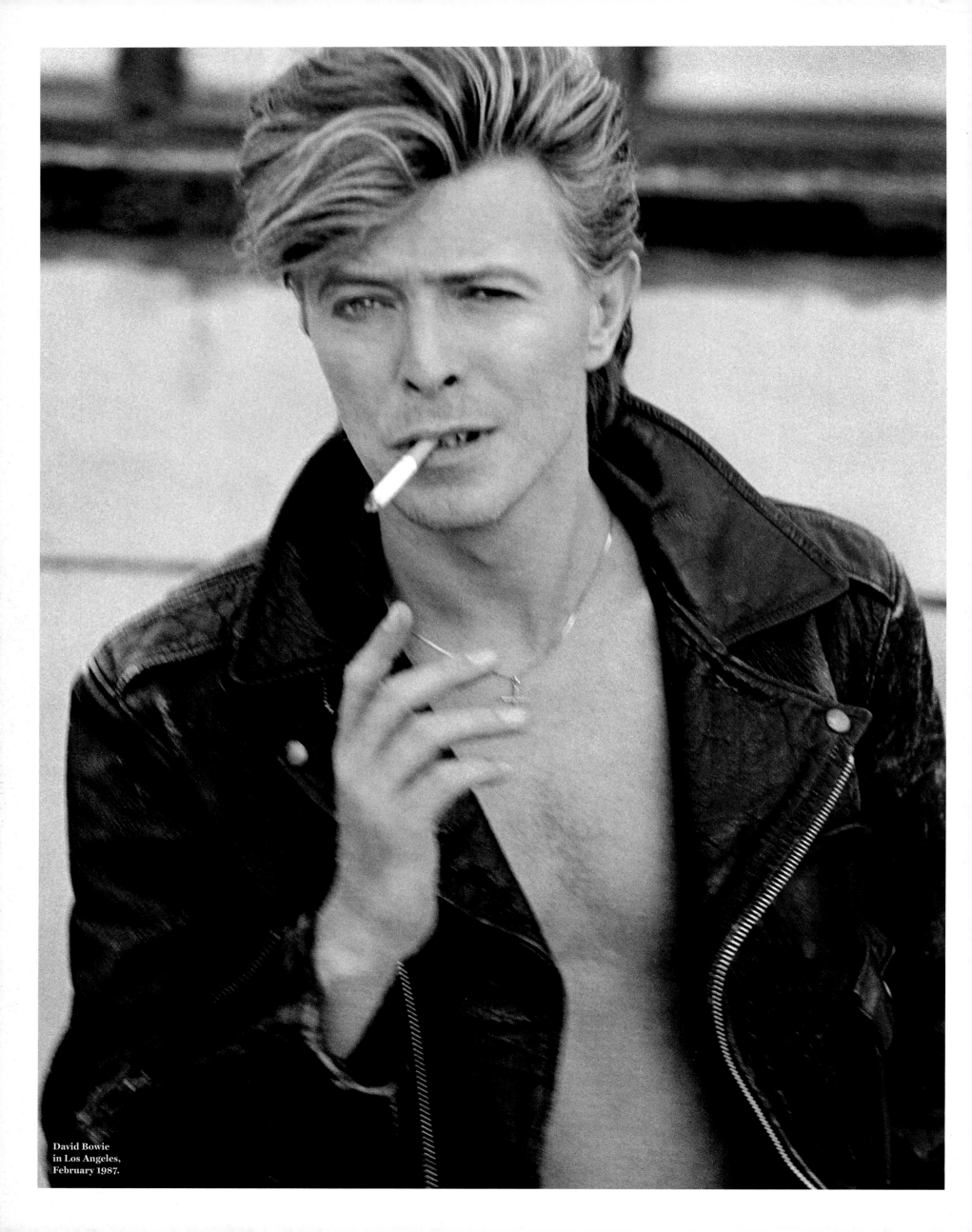

David Bowie
in Los Angeles,
February 1987.

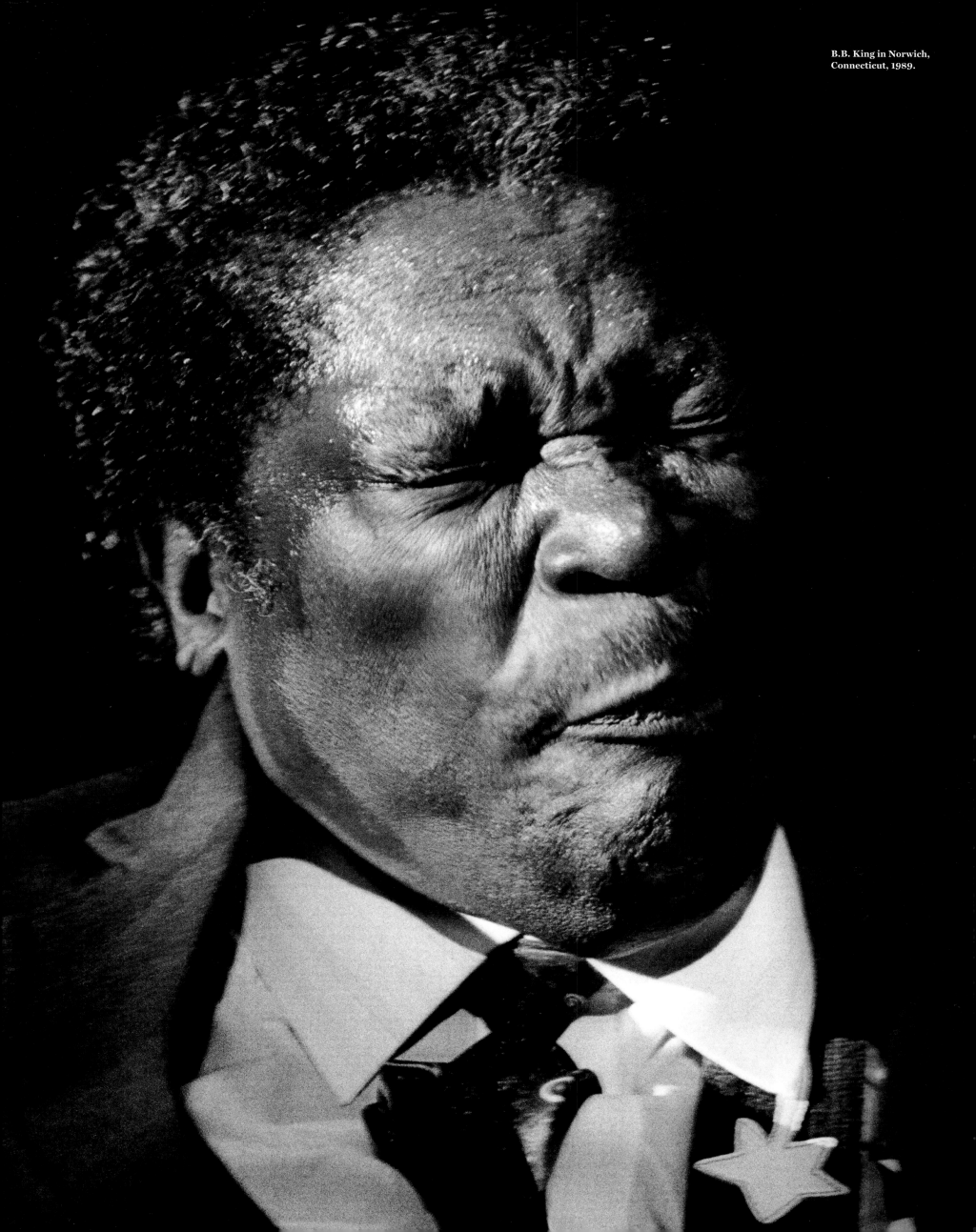

B.B. King in Norwich,
Connecticut, 1989.

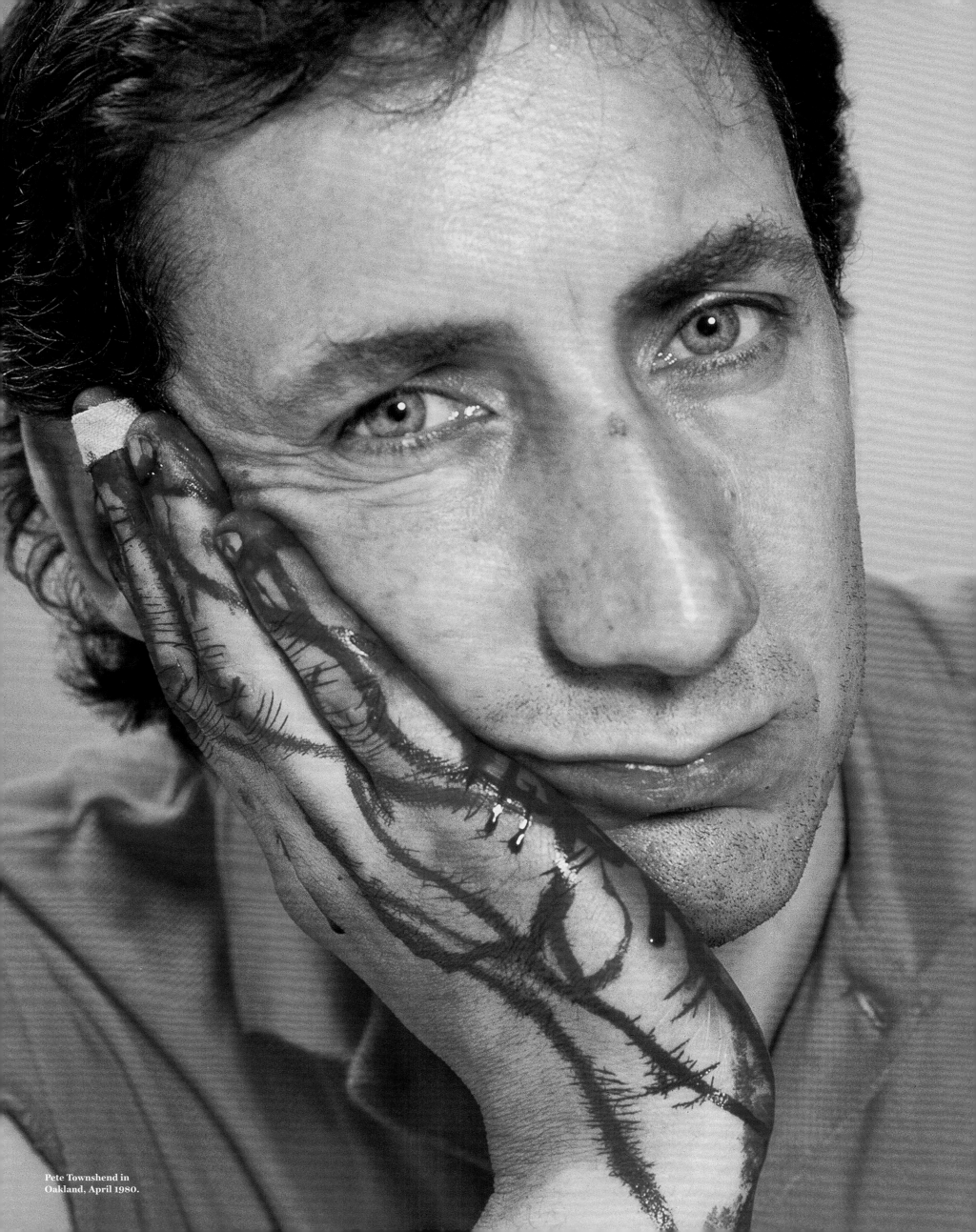

Pete Townshend in
Oakland, April 1980.

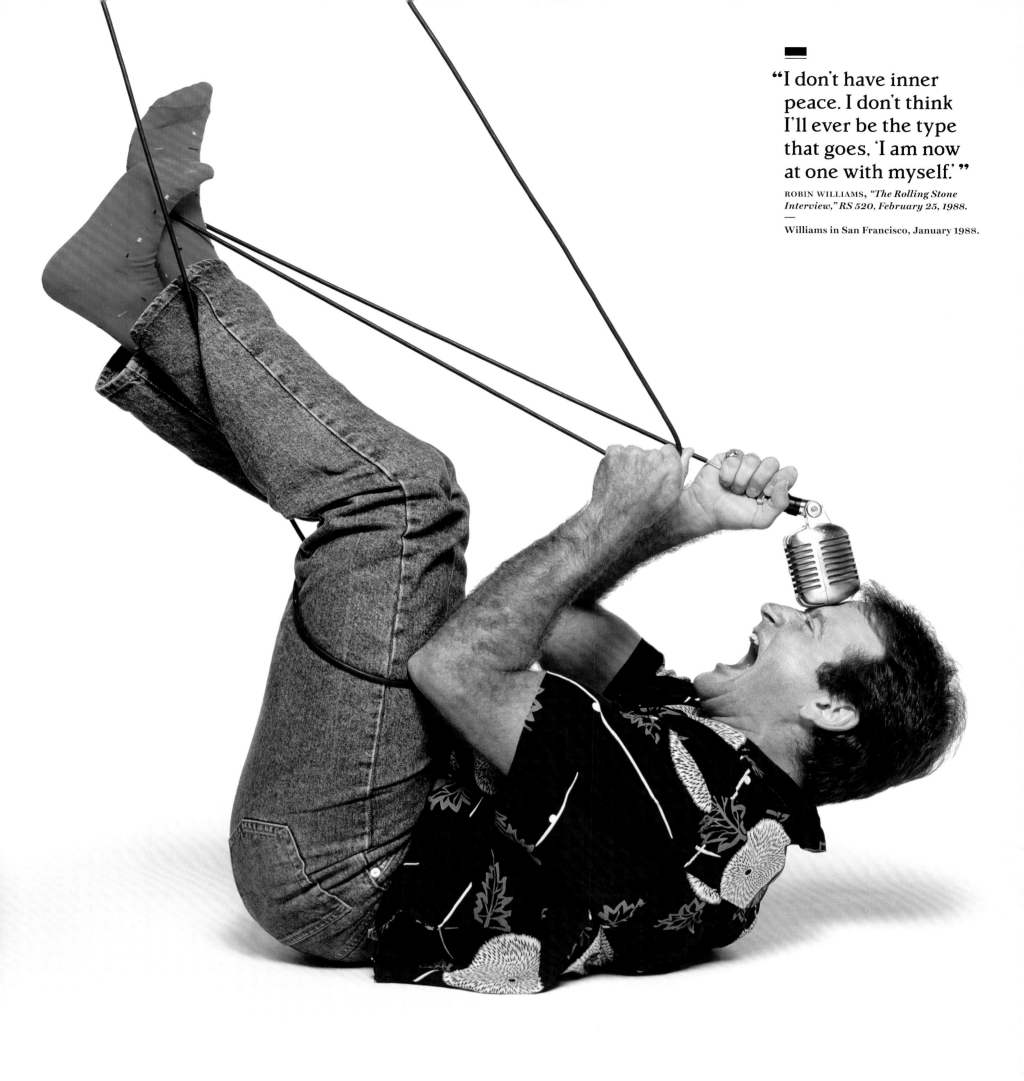

"I don't have inner peace. I don't think I'll ever be the type that goes, 'I am now at one with myself.' "

ROBIN WILLIAMS, *"The Rolling Stone Interview," RS 520, February 25, 1988.*

—

Williams in San Francisco, January 1988.

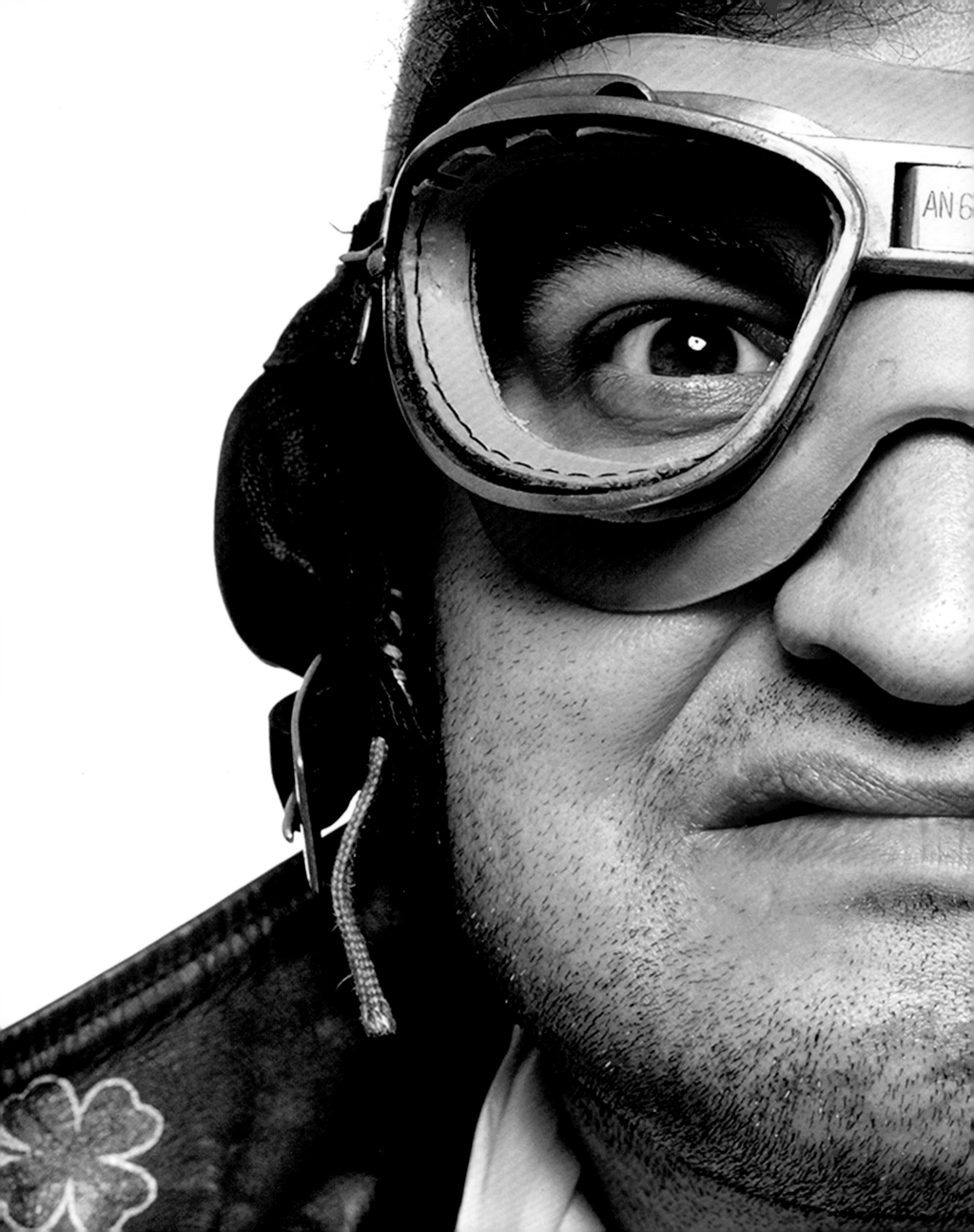

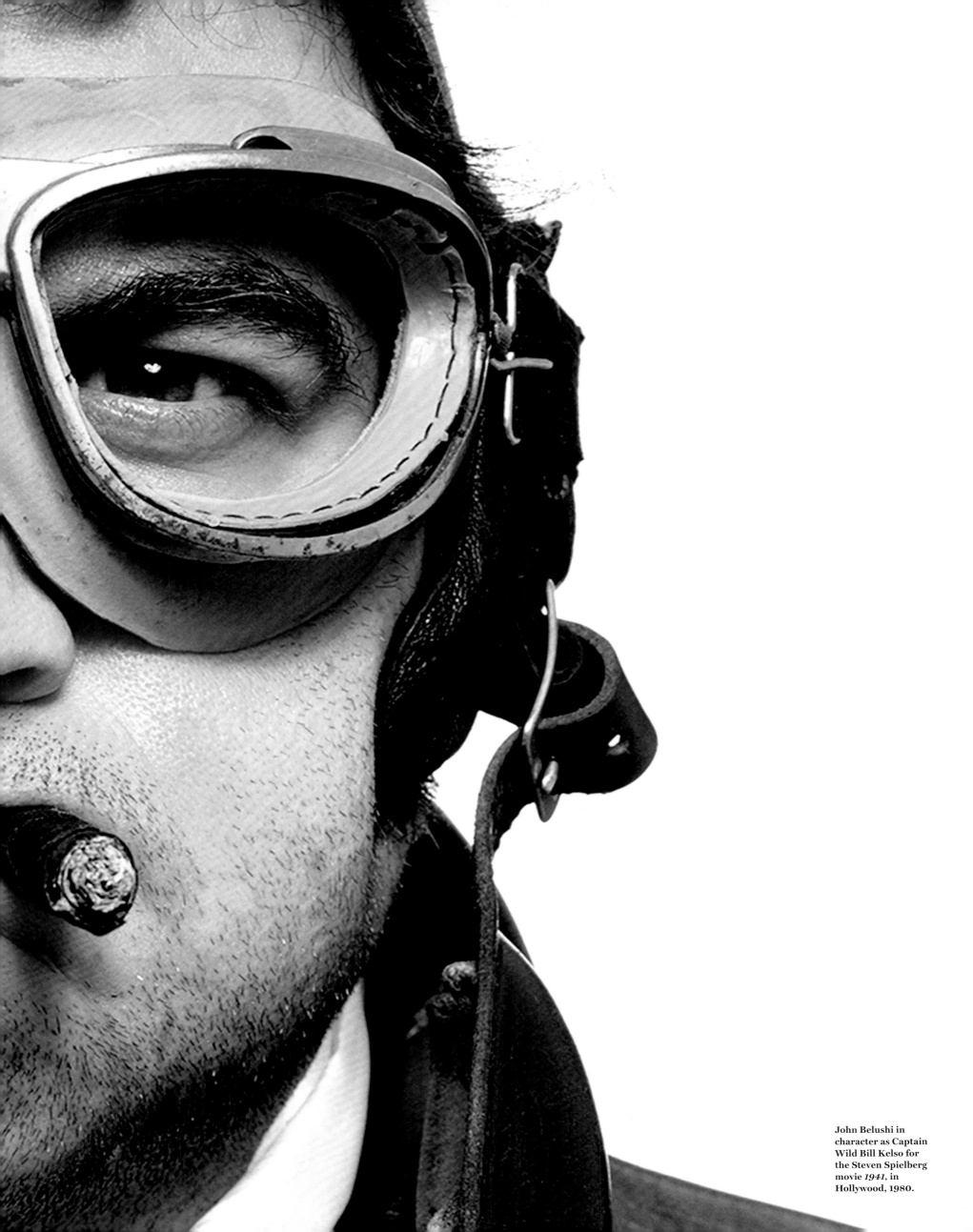

John Belushi in
character as Captain
Wild Bill Kelso for
the Steven Spielberg
movie *1941*, in
Hollywood, 1980.

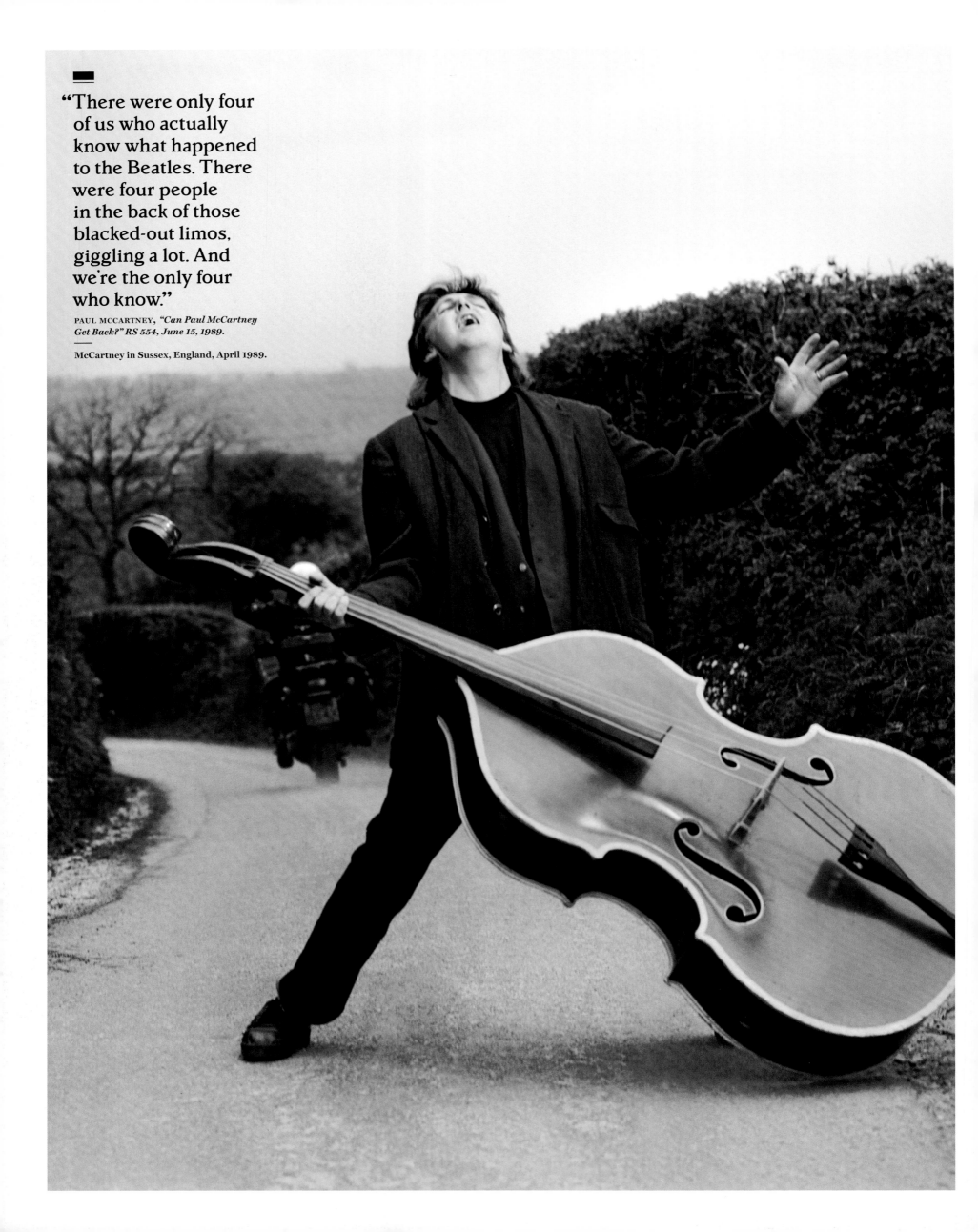

"There were only four of us who actually know what happened to the Beatles. There were four people in the back of those blacked-out limos, giggling a lot. And we're the only four who know."

PAUL MCCARTNEY, *"Can Paul McCartney Get Back?" RS 554, June 15, 1989.*

—

McCartney in Sussex, England, April 1989.

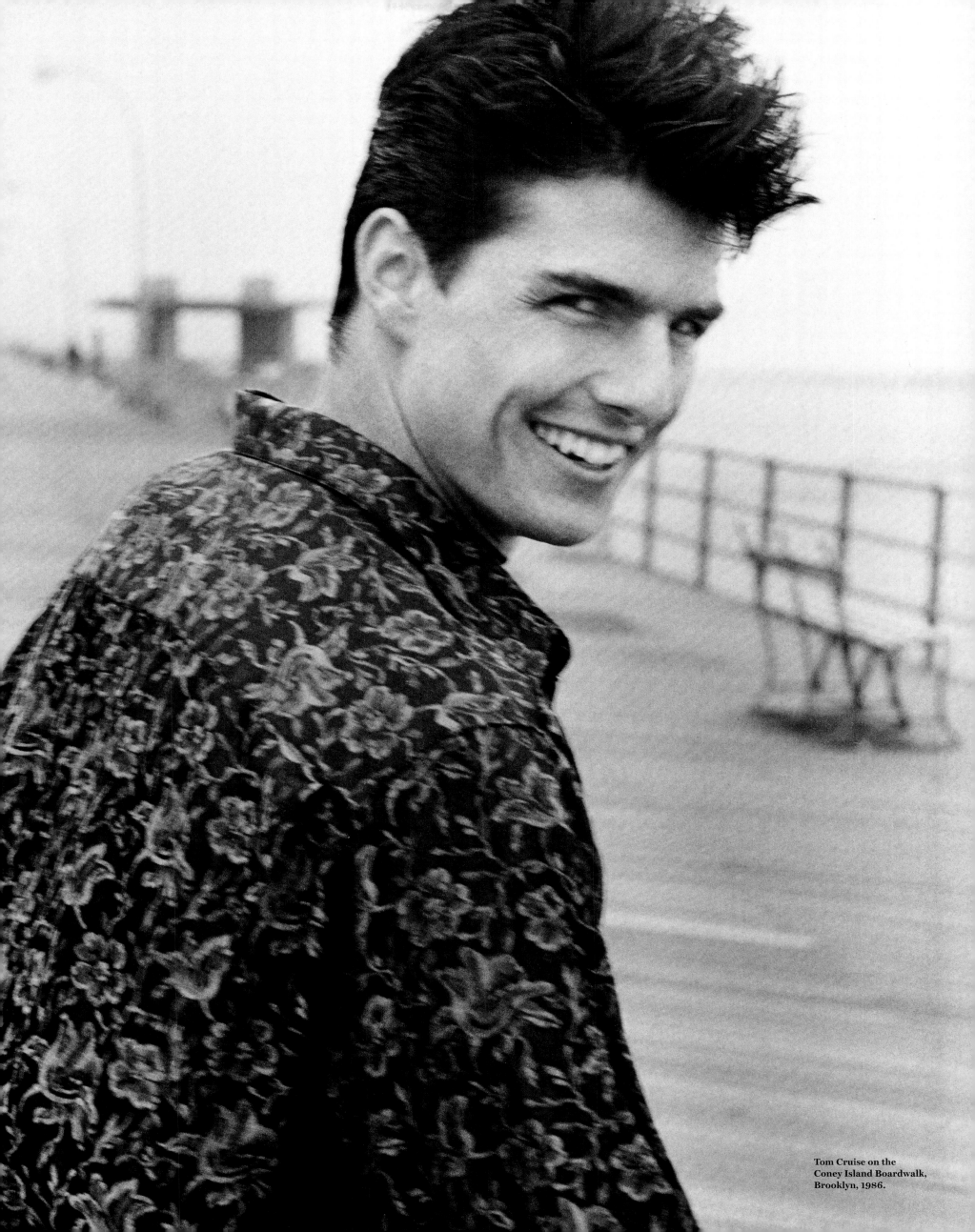

Tom Cruise on the
Coney Island Boardwalk,
Brooklyn, 1986.

Tom Wolfe

*The pioneer of New Journalism explored 'The Brotherhood of the Right Stuff'
and then wrote an epic novel chapter by chapter in the pages of ROLLING STONE*

ALTHOUGH HE DIDN'T WRITE HIS FIRST STORY FOR THE magazine until 1972, Tom Wolfe was a founding voice of ROLLING STONE. In 1965, Jann S. Wenner read Wolfe's first essay collection, *The Kandy-Kolored Tangerine-Flake Streamline Baby,* which featured profiles of uniquely American characters whose rise was tied to the freedoms and prosperity of the postwar era: stock-car racer Junior Johnson, surf guitarist Dick Dale, Andy Warhol, Muhammad Ali and producer Phil Spector, whom Wolfe memorably dubbed "The First Tycoon of Teen." In 2011, Wenner described the book as "wide-eyed dispatches from what was then the edge of American culture. I began to form my understanding of what writing and reporting could be, and it began to shape my vision for a magazine." Wenner reprinted the Spector profile in 1969 to accompany a ROLLING STONE Interview with the producer, calling it "the first great classic of rock & roll journalism."

The style Wolfe had developed in his pieces for *Esquire* and *New York* magazine – fast-paced and Technicolor, hyperdescriptive with an inner voice usually found in literature – became a crucial part of an emerging form called New Journalism. It was nonfiction writing that used the narrative and literary tools of fiction to create stories that kept up with the experience of modern life, and as such, it kept pace with not just novels but movies – Wolfe's combination of all-seeing reporting and literary bravura made his work something like a cross between cinéma vérité and experimental film. (In fact, his command of detail was so remarkable that he was accused of surreptitiously tape-recording the 1970 Leonard Bernstein charity cocktail party for the Black Panthers, which Wolfe satirized in his famous essay "Radical Chic," though he had worked from his notes.) "The first new direction in American literature in half a century," Wolfe wrote of the movement in the 1973 collection he co-edited, *The New Journalism.*

Wolfe began his career as an old-school journalist. After earning an American Studies Ph.D. from Yale in 1957, he worked at *The Washington Post* and then the *New York Herald Tribune,* which published a Sunday supplement called *New York* magazine and took as its slogan "Who says a good newspaper has to be dull?" On assignment for the *Tribune,* he spent an afternoon at the Hot Rod & Custom Car Show in New York in 1963. He brought back "exactly the kind of story any of the somnambulistic totem newspapers in America would have come up with," he later remembered in the introduction to *The Kandy-Kolored Tangerine-Flake Streamline Baby.* Wolfe had an idea for another story, though – a bigger piece that could fully capture the hot-rod phenomenon and the characters who design them, who took banged-up cars and turned them into art. *Esquire* sent him to California for further reporting. But Wolfe found the story was easier to conceptualize than to produce, and the night before it was due he had nothing. His editor asked for his notes, so they could be rewritten into a finished piece. By 6:15 the following morning, Wolfe had written 49 manic pages, which he brought in to the *Esquire* offices. That afternoon, his editor called him: They were running it in full.

Wolfe had discovered his voice. His 1968 book *The Electric Kool-Aid Acid Test,* about his travels with Ken Kesey and his Merry Pranksters, solidified it. Wolfe's prose exploded in all caps and punctuation, with question marks and exclamation points piling up across the page, a graphic representation of how the world was being reshaped. (In fact, Wolfe was in part transferring the flourishes of his personal correspondence – where he wrote with a decorative calligraphy style – to typed prose.) *The Electric Kool-Aid Acid Test* put him at the center of the hippie movement in San Francisco, as Kesey and his Pranksters dispensed LSD at Acid Test parties where the Grateful Dead played. "It gradually began to dawn on me that this was a religious group, a religion in its primary phase," Wolfe said later in a 1980 ROLLING STONE Interview. "By the time I met Kesey, he was already starting to promulgate the concept beyond acid: the idea that LSD could only take you to a certain level of understanding and awareness, but that you couldn't become dependent on it." *Acid Test* was the first great chronicle of the Sixties counterculture, told by a writer in his late thirties who favored three-piece suits over jeans and tie-dyed shirts. "I've taken what I think of as the 'man from Mars approach,'" Wolfe said. "I've just arrived from Mars, I have no idea what you're doing, but I'm very interested."

It wasn't Mars, but the moon, that would bring ROLLING STONE and Wolfe together in the early Seventies. Wenner had long wanted Wolfe to work for the magazine, and the two had struck up a correspondence in 1969. (Playing on Wenner's last name, Wolfe addressed him as "Janner"; Wenner addressed him back as "Tommer.") Wenner asked Wolfe to write a 10,000-word profile on Jimi Hendrix and an investigative piece on the practices of major record companies, but those assignments had not panned out. Then, in 1972, Wenner's idea to send Wolfe to cover the launch of Apollo 17, NASA's last moon landing, would produce something game-changing for both editor and writer.

"His concept was that it would be quite a scene," Wolfe later told ROLLING STONE. "And it was quite a scene. King Hussein of Jordan, who insisted on flying his own airplane – and he was such a bad pilot that people near the landing fields would take their children indoors – was there. And George Wallace. And a 135-year-old ex-slave – though I wonder how old he actually was – and [comedian] Jonathan Winters, who was very big at that time. Ahmet Ertegun was waiting for the rocket to go off, and he was playing backgammon in the grass. It was all very funny. But I got interested in the astronauts. At night, you'd go out to where they would be launching from, and here would be this monster 35-story rocket fueling up, and I remember saying, 'Who in God's name would sit up there?' They look like a little thimble up there on top of this enormous rocket. 'Who would do this?' That was my basic question."

Wolfe answered that question in a four-part series in ROLLING STONE called "Post-Orbital Remorse." This was deadline journalism – part one, titled "The Brotherhood of the Right Stuff," appeared just weeks after the launch of Apollo 17 – but it was sweeping in its command of detail and formal ambition. Wolfe looked at how the media had assembled clean-cut,

> *Acid Test* **was the first great chronicle of the counterculture. "I take what I think of as the 'man from Mars approach,'" Wolfe said. "I have no idea what you're doing, but I'm very interested."**

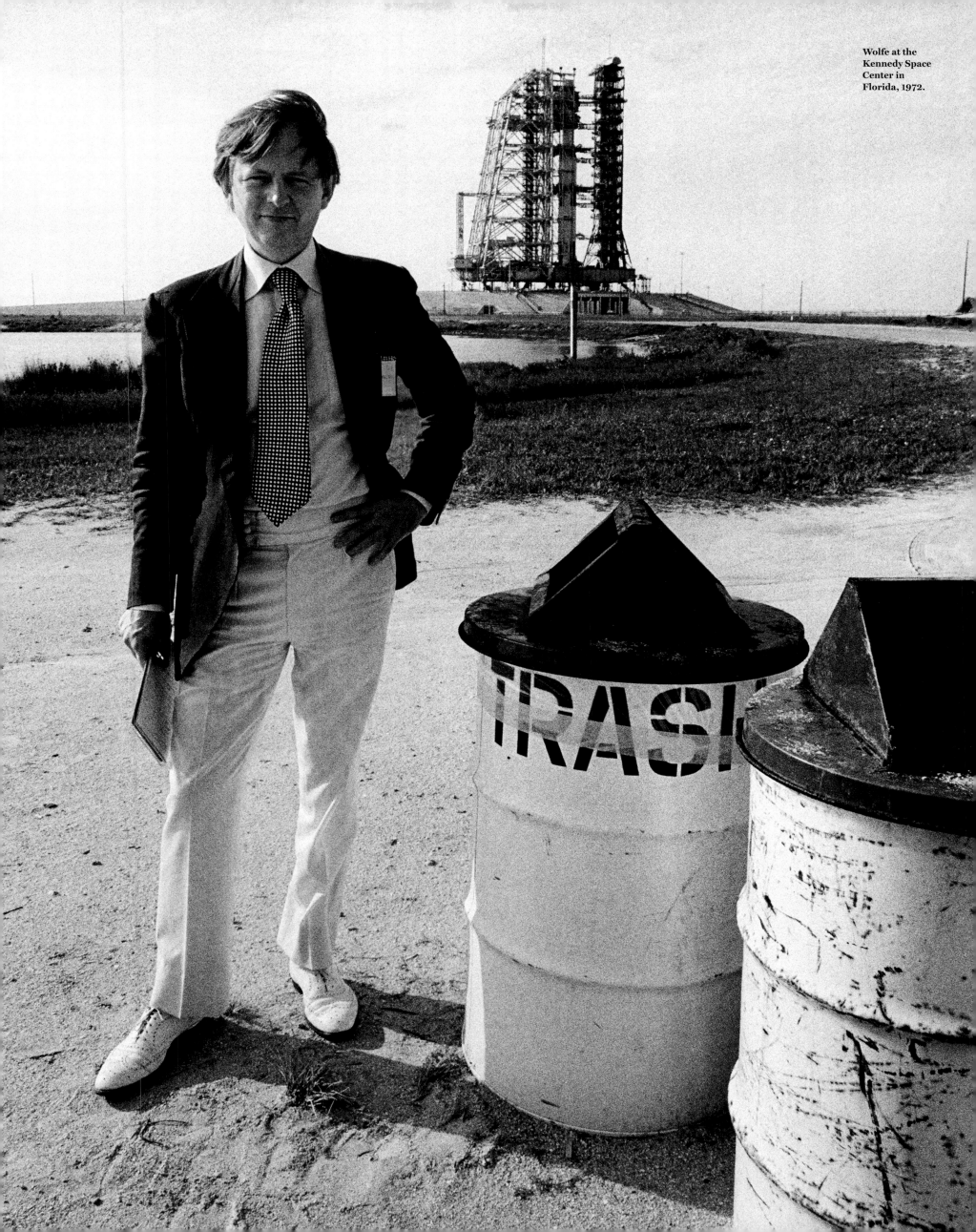

TRASH

heroic personas for the Apollo astronauts, and then pulled back the scrim to show the anxiety and bravado of these "gamblers with death."

The series unspooled as a long monologue – Wolfe was writing about the experiences of 72 astronauts and synthesized all his reporting and interviews into a first-person-plural voice he called "the astronaut we," answering that essential question, "Who would do this?" The technique created a tone that was at once omniscient and deeply personal. The astronauts engaged in drag races, poolside pickups and constant one-upmanship, driven by what Wolfe's narrator described as "titanic egos, one might say, but of a type you've probably never known in your life, Tom, because it is extremely doubtful that you have been involved in a particular competition known as *The Right Stuff*. It's a vast competition, which no one involved in will acknowledge the existence of, we being such cagey souls, called *The Right Stuff*. The main thing to know about an astronaut, if you want to understand his psychology, is not that he's going into space but that he is a flier and has been in that game for fifteen or twenty years. It's like a huge and very complex pyramid, miles high, and the idea is to prove at every foot of the way up that pyramid that you are one of the elected and anointed ones who have *the right stuff* and can move ever higher and even – ultimately, God willing, one day – that you might be able to join that very special few at the very top, that elite who truly have the capacity to bring tears to men's eyes, the very Brotherhood of the Right Stuff itself."

Wolfe expanded his Rolling Stone series into a book, a classic history of the United States space program that he said took him six years to report and six months to write. But while working on the book he kept his hand in at Rolling Stone, contributing a biting 1974 cover story on the upper-class obsession with working-class style, a kind of anti-fashion that he called "Funky Chic." "Right away, anti-fashion itself became the most raving fashion imaginable," he wrote. "Everybody had sworn off fashion, but somehow nobody moved to Cincinnati to work among the poor. Instead, everyone stayed put and imported the poor to the fashion pages."

"Funky Chic," he later told Rolling Stone, sprang from an encounter at a party in the Hamptons, where he found himself out of place. "I was wearing a four-button seersucker jacket that buttons up really high – I think it is actually Edwardian – with a little tiny collar and a white tie with small, far-apart black stripes, and I had on a collar pin and cuff links, white serge pants and white cap-toed shoes, which are real English banker shoes, only I had them made in white doeskin." He found himself in a conversation with someone who was a little drunk and a little angry, and who asked Wolfe why he was dressed up. "I looked at him, and he had on a polo shirt and some kind of go-to-hell pants, and he had this big *stain* down the front of his polo shirt, right down the middle, right down to his belt line," Wolfe remembered. "I said, 'Well, gee, I guess I can't keep up with the styles in these parts. How do you do that bright stripe down your polo shirt?' He looked down sort of in surprise and said, 'That's sweat, goddamn it, that's *sweat!*' He suddenly was very proud of it. I could see that I had landed in the midst of the era of funky chic."

In 1980, at the time of that interview, Wolfe also explained that he was at work on his first novel. He envisioned it along the lines of William Thackeray's sprawling 19th-century satire, *Vanity Fair*, and centered in New York. "I'm…very much aware of the fact that novelists themselves hardly touch the city," he said. "How they can pass up the city, I don't know. The city was a central…character is not a very good way to put it, but it was certainly a dominant theme – in the works of Dickens, Zola, Thackeray, Balzac. So many talented writers now duck the city as a subject. And this is one of the most remarkable periods of the cities. Who has been the great novelist of New York since the Second World War? Nobody."

His goal was to fill that gap, and in order to truly capture the character of the city itself, he'd put the skills he'd developed writing for a daily newspaper to use. "I don't know if I'll be charging into people's houses, but I will have to do a lot of reporting," he said. "There's more good material out there than in any writer's brain. A writer always likes to think that a good

piece of work he has done is the result of his genius. And that the material is just the clay, and it's 98 percent genius and two percent material. I think that it's probably 70 percent-30 percent in favor of the material. This ends up putting a great burden on the reporting, and I don't think many fiction writers understand this."

He knew part of the action of his book would pivot on a crime, and so he gathered material by shadowing lawyers and cops, spending time in Lower Manhattan at the Criminal Court building. Later, as he shifted the locale to the Bronx, he began spending time there. But by 1984, despite his reporting, he found himself at an impasse, beset by writer's block. "For eight months, I had sat at my typewriter every day, intending to start this novel and nothing had happened," he later said. He decided the solution was the same one that had produced his breakthrough "Kandy-Kolored" piece for *Esquire* three decades earlier. "I felt that the only way I was ever going to get going on it was to put myself under deadline pressure. I knew that if I *had* to, I could produce something under deadline pressure. I found the only marvelous maniac in all of journalism willing to let me do such a thing. That was Jann Wenner at Rolling Stone. This book would have never been written if Jann Wenner had not said, 'OK, let's do it. Let's see what happens.'"

Thackeray had written *Vanity Fair* as a serial, published in 20 monthly installments. Wolfe would do the same with *The Bonfire of the Vanities* in Rolling Stone. As a safety net, he produced the first three chapters in advance, so that if he got stuck along the way he'd have something to fall back on. Wenner read them, loved them, and published all three in Rolling Stone's July 19th, 1984, summer double issue. The safety net disappeared, and for the next year, every two weeks, Wolfe had to finish another chapter.

"At the outset, I began to wonder if my work would be more like Zola's, Dostoyevsky's or Dickens'…all serial novel writers," Wolfe told *The Paris Review*. "By the fourth chapter, the only thing I wondered about, was would the hole be filled?"

"All those deadlines were close calls," says Bob Wallace, the magazine's managing editor at the time. "It was insane." But just the same, Wallace says, Wolfe's professionalism made the process an easy one, and the sight of Wolfe in spats and white suit working in an office of denim-clad rock writers became a common one. "He would come in with 7,000 words, and I'd say, 'This is a small issue, we can only accommodate 3,000 words.' And to his great credit, I'd read it, make some suggestions, and he would sit down and make the cuts, no different than any other writer."

Wolfe had helped crystallize the Sixties with *The Electric Kool-Aid Acid Test*, and he'd dubbed the Seventies "The 'Me' Decade" in an essay for *New York*. With *The Bonfire of the Vanities*, he presented a crucial portrait of the monied frenzy of the go-go Eighties, as it was all unfolding. When he'd first begun to conceive the novel, New York was still suffering under the weight of a municipal financial crisis, but as he was writing it, things changed. "It was a boom time," says Wallace. "And Tom was right there, reporting his social novel as these great social changes started to take place." Enough so that when he revised the novel for hardcover publication in 1987, he changed his main character, Sherman McCoy, from a magazine writer to a bond trader who considered himself a Master of the Universe, a satirical gibe that stuck to Wall Street's manic money men like glue. "It still is regarded as the definitive book that captured that period," says Wallace.

Wolfe's fiction continued to appear in Rolling Stone: his novella *Ambush at Fort Bragg*, in 1996; three excerpts from his second novel, *A Man in Full*, in 1998; and two from his third novel, *I Am Charlotte Simmons*, in 2004, by which time he had appeared in the magazine for 35 years. "Tom's subject and his study has been America," Wenner said when honoring Wolfe at the 2011 ASME Awards. "He has defined and described this country in all its wacky glory in the last part of the 20th century, and now into this new one. Seen as a whole, it's a towering cultural achievement – possibly the richest record of our times from any writer – and a body of work of incredible historical significance."

> "I got very interested in the astronauts," Wolfe said. "Here would be this monster 35-story rocket fueling up, and I remember saying, 'Who in God's name would sit up there?'"

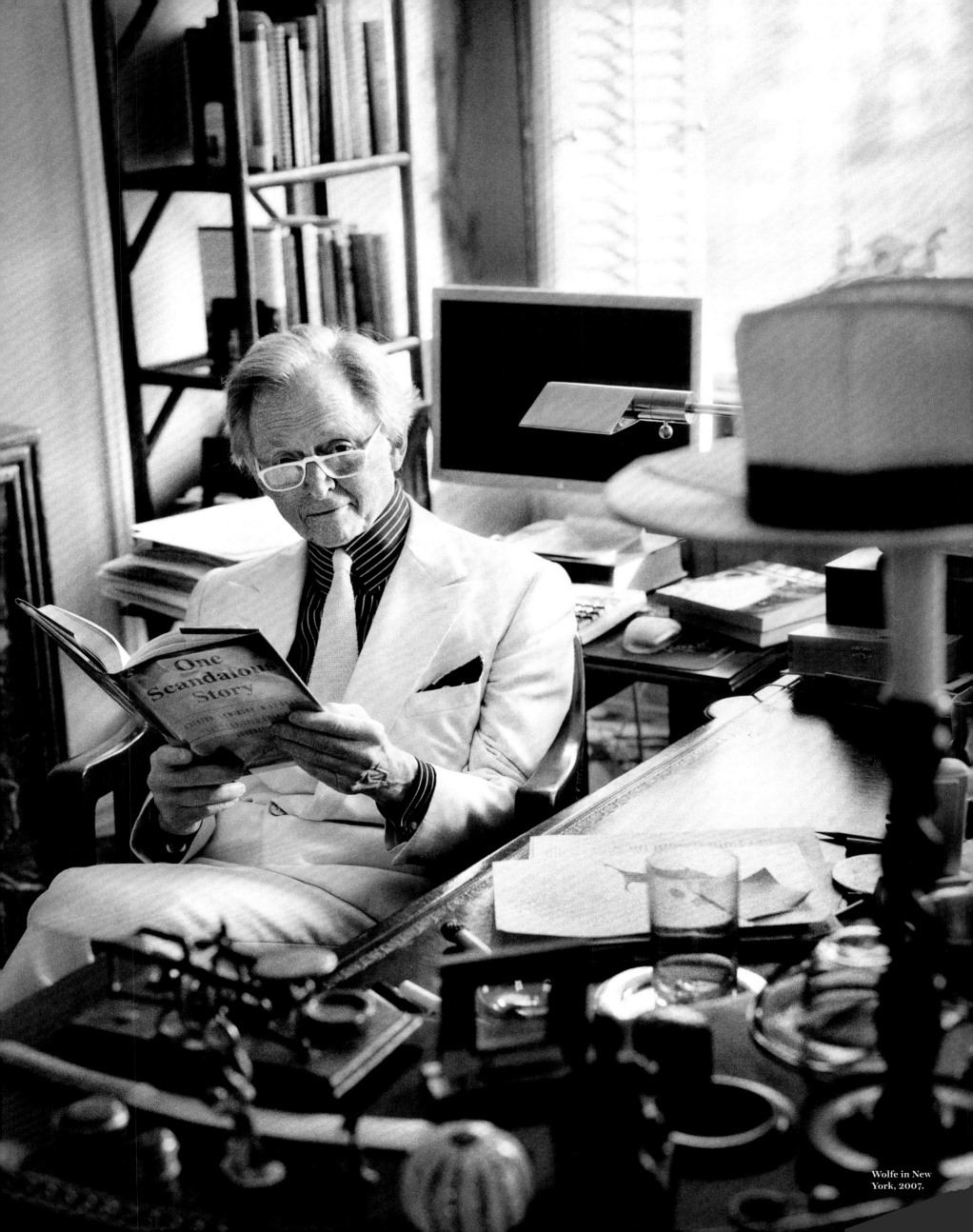

Wolfe in New York, 2007.

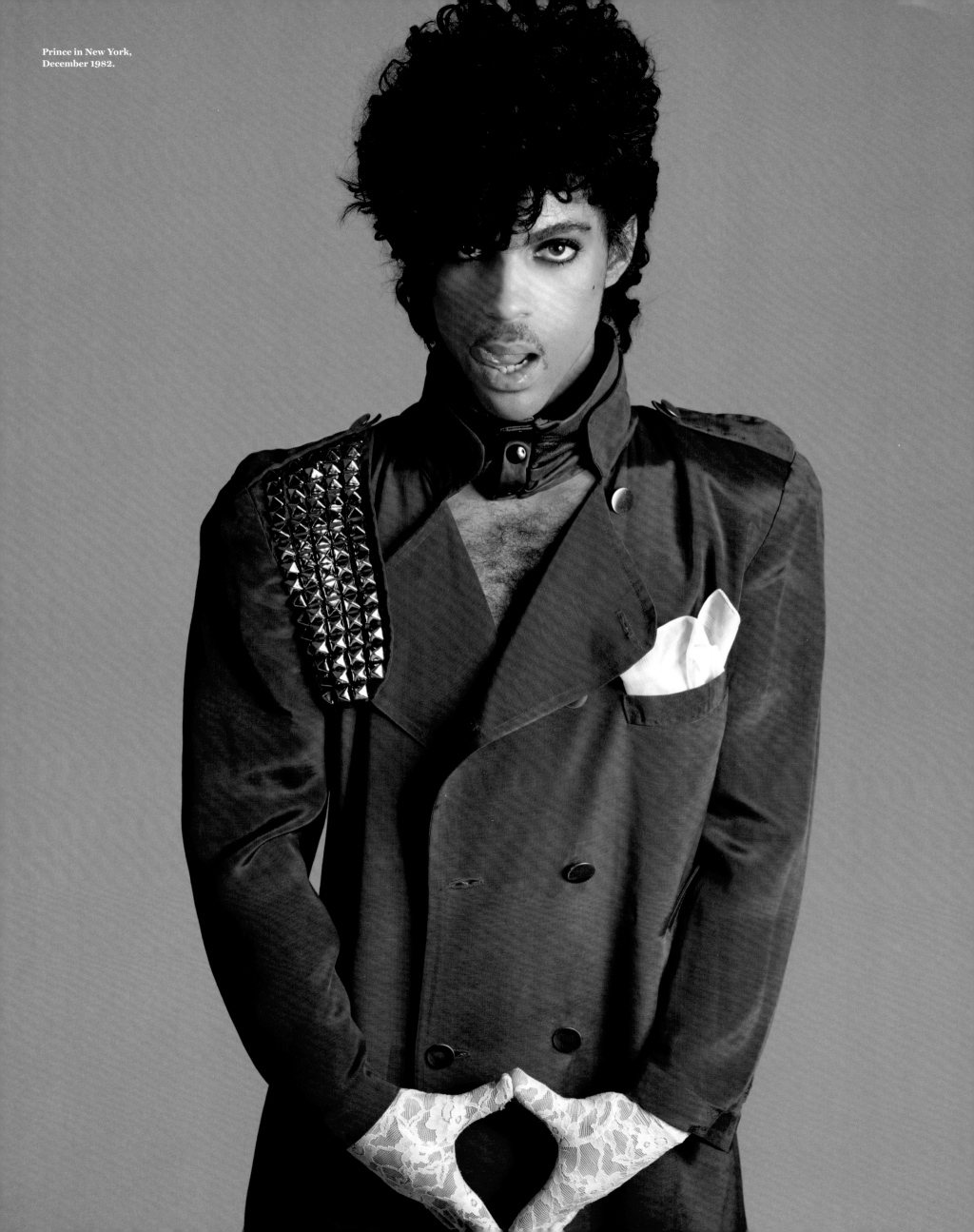

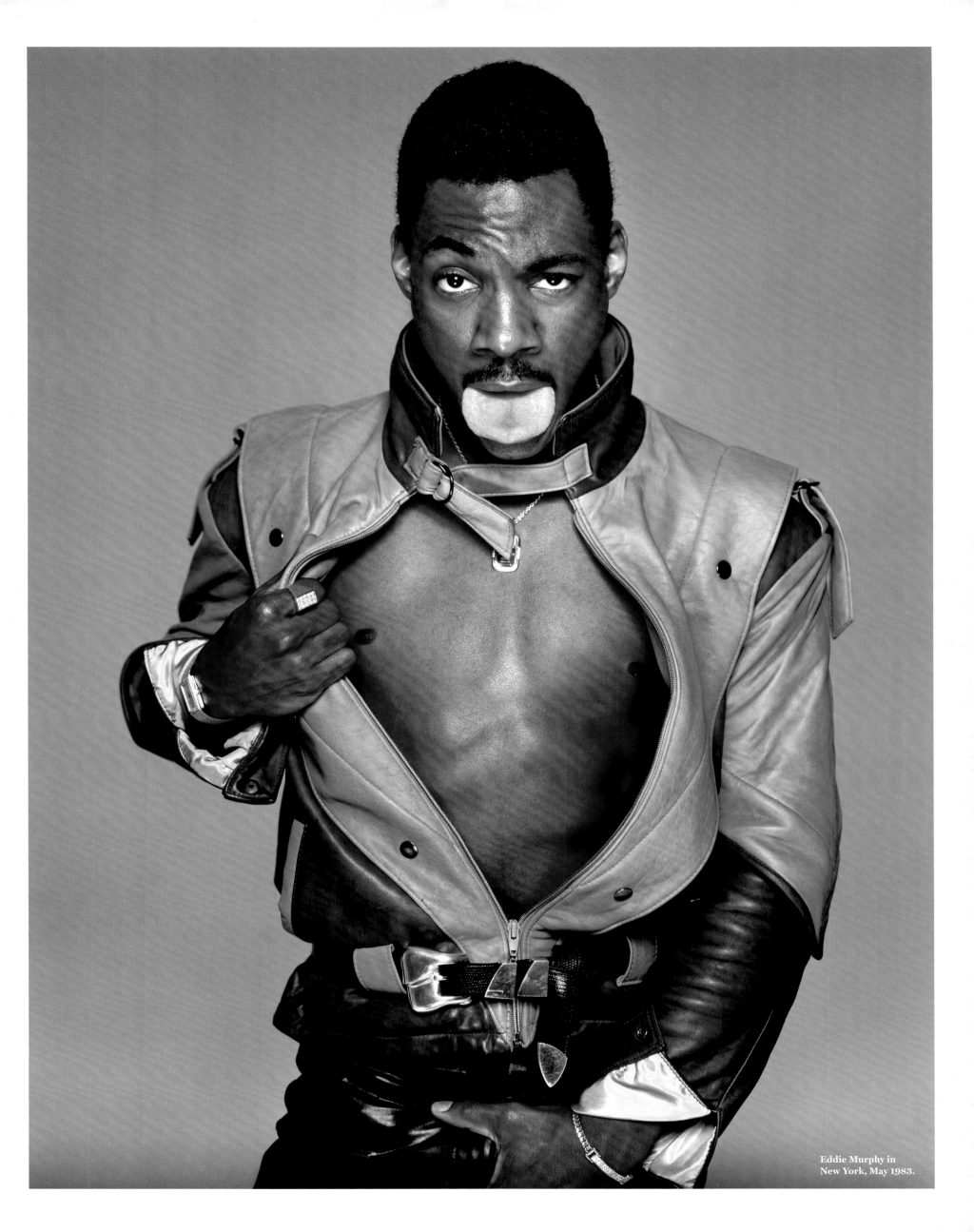

Eddie Murphy in
New York, May 1983.

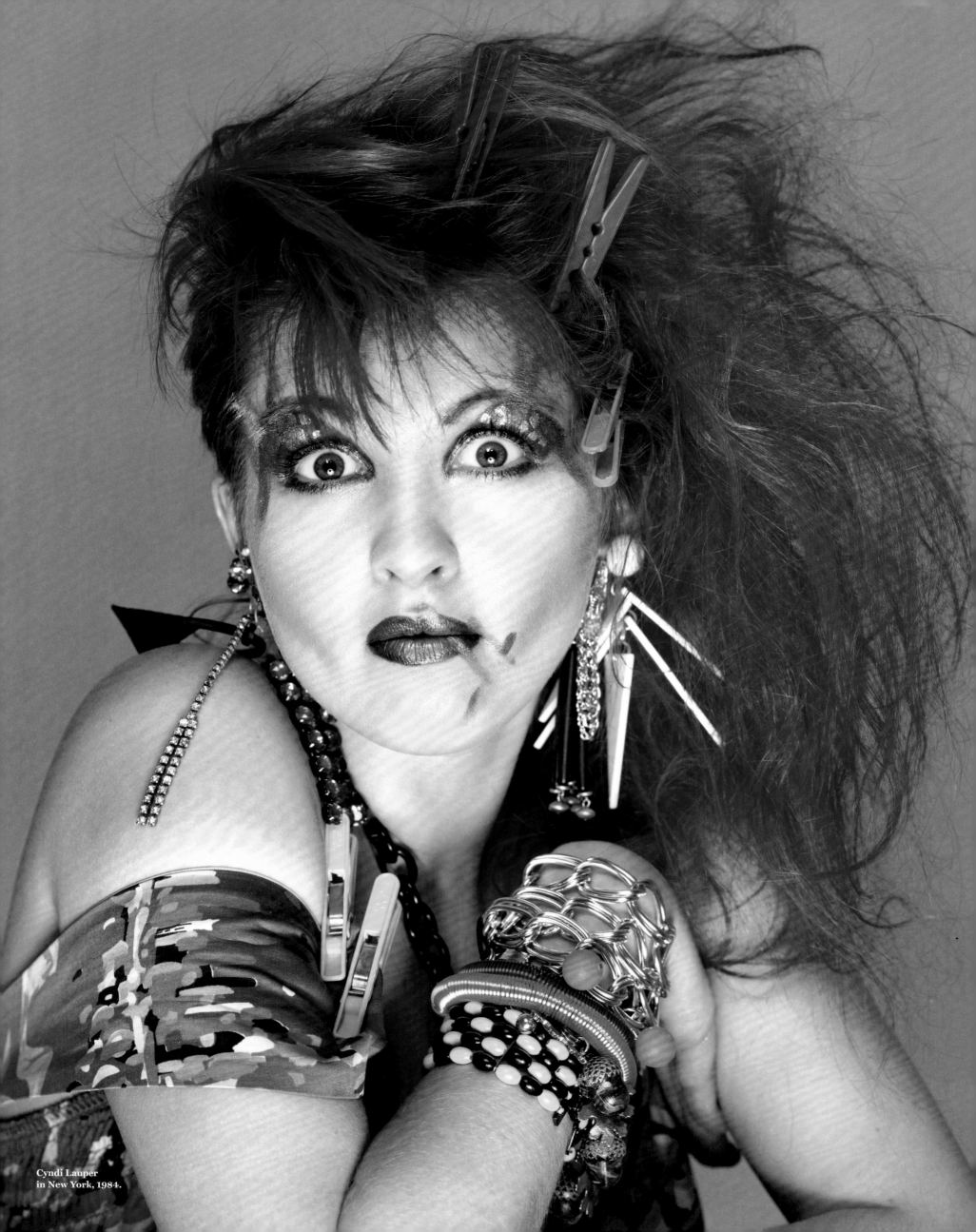

Cyndi Lauper
in New York, 1984.

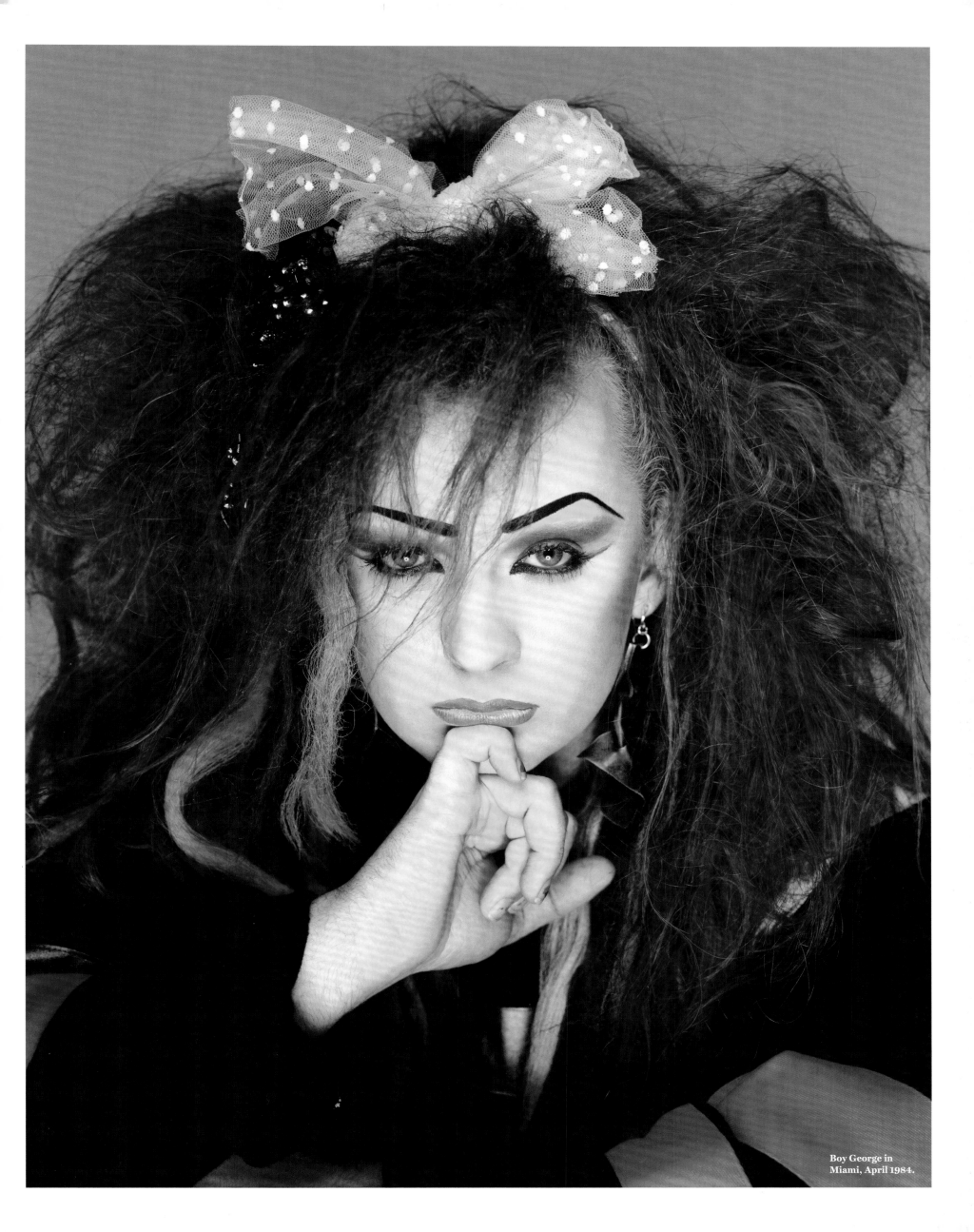

Boy George in
Miami, April 1984.

The Devil and John Holmes

It was the dark side of Hollywood: Drugs, a porn star and four dead bodies

RS 554 · JUNE 15, 1989

'J OHN HOLMES WAS FAMOUS, AT LEAST IN SOME CIRCLES," WROTE Mike Sager. "What he was famous for was his penis." Holmes was the well-endowed porn star who made more than 2,000 sexually explicit movies in the 1970s and 1980s. How well-endowed? He liked to say his penis was "bigger than a pay phone, smaller than a Cadillac."

Somewhat less well-known was his role in the 1981 quadruple murder at 8763 Wonderland Ave., in Laurel Canyon, the Los Angeles enclave that a little more than a decade before had been a bucolic refuge for Joni Mitchell, Neil Young, Jackson Browne and others. The Wonderland murders were so blood-soaked and brutal that the police initially compared them with the Manson Family slayings.

The cops didn't believe they were a mystery for long, though. On a downward spiral in the late Seventies, Holmes had become a freebase-cocaine addict and drifted into petty theft and pimping to support his habit. He'd also become a police informant, though it was unclear if he'd provided useful information. His palm print had been found at the scene of the Wonderland murders, and he was tried and acquitted in 1982 – his lawyer portrayed him as a victim in revenge killings for a drug deal gone sideways.

Holmes ultimately died from AIDS, in 1988, but in 1989 the case was winding its way to trial again, with a club owner (and drug figure) named Eddie Nash and his bodyguard, Gregory DeWitt Diles, facing charges. ROLLING STONE dispatched 32-year-old contributing editor Sager to tell the story of Holmes' wild life and what had really happened at the Wonderland house. "I came in knowing almost nothing about Holmes," says Sager. "But my unique qualification for the story is that my father was a gynecologist and he taught sex ed at my Hebrew school, so I was not uncomfortable with the subject matter. It never made me giggle."

Sager – who'd once worked the crime beat at *The Washington Post* – had covered tough stories for ROLLING STONE: a Los Angeles crack gang, Philadelphia teenagers who dealt drugs and fought pit bulls. He spent nine months reporting the Holmes piece. He interviewed more than 70 people – law-enforcement officials, porn insiders, lawyers, family, friends – and pored over more than 3,000 pages of court and police documents, as well as newspaper reports. "I saw it as three stories in one," Sager says. "First as a story about one of the first recognized porn stars from a time when you could only see those movies in a theater. It's also a story about the first porn star to die of AIDS. Finally, it was a crime story about four people getting bludgeoned to death."

Holmes had gotten into porn in the late Sixties, a few years after he'd married a nurse named Sharon Gebenini. She was the person Sager most wanted to interview – Gebenini could offer a unique perspective since she'd known Holmes before he was a porn star. In fact, she had stuck with the marriage until 1983, even at one point living with Holmes and his mistress Dawn Schiller, whom he'd been with since she was just 15. But when Sager approached Gebenini, she was represented by a sketchy Hollywood agent who demanded money as well as a co-writing credit on Sager's story.

It took months to find a way around the agent, but eventually Sager convinced Gebenini to talk. She came to the motel near UCLA where Sager was staying, and brought Schiller with her. "For 10 hours we sat around this little breakfast nook, and they unfolded this unbelievable story," says Sager. "It gave my story its heart and soul. My favorite was Sharon's memory of coming home one day early in their marriage and finding John measuring his penis. To me, that moment is the pearl of the entire story."

"The Devil and John Holmes" was classic California noir, full of soulless men who refuse to accept that a life of easy money, drugs and sex comes with a price. Holmes had promised the dealers living at the Wonderland house that he could lead them to an easy score – the drugs and money Eddie Nash kept at his home, where he danced around in a bathrobe while indulging his prodigious appetite for cocaine. After the robbery, Nash and Diles used Holmes to lead them back to the Wonderland gang, and then they beat them to death with pipes.

If the scene sounds familiar, that's because the "Sister Christian" sequence in *Boogie Nights* is based on the Nash robbery, just as Mark Wahlberg's Dirk Diggler character is based on Holmes. "There are parts of the movie that are direct lifts from my story," says Sager. "But I don't own John Holmes. I'm glad the influence my story had was acknowledged in time by the filmmakers, even though they didn't acknowledge that at first."

Holmes' career had mirrored the mainstreaming of porn, starting with film loops shown in adult bookstores, moving to theaters and then videos. But in 1989, porn wasn't the everyday subject the Internet would make it. "I remember being in Rehoboth, Delaware, when the magazine came out," Sager says. "It was a puritanical time, with the PMRC [Parents Music Resource Center] and the [anti-pornography] Meese Commission, even though people were smoking crack and having crazy sex. Anyway, I remember walking down the beach in Rehoboth, and everybody was reading the story. It was just quietly consumed by everyone in a brown-paper wrapper."

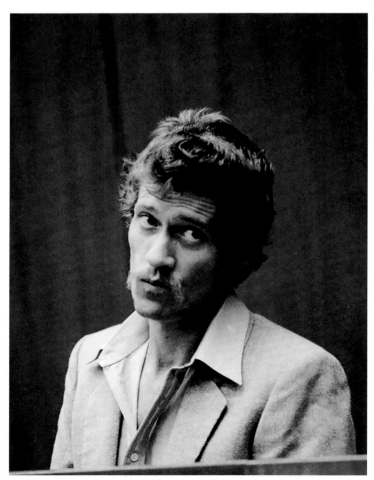

John Holmes, in a California courtroom in December 1982, was charged with four counts of murder and one of attempted murder. He was acquitted.

Inside the Epidemic

It took more than a year to report a two-part investigation of the emerging AIDS crisis

RS 444 & 446 • MARCH 28 & APRIL 25, 1985

'AREN'T YOU GOING TO ASK THE QUESTION?" David Black was interviewing a man named Ron in the hospital. Two weeks before, Ron had come down with a slight fever that didn't go away. He was gay, and his lover – he'd had only two or three in the previous five years – urged him to see a doctor. The doctor told him he had AIDS and had months, maybe weeks, to live.

Black asked Ron what question he was thinking of.

"What's it feel like to die?" he replied. "You don't really understand, do you, that probably by the time your article comes out, I won't be here to read it."

Not much was understood about AIDS when Black began reporting his story in 1983. The disease was then still called GRID (for "gay-related immune deficiency"), and it wasn't clear how it spread or what caused it.

Black spent nearly a year and a half on the piece, and things were not much clearer when the two-part story, "The Plague Years," was published in the March 28th and April 25th, 1985, issues. "Everyone has a pet theory for AIDS," Black wrote. "Environmental. Psychosocial. Genetic. Viral." At one point, Black visited a research lab where equipment was cleaned in bleach. "That usually kills the virus," a doctor told him. "Usually" was not a comforting word, and when Black was told the bleach was dumped down the toilet, he asked if there was any danger in disposing of it this way.

"To be honest," the doctor told him, "I don't know."

When the magazine first approached him about the story, Black – a freelance writer and novelist – turned the assignment down. He'd promised his family he was going to take his first vacation in years. Not a problem, he was told; it was a long-range piece that would take six or nine months to report. Black signed on. "I don't remember how much money they gave me, but it was enough where I didn't need to do any other articles for a long time," he says.

He spent a year reporting, going not just around the country but to Haiti, where an outbreak that reached beyond the gay community remained unexplained. Transmission was very much a source of debate, and Black's article covered the competing researchers in the U.S. and France who'd isolated two potential causes – both, it would later be clear, the same, but neither yet known as HIV. But a cause was not a cure, and argument continued about whether a single virus or multiple factors were to blame. "My research filled almost a dozen large file boxes," Black says. "I'd have scientists explain things to me over and over again until I understood them. I figured that if I understood it, my reader would, too. I had to be very, very clear."

Black's piece unfolded like a mystery, which it was. (Not long after this story, Black began a career as a writer for shows like *Hill Street Blues*, *Law & Order* and *CSI: Miami*. He's also an award-winning mystery novelist.) Science was one part of the mystery, but there were others. The story combined rigorous reporting with essayistic exploration of the personal, sociological and political dimensions of the subject. Black met with AIDS patients at a time when death quickly followed diagnoses, and doctors had no solid idea whether or not the disease was airborne. He remembers an interview with one man who had just returned from his third stint at a New York hospital. The patient laid out a gigantic spread of bagels and lox from Zabar's. "I thought to myself, 'Huh, I don't know how this disease is spread,'" Black says. "Nobody knew. But he had great food, so I just ate and trusted it wasn't spread through bagels and lox."

Most days Black conducted at least three interviews. He spoke with hospital workers, doctors at the Centers for Disease Control, and gay-rights activists desperate to find more public money to fight the disease. At one point, exhausted, he collapsed on a flight out of Los Angeles, then stumbled into a taxi once he'd landed and asked to be taken to the Marriott. "Is this the Marriott in downtown Houston?" he asked the driver. "Mac," the cabbie said, "this is the Marriott in downtown Denver."

The story took its title from Daniel Defoe's 1722 novel about the Black Death, *A Journal of the Plague Year*. It is difficult to overstate how uninformed – and terrified – the general public was about AIDS in 1985, and some readers weren't pleased to have the painful details, confusion and consequences laid bare. "One person punched me right in the face on Sixth Avenue," Black says.

"The Plague Years" won a National Magazine Award for Reporting, and Black began another piece, about transgender Americans. But Hollywood beckoned, and he decided he'd had enough of journalism. "I'd had such an extraordinary experience with 'The Plague Years,'" he says. "I knew I'd never have a better one." Now in his early seventies, Black remains busy writing procedural shows, but he can't help thinking there's still an important piece to be done about AIDS, even after new medications have drastically reduced the death rate and taken it out of the headlines. "What happens when you have a whole generation that equates sex not with pleasure or life but death?" he asks. "That story has yet to be written."

It was part mystery, part horror show: No one could agree what caused AIDS, and there was no treatment. In 1985, a diagnosis was tantamount to a death sentence.

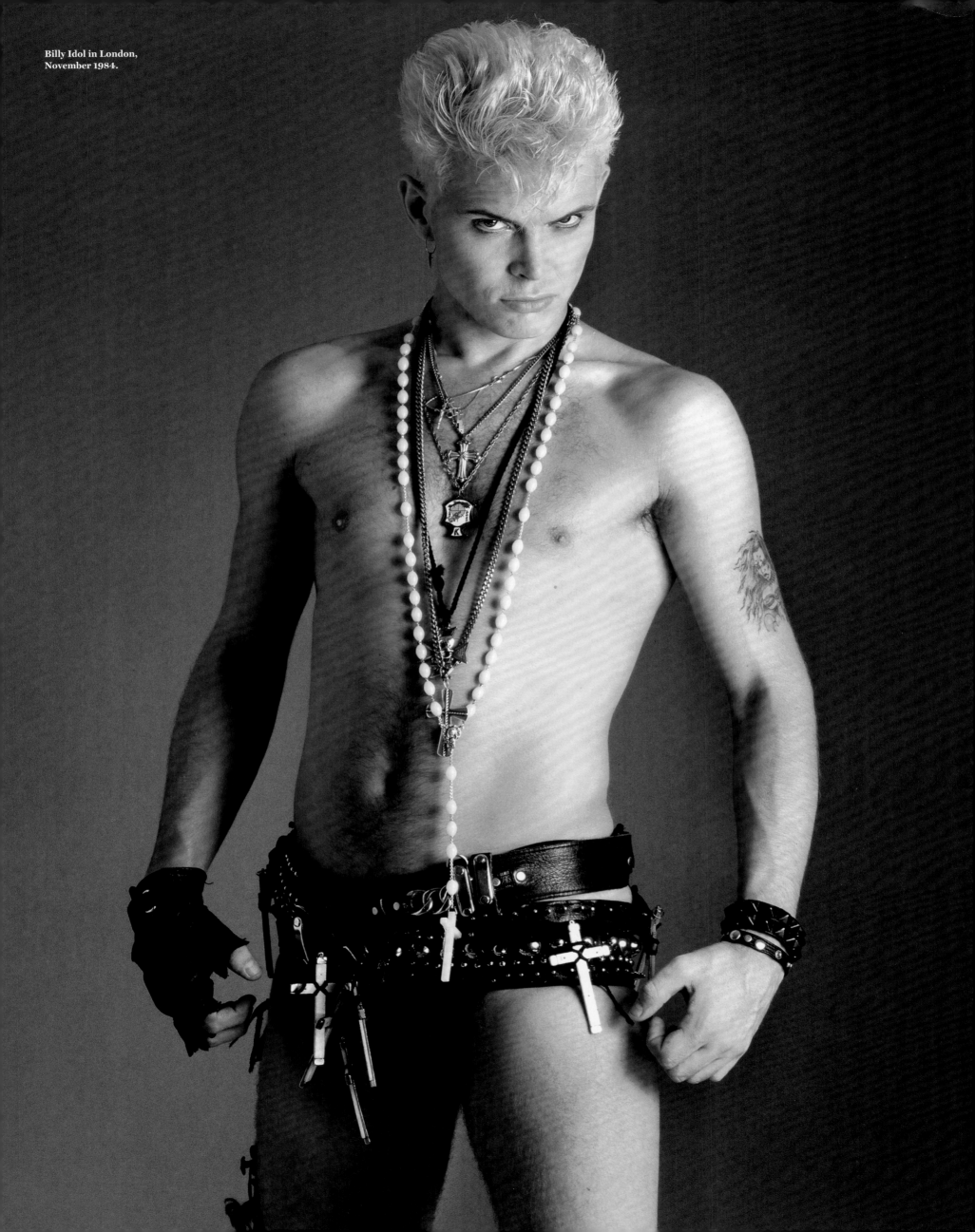

Billy Idol in London,
November 1984.

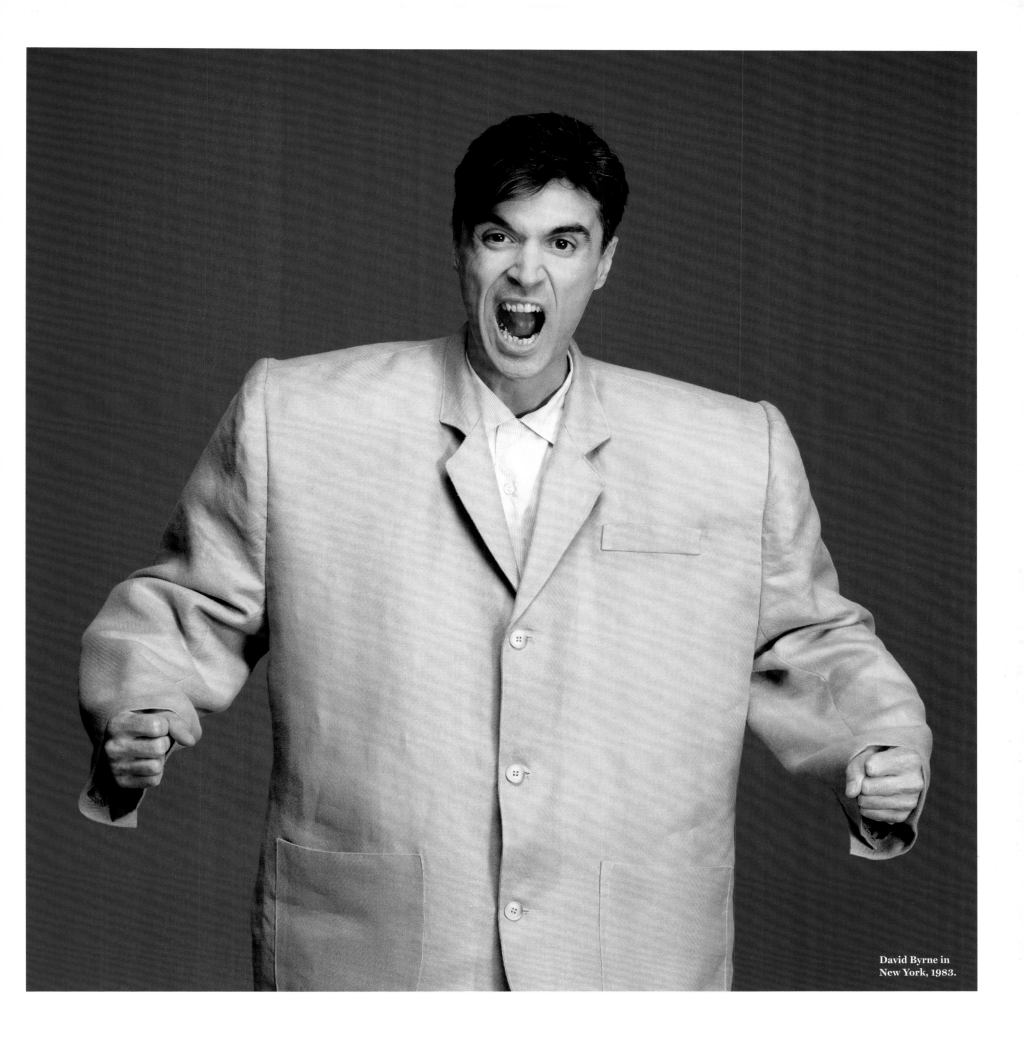

David Byrne in
New York, 1983.

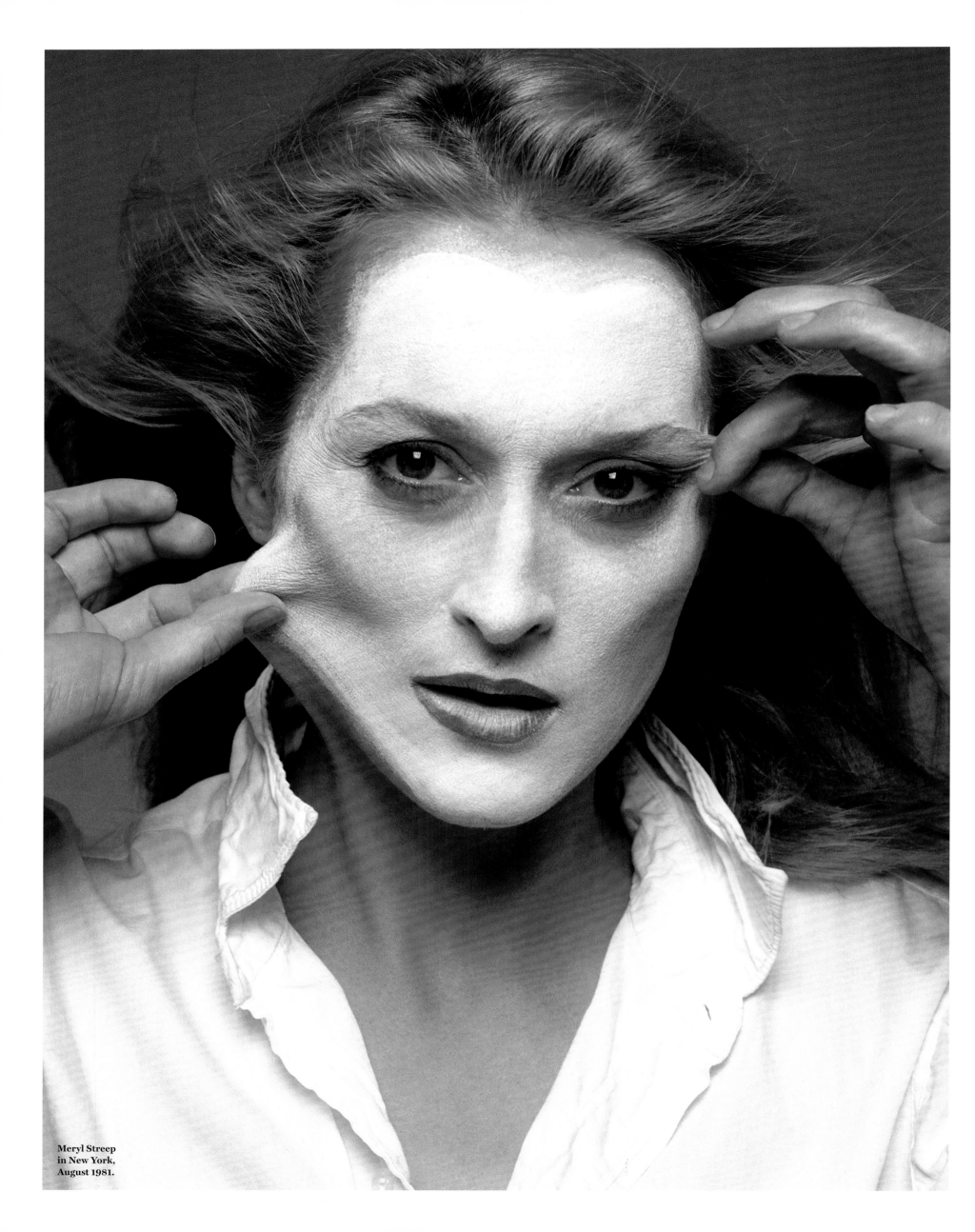

Meryl Streep
in New York,
August 1981.

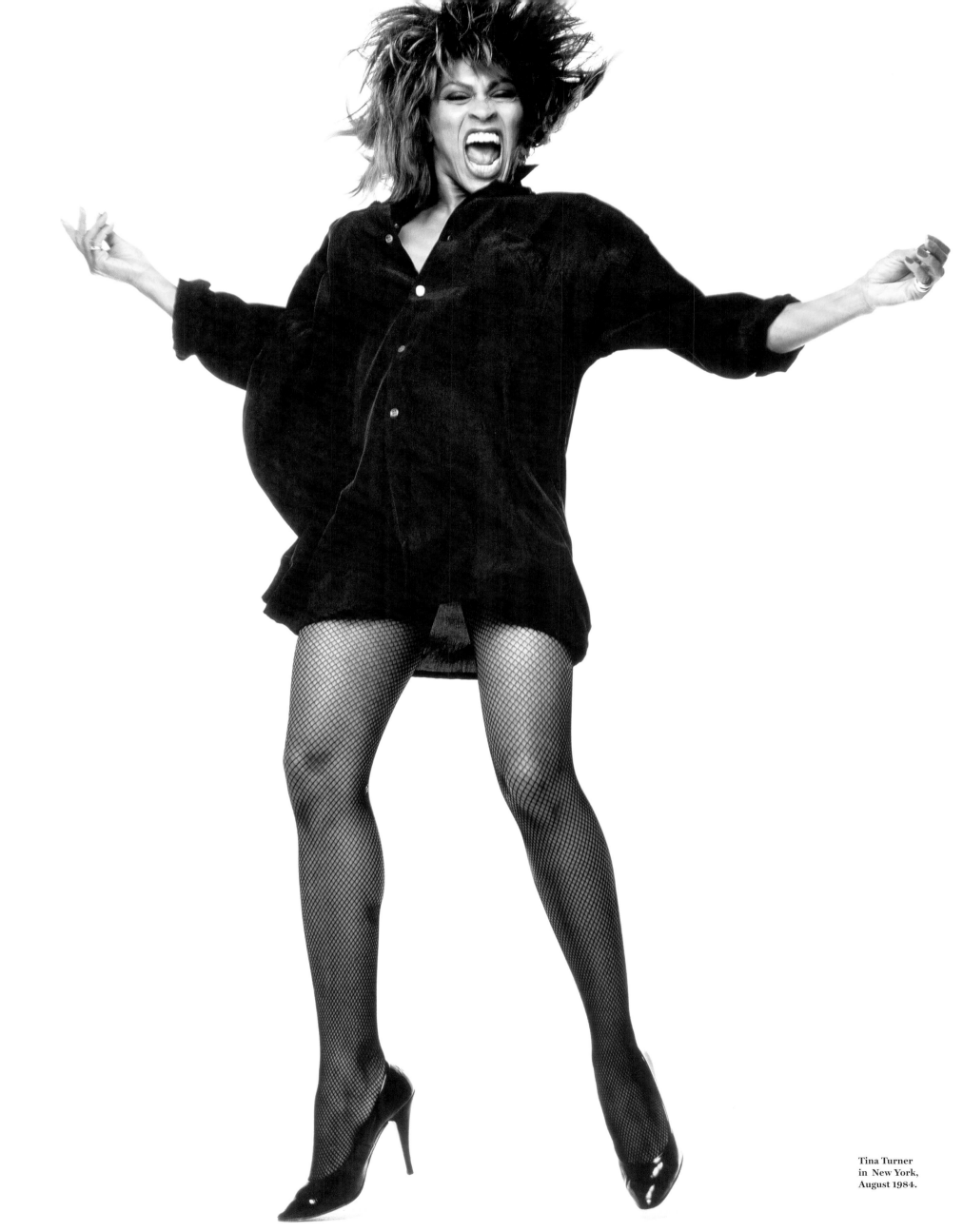

Tina Turner
in New York,
August 1984.

David Letterman's Shtick Shift

In our first Comedy Issue, late night's clown prince talked politics, bad TV and life after Johnny

By Peter W. Kaplan

RS 538 • NOVEMBER 3, 1988

In 1988, David Letterman was on the cover of ROLLING STONE for the third time (he'd make eight appearances there), but with a twist: It was ROLLING STONE's first Comedy Issue, and the magazine marked the occasion by bringing together Letterman and Johnny Carson, the two titans of late-night television, for a summit meeting. In the 1980s, as cable TV began rewiring America and stand-up clubs spread across the nation, something strange happened to the world of comedy: It became both big business and kind of cool. "Kids in the Fifties wanted to strap on a guitar and be Elvis," Richard Belzer told ROLLING STONE in a piece about the boom (which also featured a club veteran named Jerry Seinfeld, "the most successful total unknown in show business"). "Now they want to be Jay Leno or Eddie Murphy or Steve Martin or Robin Williams." Letterman was then still Carson's likely successor, another all-American boy from the heartland. (Jay Leno, who'd steal the *Tonight Show* throne out from under him, was on the cover of the second RS Comedy Issue, the following year, alongside Arsenio Hall.) "He revels in Americans; he is mad at Americans," Peter W. Kaplan wrote of Letterman. "He is the captivated, furious observer of the wild framed portrait that is American television – he has watched it closer than you and I, and it drives him *crazy*."

ROLLING STONE's debut Comedy Issue marked the third time David Letterman appeared on the cover, this time with his idol.

ONE NIGHT IN SEPTEMBER, "LATE NIGHT" ANNOUNCER BILL WENDELL wound up his hyperbolic introduction of his talk-show boss with this: "And now, a man who is better equipped to be vice president than Dan Quayle…*Daaaaaaaay-viiid* Letterman!!!!!"

Certainly he is! For the torch is being passed. Media-fed and video-schooled, we know nothing better than how to respond to television. We have become a nation of Lettermen. This is no casual transfer: It is Turnover Time. When Dan Quayle came onto the national scene, one of Bush's top advisers described it as playing the generational card. But Letterman is another kind of generational card, a young man with a cigar, tested in peace, practiced in national office for the last seven years, serviced in speech communication, ready to address the audience of his nation.

But today the candidate is angry. David Letterman is pounding the floor of his office in the RCA Building with a baseball bat. *Bam.* "It's just bullshit!" he keeps saying. *Bam.* He says he is angry about television, but he's really angry about something else. The culture. "Come on," he says, his voice rising in genuine outrage. "Let's not be so readily entertained! Give it up! I think we're about to bring down the curtain on this society, and it's television that's doing it." *Bam!*

He rubs the bat between his hands. Why is television so bad? Why are people happy to watch it anyway? And if they are happy to watch it, why are they so happy to watch his show, which tries to devastate television every night? On the one hand there is Dave, and on the other hand there is the video abyss – and on a bad night (*aaaugh!*) they can be one and the same. After all, he says, "on any given night we can turn out an enormous piece of shit." This is his dilemma.

"I know," he says, "that people are going to be sitting out there reading this, thinking, 'Dave's gone off the deep end. He's having a breakdown right there.'" But Letterman asks, "Why can you turn on the television any time of the day or night and find pro wrestling? How come? Tell me!"

It's a reasonable question, and it drives Letterman's comedy. For 26 years, Johnny Carson has prodded the content of American life, but Letterman aims at the form of television itself. Carson, a precise, surgical comedian, guided the nation through six presidencies and was, in fact, the president of comedy, governing cleanly, dispensing patronage, steering the dialogue, his staff supporting him as it would a head of state.

Then Letterman entered the talk-show mainstream by reinventing the genre called found comedy, which casts a cold video eye on the conventions of the landscape – dumb ads, bad TV, stores that advertise things they don't have. It was the high point of consumer comedy: Letterman got on the telephone and sent out cameras to try and gauge the disparity between what television had told us and what really existed. For six years and eight months, he has been shooting arrows at television, at the culture, and they never seem to fall back to Earth, like the pencils that still hang from the acoustically dotted ceiling of his office. "I mean," he often says on the show, "what's the *deal* here?"

Letterman seemed Carson's heir apparent, and knowing it would do him no good to compete with Johnny's monologues, he tried the very worst jokes, pleasing the audiences with *that* statement about the rest of television. And at first he was bad at, almost embarrassed by, interviewing people. But he slowly became better at making his suspicion of convention work for him. His staff often points out his interview with boxing promoter Don King as the breakthrough: "Come on, Don," he said. "What's the deal with the hair?"

"When I think about television and show business," Letterman says in his office, "it grinds my stomach. I want to say to people, 'Don't you understand this is just bullshit, driven by egos, and that's all it is?' I mean, nothing makes me madder than to be sitting there, watching somebody who's just the winner of the genetic crapshoot, and there they are, big stuff on the air, a *star*."

Letterman sighs and looks at the floor of the same office he's had for years, one that's a little shabbier than you might expect. It is twilight. His brow is actually furrowing, and he clutches the baseball bat. "I just don't get it," he says. "It just drives me crazy."

Jack Nicholson
in Los Angeles, 1986.

Steve Martin in front
of Franz Kline's "Rue,"
in the actor's Los Angeles
home, December 1981.

Michael Jackson

Life in the Magical Kingdom

By Gerri Hirshey

RS 389 • FEBRUARY 17, 1983

"He was shaking like a leaf," says Gerri Hirshey of interviewing Michael Jackson. "He was terrified. The press was something alien to him." Jackson had never done an interview without his family or handlers around before Hirshey met him at the condo he was living in until his Encino, California, home was rebuilt. He'd just finished *Thriller*, and the Michael Jackson she encountered was surprisingly casual – he wore a rumpled shirt, dirty corduroys and unlaced shoes. "According to people I know well who used to work with him, that's just how he was," says Hirshey. "Unless it was for a public appearance, he had no interest in fashion or presentation of self, really." But she saw the public Jackson when she accompanied him to a Queen show at the L.A. Forum. "When we went out at night, he wore more makeup than I did. He looked very different then. He was very handsome, completely disheveled until he was going out to the Queen concert." Her story was a rare intimate encounter with one of music's most elusive and troubled superstars just as his career went supernova and his myth hardened into reality. "He was very open about what an airless environment it was and how he missed his childhood almost completely," Hirshey says. "He had no filter. He had no defenses. He certainly learned that, and learned it the hard way."

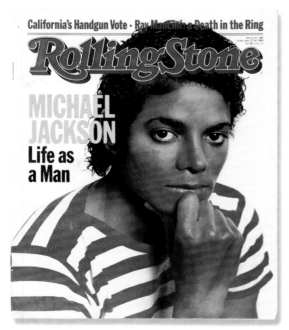

Michael Jackson was on the cover of ROLLING STONE seven times, starting in 1971, in the days of the Jackson 5.

CARTOONS ARE FLASHING SILENTLY ACROSS THE GIANT SCREEN THAT glows in the darkened den. Michael mentions that he loves cartoons. In fact, he loves all things "magic." This definition is wide enough to include everything from Bambi to James Brown.

"He's *so* magic," Michael says of Brown, admitting that he patterned his own quicksilver choreography on the Godfather's classic bag of stage moves. "I'd be in the wings when I was like six or seven. I'd sit there and watch him."

Michael's kindergarten was the basement of the Apollo Theater in Harlem. He was too shy to actually approach the performers the Jackson 5 opened for – everyone from Jackie Wilson to Gladys Knight, the Temptations and Etta James. But he says he had to know everything they did – how James Brown could do a slide, a spin and a split and still make it back before the mic hit the floor. He stood in the protective folds of the musty maroon curtain, watching his favorite acts, committing every double dip and every bump, snap, whip-it-back mic toss to his inventory of night moves. Recently, for a refresher course, Michael went to see James Brown perform at an L.A. club. "He's the *most* electrifying. He can take an audience anywhere he wants to. The audience just went bananas. He went wild – and at his age. He gets so *out* of himself."

Getting out of oneself is a recurrent theme in Michael's life, whether the subject is dancing, singing or acting. As a Jehovah's Witness, Michael believes in an impending holocaust, which will be followed by the Second Coming of Christ. Religion is a large part of his life, requiring intense Bible study and thrice-weekly meetings at a nearby Kingdom Hall. Still, despite the prophesied Armageddon, the spirit is not so dour as to rule out frequent hops on the fantasy shuttle.

"I'm a collector of cartoons," he says. "All the Disney stuff, Bugs Bunny, the old MGM ones. I've only met one person who has a bigger collection than I do, and I was surprised – Paul McCartney. He's a cartoon fanatic. Whenever I go to his house, we watch cartoons. When we came here to work on my album, we rented all these cartoons from the studio, Dumbo and some other stuff. It's real escapism. It's like everything's all right. It's like the world is happening now in a faraway city. Everything's fine."

* * *

"STAY RIGHT THERE," he says, "and I'll show you something." He takes the stairs to his bedroom two at a time. Though I know we are the only people in the apartment, I hear him talking.

"Aw, were you asleep? I'm sorry...."

Seconds later, an eight-foot boa constrictor is deposited on the dining-room table. He is moving in my direction at an alarming rate.

"This is Muscles. And I have trained him to eat interviewers."

Muscles, having made it to the tape recorder and flicked his tongue disdainfully, continues on toward the nearest source of warm blood. Michael thoughtfully picks up the reptile as its snub nose butts my wrist.

"Snakes are very misunderstood," he says. Snakes, I suggest, may be the oldest victims of bad press. Michael whacks the table and laughs.

"Bad press. Ain't it *so*, Muscles?"

The snake lifts its head momentarily.

"Know what I also love?" Michael volunteers. "Mannequins."

Yes, he means the kind you see wearing mink bikinis in Beverly Hills store windows. When his new house is finished, he says, he'll have a room with no furniture, just a desk and a bunch of store dummies.

"I guess I want to bring them to life. I like to imagine talking to them. You know what I think it is? I think I'm accompanying myself with friends I never had. I probably have two friends. And I just got them. Being an entertainer, you just can't tell who is your friend. And they see you so differently. A star instead of a next-door neighbor.

"That's what it is. I surround myself with people I want to be my friends. And I can do that with mannequins. I'll talk to them."

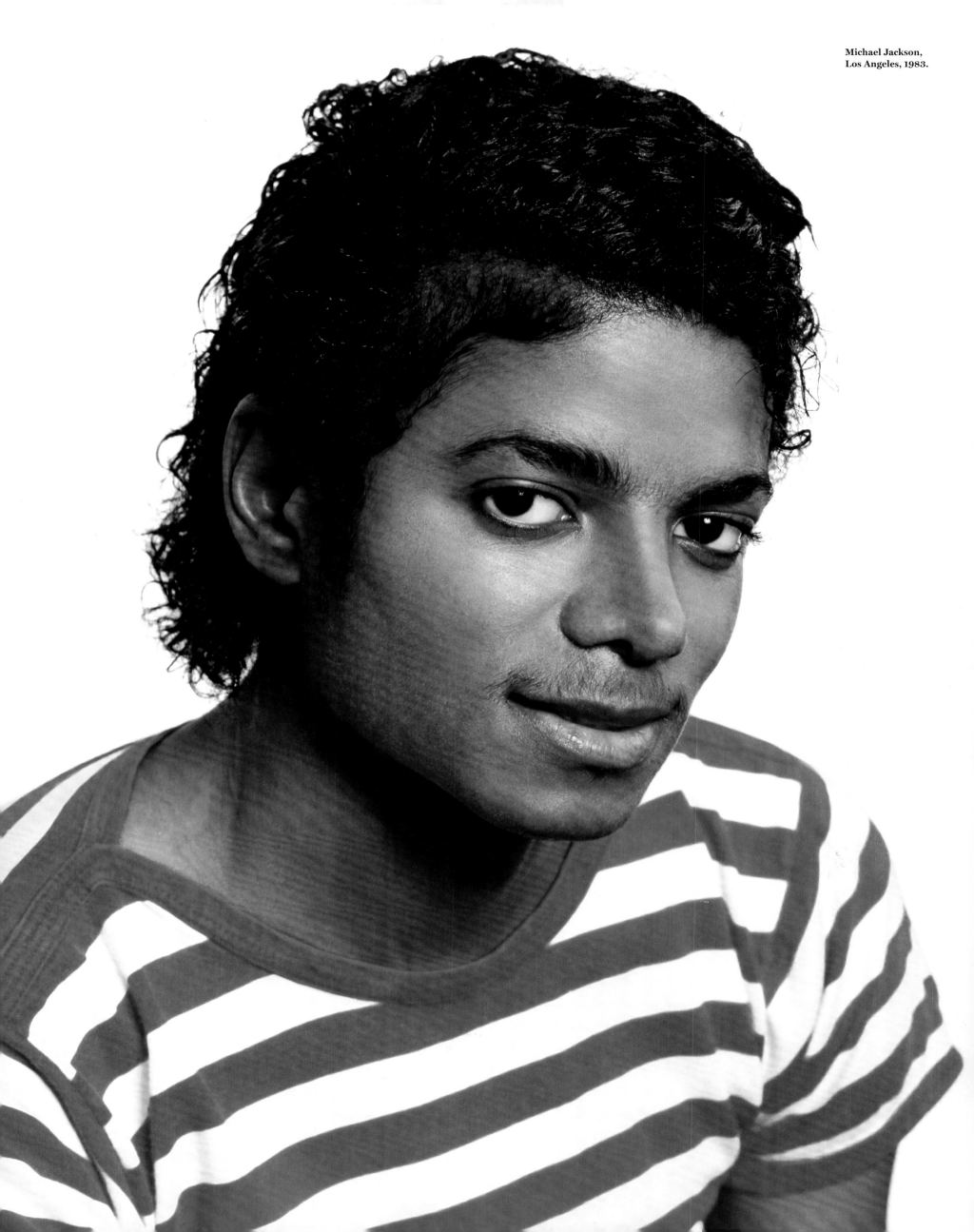

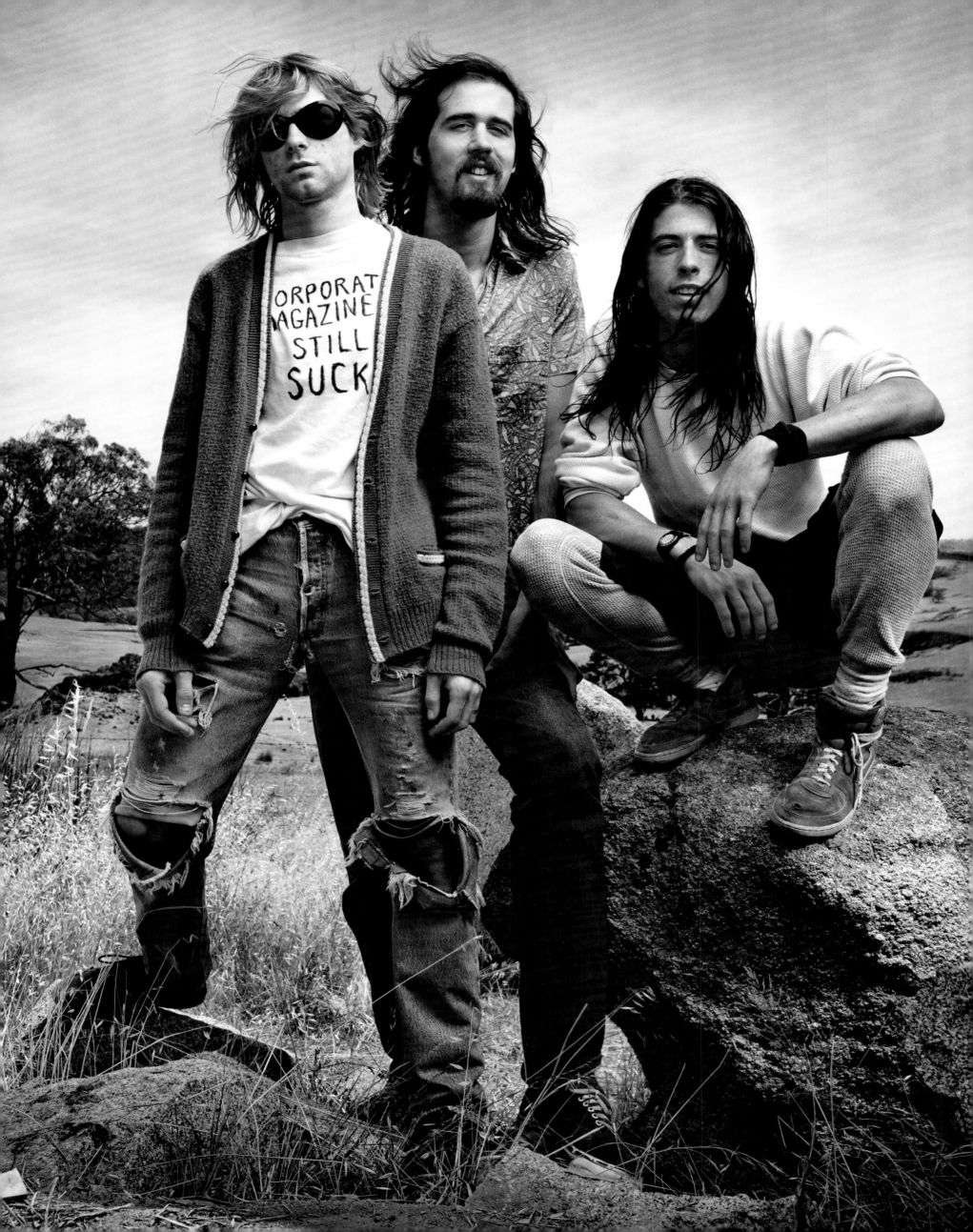

‘**T**HE POSTWAR GENERATION WAS RAISED WITH this sense of unlimited possibility," Bill Clinton said in a 1992 ROLLING STONE Interview before he was elected. "I think, fundamentally, people in our generation are much more idealistic than a lot of others have been, 'cause we were raised to believe things were possible, that we can make a difference." In the Nineties, there was a shift as a new generation took over the White House, bringing a fresh sense of hope. But there was another shift as well, as the music of Nirvana and Dr. Dre put a different generation center stage in popular culture and took the dreams of the Sixties to darker places. "For a few years in Seattle, it was the Summer of Love, and it was so great," Kurt Cobain told the magazine in 1993. "It was a celebration of something that no one could put their finger on. But once it got into the mainstream, it was over." ¶ ROLLING STONE became a place where these two generations spoke to each other, their visions presented with power and clarity and often accompanied by photographs from Mark Seliger, who became the magazine's third chief photographer. Seliger created iconic cover images of Clinton, Cobain, and Dre and Snoop Dogg. His work brought a playful conceptual edge to shots of the *Seinfeld* cast and startling intimacy to a portrait of Jennifer Aniston. ¶ As ROLLING STONE's visuals continued to develop, so did its journalistic mission. The Nineties saw powerful work from William Greider, whose investigation of mandatory-minimum sentences exposed a growing prison state within America, and Eric Schlosser, whose future bestseller *Fast Food Nation* began as a ROLLING STONE series.

Previous spread: Nirvana, Melbourne, Australia, 1992.

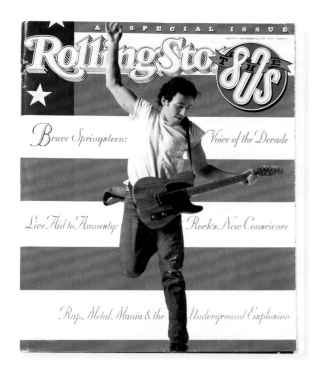

A SPECIAL ISSUE

RollingStone THE 80s

Bruce Springsteen: *Voice of the Decade*

Live Aid to Amnesty: *Rock's New Conscience*

Rap, Metal, Mania & the Underground Explosion

RollingStone

ROBIN
WILLIAMS
FEAR OF A
CLOWN

ROGER
McGUINN

STING

King's X

PEARL JAM LIVE WHITE ZOMBIE GUNS N' ROSES INXS

RollingStone

Life in
the Fast Lane
President
CLINTON

The Rolling Stone
Interview

NRA
ON THE RUN

The New Politics
of Gun Control

ADOLESCENCE
IN AMERICA

The Years of
Living Dangerously

30TH ANNIVERSARY SPECIAL

RollingStone

WE'RE OFF...
Seinfeld
Hits the
Road!

RollingStone

SEARCHING
FOR THE NEW
NIRVANA

Ice-T
Talks
Back
(You Got
a Problem
With
That?)

Greenmail
in Rio:
P.J. O'Rourke
at the Earth
Summit

RollingStone

U2

ARTIST OF THE YEAR

BONO

VOTE
THE
ROCK

ANNUAL MUSIC AWARDS

RollingStone

THE TRIAL OF
HUNTER
THOMPSON

EXCLUSIVE!
At Home
With
BART
SIMPSON
Underachiever
or Just a Kid?

MIDNIGHT OIL
Turns to Gold

P.J. O'ROURKE'S
Earth Day

World Party
Soul II Soul
New Girl
Groups

Helmet The Black Crowes Nick Cave Seal

RollingStone

"String Us Up and We Still Won't Die"
The Rolling Stones
Out for Blood

Barry Diller
The Rolling Stone Interview

Lollapalooza's
Flaming Lips & Luscious Jackson

PRESIDENTS OF THE UNITED STATES YOKO ONO

RollingStone

How
Smashing
Pumpkins
Beat the
Ticket
Scalpers

Playing Politics
With God
The
Republicans
and the
Religious
Right

Jennifer
Aniston

The
Girl
Friend

Eric Clapton, New York,
August 1991.

"The whole success thing, I feel like everybody else in the band is a lot happier with it than me."

EDDIE VEDDER, *"Five Against the World," RS 668, October 28, 1993.*

Vedder in Spokane, Washington, June 1993.

Beastie Boys,
New York,
May 1998.

"I had this idea where we're in school and bored out of our minds, and we have Catholic uniforms on. And I said, 'Why don't we have knee-highs and tie the shirts up to give it a little attitude?' "

BRITNEY SPEARS, *"Inside the Heart and Mind (and Bedroom) of America's New Teen Queen," RS 810, April 15, 1999.*

Spears in Kentwood, Louisiana, March 1999.

"People ask me how I come up with these hits, and I can only say that I know what I like, I'm quick to tell a motherfucker what I don't like, and know what people like to play in their cars."

DR. DRE, *"Day of the Dre," RS 666, September 30, 1993.*

Dr. Dre and Snoop Dogg in Los Angeles, August 1993.

Green Day in
Berkeley, 1995.

Eminem Blows Up

As he grappled with stardom, the rapper born Marshall Mathers proved you can go home again

RS 811 • APRIL 29, 1999

'He didn't speak to me for the first 24 hours," says writer Anthony Bozza of meeting Eminem in March 1999. "He glared at me a lot, and a few times when he was freestyling he included quick, offhand couplets about me that I believe were designed to test the thickness of my skin." Eminem's breakthrough, "The Slim Shady LP," had just been released, and Bozza followed the rapper on a wild night of Ecstasy-fueled live performances around New York, before flying back to Eminem's home state, Michigan. "Somewhere in there, I passed his unspoken trial by fire," says Bozza, who watched as Eminem and his girlfriend, Kim, put their three-year-old daughter, Hailie, to bed. Slim Shady receded, and the real Marshall Mathers revealed himself in the pages of ROLLING STONE.

* * *

"HEY, TURN HERE," Eminem says to the driver of the big white van currently crunching through the snow-covered streets of east Detroit. "Stop. That was our house. My room was upstairs, in the back." The small two-story homes on the gridlike streets are identical – square patch of grass in the front, a short driveway on the side – differentiated only by their brick face or shingles. The van turns off 8 Mile, passing Em's high school, then the field next to the Bel-Air Shopping Center, where Em lost his boombox and nearly his life. Em is looking out of the window like a kid at Disneyland, pointing, recalling happy and heartbreaking memories with equal excitement. "I like living in Detroit, making it my home," he says as the van heads toward the highway. "I like working out in L.A., but I wouldn't want to live there. My little girl is here."

The van winds back through Detroit, stopping at a modest home. Eminem's girlfriend, Kim, a pretty blonde, hops in holding Hailie, a groggy but smiley blue-eyed beauty who immediately dives onto Em's lap and wraps her arms around his neck. The van whisks off, Hailie falls back to sleep, and Em tells Kim about the New York shows. Forty minutes later, the van turns into the trailer park – more of a village, really – that Em calls home. "After I got my record deal, my mother moved back to Kansas City," he says. "I took over the payments on her trailer, but I'm never here."

The double-wide mobile home houses Em's possessions, which, after robberies and moving around, have been acquired in the past six months. An autographed glossy of Dre that reads "Thanks for the support, asshole" (mirroring Shady's autograph in "My Name Is") is on a wall, as is the album art from the *Shady* EP. Above the TV are two shots of Em and Dre from the video shoot, along with pictures of

Hailie. A small rack holds CDs by 2Pac, Mase, Babyface, Luther Vandross, Esthero and Snoop Dogg. A baby couch for Hailie sits in front of the TV. On a wall near the kitchen is a flyer titled "Commitments for Parents," which lists directives like "I will give my child space to grow, dream, succeed and sometimes fail."

Hailie settles down on the floor with a stuffed polar bear as Kim prepares her bed. The couple are happy to see each other tonight, but songs like "'97 Bonnie and Clyde" make it clear that times are not always this tranquil. Their relationship has been volatile – all the more so since their daughter's birth. At one point two years ago, when they were on the outs and dating other people, Kim, according to Eminem, made it difficult for him to see his daughter and even threatened to file a restraining order. Em wrote "Just the 2 of Us," on the *Shady* EP, to tell the tale of a father killing his baby's mother and cleaning up the mess with the help of his daughter: "Here, you wanna help Dada tie a rope around this rock?/Then we'll tie it to her footsie, then we'll roll her off the dock/Here we go, count of three. One, two, three, wee!/There goes Mama, splashing in the water/No more fighting with Dad, no more restraining order."

Em is the first to admit he's got a bad temper, which he has harnessed into a career. "My thoughts are so fucking evil when I'm writing shit," he says. "If I'm mad at my girl, I'm gonna sit down and write the most misogynistic fucking rhyme in the world. It's not how I feel in general, it's how I feel at that moment. Like, say today, earlier, I might think something like, 'Coming through the airport sluggish, walking on crutches, hit a pregnant bitch in the stomach with luggage.'"

Slim Shady is Marshall Mathers' way of taking revenge on the world, and he's also a defense mechanism. On the one hand, a lot of Slim Shady's cartoonish fantasies are offensive; on the other, they're better than Mathers re-creating the kind of abuse the world heaped upon him while growing up. "I dealt with a lot of shit coming up, a lot of shit," he says. "When it's like that, you learn to live day to day. When all this happened, I took a deep breath, just like, 'I did it.'" The magnitude of what he's done doesn't seem to have sunk in. Em hasn't sipped the bubbly or smelled the roses – and if he allots time for that in the next few months, it will have to be at the drive-through. As for the future, he won't even wager a guess.

"If he remains the same person that walked into the studio with me that first day, he will be fucking larger than Michael Jackson," says a confident Dre. "There are a lot of ifs and buts, but my man, he's dope and very humble." As Em closes the door, with Hailie's blanket in his hands, he looks humble, a little tired and pretty happy. For now.

Eminem performs at Tramps nightclub in New York, 1999.

The Music Never Stops

Two years before his death, Jerry Garcia reflected on the Grateful Dead, his health and the road ahead

RS 664 • SEPTEMBER 2, 1993

I n June 1993, when Anthony DeCurtis interviewed Jerry Garcia at the Four Seasons Ritz-Carlton Hotel in Chicago, the Grateful Dead guitarist was trying to turn his life around. A diabetic coma in 1986 had nearly taken his life, and in 1992 he collapsed from exhaustion, forcing some Dead shows to be canceled. Now, at 51, Garcia was smoking less, eating better and was back on the road with the Dead. Yet he continued to struggle. "I had no idea how bad his health was," says DeCurtis. "What most stood out to me was when, after acknowledging being moved by fans' good wishes for his health, he admitted that part of him felt like telling people to fuck off and mind their own business. I'd never heard him say anything like that before, and it concerned me." Two years later, Garcia would suffer a fatal heart attack while in a California rehab facility.

* * *

With your health problems, were you concerned that you might never get to do all the things you've been talking about wanting to do?

Absolutely. I was getting to the place where I had a hard time playing a show. I was in terrible fucking shape. I mean, I was just exhausted, totally exhausted. I could barely walk up a flight of stairs without panting and wheezing. I just let my physical self slide as far as I possibly could.

Did you deny to yourself what was happening?

Oh, yeah, because I'm basically a lazy fuck. Things have to get to the point where they're screaming before I'll do anything. I could see it coming, and I kept saying to myself: "Well, as soon as I get myself together, I'm going to start working out. I'm going on that diet." Quit smoking – *ayiiiiii* [*waves lit cigarette*].

In a way, I was lucky, insofar as I had an iron constitution. But time naturally gets you, and finally your body just doesn't spring back the way it did. I think it had to get as bad as it did before I would get serious about it. I mean, it's a powerful incentive, the possibility that, hey, if you keep going the way you are, in two years you're going to be dead.

But I definitely have a component in my personality which is not exactly self-destructive, but it's certainly ornery. There's a part of me that has a *bad attitude*. It's like "*Fuck* you," you know? [*Laughs*] "Try to get healthy" – "Fuck you, man." And I mean, part of this whole process has been coming to terms with my bad-attitude self, trying to figure out "What does this part of me want?"

What is that about?

I don't know what it comes from. I've always clung to it, see, because I felt it's part of what makes me me. Being anarchic, having that anarchist streak, serves me on other levels, artistically, certainly. So I don't want to eliminate that aspect of my personality. But I see that on some levels it's working against me.

They're gifts, some of these aspects of your personality. They're helpful and useful and powerful, but they also have this other side. They're indiscriminate. They don't make judgments.

What about in terms of the Dead? Were there times when the band was discouraged about its future?

Well, there were times when we were really in chaotic spaces, but I don't think we've ever been totally discouraged. It just has never happened. There have been times everybody was off on their own trip to the extent that we barely communicated with each other. But it's pulses, you know? And right now everybody's relating pretty nicely to each other, and everybody's feeling very good, too. There's a kind of healthy glow through the whole Grateful Dead scene. We're gearing up for the millennium.

Oh, yeah? What's the plan?

Well, our plan is to get *through* the millennium [*laughs*]. Apart from that, it's totally amorphous.

Historically, turns of the century have been really intriguing times. Does that date hold any real significance for you?

No, the date that holds significance for me is 2012. That's Terence McKenna's alpha moment, which is where the universe undergoes its most extraordinary transformations. He talks about these cycles, exponential cycles in which, in each epic, more happens than in all previous time. So he's got us, like, in the last 40-year cycle now – it's running down, we're definitely tightening up – and during this period, more will happen than has happened in all previous time. This is going to peak in 2012. He's got a specific date for it, too – maybe December some time, I don't remember. But that moment, at the last 135th of a second or something like that, something like 40 of these transformations will happen. Like *immortality*, you know [*laughs*].

It's an incredibly wonderful and transformational view of the universe. I love it, personally. It's my favorite ontology, my favorite endgame. It's much, much more visionary and sumptuous than…like, say, *Christ* is coming back [*laughs*]. "Oh, swell. That would be fun."

Are you concerned about what you'd leave behind?

No. I'm hoping to leave a clean field – nothing, not a thing. I'm hoping they burn it all with me. I don't feel like there's this body of work that must exist. I'd just as soon take it all with me. There's enough stuff – who needs the clutter, you know? I'd rather have my immortality here while I'm alive. I don't care if it lasts beyond me at all. I'd just as soon it didn't.

Jerry Garcia in Indianapolis, June 1993.

Steven Tyler,
New York, 1992.

Joe Perry,
New York, 1992.

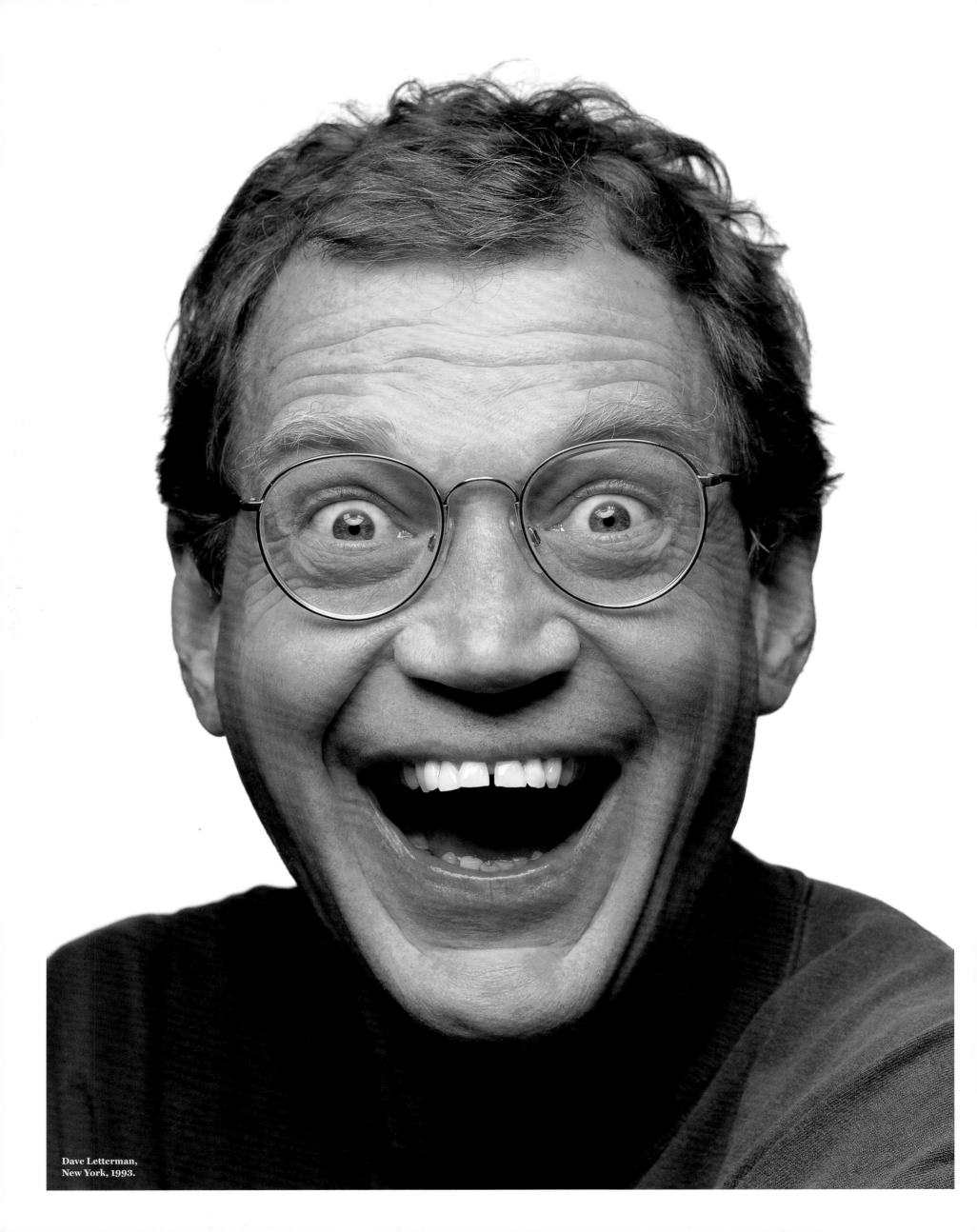

Dave Letterman,
New York, 1993.

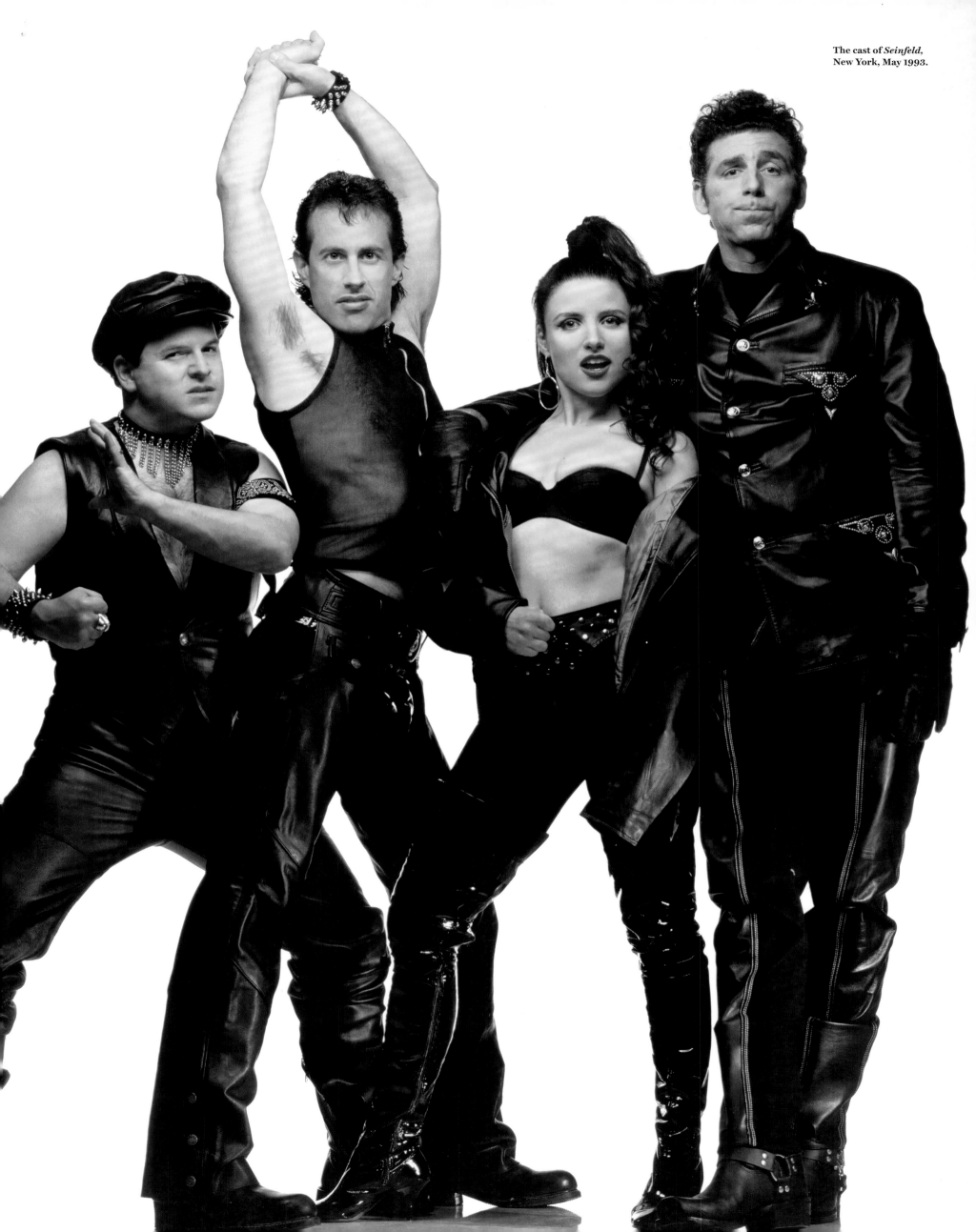

George Harrison,
Los Angeles, 1992.

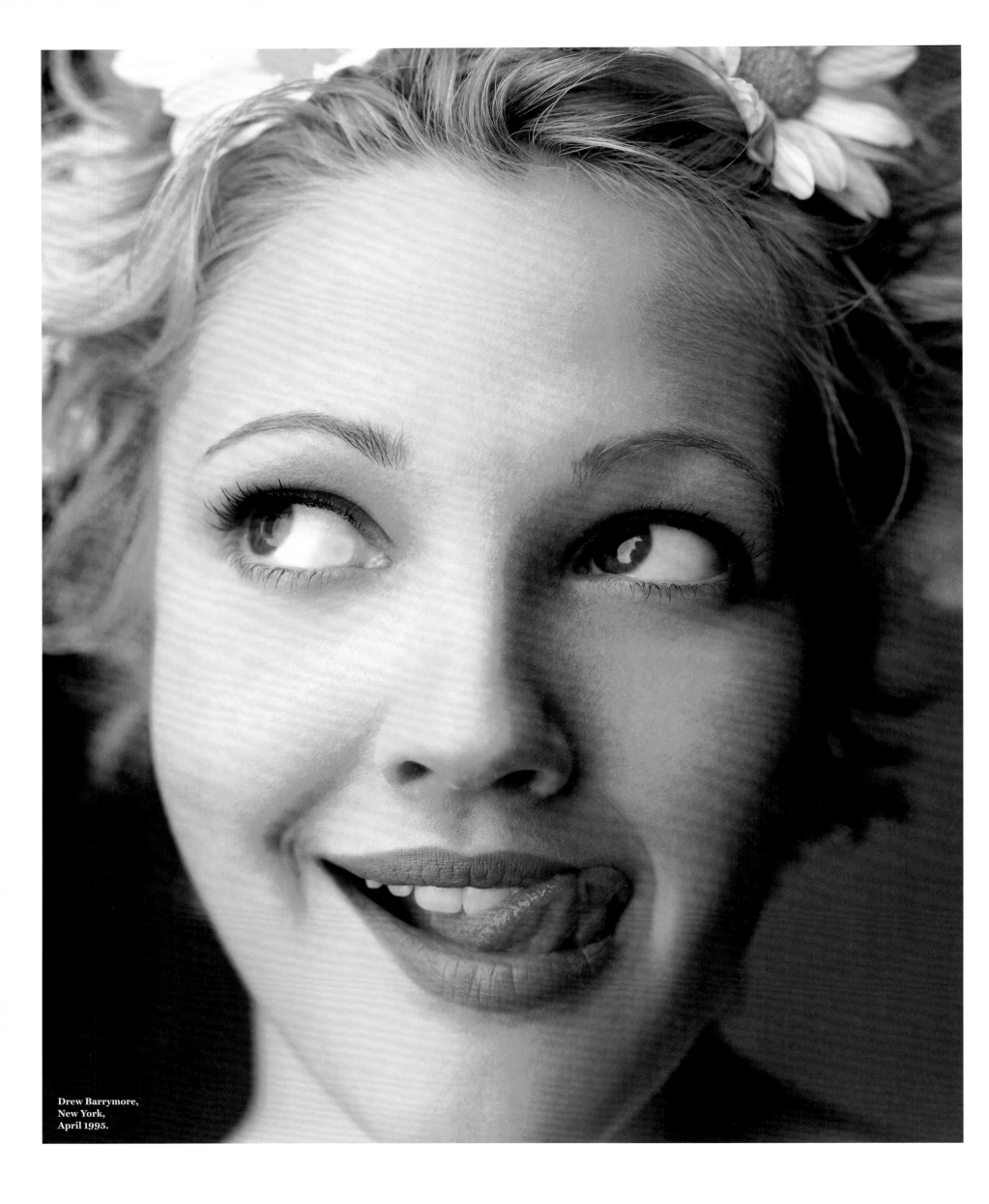

Drew Barrymore,
New York,
April 1995.

Sinéad O'Connor,
Los Angeles,
January 1991.

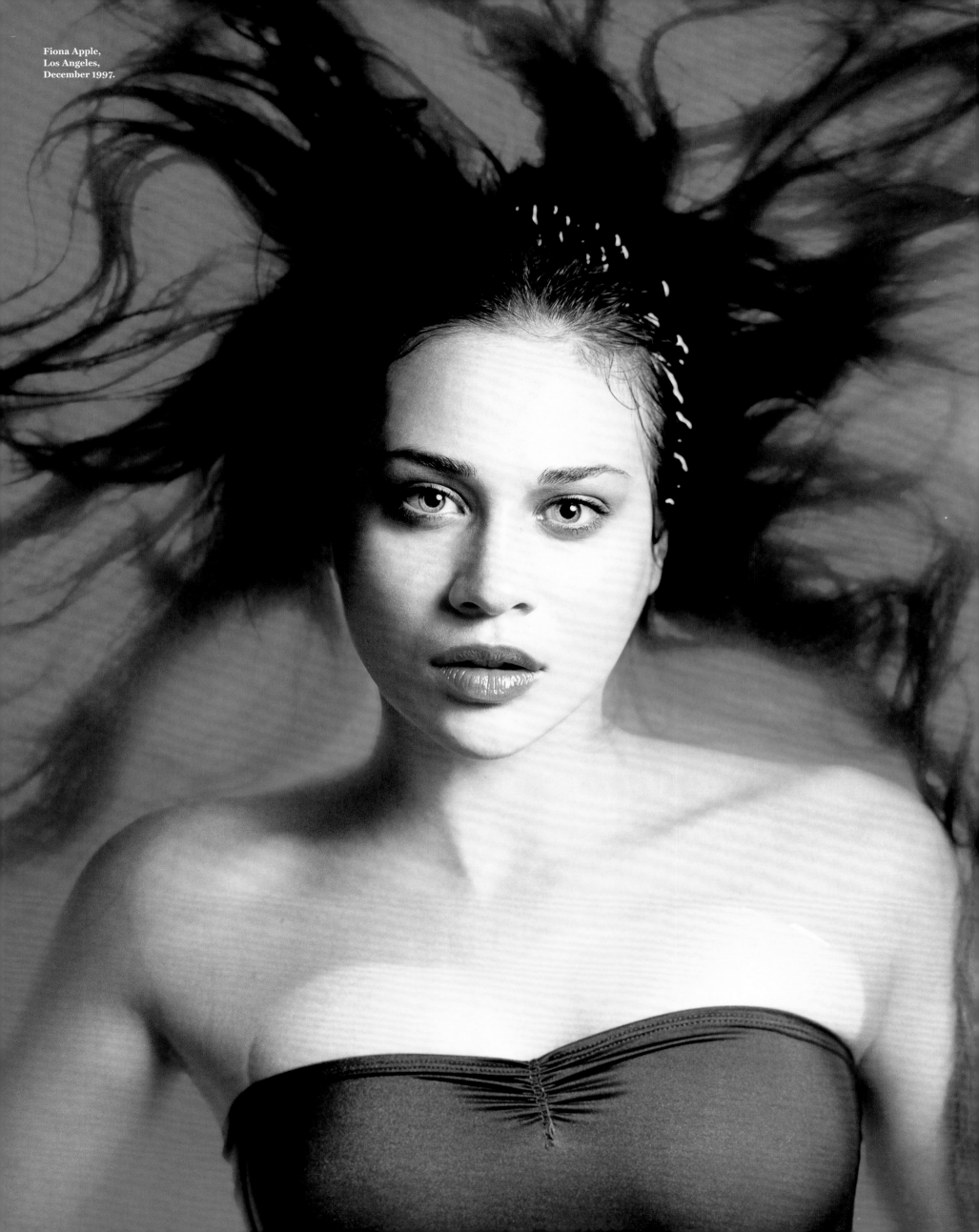

Fiona Apple,
Los Angeles,
December 1997.

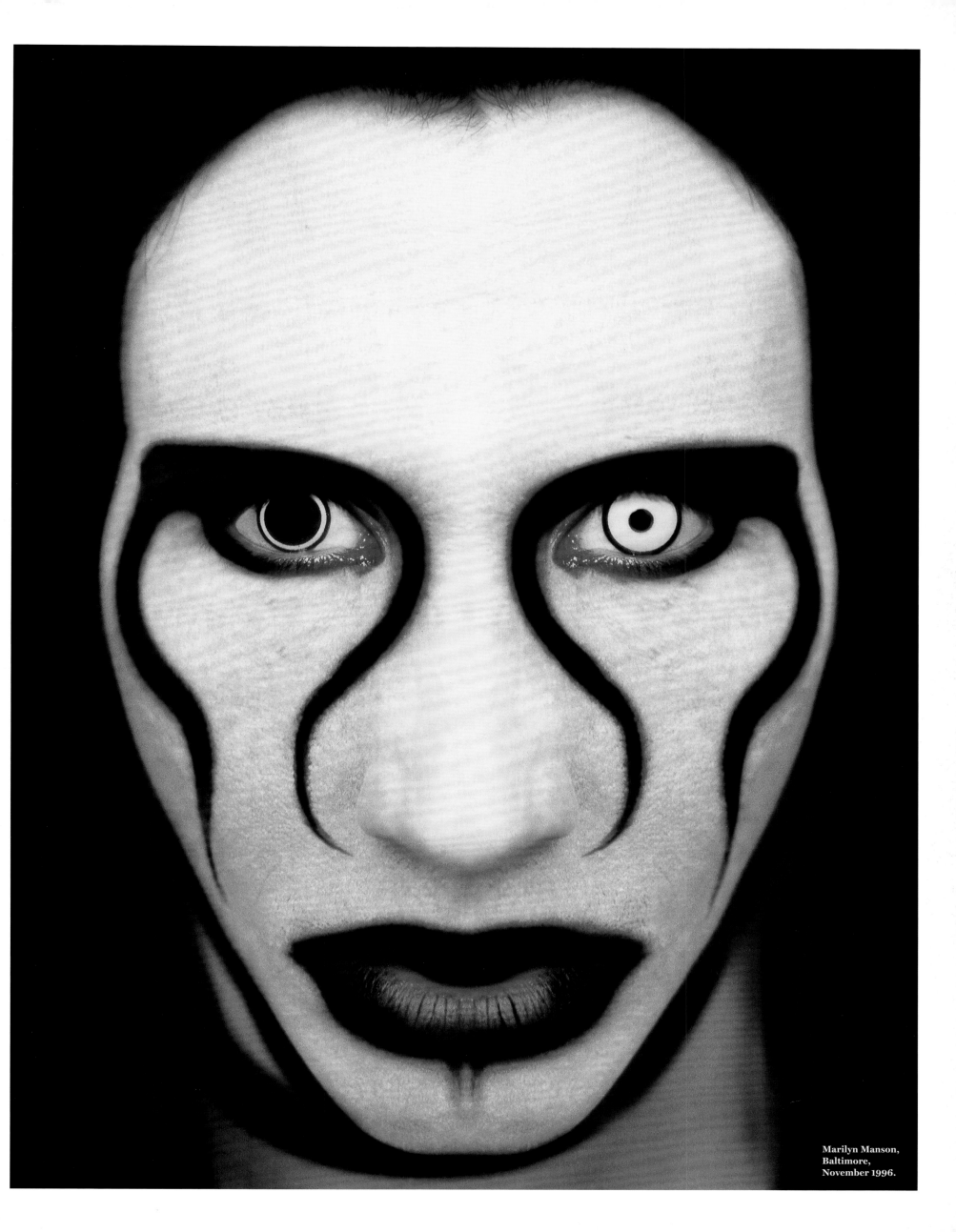

Marilyn Manson,
Baltimore,
November 1996.

Mick Jagger

By Jann S. Wenner

RS 723 • DECEMBER 14, 1995

From November 1994 to October 1995, Jann S. Wenner conducted a series of interviews with Mick Jagger that were unprecedented in their depth. Jagger had long been one of rock's most reluctant subjects, often agreeing to speak with the press about a Rolling Stones album or tour but not always revealing that much about himself. "His life has been public for so long, he sees little need to explain or justify himself and has everything to be gained by holding on to what privacy he has – such as the privacy of his thinking – as well as the value of a little mystery," wrote Wenner. This was different, though. Wenner and Jagger had known each other for 25 years at the time of this ROLLING STONE Interview, which was conducted in three- to four-hour sessions during the Rolling Stones' *Voodoo Lounge* tour, in Palm Beach, Florida; Montreal; and Cologne, Germany, and then continued on the phone. Jagger had never before spoken in such detail about his life or career. He revealed the workings of his songwriting partnership with Keith Richards – including who wrote which songs – what drew him to performing as a teenager and how his command of the stage had grown over the years. The cover story this excerpt is drawn from was published as "Jagger Remembers," the title an echo of the groundbreaking 1971 ROLLING STONE Interview with John Lennon, published in book form as *Lennon Remembers*. It remains Jagger's definitive statement on his music.

T*ell me about meeting Keith.*
I can't remember when I didn't know him. We lived one street away; his mother knew my mother, and we were at primary school together from [ages] seven to 11. We used to play together, and we weren't the closest friends, but we were friends.

Keith and I went to different schools when we were 11, but he went to a school which was really near where I used to live. But I always knew where he lived, because my mother would never lose contact with anybody, and she knew where they'd moved. I used to see him coming home from his school, which was less than a mile away from where I lived. And then – this is a true story – we met at the train station. And I had these rhythm & blues records, which were very prized possessions because they weren't available in England then. And he said, "Oh, yeah, these are really interesting." That kind of did it. That's how it started, really.

We started to go to each other's house and play these records. And then we started to go to other people's houses to play other records. You know, it's the time in your life when you're almost stamp-collecting this stuff. I can't quite remember how all this worked. Keith always played the guitar, from even when he was five. And he was keen on country music, cowboys. But obviously at some point, Keith, he had this guitar with this electric-guitar pickup. And he played it for me. So I said, "Well, I sing, you know? And you play the guitar." Very obvious stuff.

I used to play Saturday night shows with all these different little groups. If I could get a show, I would do it. I used to do mad things – you know, I used to go and do these shows and go on my knees and roll on the ground – when I was 15, 16 years old. And my parents were extremely disapproving of it all. Because it was just not done. This was for very low-class people, remember. Rock & roll singers weren't educated people.

I recently listened to the very early albums, the first four or five, and they're all pretty much the same. You were doing blues and covers, but one song stood out: "Tell Me (You're Coming Back)," your first U.S. hit and your first composition together with Keith. It's the first one that has the seeds of the modern Stones in it.

Keith was playing 12-string and singing harmonies into the same microphone as the 12-string. We recorded it in this tiny studio in the West End of London called Regent Sound, which was a demo studio. I think the whole of that album was recorded in there. But it's

> "I used to do these shows on my knees, roll on the ground – when I was 15. My parents were extremely disapproving."

very different from doing those R&B covers or Marvin Gaye covers and all that. There's a definite feel about it. It's a very *pop* song, as opposed to all the blues songs and the Motown covers, which everyone did at the time.

The first full album that really kind of jumps out is "Out of Our Heads."

Most of that was recorded in RCA Studios, in Hollywood, and the people working on it, the engineers, were much better. They knew how to get really good sounds. That really affects your performance, because you can hear the nuances, and that inspires you.

And your singing is different here for the first time. You sound like you're singing more like soul music.

Yeah, well, it is obviously soul-influenced, which was the goal at the time. Otis Redding and Solomon Burke. "Play With Fire" sounds amazing – when I heard it last. I mean, it's a very in-your-face kind of sound and very clearly done. You can hear all the vocal stuff on it. And I'm playing the tambourines, the vocal line. You know, it's very pretty.

Who wrote that?
Keith and me. I mean, it just came out.
A full collaboration?
Yeah.
That's the first song you wrote that starts to address the lifestyle you were leading in England and, of course, class consciousness.

No one had really done that. The Beatles, to some extent, were doing it, though they weren't really doing it at this period as much as they did later. The Kinks were kind of doing it – Ray Davies and I were in the same boat. One of the first things that, in that very naive way, you attempted to deal with were the kind of funny, swinging, London-type things that were going on. I didn't even realize I was doing it at the time. But it became an interesting source for material. Songwriting had only dealt in clichés and borrowed stuff, you know, from previous records or ideas. "I want to hold your hand," things like that. But these songs were really more from experience and then embroidered to make them more interesting.

"Beggars Banquet" is a record that you could not have predicted from your earlier work. It had extraordinary power and sophistication, with songs like "Street Fighting Man," "Salt of the Earth," "Stray Cat Blues" and "Jig-Saw Puzzle." What was going on in your life at this time? What were you listening to and reading?

God, what was I doing? Who was I living with? It was all recorded in London, and I was living in this rented house in Chester Square. I was living with Marianne Faithfull. Was I still?

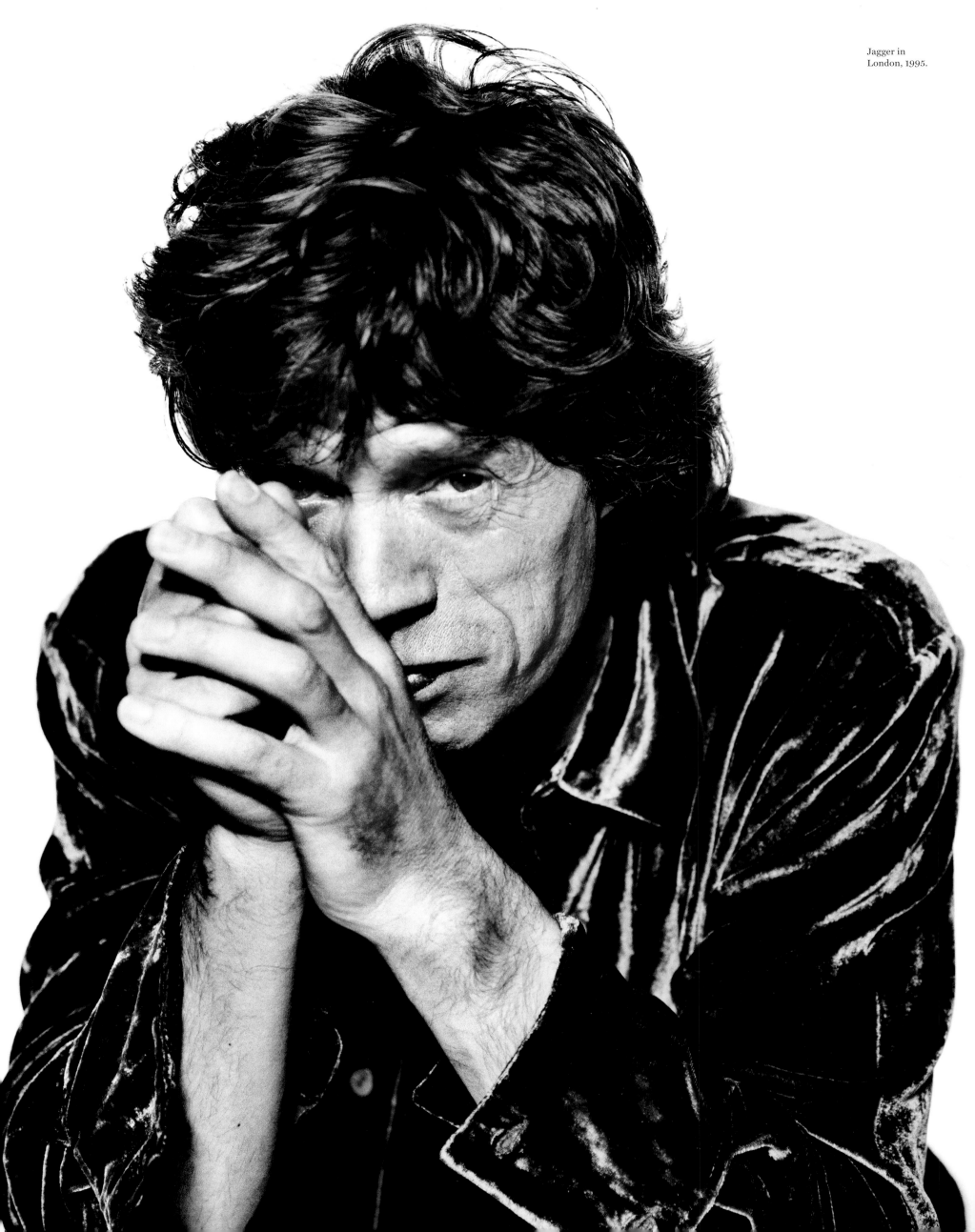

> # " 'Brown Sugar' is all the nasty subjects in one go. I never would write that song now. I'd think, 'Oh, God, I can't. I've got to stop. I can't just write raw like that.' "

Yeah. And I was just writing a lot, reading a lot. I was educating myself. I was reading a lot of poetry, I was reading a lot of philosophy. I was out and about. I was very social, always hanging out with [art-gallery owner] Robert Fraser's group of people.

And I wasn't taking so many drugs that it was messing up my creative processes. It was a very good period, 1968 – there was a good feeling in the air. It was a very creative period for everyone. There was a lot going on in the theater. Marianne was kind of involved with it, so I would go to the theater upstairs, hang out with the young directors of the time and the young filmmakers.

Let's start with "Sympathy for the Devil."

That was taken from an old idea of Baudelaire's, I think, but I could be wrong. Sometimes when I look at my Baudelaire books, I can't see it in there. But it was an idea I got from French writing. And I just took a couple of lines and expanded on it. I wrote it as sort of like a Bob Dylan song.

You wrote that song.

Uh-huh.

So that's a wholly Mick Jagger song.

Uh-huh. I mean, Keith suggested that we do it in another rhythm, so that's how bands help you.

Were you trying to put out a specific philosophical message here? You know, you're singing,

"Just as every cop is a criminal and all the sinners saints…"

Yeah, there's all these attractions of opposites and turning things upside down.

When you were writing it, did you conceive of it as this grand work?

I knew it was something good, 'cause I would just keep banging away at it until the fucking band recorded it.

There was resistance to it?

No, there wasn't any resistance. It was just that I knew that I wanted to do it and get it down. And I hadn't written a lot of songs on my own, so you have to teach it. When you write songs, you have to like them yourself first, but then you have to make everyone else like them, because you can force them to play it, but you can't force them to like it. And if they like it, they'll do a much better job than if they're just playing 'cause they feel they're obligated.

They get inspired.

And then you get inspired, and that's what being in a band's about rather than hiring people. But I knew it was a good song. You just have this feeling. It had its poetic beginning, and then it had historic references and then philosophical jottings and so on. It's all very well to write that in verse, but to make it into a pop song is something different. Especially in England – you're

skewered on the altar of pop culture if you become pretentious.

After Brian [Jones] died, you recorded what has to be considered another classic Stones album, "Sticky Fingers." Why does "Brown Sugar" work like mad?

That's a bit of a mystery, isn't it? I wrote that song in Australia in the middle of a field. They were really odd circumstances. I was doing this movie, *Ned Kelly,* and my hand had got really damaged in this action sequence. So stupid. I was trying to rehabilitate my hand and had this new kind of electric guitar, and I was playing in the middle of the outback and wrote this tune.

But why it works? I mean, it's a good groove and all that. I mean, the groove is slightly similar to Freddy Cannon, this rather obscure Fifties rock performer – "Tallahassee Lassie" or something. Do you remember this? "She's down in F-L-A." Anyway, the groove of that – boom-boom-boom-boom-boom – is "going to a go-go" or whatever, but that's the groove.

And you wrote it all?

Yeah.

This is one of your biggest hits, a great, classic radio single, except the subject matter is slavery, interracial sex, eating pussy…

[Laughs] And drugs. That's a double-entendre, just thrown in.

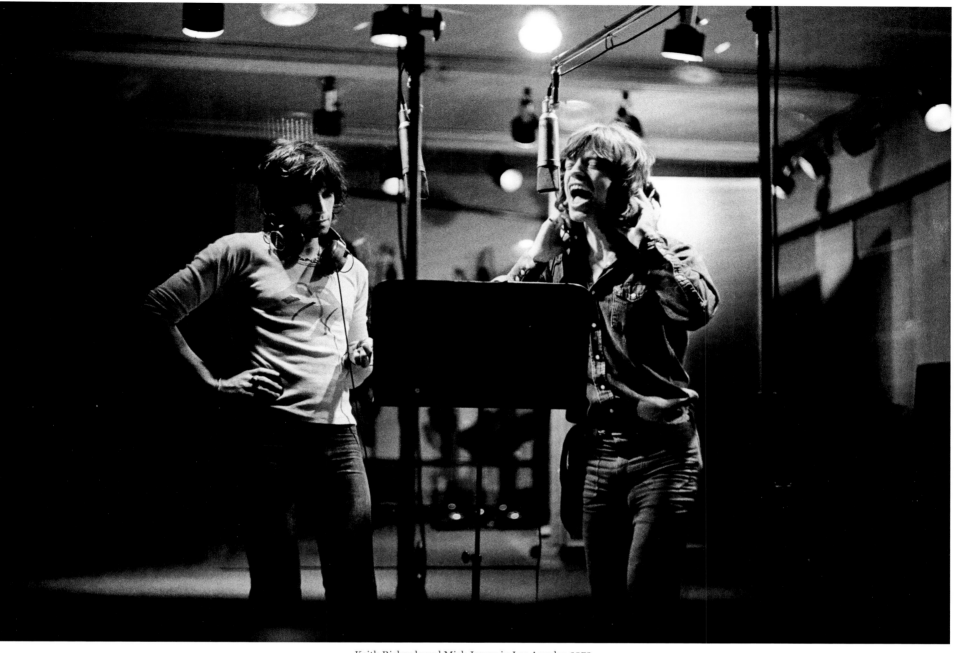

Keith Richards and Mick Jagger in Los Angeles, 1972.

Brown sugar being heroin?

Brown sugar being heroin and—

And pussy?

That makes it…the whole mess thrown in. God knows what I'm on about on that song. It's such a mishmash. All the nasty subjects in one go.

Were you surprised that it was such a success with all that stuff in it?

I didn't think about it at the time. I never would write that song now.

Why?

I would probably censor myself. I'd think, "Oh, God, I can't. I've got to stop. I can't just write raw like that."

* * *

When you're performing, what's that feeling? Can you describe that thrill of performing and dancing around and singing?

It's very high-adrenaline. If you've ever been in this high-adrenaline situation – like driving a car very fast or being in a championship basketball team in the finals or whatever it was – it's really high-adrenaline.

But it's quite hard to describe just in trying to offer a description. I've sometimes tried to write it down – what it's like, what you feel like. But there's so much going on, it's hard unless

you're really in a stream-of-consciousness thing. Because there are so many references: "Oh, I'm doing this, and I'm doing that," and you're sort of watching yourself doing it. "Oh, God, look at that girl; she's rather pretty. Don't concentrate on her!" But it's good to concentrate on her, she's good to contact one-on-one. Sometimes I try to do that. They're actually real people, not just a sea of people. You can see this girl has come, and she's got this dress on and so on, and so you make good contact with one or two people. And then you make contact with the rest of the band. You might give a look-see if everyone's all right.

You're always checking everything?

The first number, I'm totally checking everything.

Now, you said you wrote down this other thing about feeling transported?

I don't let myself get transported on the first number, because that is very dangerous. I used to let myself do that, but it's not such a good idea, because there's too much to check. I mean, is everything working?

You seem to be split in various parts. There's part of you which is saying to you, "OK, don't forget this, don't forget that." And there's this other part of you, which is just your body doing things that it isn't really commanded to do, which I found is the dangerous part. You can

hurt yourself if you don't watch out – because you've got so much adrenaline.…If you start off with a number like, say, "Start Me Up," which we did on the last tour, your body starts to do all kinds of things on this adrenaline thing. You've got to watch out. You can really hurt yourself – or just tire yourself out too quickly in the first five minutes, and you're just wiped out.

I was standing down at the bottom of the stage in San Antonio, watching you do "Brown Sugar," and there was a look on your face like ecstasy.

At some point in the show, you just lose it. You get such interaction with the audience that it feels really good. And it should be pushed. You should let yourself go. I mean, have those moments when you really are quite out of your brain. But there's always a point when a good performer knows when—

To pull back?

Yeah, when they're allowed to happen, if they're going to happen, and when they're not allowed to really happen, if they start to happen. And it's all to do with concentration, really.

Is it sustained, or does it come in isolated moments?

It comes in isolated moments. It's just a transcendent moment – I don't know whether you can say it's joyful. Sometimes it can be joyful; sometimes it's just crazy.

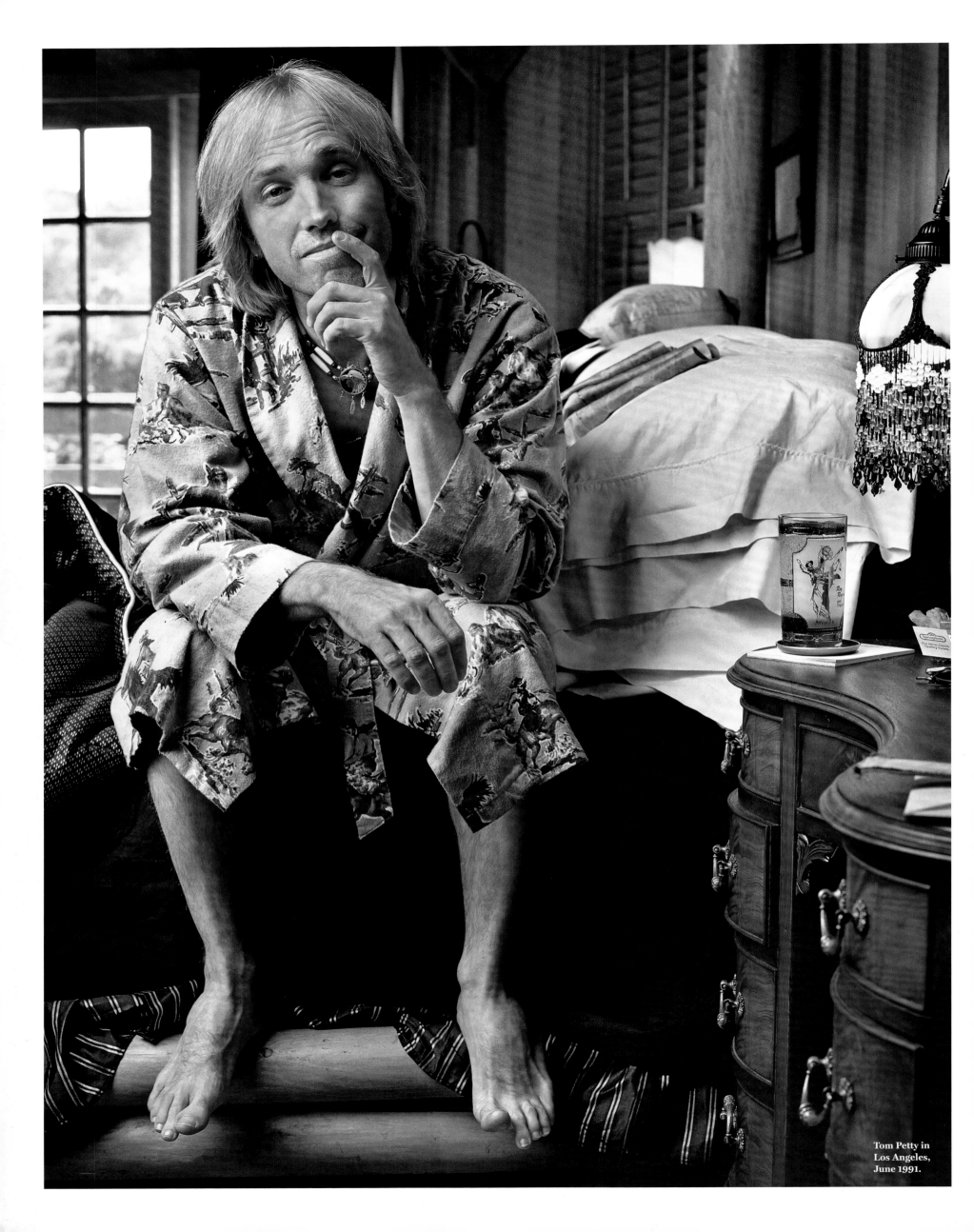

Tom Petty in
Los Angeles,
June 1991.

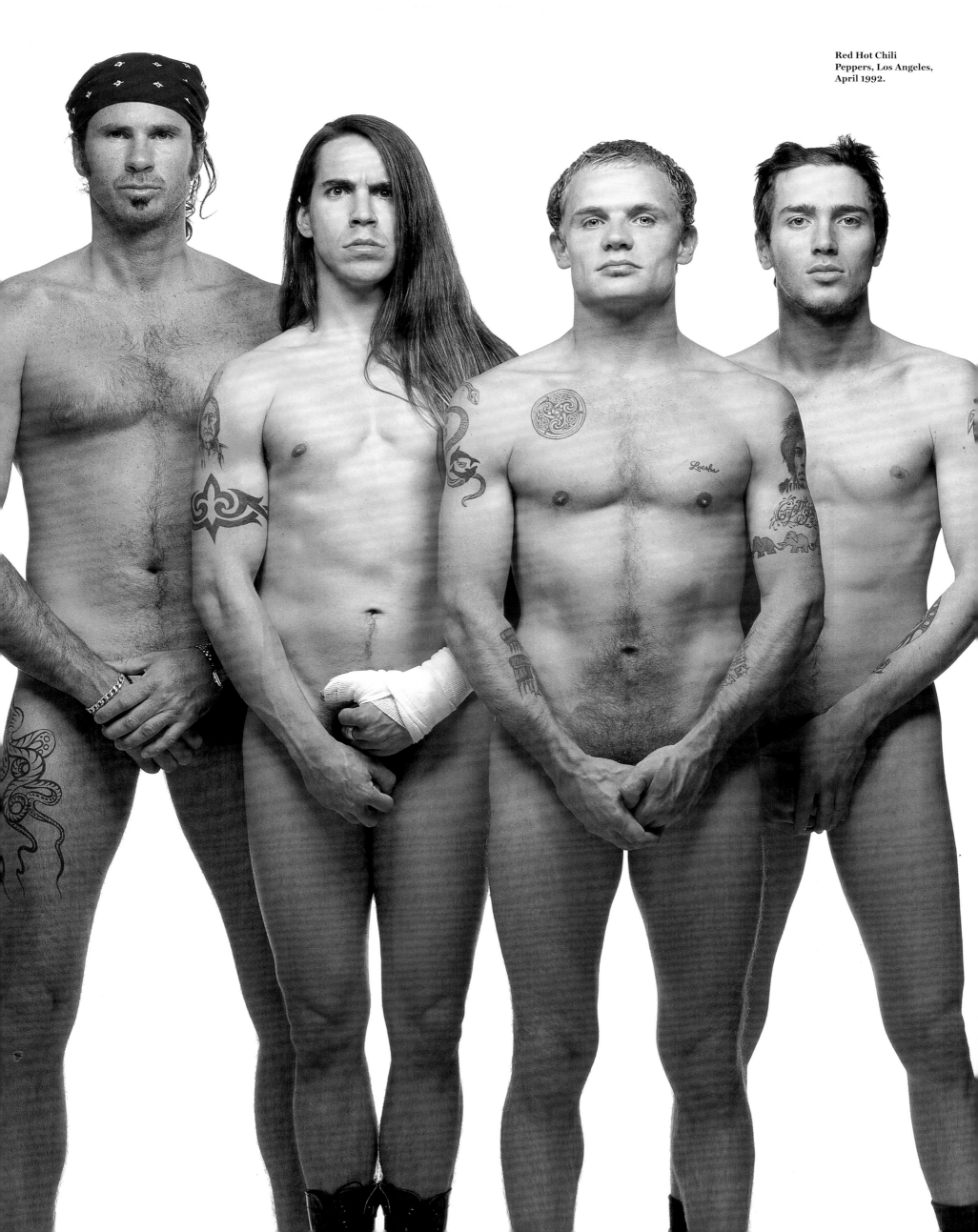

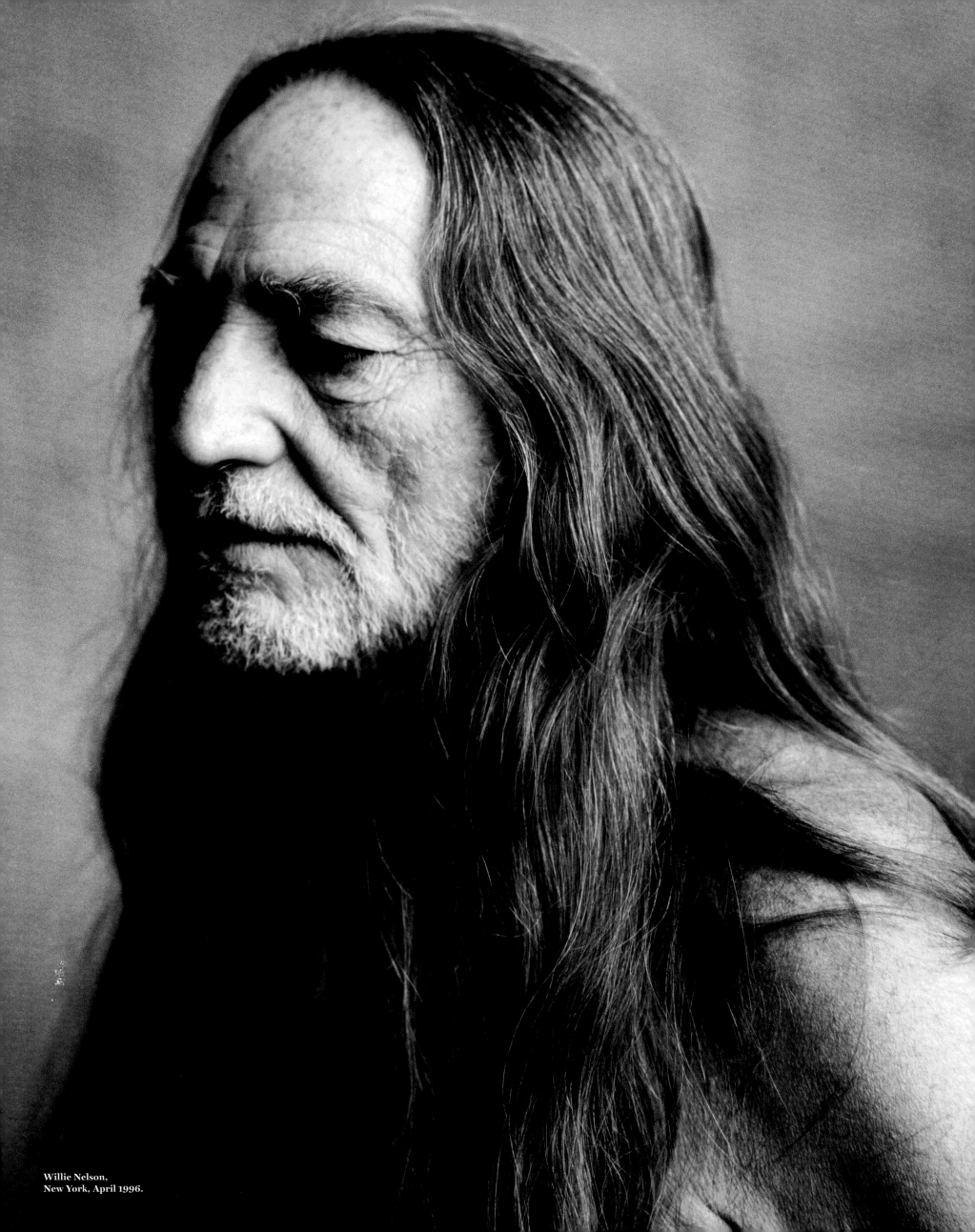

Willie Nelson,
New York, April 1996.

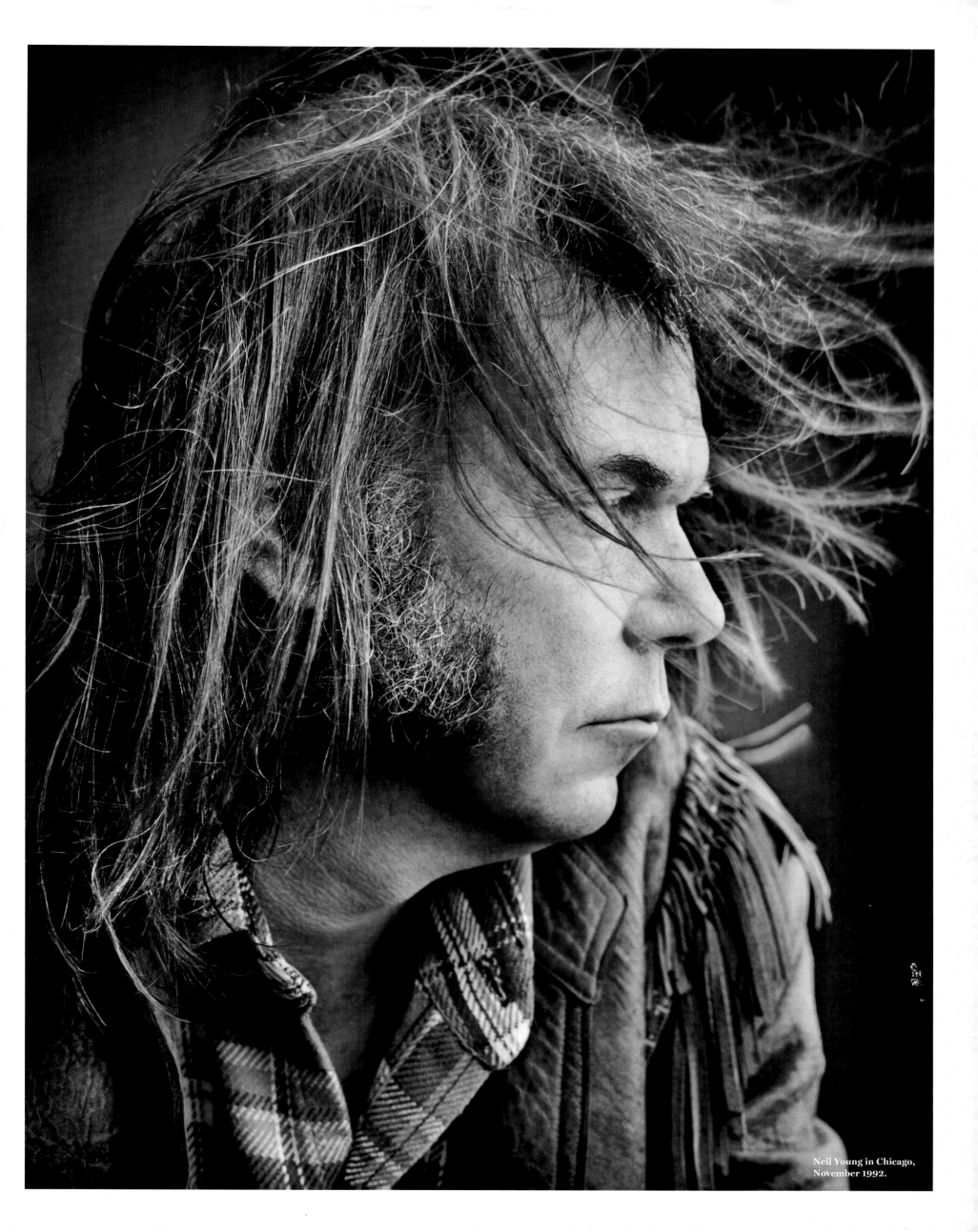

Neil Young in Chicago,
November 1992.

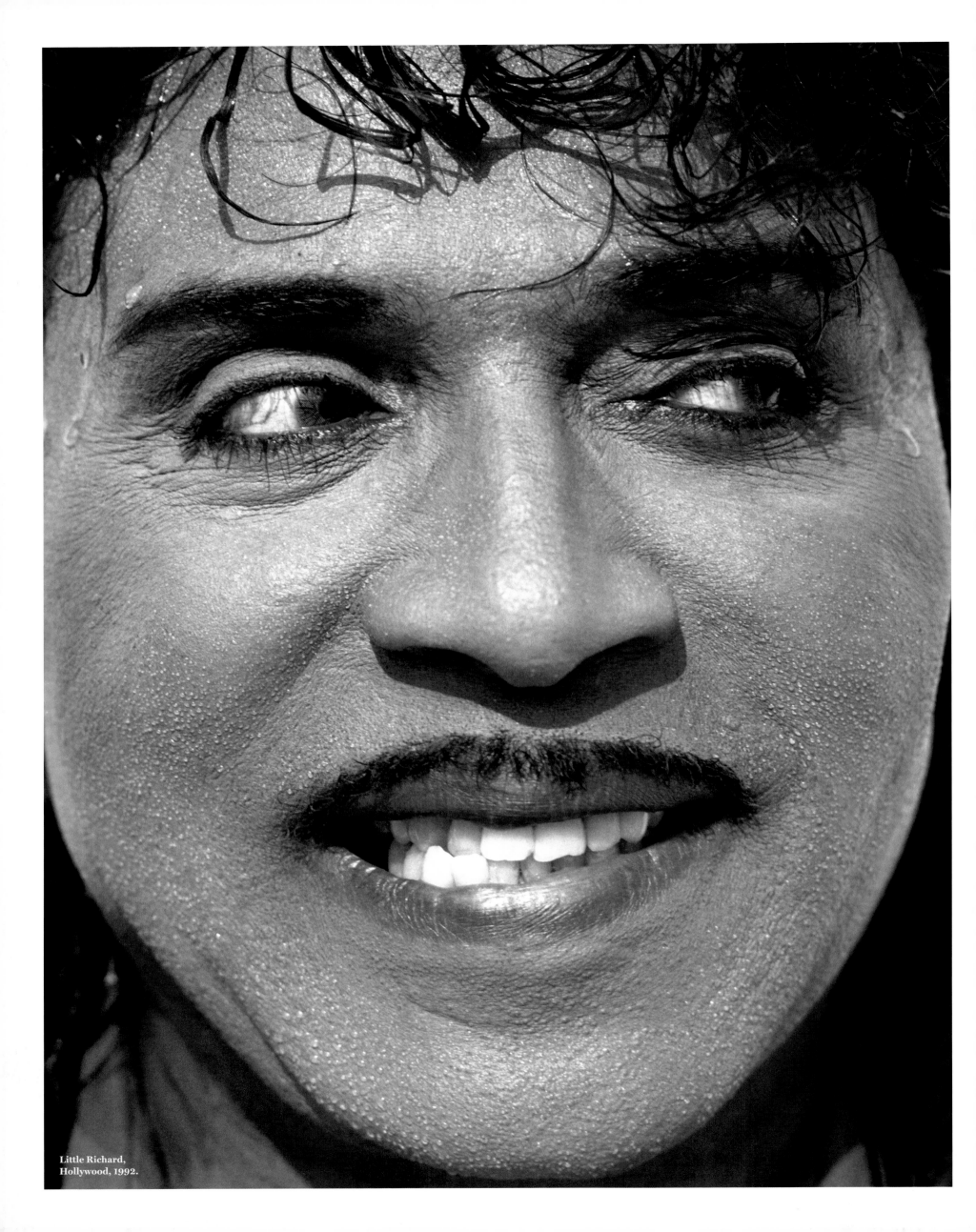

Little Richard,
Hollywood, 1992.

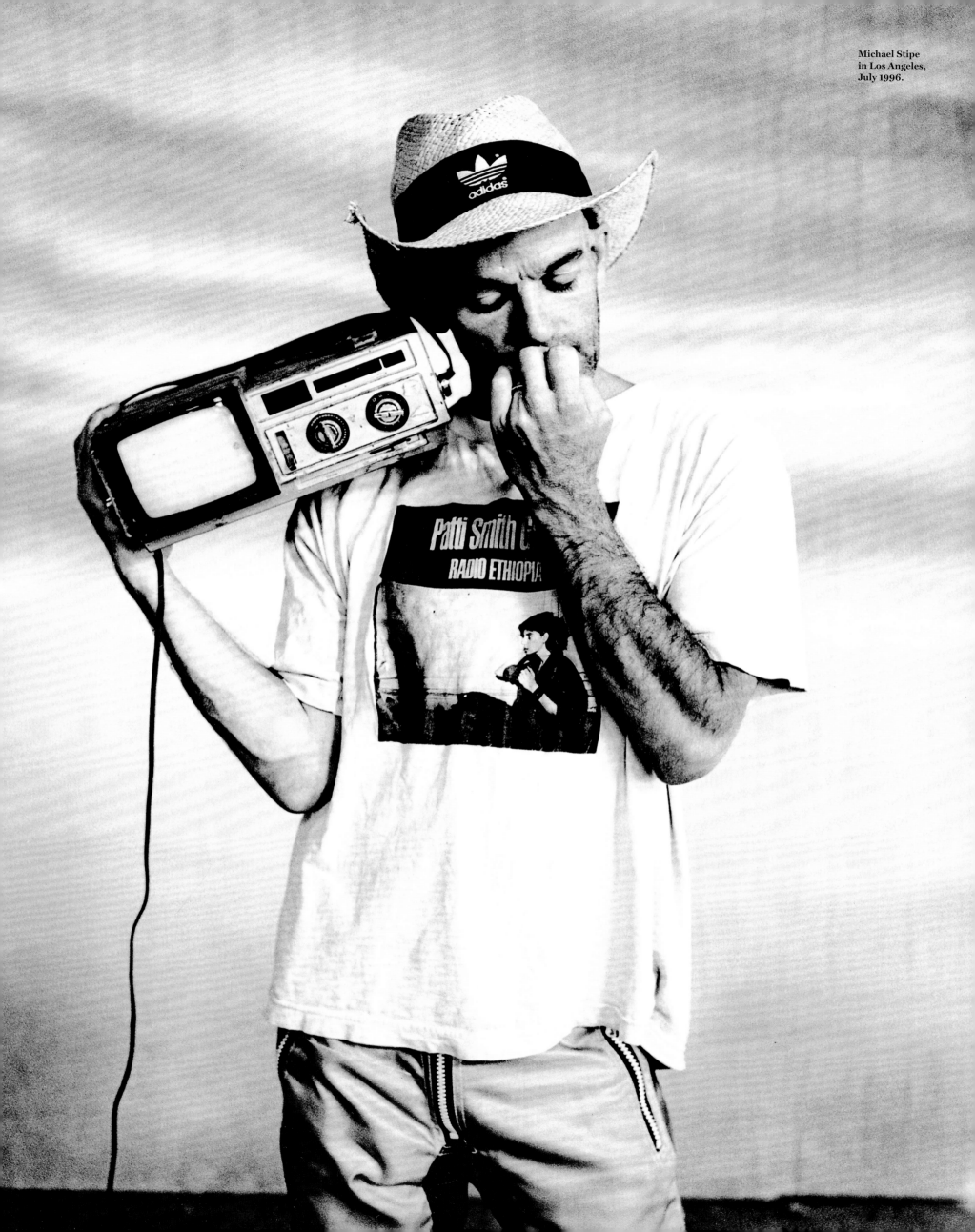

Something Stinks in Washington

Looking to explain the absurdity of government, P.J. O'Rourke turned to 'Manuregate'

RS 582/583 · JULY 12–26, 1990

THE FIRST PIECE P.J. O'ROURKE WROTE FOR *ROLLING STONE* was in 1975, a review of *Monty Python and the Holy Grail*. Stepping way out on a limb, he liked it. It may have been the first and last time he expressed an opinion in the pages of ROLLING STONE that everyone at the magazine agreed with.

O'Rourke knew a thing or two about funny. He began working at *National Lampoon* in 1973, eventually becoming editor-in-chief, and worked on both the *National Lampoon Lemmings* stage show (a launching pad for John Belushi and Chevy Chase) and *National Lampoon's 1964 High School Yearbook* – a pitch-perfect parody he co-authored with Doug Kenney, the driving force behind *Animal House* and *Caddyshack*.

But after Kenney's death in 1980, O'Rourke went looking for more serious stuff. "I felt like the grown-ups were eating at the dinner table, and me and the kids were standing outside in the flower garden peeking through the dining-room window and making funny faces," he says. "Maybe it was a good time for me to take my place at the table."

He turned his attention to world affairs, as a foreign correspondent. His reports on the chaos unfolding in trouble spots like Lebanon, El Salvador, Panama and the Philippines replaced satire with reality, though not so you'd notice. The hotels of Beirut had been destroyed during the first year of the Lebanese civil war, a decade earlier, he wrote in 1985. "The best hotel, the St. George, is a burned hulk. But its bar is still open, and people water-ski from the beach there in all but the worst of the fighting." O'Rourke asked someone if snipers weren't a worry. "Oh," he was told, "most of the snipers have automatic weapons. They aren't very accurate."

He traveled the globe for ROLLING STONE from 1985 to 2001, becoming the magazine's foreign-affairs chief, but he often tackled domestic politics as well, deploying a conservative-leaning libertarian wit that gleefully skewered both the left and the right. "Every politician experiences mindless brainstorms," he wrote in a scathing April 2001 takedown of George W. Bush's new White House Office of Faith-Based and Community Initiatives. "LBJ had the Great Society – now late great. Reagan was intent on Star Wars, a technology he'd discovered reading X-Men comic books. Clinton proposed health care reform – medical treatment delivered by the government with the same zealous efficiency with which the government delivers mail."

The folly of the federal government was a frequent subject, and O'Rourke found himself looking for a policy so inarguably huge and stupid that no one – regardless of political beliefs – could support it. He settled on farm policy. "I could've tackled welfare," he says. "But welfare was and remains a really fraught issue. Defense spending presents a paradox in that it's absolutely necessary, yet at the same time it's absolutely atrocious because they're spending $400 on a claw hammer." But the 1990 Farm Bill was "a simple problem with a simple solution," he wrote in a piece titled "Manuregate." "Drag the thing behind the barn and kill it with an ax."

O'Rourke calls the $50 billion bill "the perfect example of government excess" – by which he means the subsidies and protections it called for, though just reading the bill brought him face-to-face with excess. "Next to my desk when I was writing, I had all the information," he says. "The whole farm bill and all the background information. It was a stack of papers that reached a good two feet above my desktop from the floor."

American farm policy had piled absurdity on top of absurdity for decades, and O'Rourke went deep into the history of the boondoggle. The federal Wool and Mohair Program was established in 1954 to "encourage domestic wool production in the interest of national security." That unlocked $1.1 billion, spent from 1955 to 1980, for "wool and mohair price supports." How wool could help defend against Soviet aggression wasn't really clear, though. Farm policy was best known for subsidies: The government paid farmers to not farm their land, in order to control supply and prop up prices. But less well-known was that this had involved mass killings of cows. "During the mid-1980s, the dairy industry had its own plan to limit production, the Dairy (Production) Termination Program, or 'whole-herd buyout,'" he wrote. "Dairy farmers decided there was too much cheap milk at the supermarket. Hell, even homeless welfare babies were drinking moo juice. So the government bought and slaughtered 1.6 million cows. How come the government never does anything like this with lawyers?"

Willie Nelson, John Mellencamp and Neil Young had started Farm Aid in 1985 to help family farmers. But, O'Rourke pointed out, 60 percent of the support money in the 1990 Farm Bill went not to those family farmers but to the largest farms in America, amounting to corporate welfare. The way O'Rourke saw it, "while America was fighting commies all over the world, communism grew apace in our own back 40.... This being America, we haven't pursued Marxist goals with tanks, secret police and gulag camps; we've used money. And the result has been a uniquely American economic screw-up. Instead of terrible shortages, we've created gross overproduction. Instead of making people dirt poor, we've made them filthy rich."

More than two decades after his "Manuregate" piece, O'Rourke returns to these points when talking to businesspeople about why they shouldn't expect help, or common sense, from the government. "Three or four farm bills later, I'm using the same basic structure," he says. "I've had to change the numbers and the names of the programs, but it's still the same fucked-up thing."

A $50 billion farm bill was the perfect example of government run amok.

Sympathy for the Devil

Writing about Marilyn Manson, a ROLLING STONE reporter found himself in hot water

RS 752 • JANUARY 23, 1997

I n their quest to delve deep into the lives and minds of rock stars, ROLLING STONE reporters have found themselves in some surreal situations, but few were as unusual as the hot tub at a Holiday Inn in Florida where, in late 1996, writer Neil Strauss found himself toe-to-toe with Marilyn Manson. "Later, he said, in a very canny way, that going into a hot tub with the Antichrist would be a good thing for ROLLING STONE," Strauss recalls. "He knew it would make a good lead for the story." Joining up with Manson on tour during a weeklong stretch, Strauss encountered a musician happy to play the rock-idol role. "His entire room was like you'd want a rock-star hotel room to be, with skulls and CDs lying around," says Strauss. "The big question was: Is this a cynical shtick and total theater, or is this the person you're seeing?"

* * *

BE CAREFUL WHEN you gossip: A little rumor can go a long way. Especially when the subject is Marilyn Manson.

"For a solid year, there was a rumor that I was going to commit suicide on Halloween," says Manson. He is sitting in a hot tub (yes, a hot tub!) in Fort Lauderdale, Florida.

"I started to think, 'Maybe I have to kill myself, maybe that's what I was supposed to do.' Then, when we were performing on Halloween, there was a bomb threat. I guess someone thought they would take care of the situation for me. It was one of those moments where chaos had control." He pauses, raises his tattoo-covered arm from the water and stares nervously through a pair of black wraparound sunglasses at the spa door. It opens a crack, then closes. No one enters. "Sometimes I wonder if I'm a character being written, or if I'm writing myself," Manson continues. "It's confusing."

Never has there been a rock star quite as complex as Marilyn Manson, frontman of the band of the same name. In the current landscape of reluctant rock stars, Manson is a complete anomaly: He craves spectacle, success and attention. And when it comes to the traditional rock-star lifestyle, he can outdo most of his contemporaries. Manson and his similarly pseudonymed bandmates – bassist Twiggy Ramirez, drummer Ginger Fish, keyboardist Madonna Wayne Gacy and guitarist Zim Zum – have shat in Evan Dando's bathtub and, just last night, they coaxed Billy Corgan into snorting sea monkeys. When it comes to getting serious about his work, Manson is among the most eloquent and artful musicians. And among the most misunderstood. The rumor-hungry fans who see him as a living demon who's removed his own ribs and testicles know just as little about Manson as the detractors who dismiss him as a Halloween-costumed shock rocker riding on Trent Reznor's

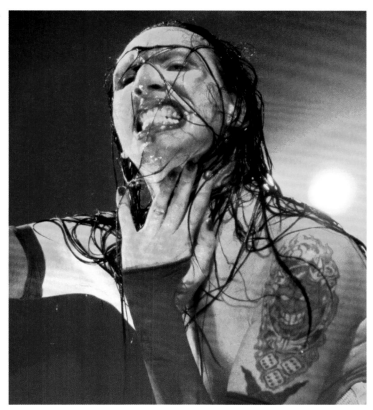

Marilyn Manson performs during his Dead to the World Tour, 1997.

coattails. The people who work with Manson on tour aren't any more privy to his personality. They have to follow the rules – no smoking, no talking about sports, no disturbing Manson in the three hours before a show – and clean up after his occasional temper tantrums that have left dressing rooms destroyed and a drummer hospitalized. In past articles on his band, Manson has deliberately toyed with the truth and with his interviewers.

"It's part of the shell that I've always built up around myself," Manson says. "And it's only because what is inside is so vulnerable that the shell has to be so hard. That is the only reason."

In the week we spend together, Manson is determined to come clean on everything, to lay all the pieces of his life on the table and see whether we can figure out how they fit together. He's doing a good job of revealing himself so far, because he's in a Jacuzzi at the local Holiday Inn. It was difficult for him to be here: He tried once and backed out because someone was already in the tub. He tried a second time and changed his mind because one of the garter-clad fans scouring the hotel for him had just walked by. Only when no one else was around did he finally strip down to his swim trunks and get into the tub. Though after about 10 minutes, he begins to feel sick. Maybe he doesn't really belong here.

"This is going to be an important piece of press," Manson says as we get started on the first of many conversations. "It's going to be a piece of history that I want people to look at when I'm gone, and maybe it'll help them understand what I was thinking at the time when I did this record. There's been so much press and so many people feeding this sensationalism – and that's all part of Marilyn Manson. But at the same time, I want people to know that I tried to explain it to them when they had a chance to listen."

It's not going to be an easy task, he insists: "I pity anybody who has to spend a day with me."

Manson uses a number of different metaphors to describe himself: a snake, an angel, an alien, the childcatcher from *Chitty Chitty Bang Bang*. One of the most vivid ones is a Hydra, the nine-headed serpent of Greek mythology. This image is at the heart of *Antichrist Superstar*, which explores a transformation and metamorphosis – of a worm to an angel to a world-destroying demon; of a boy named Brian Warner to the performer Marilyn Manson to the icon Antichrist Superstar.

"If you thought about it long enough," Manson says later, sitting at a Mexican restaurant, "you could pose the question: Did Antichrist Superstar create Marilyn Manson as a vehicle for its rise to power? I really feel like where I'm at now is where there's no line between what's on the album and what's in reality. They work together, and one just feeds off the other. The album talks about us being the biggest rock band in the world, and that is going to happen."

Kurt Cobain

By David Fricke
RS 674 • JANUARY 27, 1994

It was a recipe for disaster. David Fricke joined Nirvana in October 1993 on their first U.S. tour in two years to conduct the ROLLING STONE Interview with Kurt Cobain – and ended up seeing a lousy show. "They were at the Aragon Ballroom, in Chicago," says Fricke. "There were a lot of yahoos down on the floor moshing and not paying a whole lot of attention. You could tell there was some unhappiness onstage. When they walked off without playing 'Smells Like Teen Spirit,' I thought, 'This ain't happening tonight.'" Cobain had struggled with success, as well as heroin addiction, and become wary of the press. But backstage Fricke was greeted by a laughing Cobain, who said, "Welcome to the worst show on the tour." They met later that evening in Cobain's hotel room, and when Fricke set up his tape recorder, a publicist appeared with another recorder – Cobain taped his interviews as a precaution. But not this one. "That's OK," he said. "We don't need it." Perhaps the most painful moment of the interview, given Cobain's suicide six months later, came when Fricke asked about a song dropped from Nirvana's *In Utero*, "I Hate Myself and Want to Die." "He started laughing," says Fricke. "It's a chilling moment. On the one hand, he's saying it's a joke. At the same time, he wasn't joking, because he'd contemplated suicide. He was clearly dealing with issues of self-loathing. So when he says it's as literal as a joke can be, there are two operative words in there: 'joke' and 'literal.'"

Along with everything else that went wrong onstage tonight, you left without playing "Smells Like Teen Spirit." Why?

That would have been the icing on the cake. That would have made everything twice as worse. I don't even remember the guitar solo on "Teen Spirit." It would take me five minutes to sit in the catering room and learn the solo.

Where did the line "Here we are now, entertain us" come from?

That came from something I used to say every time I used to walk into a party, to break the ice. A lot of times, when you're standing around with people in a room, it's really boring and uncomfortable. So it was, "Well, here we are, entertain us. You invited us here."

How did it feel to watch something you'd written in fun become the grunge national anthem, not to mention a defining moment in youth marketing?

Actually, we did have our own thing for a while. For a few years in Seattle, it was the Summer of Love, and it was so great. To be able to just jump out on top of the crowd with my guitar and be held up and pushed to the back of the room, and then brought back with no harm done to me – it was a celebration of something that no one could put their finger on.

But once it got into the mainstream, it was over. I'm just tired of being embarrassed by it. I'm beyond that.

This is the first U.S. tour you've done since the fall of '91, just before "Nevermind" exploded. Why did you stay off the road for so long?

I needed time to collect my thoughts and readjust. It hit me so hard, and I was under the impression that I didn't really need to go on tour, because I was making a whole bunch of money. Millions of dollars. Eight million to 10 million records sold – that sounded like a lot of money to me. So I thought I would sit back and enjoy it.

I don't want to use this as an excuse, and it's come up so many times, but my stomach ailment has been one of the biggest barriers that stopped us from touring. I was dealing with it for a long time. But after a person experiences chronic pain for five years, by the time that fifth year ends, you're literally insane. I couldn't cope with anything. I was as schizophrenic as a wet cat that's been beaten.

How much of that physical pain do you think you channeled into your songwriting?

That's a scary question, because obviously if

> "For a few years in Seattle, it was the Summer of Love, and it was so great. Once it got into the mainstream, it was over."

a person is having some kind of turmoil in their lives, it's usually reflected in the music, and sometimes it's pretty beneficial. I think it probably helped. But I would give up everything to have good health. I wanted to do this interview after we'd been on tour for a while, and so far, this has been the most enjoyable tour I've ever had. Honestly.

It has nothing to do with the larger venues or people kissing our asses more. It's just that my stomach isn't bothering me anymore. I'm eating. I ate a huge pizza last night. It was so nice to be able to do that. And it just raises my spirits. But then again, I was always afraid that if I lost the stomach problem, I wouldn't be as creative. Who knows? [*Pauses*] I don't have any new songs right now.

Every album we've done so far, we've always had one to three songs left over from the sessions. And they usually have been pretty good, ones that we really liked, so we always had something to rely on – a hit or something that was above average. So this next record is going to be really interesting, because I have absolutely nothing left. I'm starting from scratch for the first time. I don't know what we're going to do.

One of the songs that you cut from "In Utero" at the last minute was "I Hate Myself and Want to Die." How literally did you mean it?

As literal as a joke can be. Nothing more than a joke. And that had a bit to do with why we decided to take it off. We knew people wouldn't get it; they'd take it too seriously. It was totally satirical, making fun of ourselves. I'm thought of as this pissy, complaining, freaked-out schizophrenic who wants to kill himself all the time. "He isn't satisfied with anything." And I thought it was a funny title. I wanted it to be the title of the album for a long time. But I knew the majority of the people wouldn't understand it.

Have you ever been that consumed with distress or pain or rage that you actually wanted to kill yourself?

For five years during the time I had my stomach problem, yeah. I wanted to kill myself every day. I came very close many times.... It was to the point where I was on tour, lying on the floor, vomiting air because I couldn't hold down water. And then I had to play a show in 20 minutes. I would sing and cough up blood.

This is no way to live a life. I love to play music, but something was not right. So I decided to medicate myself.

Even as satire, though, a song like that can hit a nerve. There are plenty of kids out there who, for whatever reasons, really do feel suicidal.

That pretty much defines our band. It's both those contradictions. It's satirical, and it's serious at the same time.

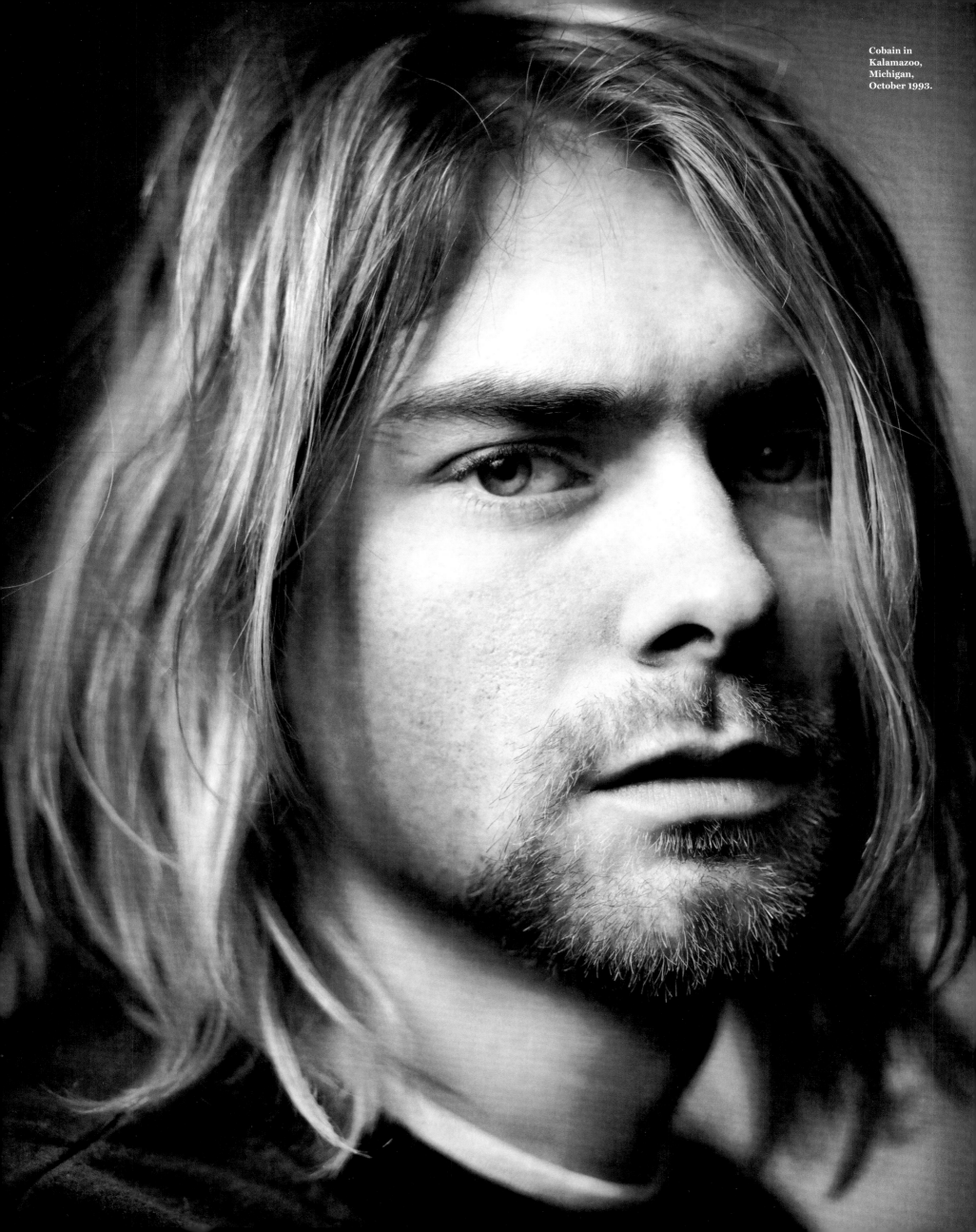

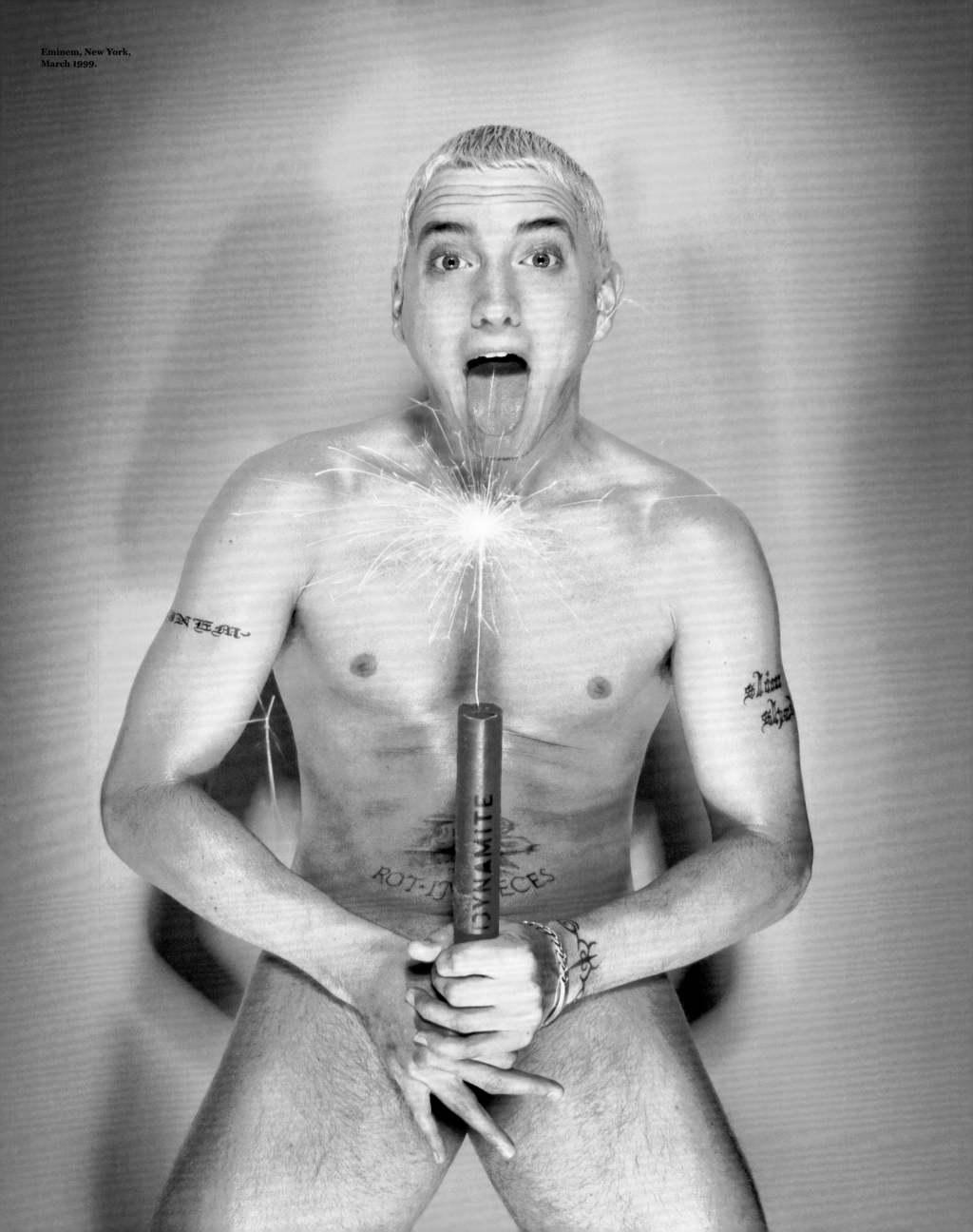

Eminem, New York,
March 1999.

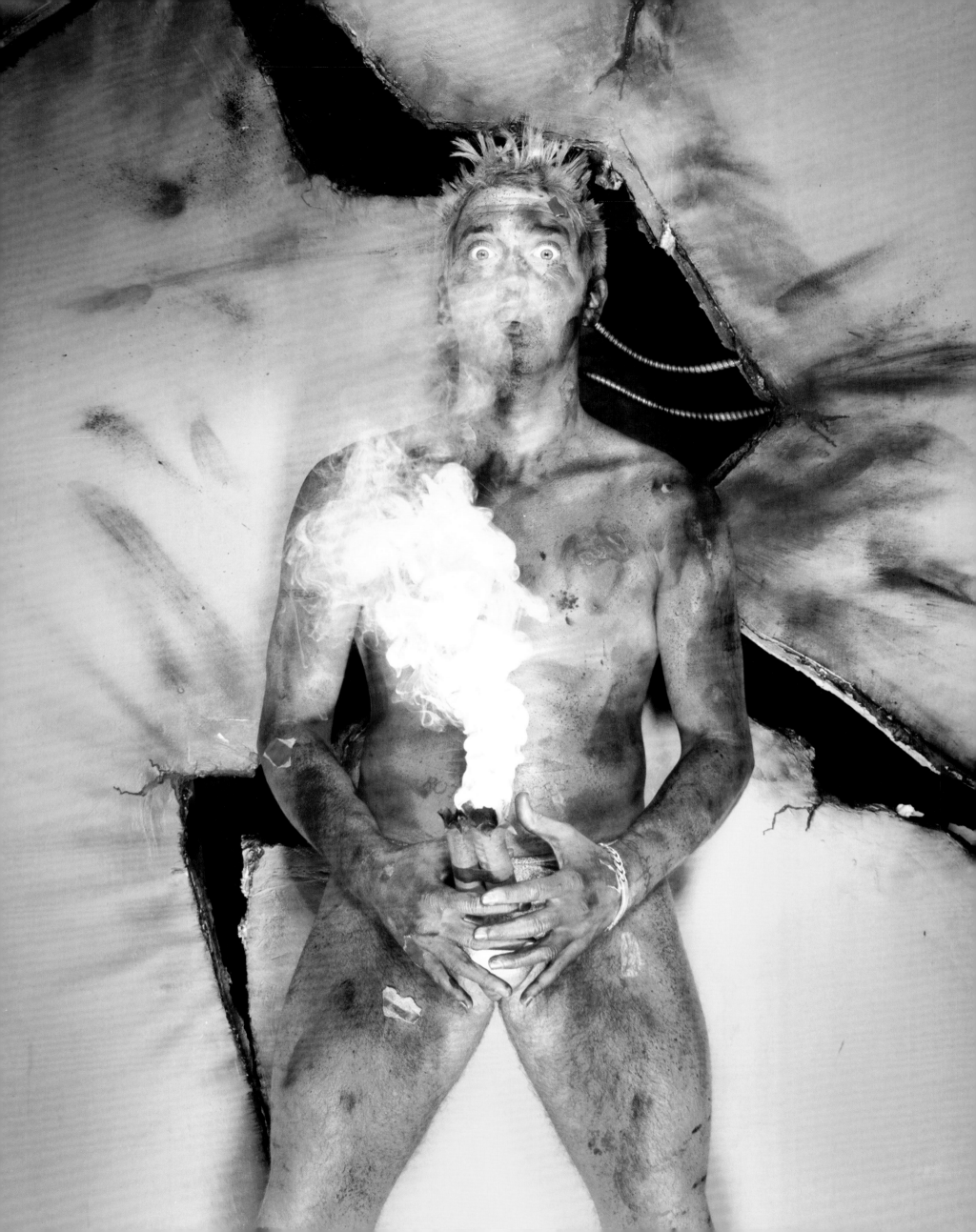

Janet Jackson,
Miami, 1993.

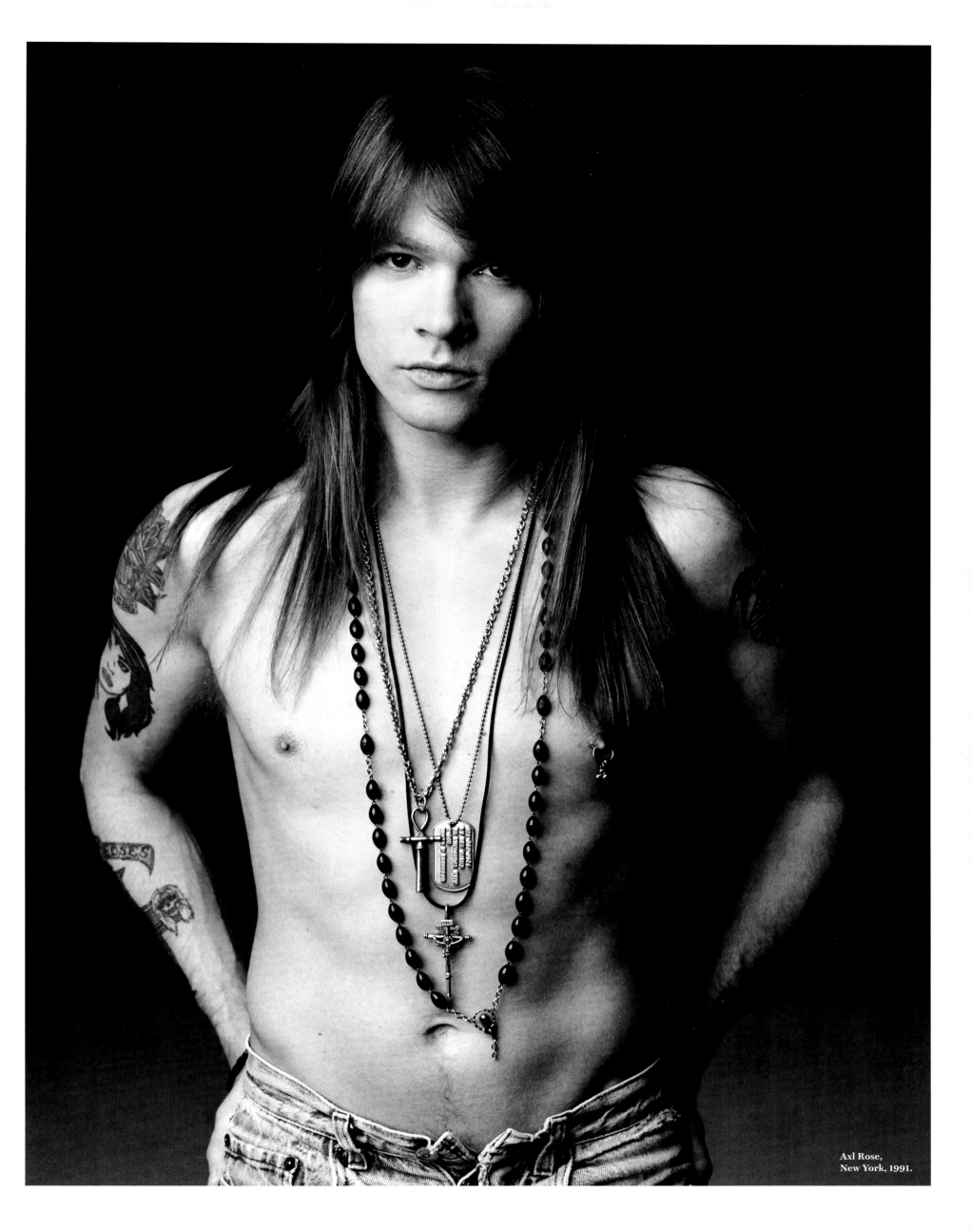

Axl Rose,
New York, 1991.

Billy Joel at home in
Long Island, 1992.

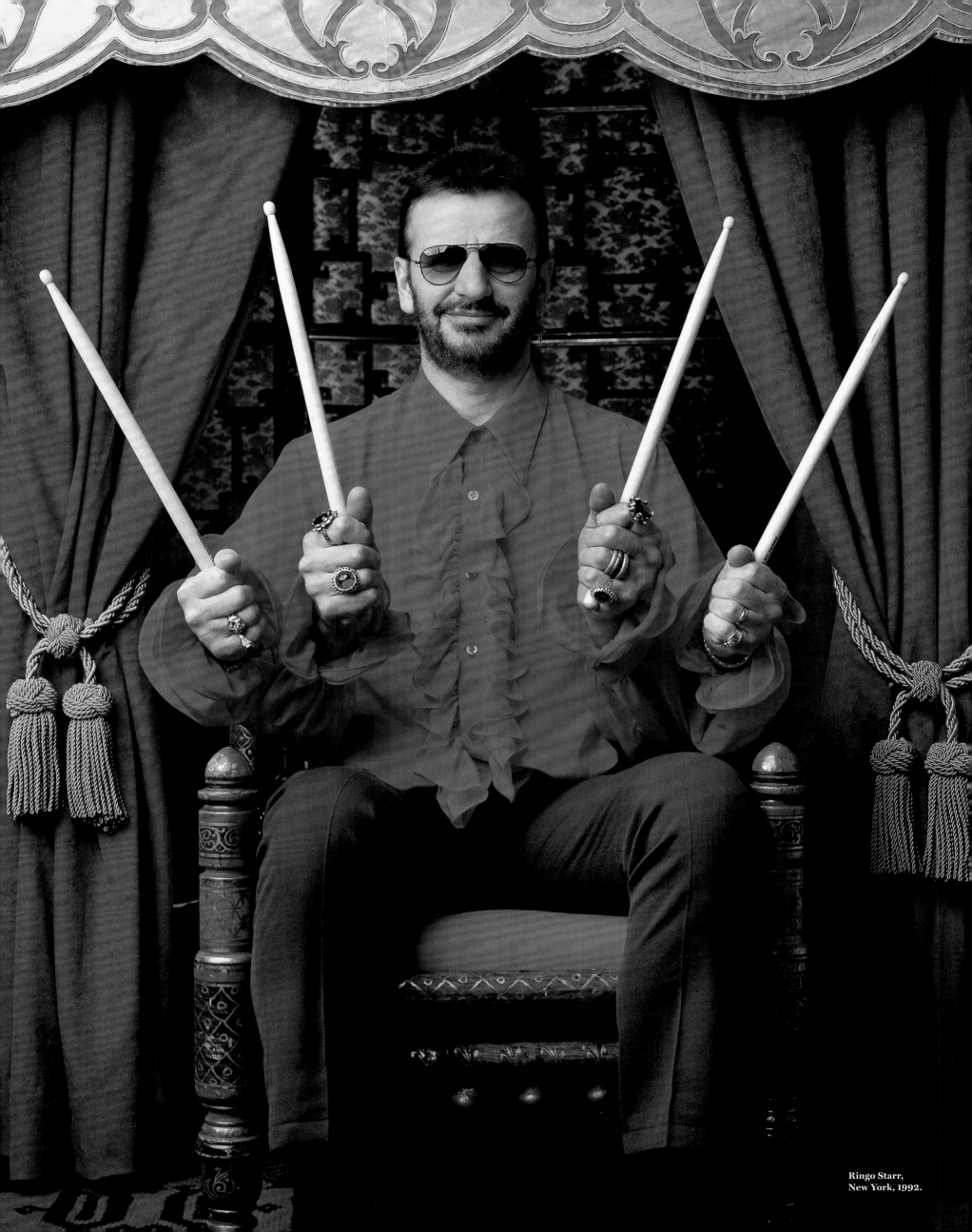

Ringo Starr,
New York, 1992.

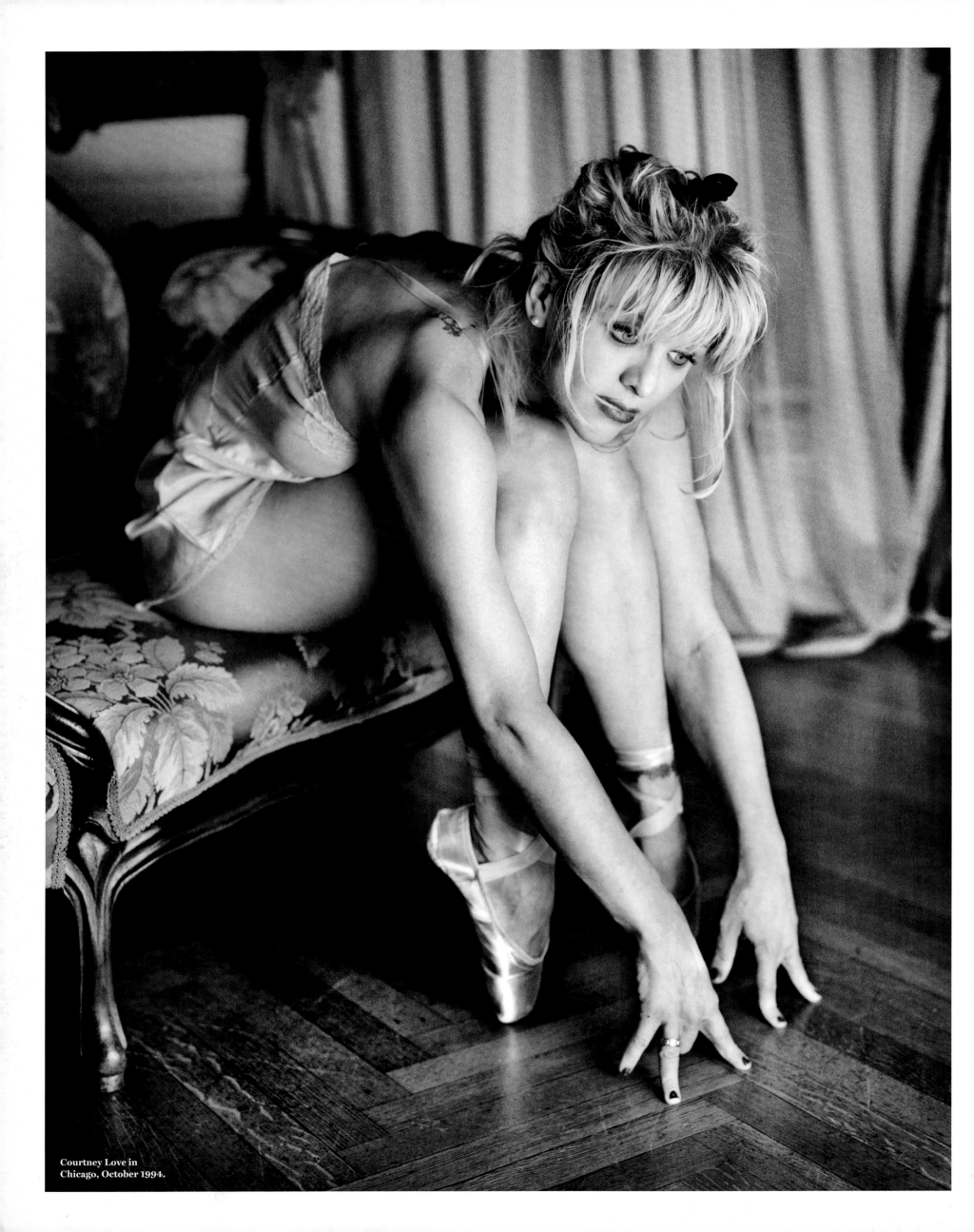

Courtney Love in
Chicago, October 1994.

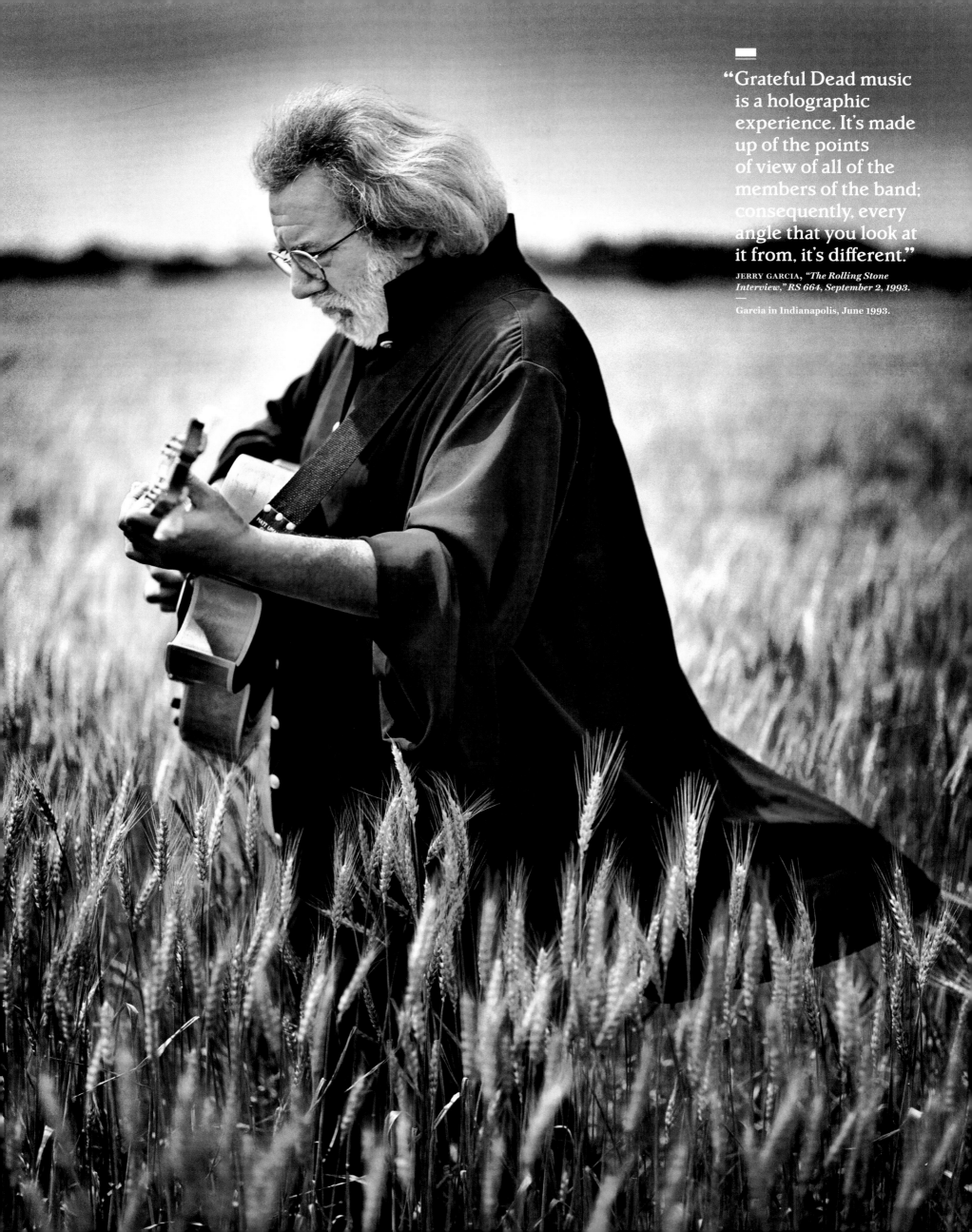

"Grateful Dead music is a holographic experience. It's made up of the points of view of all of the members of the band; consequently, every angle that you look at it from, it's different."

JERRY GARCIA, *"The Rolling Stone Interview,"* RS 664, September 2, 1993.

Garcia in Indianapolis, June 1993.

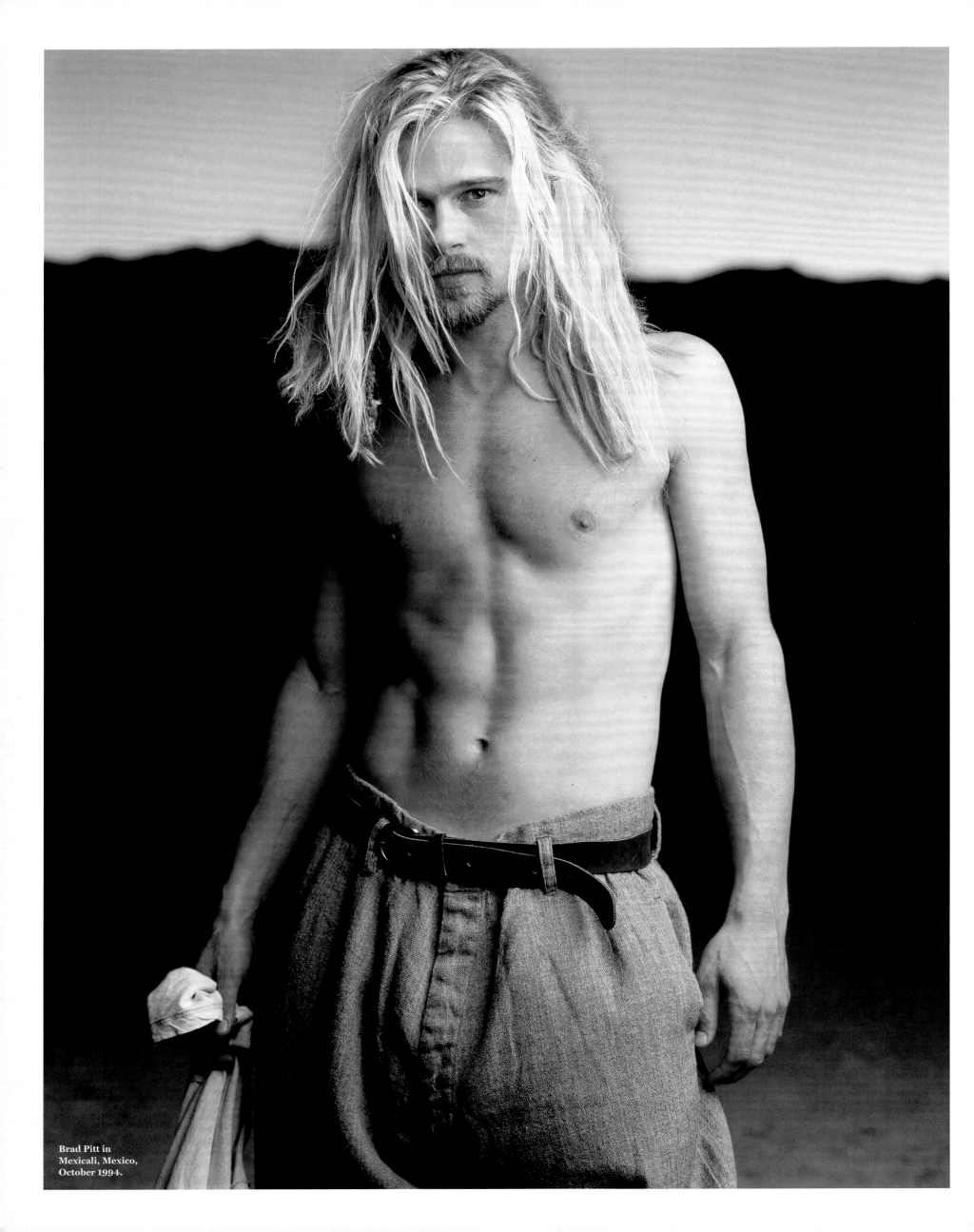

Brad Pitt in
Mexicali, Mexico,
October 1994.

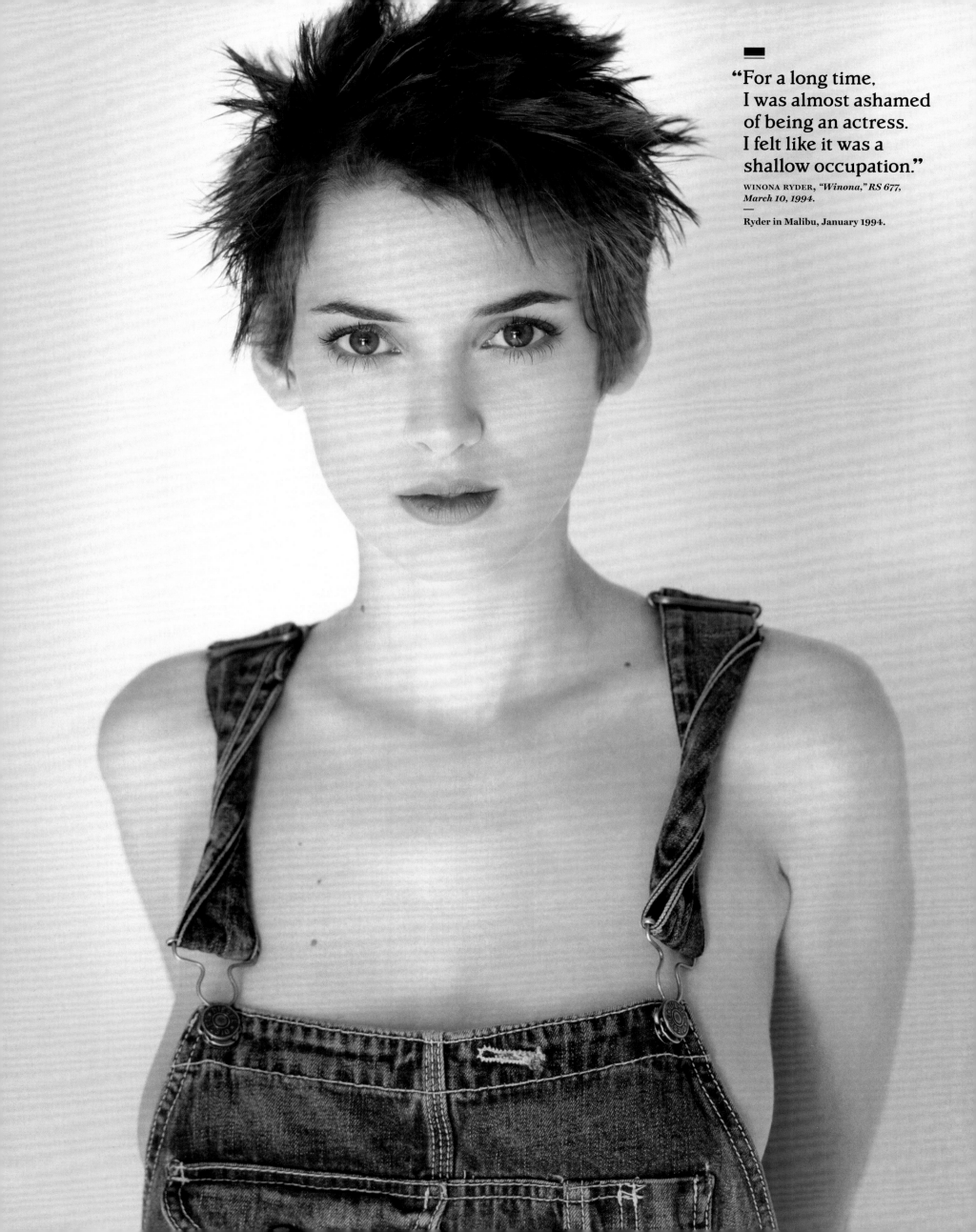

"For a long time,
I was almost ashamed
of being an actress.
I felt like it was a
shallow occupation."
WINONA RYDER, *"Winona," RS 677,
March 10, 1994.*
—
Ryder in Malibu, January 1994.

Flesh and Fantasy

Portfolio by Steven Meisel

RS 606 • JUNE 13, 1991

IT WAS PEAK MADONNA. THERE WAS NO BOUNDARY SHE WOULD not push, no part of her body or soul she would not reveal. The documentary *Truth or Dare* had recently hit theaters when ROLLING STONE published "Flesh and Fantasy," an eight-page Steven Meisel photo portfolio that accompanied a ROLLING STONE Interview conducted by Carrie Fisher. Meisel and Madonna were inspired by the photographer Brassaï, who'd documented the demimonde of Paris in the Twenties and Thirties. The photos Brassaï shot of street life made him famous, but the pictures he took in cabarets, brothels, and gay and lesbian clubs were not made public until 1976, when they were collected as *The Secret Paris of the 30's.*

For Madonna and Meisel, though, there were no secrets. Meisel had begun his career as a fashion illustrator, but became famous for his iconic images of supermodels like Linda Evangelista and Naomi Campbell. Madonna once called him "the first person to introduce me to the idea of reinvention." In "Flesh and Fantasy," they worked inversions on gender and exhibitionism. They re-created one of Brassaï's most famous pictures, of a man and a woman embracing in a Paris cafe, with a same-sex couple. In another shot, Madonna lounges in front of a mirror reflecting a naked man, returning his gaze and turning the voyeur's eye back on itself; who is in control and who is submitting is impossible to say. The uninhibited bravery of these pictures foreshadowed the book of Meisel photographs that Madonna released a year later, *Sex*, which deployed glamour and nudity the way punk bands used guitars: as weapons to make the world listen.

The ROLLING STONE Interview published alongside "Flesh and Fantasy" went so deep that it ran across two issues. Fisher and Madonna were seeing the same shrink, and their talk was as playful and explicit as the pictures, a cross between a therapy session and gossip between friends. (At one point, Madonna told Fisher that growing up she'd wanted to be a nun. "Sister Mary Blow Job," Fisher joked. "Sister Mary Fellatio," Madonna corrected.) Madonna talked openly about her divorce two years earlier from Sean Penn. "My heart was really broken," she said. "You can be a bitch until your heart's broken, and when your heart's broken, you're a superbitch about everything except that. You guard that closely."

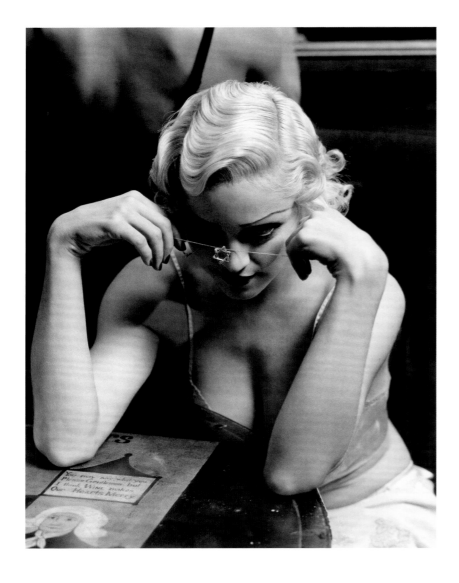

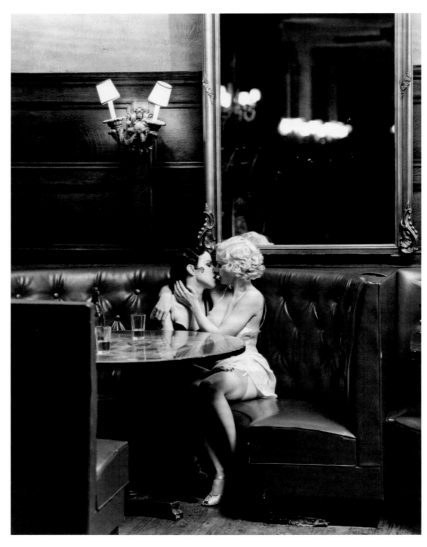

Fast Food Nation

Burgers and fries transformed America, but this piece changed how America saw meat and potatoes

RS 794 & 800 • SEPTEMBER 3 & NOVEMBER 26, 1998

'MY HOST HANDS ME WELLINGTONS, THE KIND OF KNEE-high rubber boots that English gentlemen wear in the countryside," Eric Schlosser wrote of a clandestine visit he made to a slaughterhouse for his two-part story on fast food. He was also given a chain-mail apron and gloves – workers at this plant in the High Plains, one of the nation's largest, wore some eight pounds of metal to protect themselves as they butchered about 5,000 head of cattle a day. "Tuck your pants into the boots," Schlosser was told. "We'll be walking through some blood."

Outsiders – to say nothing of reporters – were not welcome at the plant, and Schlosser had to be sneaked in by someone who was upset by the working conditions there. (It was dangerous work, there was little or no training, and injuries of all sorts were common.) Once he was inside, what Schlosser found there was surreal. He progressed through a series of rooms – the first orderly, where the meat looked like what you would see "in the back of your local supermarket" – to the kill floor. "What I see no longer unfolds in a logical manner," he wrote. It was hot and humid and stunk of manure, with cattle carcasses swinging by rapidly. "My host stops and asks how I feel, whether I want to go any farther. This is where some people get sick." But Schlosser stayed, and unblinkingly described what made people sick: racks of cow tongues, a man stripping carcasses of kidneys, another slitting the neck of a steer every 10 seconds or so. "A man turns and smiles at me. He wears safety goggles and a hard hat. His face is splattered with gray matter and blood. He is the knocker, the man who welcomes cattle to the building." His job was to shoot the cattle in the head with compressed air through a bolt stunner, knocking them unconscious. "For eight and a half hours, he just shoots."

When ROLLING STONE first approached Schlosser about an in-depth look at the business of fast food, he was reluctant. "I didn't want to write a piece that was condescending and elitist toward fast food," he says. "I ate at McDonald's all the time and really like hamburgers and french fries." But the magazine assured him his hamburger-loving perspective was welcome, and once he'd jumped in, he quickly realized that fast food was an all-encompassing subject. It had transformed the diet and economics of America and then the rest of the world.

Part one of his piece focused on how fast food had taken over the restaurant industry – at the time, the largest private employer in the United States. He focused on a single city – Colorado Springs, Colorado, which McDonald's used as a test site to try out new technology. "I had spent time there from

the age of seven," Schlosser says. "So I had a time-lapse-photography view of the place and how the sprawl had changed it. You're right next to the ranch land that provides the hamburgers. They had slaughterhouses and feed lots, and it's not a far drive to potato fields. You've got the meal pretty much right there, and the people who work in the restaurants and factories all live within driving distance."

Dave Feamster – a former Chicago Blackhawks defenseman – showed him around the five Little Caesar's franchises he owned, and Schlosser also rode along with one of the deliverymen. Telling their stories made the sprawling fast-food business human, even as that business turned people into machines. "He really cared about his employees," Schlosser says of Feamster. "I tried not to demonize individuals and to really see the bigger problems in the system."

Part two of the story looked at how fast food had industrialized American agriculture. Schlosser met with 89-year-old J.R. Simplot, an eighth-grade dropout who'd become one of the richest men in America by selling potatoes to McDonald's and other chains. He also explained how the volume business that made Simplot rich crushed others: "Out of every $1.50 spent on a larger order of fries at a fast-food restaurant, perhaps two cents goes to the farmer who grew the potatoes." And then Schlosser moved on to the more messy business of the meat.

Meatpacking was the story of the American economy written in blood: corporate consolidation, mechanization, busted unions, falling wages, undocumented-immigrant employees, brutal working conditions. "You cannot imagine a more gruesome job," Schlosser says, comparing it with *The Jungle*, the 1906 novel by Upton Sinclair, who worked undercover at the Chicago stockyards to gather information on the meatpacking industry. "Upton Sinclair saw the slaughterhouse as a metaphor for the cruelties of the American capitalism of his age, and in some ways that's still true."

Schlosser had more than enough material for a book, but many publishers told him that the only food books that sold contained recipes. When Houghton Mifflin released *Fast Food Nation* in 2001, the initial printing was small, but the book was a bestseller. "They sold out within a few weeks," Schlosser says. "I was on a book tour talking about a book you couldn't buy."

Schlosser wrote about abuses in the industry, but he believed in solutions as well, and he's proud to have been part of a change in how America looks at food. "The rise of Whole Foods, Trader Joe's, farmers' markets, changing school meals, and organics," he says. "*Fast Food Nation* was part of the beginning of this modern food movement."

In fabricating rooms (like this one in L.A.), workers try to keep up cutting beef on a conveyor belt, breaking into a sweat even though it's freezing cold.

The Government's Addiction

Congress was hooked on mandatory-minimum laws that made no sense and destroyed lives

RS 784 • APRIL 16, 1998

STEPHANIE GEORGE WAS 27 YEARS OLD, WORKING AS A HAIR-dresser and living in Pensacola, Florida, with her three kids. The father of her middle child was a crack dealer, and when she was caught in 1996 with his product and cash in a safe in her attic, she got a life sentence. Her previous arrests had been for minor offenses, but this was her third strike. "I wish I had another alternative," said Judge Roger Vinson. Mandatory minimums meant that he didn't.

"Putting Stephanie George away for good is a bipartisan achievement," wrote William Greider in the bluntly titled "Mandatory Minimums: A National Disgrace." Anti-drug hysteria had led Congress to pass stiff laws in 1984 and 1986, which had been reaffirmed or strengthened in election cycle after election cycle, producing "some harsh and bizarre results. The new laws are embraced by both Democrats and Republicans, blessed by Reagan, Bush and Bill Clinton."

In 1990, a ROLLING STONE editorial by Jann S. Wenner argued that without legalization, the War on Drugs would become our next Vietnam. By 1997, it was sadly clear that this was all too true, and the War on Drugs had created a staggering number of POWs. Low-level drug offenders were receiving harsher sentences than violent criminals, with first-timers drawing stiff prison terms. The federal prison population had ballooned from 24,000 in 1980 to 112,000 in 1997.

The mainstream press had taken little notice of the injustices caused by mandatory minimums, but ROLLING STONE responded with a 10-page investigation by Greider, its national-affairs columnist. "I was always trying to go in the other direction from where the media conventional wisdom was," Greider says. "ROLLING STONE always had an outlaw sense of itself."

Greider had cut his teeth as a *Washington Post* reporter in the Sixties and Seventies, but after Ronald Reagan took the White House in 1980, Greider found himself less satisfied churning out straightforward news stories about an America he felt was in a state of decline. He craved advocacy journalism, and in 1982 ROLLING STONE was looking for a new national-affairs columnist. "The great Hunter Thompson was a friend from my reporting days," Greider says. "The way he told the story was, 'I was taking a leak one night and I thought of Greider.'" Thompson called up Wenner and made his recommendation: "Get Greider," he said. "He knows these people. He'll tear their heads off."

Greider became ROLLING STONE's national editor, writing more than 200 pieces over the next 17 years. His column laid out the

issues in a brisk two to three pages – NAFTA, nuclear weapons, global sweatshops, gun control – but to tackle the madness of mandatory minimums, he dived in deeper. He spent months talking to prosecutors, judges, district attorneys and those whose lives had been destroyed by the laws.

Mandatory minimums were gender- and racially biased. Women like Stephanie George were often implicated because of their boyfriends, who had enough drug connections to barter their way to shorter sentences. The racial disparities were even more stark. "Most crack users are black; powder cocaine is the preferred drug among affluent whites," Greider wrote. Sentences for crack were 100 times greater than for cocaine, and five grams of crack carried the same penalty as that for 500 grams of powder. "Because crack is dealt with so much more severely than other drugs, the longest sentences are assigned overwhelmingly to African-Americans," he wrote.

Mandatory minimums had been a way for Congress to show itself as tough on crime while crack began to ravage American cities in the mid-Eighties. Incumbent politicians had become addicted to these "get tough" laws. "Like with any other addiction, what followed was a craving to do it again," Greider wrote. "And so they did, enacting in subsequent years many similar anti-crime measures.... Each new law produced a temporary high, the feeling that something real was being accomplished."

The mania may have begun during the Reagan administration, but it crested in the 1990s under Bill Clinton. In 1994, Clinton signed the Violent Crime Control and Law Enforcement Bill, which granted $9.7 billion in funding for new prisons and pledged to put 100,000 new police officers on the streets. In January 2001, during his final days in office, Clinton pardoned many nonviolent drug offenders swept up in the sort of mandatory-minimum sentences he'd supported (and has expressed regret for since). In 2013, Barack Obama pardoned Stephanie George after 17 years in prison.

ROLLING STONE's coverage of the War on Drugs, and the growing state-by-state legalization of marijuana, continued in national-affairs columns and more extensive features. In 2001, the magazine published a forum in which police chiefs, Republican and Democratic lawmakers, musicians from the Grateful Dead's Bob Weir to rapper Nelly, and even Bill O'Reilly weighed in on the need to rehabilitate America's drug policy.

In 2007, a comprehensive investigation by Ben Wallace-Wells, "How America Lost the War on Drugs," laid out the history of a failure that had then dragged on for 35 years and cost more than $500 billion. The point Greider had made a decade earlier still held: The War on Drugs was an addiction the government couldn't shake.

Federal prison populations jumped from 24,000 in 1980 to 112,000 in 1997 due to mandatory-minimum laws that were biased against minorities and women.

Sean Penn,
Los Angeles,
December 1995.

"There's been nothing ever throughout my 27 years that's comparable to the feeling I have with Winona.... This 'Winona Forever' tattoo is not something I took lightly."

JOHNNY DEPP, *"Sweet Sensation," RS 595, January 10, 1991.*
—
Depp at the Chateau Marmont hotel, Los Angeles, October 1990.

James Hetfield in
St. Petersburg, Florida,
February 1993.

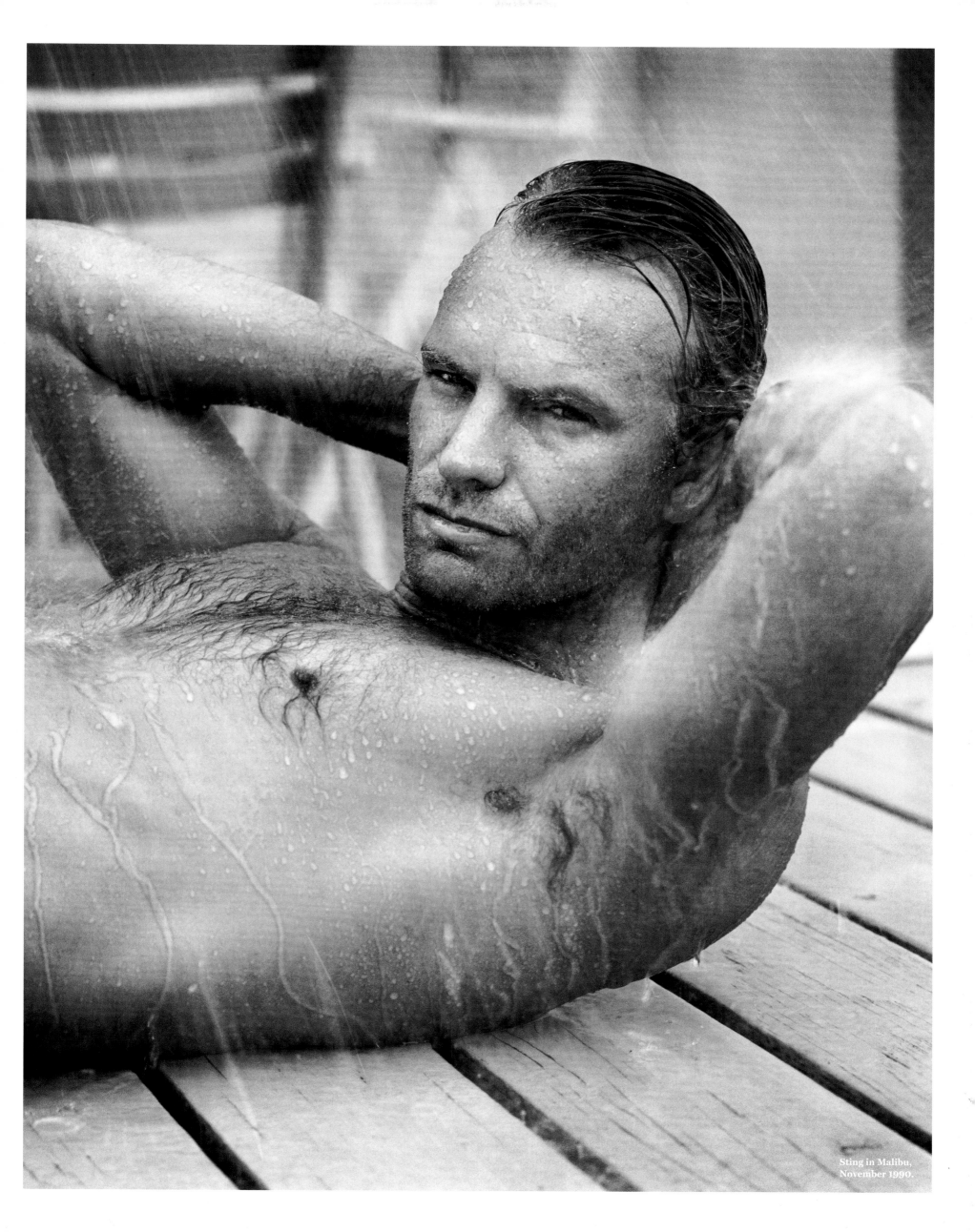

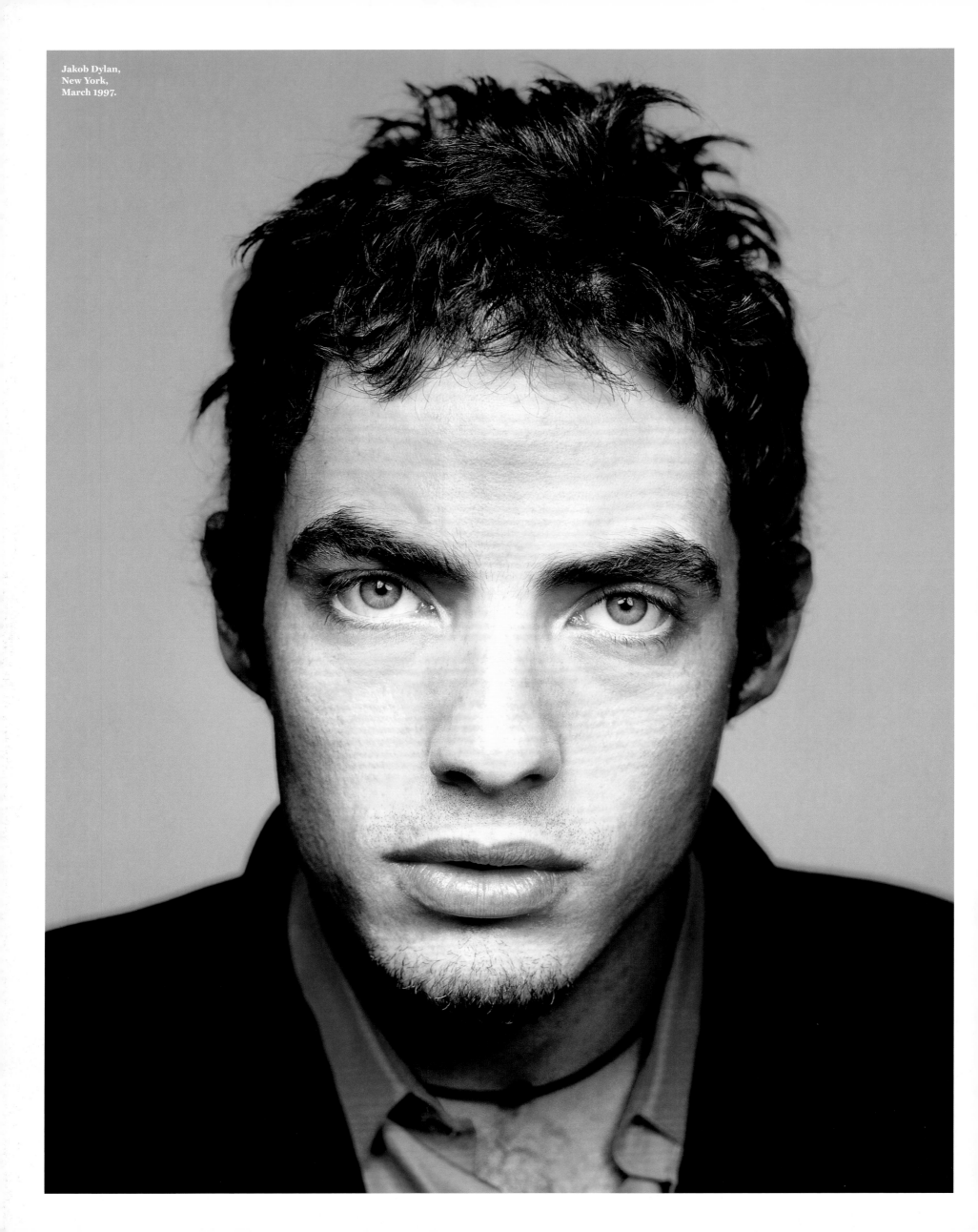

Jakob Dylan,
New York,
March 1997.

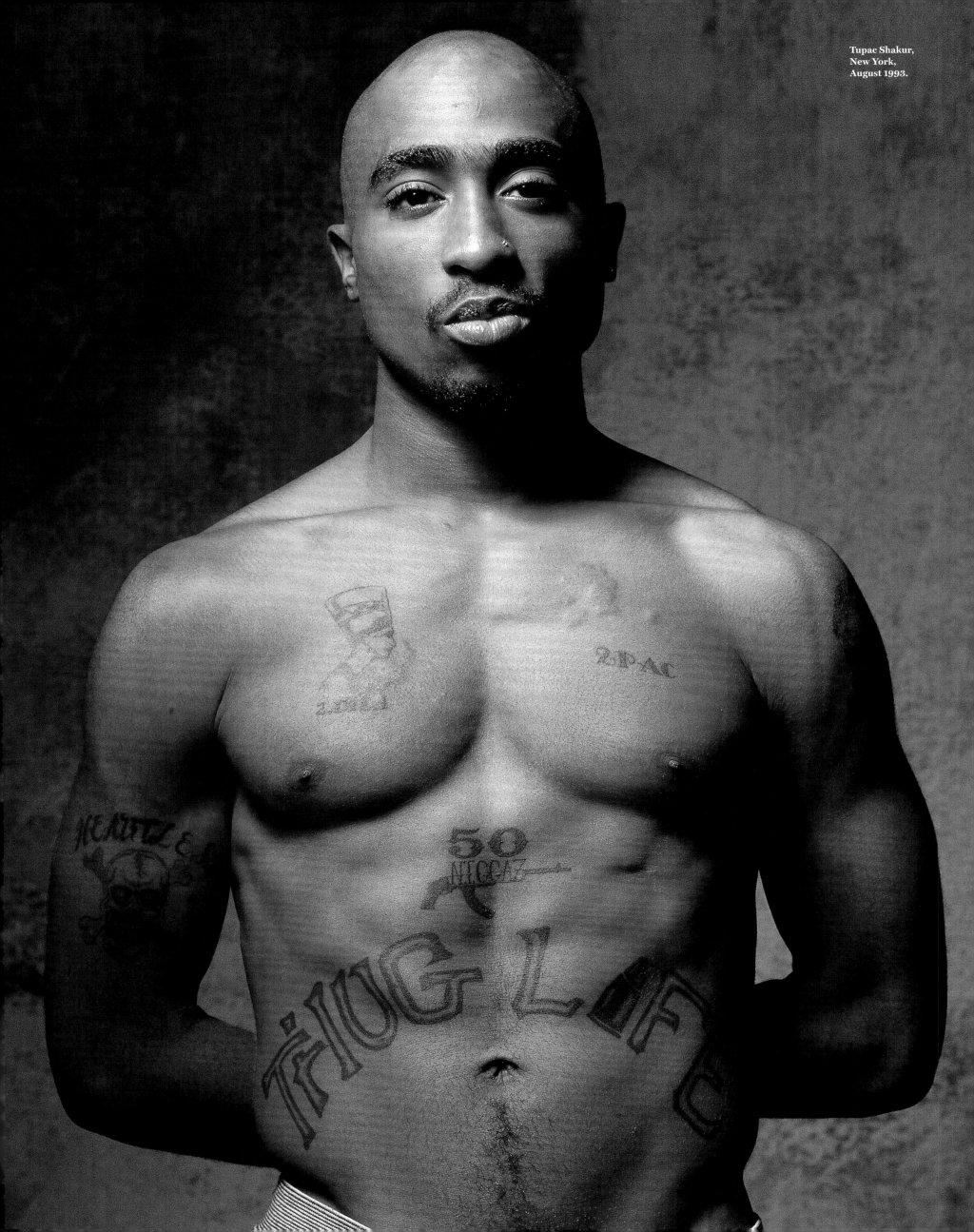

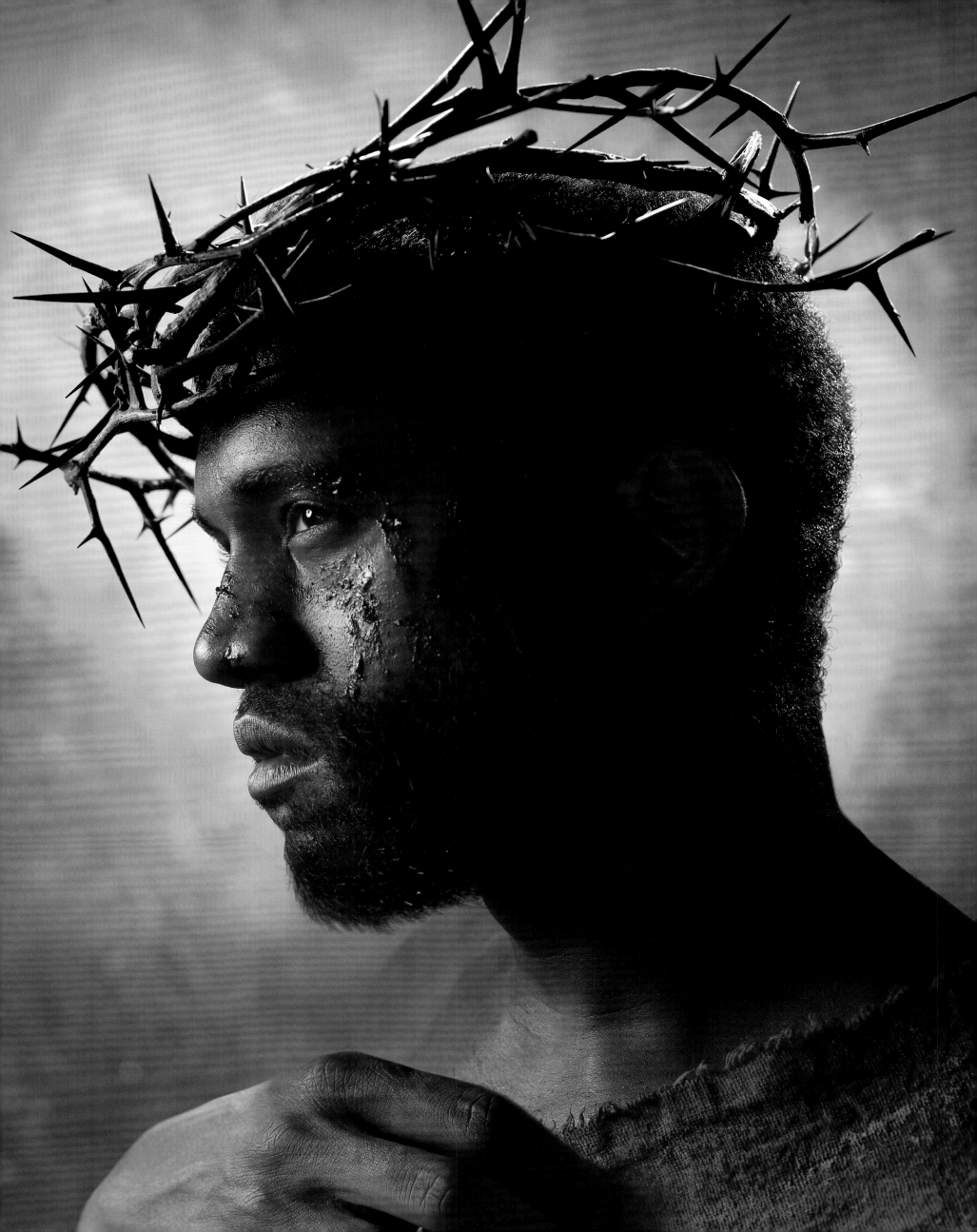

T

HE NEW MILLENNIUM SAW NEW SOUNDS AND new challenges. ROLLING STONE was at the forefront of documenting both. The decade was rooted in the tragedy of 9/11. "It is time now for great men to come forward," Bob Dylan told the magazine afterward. "With small men, no great thing can be accomplished." Yet the country's response was shaped not by great men, but by the disastrous presidency of George W. Bush, adjudged by Princeton historian Sean Wilentz in a ROLLING STONE cover story to be perhaps the worst president of all time. As it had in the Sixties, rock & roll responded to the current moment, and the folly of Bush's war in Iraq was behind Green Day's 2004 album, *American Idiot,* which helped turn the band into one of rock's biggest, connecting a younger generation with the sound of punk guitars. Then there was the upheaval of the 2008 financial crisis, which prompted a series of profanely hilarious and deeply reported pieces from Matt Taibbi, most memorably one dissecting the inner workings of the "great vampire squid," as he dubbed the investment bank Goldman Sachs. ¶ As the decade opened, classic artists like Dylan and U2 were doing their strongest work in many years, but the soundtrack of the 2000s also included the pop of Britney Spears and Justin Timberlake, who ushered in a new kind of celebrity that would go on to be shaped by the age of social media. All this was woven into the magazine's coverage, which included an eight-year project with photographer Sebastião Salgado to document the world as it appeared at the dawn of time, and the first investigation of Scientology to reveal the inner workings of the self-styled religion.

Britney Spears,
West Hollywood,
October 2008.

"It may take me a long time to give myself away to you, but once I do, that's it. You can have whatever you want. But I've had my heart broken plenty of times."

JUSTIN TIMBERLAKE, *"Justin Timberlake, the Bachelor," RS 914, January 23, 2003.*
—
Timberlake in Los Angeles, 2002.

Lady Gaga,
Los Angeles,
May 2009.

Chris Rock in
Los Angeles, 2008.

Bono

By Jann S. Wenner

RS 986 • NOVEMBER 3, 2005

In October 2005, Jann S. Wenner traveled to Cancun, Mexico, to conduct the ROLLING STONE Interview with Bono. The singer, who first appeared with U2 on the cover of the magazine in 1985, had become as well-known for his intellect and his political activism as he was for being the frontman of the world's biggest touring rock band. But he had rarely spoken in this kind of detail about his life, his art and his ambitions. In an interview session that stretched more than 10 hours across two days – and then continued in the ROLLING STONE offices two weeks later – Bono talked about his troubled relationship with his father, his faith and his uninterrupted songwriting partnership with the Edge, Adam Clayton and Larry Mullen Jr. of U2. ❖ The connection between U2 and the magazine had always been a strong one. ROLLING STONE had made a bold statement by putting the band on the cover in March 1985 and declaring, "Our Choice: Band of the '80s" – a correct assessment, as it turned out, though the decade was barely half over. And reflecting in this interview on what had drawn him so deeply to Martin Luther King Jr., the subject of U2's 1984 breakthrough track "Pride (In the Name of Love)," Bono explained that it was former ROLLING STONE music writer Jim Henke who had given him a biography of King, *Let the Trumpet Sound*, that changed his life. This conversation with Wenner marked Bono's 12th cover – five on his own and seven with the band. "The truth is, I need them more than they need me," he said of his bandmates. "I'm a better person for being around these men. . . . They raise my game."

What was your childhood in Dublin like?

I grew up in what you would call a lower-middle-class neighborhood. You don't have the equivalent in America. Upper working class? But a nice street and good people. And, yet, if I'm honest, a sense that violence was around the corner.

Home was a pretty regular three-bedroom house. Mother departed the household early: died at the graveside of her own father. So I lost my grandfather and my mother in a few days, and then it became a house of men. And three, it turns out, quite macho men – and all that goes with that. The aggression thing is something I'm still working at. That level of aggression, both outside and inside, is not normal or appropriate.

You're this bright, struggling teenager, and you're in this place that looks like it has very few possibilities for you. The general attitude toward you from your father – and just the Irish attitude – was "Who the fuck do you think you are? Get real." Is that correct?

Bob Hewson – my father – comes from the inner city of Dublin. A real Dublin man but loves the opera. Must be a little grandiose himself, OK? He is an autodidact, conversant in Shakespeare. His passion is music – he's a great tenor. The great sadness of his life was that he didn't learn the piano. Oddly enough, kids aren't really encouraged to have big ideas, musically or otherwise. To dream was to be disappointed. Which, of course, explains my megalomania.

You wrote an extraordinary song about your father, "Sometimes You Can't Make It on Your Own." When I spoke to Edge this week, he said that you're turning into your dad.

He was an amazing and very funny man. But I don't think I'm like him. I have a very different relationship with my kids than he had with me. He didn't really have one with me. . . . By not encouraging me to be a musician, even though that's all he ever wanted to be, he's made me one. By telling me never to have big dreams, he made me have big dreams. By telling me that the band would only last five minutes or 10 minutes – we're still here.

It seems there's some power in this relationship that's beyond the ordinary father-son story. You were probably one of the most difficult children to have around.

I must've been a bit difficult.

He was trying to raise two children without a mother. And here you are, unforgiving and un-

> "Music is how we speak to God. If there's a spirit, music is the thing that wakes it up. It woke mine up."

relenting, showing up at all hours, in drag and with all kinds of weird people. I think it's amazing he didn't just throw you the fuck out. Do you ever feel guilty about how you treated him?

No, not until I fucking met you! He loved a row. Christmas Day at our house was just one long argument. We were shouting all the time – my brother, me and then my uncles and aunts. He had a sense of moral indignation, that attitude of "You don't have to put up with this shit." He was very wise, politically. He was from the left, but, you know, he praised the guy on the right.

The more you talk about it, the more it sounds like you're describing yourself.

That is a very interesting way of looking at it, and I think there'll be a lot of people who might agree with you. I loved my dad. But we were combatants. Right until the end. Actually, his last words were an expletive. I was sleeping on a little mattress right beside him in the hospital. I woke up, and he made this big sound, this kind of roar. It woke me up. The nurse comes in and says, "You OK, Bob?" He kind of looks at her and whispers, "Would you fuck off and get me out of here? This place is like a prison. I want to go home." Last words: "Fuck off."

* * *

About Edge, what's his importance in U2? Do you think he's getting the credit he deserves?

I'm definitely overrated in the scheme of things for U2. It's just one of those things that comes with the turf. However, it is annoying to me that this genius of the guitar – and genius rarely comes with modesty – never pushes himself forward. Most guitar playing in the rock era is white guys redoing black riffs. Some amazing versions of that; but this man, this kind of Zen Presbyterian, has really redefined the emotional terrain that a guitar player can create. Edge is a giant of guitar playing. He's right up there.

Can you describe the sound of his playing?

Those icy notes and those fragile arpeggios belie a rage beneath that calm surface. He has a lot going on in his head, but he doesn't speak about it like I do. He's a musician, and it comes out in these tones that no one's heard before, and it allows me to get to that ecstatic thing that I'm looking for. Without that, it's difficult.

Other singer-songwriter partnerships are really tough: Lennon-McCartney, Jagger-Richards, Gilbert-Sullivan and so forth. Yours keeps working, it keeps going. Why?

We're tough on the work, but not on each other. Edge deserves the lion's share of the credit. He has, in a sort of sacramental fashion, learned to sublimate his ego to his music.

Bono,
New York,
2005.

> "I used to think that one day I'd be able to resolve the different drives I have, the tension between the different people I am. Now I realize that is who I am, and I'm more content to be discontent."

And allows you to be the big ego?

I think he's delighted to be out of the line of fire. He's the clever guy who actually figures being the frontman is hard work. Smart people know what he does, and he doesn't care about the rest of the world. I get annoyed and I say, "How do people not know?" An example would be "With or Without You." It was clear early on that this was a little bit special. The song is all one build to a crescendo. The song breaks open and comes down, and then comes back. Everyone in the room is "OK, Edge, let's see if you can let off some fireworks here." Three notes – restraint. I mean psychotic restraint, and that is the thing that rips your heart out, not the chorus. It's really extraordinary.

Are you guys best friends?

He's one of my very best friends. I tend to put people into two categories: friends I worry about and friends I don't worry about. [My wife] Ali and Edge are definitely the friends I don't worry about. They're similar and they have similar roles in my life. I'm just in awe of them.

Tell me about Bob Dylan. How did you first meet him?

I went to interview him for the *Hot Press*, an Irish music paper, in 1984. We talked about playing chess. Van Morrison was there, too. Dylan was responsible for *Rattle and Hum* because he's the one who said, in that interview, that you have to understand the past, where the music comes from. He was talking to me about the McPeake family and the Clancy Brothers and then Hank Williams and Leadbelly, none of whom we knew. Bob came out on the *Joshua Tree* tour, played a few songs with us. During *Rattle and Hum*, he came down and played keyboards. We went out to his house in California and wrote a couple of songs together.

What was that like?

I think he was just keeping an eye out for me, and I may not have respected his privacy the way I should have.

In what sense do you mean?

People say, "Oh, you've written with Bob Dylan," and I'd tell them what happened, not realizing that his privacy was sacrosanct. So I don't know why he continued to be my friend. He kind of comes and goes.

What's hanging out with him like?

I find him to be the least obtuse person in the world, except when there's more than a few people in the room. He's much better one to one. The collision of the Beatles and Bob Dylan gave us the galaxy that our planet is in. I would consider myself to be more of a fan than a friend. He might call me friend; I would call me a fan. I find him very old-school – ancient values, ancient wisdom. For a man who helped to give birth to the modern era, he's really coming from a very old place. A pilgrim, a sojourner, a troubadour. It's almost a medieval way he sees the world, in terms of performing.

What about Bruce Springsteen?

Bruce taught us so much – how to play arenas, and not rip people off, how to communicate to the back of the stalls, how to be operatic and not overblown, how to have dignity.

Yet we couldn't be more different. Back in the Eighties I remember saying to Bruce, "All these characters in your songs. Why don't you write about yourself?" He looked at me and said, eyes darkened, "What's there to write about? What's my life? I play gigs, I go home." You know, chastising me with his humility.

What's your relationship with him like?

We both belong to the big top. I think he's bemused that I'm still up on the tightrope. As big brother, he would advise a net. He's careful, considered. Bruce taught me some very valuable lessons, like how to hold on to your life as a civilian and how to disappear out the back door in your civvies, back to ordinary life. I'd like to teach him a few lessons, too.

Like?

How to crawl out of a nightclub on your hands and knees by pretending you've lost some loose

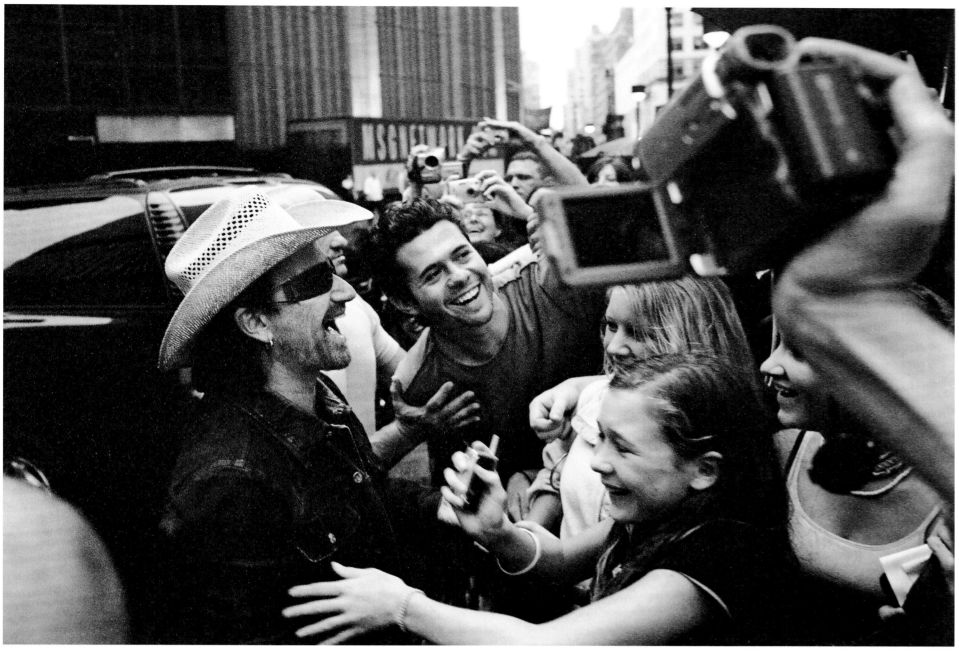

Bono greets fans in New York's Times Square, October 7, 2005.

change.... And then magic tricks, like how to disappear into a continent like Africa, where people really don't know who you are.

What are your favorites of Bruce's songs?

Darkness on the Edge of Town, the early Van Morrison-influenced stuff, *The Wild, the Innocent and the E Street Shuffle.* It's a haunting, spooky music that he can make. I don't know the landscapes he's traveling through. I like when they're a little topsy-turvy, and you feel he might get lost.

If Dylan is Faulkner, then Springsteen is Steinbeck.

Where do you see yourself in 20 years?

I'd like to return to fiction and poetry. I'd like to just be a writer and a singer and a performer. At 60, I'm going to be much better-looking than I am now. I'm sure of that. I don't hope I die before I get old. A lot of my heroes tend to be people who are alive, not dead, and living long.

In other words, you want to be doing the same thing but in a more pure form, maybe without all the outside work?

Words are becoming more and more important to me. I was never a guy who listened to the words. I just wrote them. And I'm really enjoying writing, whether it's speeches or letters or prose poems, scripts or lyrics. Maybe it's because I stop talking when I start writing.

If you hadn't been in U2, what would've happened to you?

I would've been a journalist.

Why do you say that?

Curiosity. I like writing. I'm attracted to things I'm afraid of. Disaster groupie, journalist, scriptwriter. The media plays a really valuable role in a free society. The United States has the best-quality journalism in the world, though your television really sucks.

Can rock & roll contain everything that you want to do?

It's so exciting – music. It really is. I believe that old adage that all art aspires to the condition of music.

What does that mean?

It's such an extraordinary thing, music. It is how we speak to God finally – or how we don't. It's the language of the spirit. If you believe that we contain within our skin and bones a spirit that might last longer than your time breathing in and out – if there is a spirit, music is the thing that wakes it up. And it certainly woke mine up.

I just came back from one of the most moving experiences of my life: playing Poland, hearing huge audiences singing every word of a language they weren't born into. They felt them before they understood them. It's humbling as a lyricist and hugely uplifting as a musician.

The thing that drives me on is a sort of curiosity about the world and people. Occasionally I lift the stones and find a few creepy-crawlies under there. The access that I've had through music to other artists in other fields, economists, novelists, doctors, nurses in the field – it's been amazing for me.

When we were in the middle of punk rock, I wanted to hang out with Johnny Cash. I wanted to know what was going on under his hat. And I got to. And Frank Sinatra – I got to know what was going on under his hat, and he shared things with me. That blessing that I was talking about – I've been chasing that blessing all my life, from all different sources and places. From Bob Dylan to Willie Nelson to Billy Graham.

Do you have any regrets?

Loads. I won't speak about them, but yes, I do.

Have you found what you're looking for?

I used to think that one day I'd be able to resolve the different drives I have in different directions, the tension between the different people I am. Now I realize that is who I am, and I'm more content to be discontent. I do feel I'm getting closer to the song I hear in my head, getting closer to not compromising that melody with some crap words. I mean that on every level. I wasn't looking for grace, but luckily grace was looking for me.

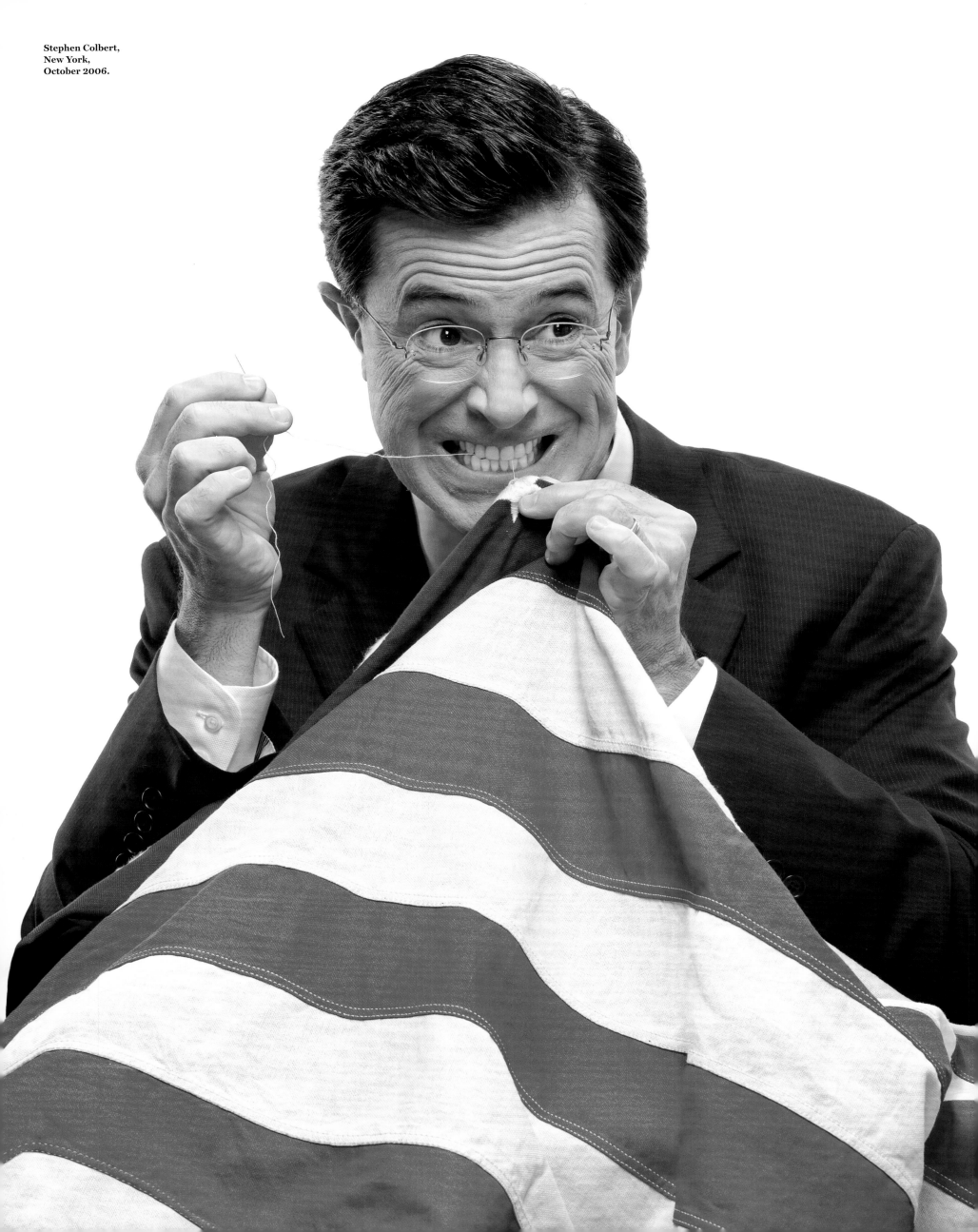

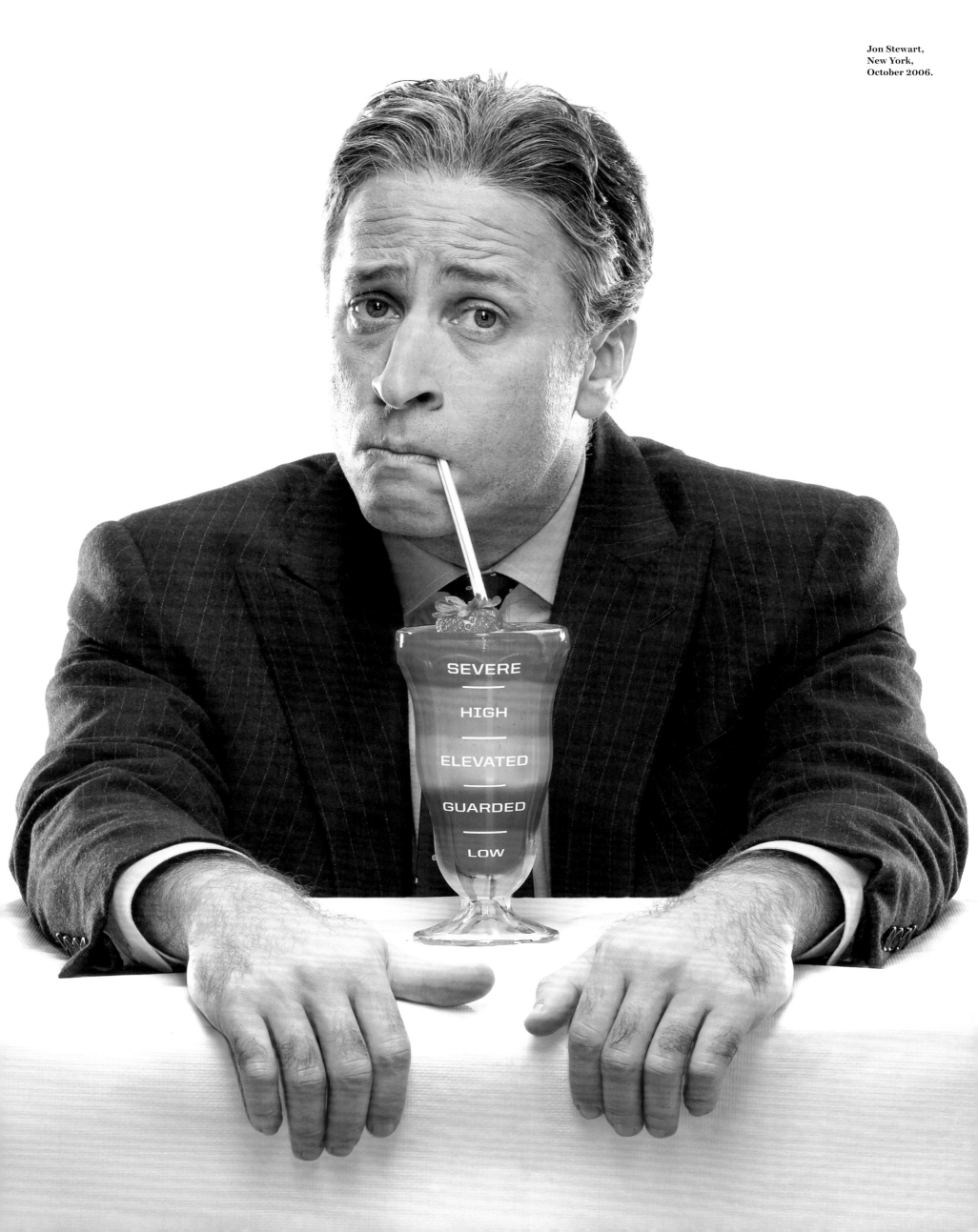

SEVERE

HIGH

ELEVATED

GUARDED

LOW

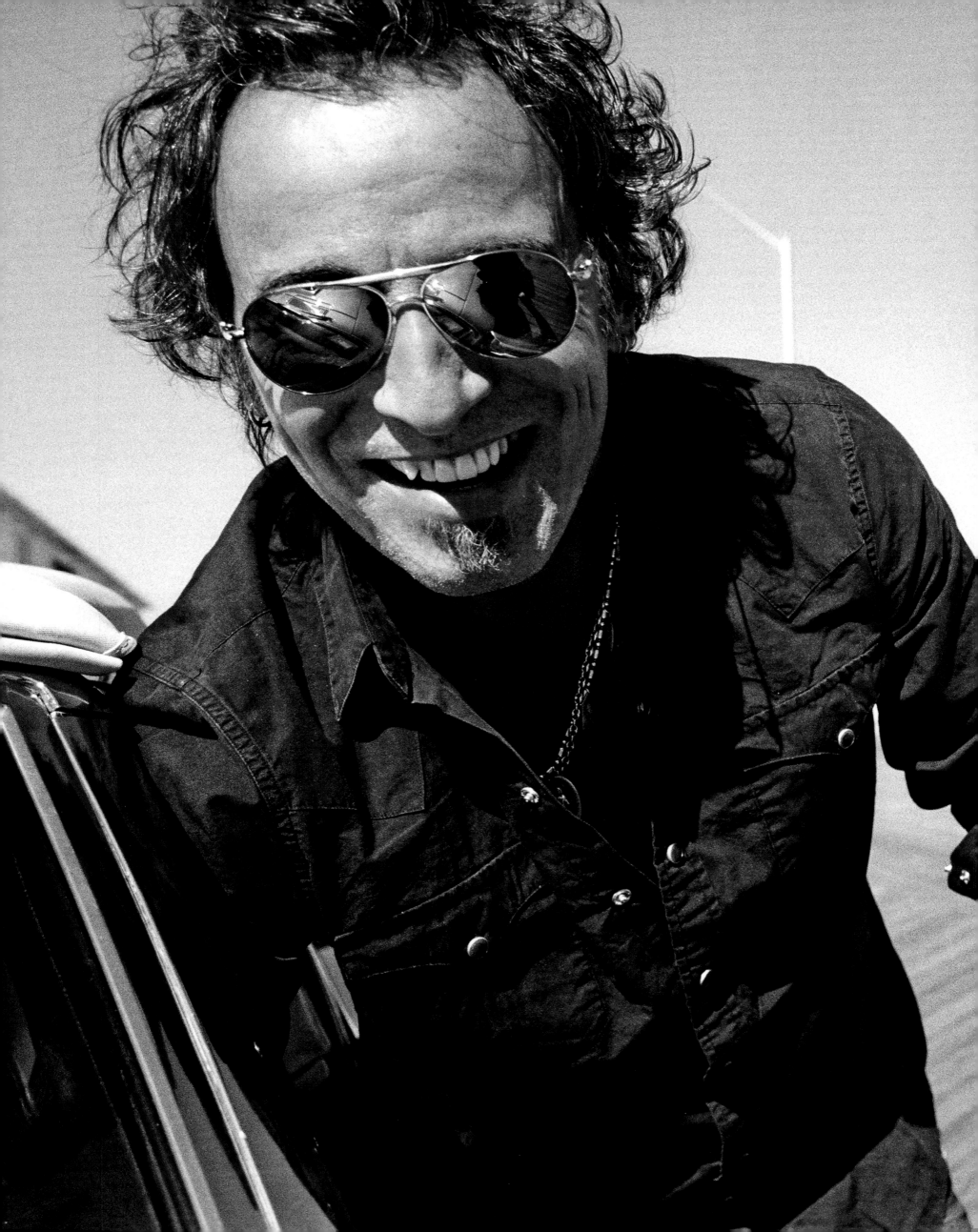

"The people I loved –
Woody Guthrie,
Dylan – they were
out on the frontier
of the American
imagination, and they
were changing the
course of history and
our own ideas about
who we were."

BRUCE SPRINGSTEEN, *"The Rolling Stone
Interview," RS 1038, November 1, 2007.*
—
Springsteen on the Asbury Park
Boardwalk, New Jersey, 2007.

The Great American Bubble Machine

As the nation descended into financial turmoil, Matt Taibbi took aim at Wall Street's 'Great Vampire Squid'

RS 1082/1083 · JULY 9-23, 2009

'The first thing you need to know about Goldman Sachs is that it's everywhere," wrote Matt Taibbi in July 2009. "The world's most powerful investment bank is a great vampire squid wrapped around the face of humanity, relentlessly jamming its blood funnel into anything that smells like money." For most of the 2000s, Taibbi carried the banner of Hunter S. Thompson, raging against the body politic as the magazine's National Affairs correspondent, and winning a National Magazine Award in 2008 for his columns. But with the Great Recession, he trained his explosive style and eye for detail on America's financial sector. No target earned more of his indignation than Goldman Sachs, and the American public would never look at vampire squids the same way again.

* * *

AFTER THE OIL BUBBLE COLLAPSED LAST FALL, the money seems to be gone, like worldwide-depression gone. So the financial safari has moved elsewhere, and the big game in the hunt has become the only remaining pool of dumb, unguarded capital left: taxpayer money. Here, in the biggest bailout in history, is where Goldman Sachs really started to flex its muscle.

It began in September of last year, when then-Treasury Secretary (and former Goldman CEO) Hank Paulson made a momentous series of decisions. Although he had already engineered a rescue of Bear Stearns and helped bail out quasi-private lenders Fannie Mae and Freddie Mac, Paulson elected to let Lehman Brothers – one of Goldman's last real competitors – collapse without intervention. The very next day, Paulson greenlighted a massive $85 billion bailout of AIG, which promptly turned around and repaid $13 billion it owed to Goldman. Thanks to the rescue effort, the bank ended up getting paid in full for its bad bets. By contrast, retired autoworkers awaiting the Chrysler bailout will be lucky to receive 50 cents for every dollar they are owed.

The collective message is that when it comes to Goldman Sachs, there isn't a free market at all. The government might let other players on the market die, but it simply will not allow Goldman to fail. Its edge in the market has suddenly become an open declaration of supreme privilege. "In the past, it was an implicit advantage," says Simon Johnson, an economics professor at MIT and former official at the International Monetary Fund. "Now it's more of an explicit advantage."

Once the bailouts were in place, Goldman went right back to business as usual, dreaming up impossibly convoluted schemes to pick the American carcass clean of its loose capital. One of its first moves

in the post-bailout era was to quietly push forward the calendar it uses to report its earnings, essentially wiping December 2008 – with its $1.3 billion in pretax losses – off the books. At the same time, the bank announced a highly suspicious $1.8 billion profit for the first quarter of 2009 – which apparently included a large chunk of money funneled to it by taxpayers via the AIG bailout. "They cooked those first-quarter results six ways from Sunday," says one hedge-fund manager. "They hid the losses in the orphan month and called the bailout money profit."

Two more numbers stand out from that stunning first-quarter turnaround. The bank paid out an astonishing $4.7 billion in bonuses and compensation in the first three months of this year, an 18 percent increase over the first quarter of 2008. It also raised $5 billion by issuing new shares almost immediately after releasing its first-quarter results. Taken together, the numbers show that Goldman essentially borrowed a $5 billion salary payout for its executives in the middle of the global economic crisis it helped cause, using half-baked accounting to reel in investors, just months after receiving billions in a taxpayer bailout.

And here's the real punchline. After playing an intimate role in four historic bubble catastrophes, after helping $5 trillion in wealth disappear from the NASDAQ, after pawning off thousands of toxic mortgages on pensioners and cities, after helping to drive the price of gas up to $4 a gallon and to push 100 million people around the world into hunger, after securing tens of billions of taxpayer dollars through a series of bailouts overseen by its former CEO, what did Goldman Sachs give back to the people of the United States in 2008?

Fourteen million dollars.

That is what the firm paid in taxes in 2008, an effective tax rate of exactly one, read it, one percent. The bank paid out $10 billion in compensation and benefits that year and made a profit of more than $2 billion – yet it paid the Treasury less than a third of what it forked over to CEO Lloyd Blankfein, who made $42.9 million last year.

How is this possible? Thanks to our completely fucked tax system, companies like Goldman can ship their revenues offshore and defer taxes on those revenues indefinitely. This is why any corporation with an at least occasionally sober accountant can usually find a way to zero out its taxes.

This should be a pitchfork-level outrage – but somehow, when Goldman released its post-bailout tax profile, hardly anyone said a word. One of the few to comment was Rep. Lloyd Doggett, a Democrat from Texas who serves on the House Ways and Means Committee. "With the right hand out begging for bailout money," he said, "the left is hiding it offshore."

In 2008, Goldman Sachs got billions from bailouts and paid $14 million in taxes.

Meet the Osbournes

Before MTV made them reality stars, the first family of metal welcomed ROLLING STONE *into their home*

RS 844/845 · JULY 6-20, 2000

Two years before "The Osbournes" made its way to MTV, Erik Hedegaard captured the strange domestic drama of a heavy-metal icon trying to discipline his children. The picture that emerged was miles away from Ozzy Osbourne's onstage persona. He was, according to Hedegaard, "deeply modest and reserved," and his life was defined by his love for his wife and manager, Sharon. "Once you get in the bosom of Sharon – if she likes you – everything becomes easy," says Hedegaard. After "The Osbournes" became a hit, Sharon remembered the writer who'd helped introduce her family to the world. It didn't hurt that he had left an impression. "She sent me two bottles of cologne," Hedegaard recalls. "She didn't send me a million dollars for all I did for her and Ozzy with their TV show."

* * *

UPSTAIRS IN HIS BEDROOM, trying to sleep, Ozzy Osbourne has just about had it with all the goddamn noise floating in from outside his window. He tosses and turns, frets and stews, moans and groans, and finally shakes himself loose of his sheets. This is in Beverly Hills, inside an arid marble palace just off Sunset Boulevard, where Ozzy lives with his wife, Sharon, and their three teenage kids, Aimee, Kelly and Jack. And it's those kids, splashing and laughing in the family swimming pool, who are denying Oz his sleep. Fingers trembling in the darkness, he tries to decide what to do. He'd like to lay some words on the kids. These would be words of instruction, admonition and correction, the feared words of a dad. Maybe he has those words somewhere, but he can't find them right now. He starts to reach for the bedroom intercom.

Meanwhile, downstairs in the kitchen, Sharon has finished clearing the dinner table. Besides being Ozzy's wife, she is also his manager, and so she knows a few things about the former Black Sabbath frontman, highly successful hard-rock solo artist and current namesake of the big summertime hard-rock extravaganza known as Ozzfest. "He's vulnerable," she says. "And he's more vulnerable now, because he's cold turkey on everything – drugs, drinking, caffeine, cigarettes. He's raw. He's fucking raw as they come. Sometimes he trembles so bad, he's like a frightened Chihuahua. It's like every nerve in his body is wanting something, something, something – 'Ozzy, please, give me something, something, please!'" Just then the intercom crackles to life, and through it comes an agitated voice: "Kelly, please! You sound like a lunatic. Quiet, please! OK?"

Ozzy Osbourne at home in Beverly Hills, May 2000.

Sharon jumps up from the table. "Hold on, Ozzy. I've got it." She goes to the door leading to the pool. "Kelly?"

"Yeah?" says 15-year-old Kelly.

"Please. You've woken Daddy."

Jack, who is 14, and Aimee, who is 16, start laughing.

"Shut up, you two," snaps Sharon. "All of you, stop it. Be respectful!"

Sharon sits back down, smiling. She is a lovely, intelligent and rather fierce woman in her late forties. She's been married to Ozzy for 18 years. "Yes, it's been a challenge," she says. "Yes, indeed."

Then there's noise again. The laughter of the kids, the shouting, the high-pitched squealing. It rises through the night sky and once more finds its way into the upstairs bedroom, this time forcing Ozzy to roll out of bed, off the lacy pink sheets. He wobbles to the window in his black underpants, long hair dangling. He is concerned now not only for his own sleep but also for that of his closest neighbor, the seriously religious crooner Pat Boone.

Glaring down at his brood, he opens his mouth and says, "If you all don't shut up, I'll— I'll—"

His kids look up at him, chins resting on the lip of the pool.

"I'll— I'll—"

"Well, yes, what will you do?"

"Now listen to me, children," he says. And then they start snickering and giggling. For, indeed, what dadlike words can he say to them? What is he, Ozzy Osbourne, legendary drug-addled Prince of Darkness, the very founder of parent-freaking-out heavy-metal music, going to do to them if they don't settle down? A bunch of thoughts crumple his brain. *How can I give out the rules when I'm worse than them most of the time? When they've seen me coming home in police cars, in fucking ambulances, in straitjackets and chains? When I have gone to parent-teacher conferences stoned on Vicodins or Percocets and nodded off in the middle, and Sharon has had to kick me under the table, and I wake up shouting, "Hey, what do you keep fucking hitting me for, man?" I try to be a figure of authority, but do they listen to me? Fuck, no!*

Jack, Kelly and Aimee are still perched by the poolside, impatiently waiting for an answer.

Ozzy – who is in fact a deeply modest fellow – blinks a few times. Then, in a very small voice, he says, "Well, try to be quiet, will you?" And then this rawest of men – raw like no one else probably in the history of raw – aims himself back toward his bed to find sleep amid the ruckus, if only he can.

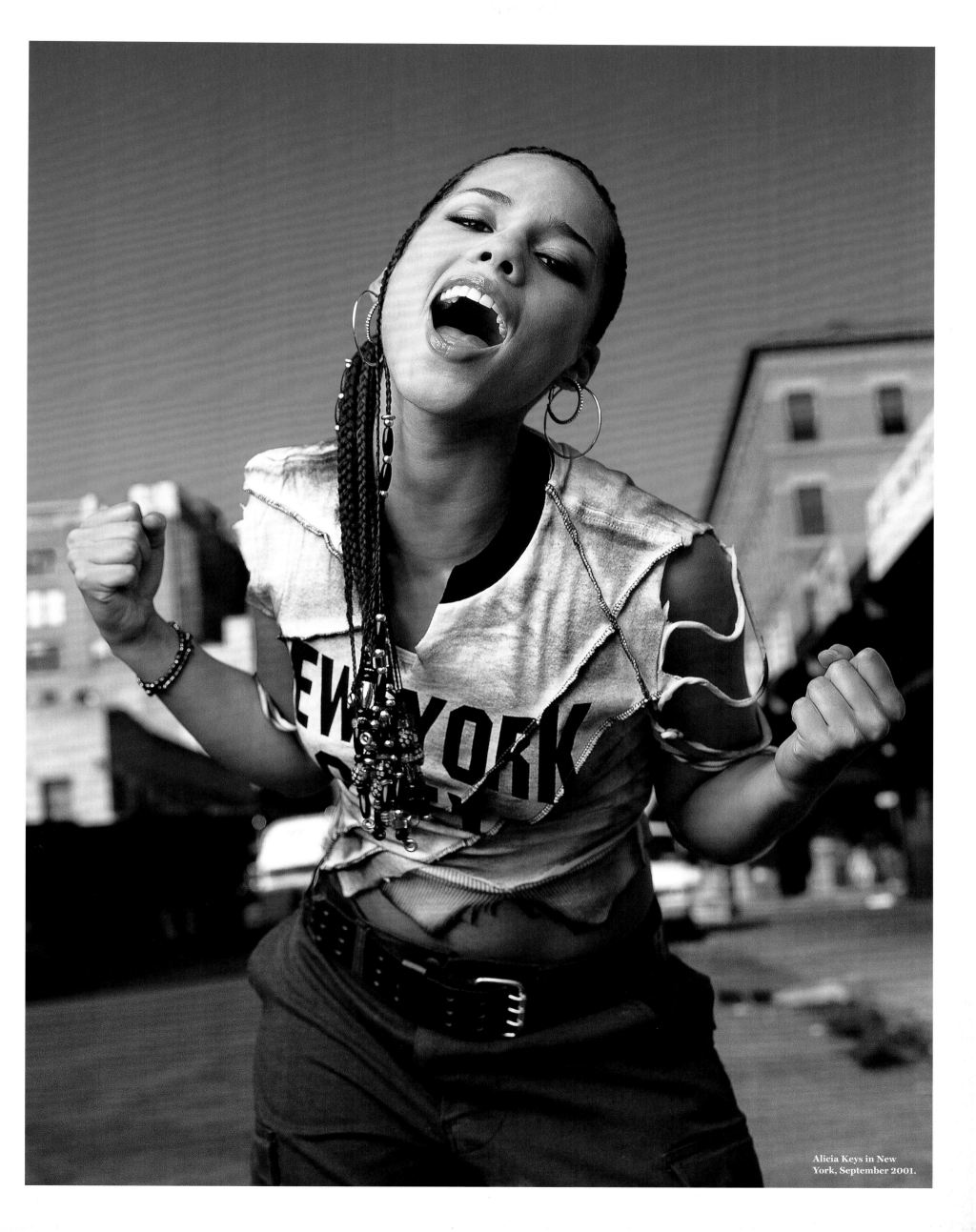

Alicia Keys in New
York, September 2001.

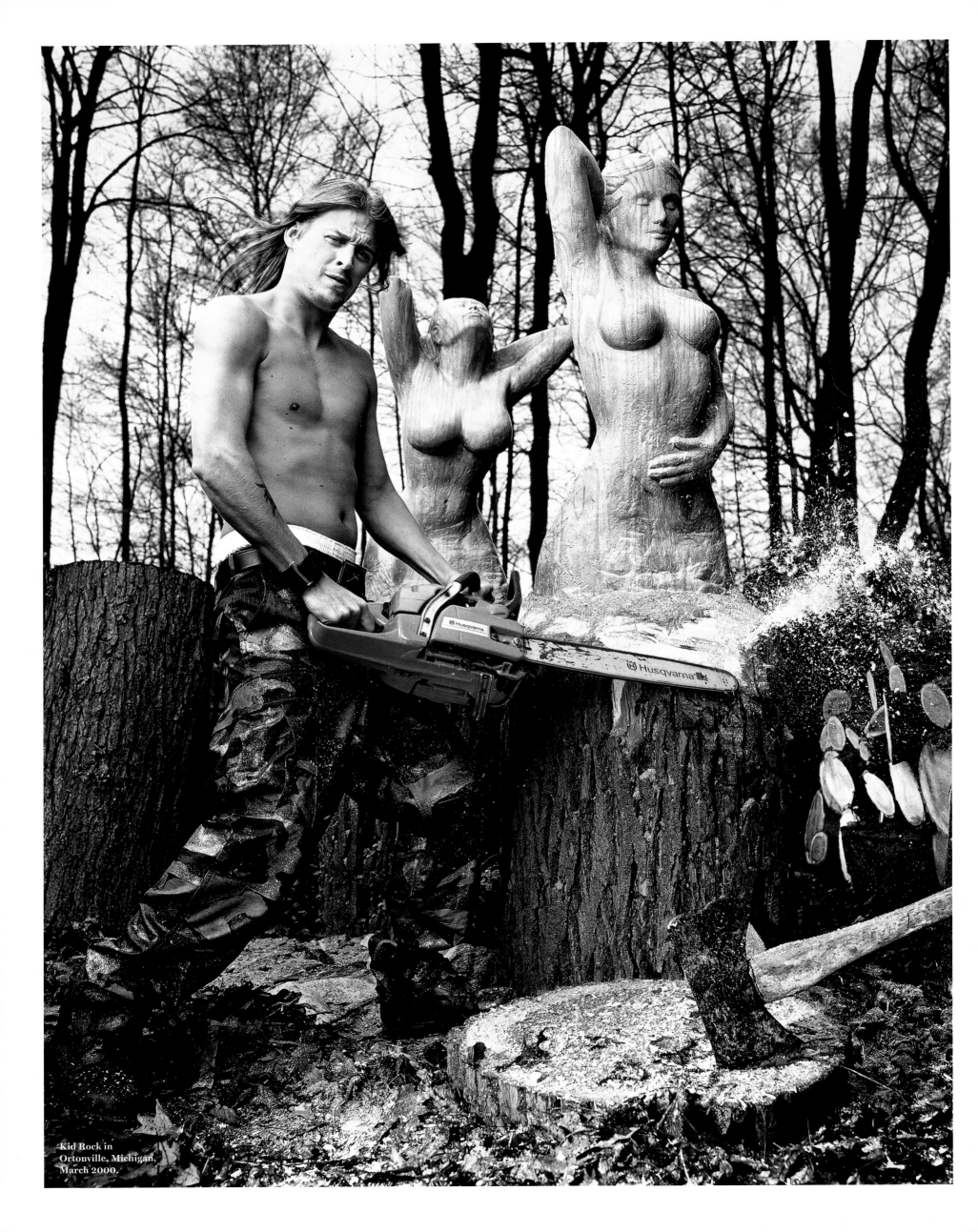

Kid Rock in
Ortonville, Michigan,
March 2000.

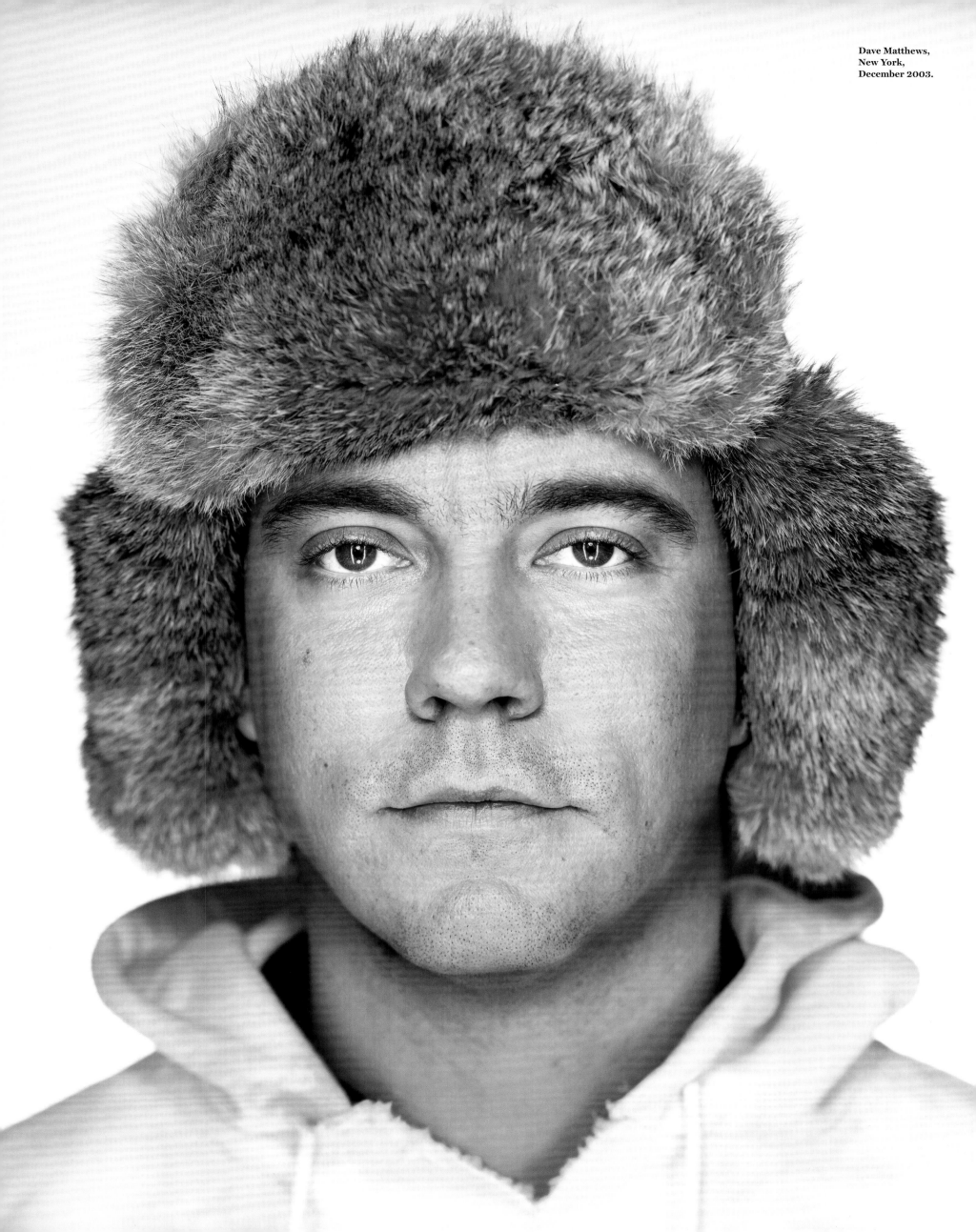

Bob Dylan

By Mikal Gilmore

RS 882 • NOVEMBER 22, 2001

It was a moment when Bob Dylan was in full command of his powers for the first time in decades. His artistic renaissance had begun a few years earlier, with the release of *Time Out of Mind* in 1997. But that album – produced by Daniel Lanois – hadn't come out the way that Dylan had envisioned it. "I got so frustrated in the studio that I didn't really dimensionalize the songs," he told Mikal Gilmore. "I could've if I'd had the willpower. I just didn't at that time." ❖ There was no shortage of willpower now. He'd produced his new album, *Love and Theft*, himself, and it crackled with both hard-won perspective and the biting power of his electric youth. *Love and Theft* had been released on September 11th, 2001, and for many listeners the darker visions it described caught the tenor of those difficult times. "The rational mind's way of thinking wouldn't really explain what's happened," Dylan responded when asked about recent events. "You need something else, with a capital 'E,' to explain it. It's going to have to be dealt with sooner or later, of course." Pressed further on the subject, Dylan was, as ever, both evasive and incisive. "I don't really know what I could tell you. I don't consider myself an educator or an explainer. You see what it is that I do, and that's what I've always done. But it is time now for great men to come forward." And then he added, "Things will have to change. And one of these things that will have to change: People will have to change their internal world."

*S*tarting in the 1990s, [your shows] grew more musical. You've opened the songs up to more instrumental exploration – like you're trying to stretch or reinvent them. You're your own band director at this point.

Well, I don't think you've seen me play too many mindless jams. What I do is all done with technique and certain stratagems. But they're not intellectual ones; they're designed to make people feel something.... I would like to be a performer who maybe could read and write music and play the violin. Then I could design a bigger band with more comprehensive parts of harmony in different arrangements, and still have the songs evolve within that.

It seems that some of your most impassioned and affecting performances, from night to night, are your covers of traditional folk songs.

Folk music is where it all starts and in many ways ends. If you don't have that foundation, or if you're not knowledgeable about it and you don't know how to control that, and you don't feel historically tied to it, then what you're doing is not going to be as strong as it could be. Of course, it helps to have been born in a certain era because it would've been closer to you, or it helps to be a part of the culture when it was happening. It's not the same thing, relating to something second- or third-hand off of a record.

In "The Old, Weird America," Greil Marcus wrote about the importance of Harry Smith's "Anthology of American Folk Music" and its influence on all of your work, from your earliest to most-recent recordings.

Well, he makes way too much of that.

Why do you say that?

Because those records were around – that Harry Smith anthology – but that's not what everybody was listening to. Sure, there were all those songs. You could hear them at people's houses. I know in my case, I think Dave Van Ronk had that record. But in those days we really didn't have places to live, or places to have a lot of records. We were sort of living from this place to that – kind of a transient existence. I know I was living that way. You heard records where you could, but mostly you heard other *performers*. All those people [Marcus is] talking about, you could hear the actual people singing those ballads. You could hear Clarence Ashley, Doc Watson, Dock Boggs, the Memphis Jug Band, Furry Lewis. You could see those people live and in person. They were around. He intellectualizes it too much. Performers did know of that record, but it wasn't, in retrospect, the

> "Every one of the records I've made has emanated from the entire panorama of what America is to me."

monumental iconic recordings at the time that he makes them out to be.

The people I knew – the people who were like-minded as myself – were trying to be folk musicians. That's *all* they wanted to be, that's *all* the aspirations they had. There wasn't anything monetary about it. There was no money in folk music. It was a way of life. And it was an identity which the three-buttoned-suit postwar generation of America really wasn't offering to kids my age: an identity.

In a way, this line of talk brings us to your newest album, "Love and Theft." Its sense of timelessness and caprices reminds me of "The Basement Tapes" and "John Wesley Harding" – records that emanated from your strong folk background. But it also seems to recall "Highway 61 Revisited's" delight in new world-changing methods of language and sharp wit.

For starters, no one should really be curious or too excited about comparing this album to any of my *other* albums.... Compare this album to other artists who make albums. You know, comparing me to myself [*laughs*] is really, like... I mean, you're talking to a person that feels like he's walking around in the ruins of Pompeii all the time. It's always been that way, for one reason or another. I deal with all the old stereotypes. The language and the identity I use is the one that I know only so well, and I'm not about to go on and keep doing this – comparing my new work to my old work. It creates a kind of Achilles' heel for myself. It isn't going to happen.

Maybe a better way to put it is to ask: Do you see this as an album that emanates from your experience of America at this time?

Every one of the records I've made has emanated from the entire panorama of what America is to me. America, to me, is a rising tide that lifts all ships, and I've never really sought inspiration from other types of music.... The whole album deals with power. If life teaches us anything, it's that there's nothing that men and women won't do to get power. The album deals with power, wealth, knowledge and salvation – the way I look at it. If it's a great album – which I hope it is – it's a great album because it deals with great themes. It speaks in a noble language. It speaks of the issues or the ideals of an age in some nation, and hopefully, it would also speak across the ages. It'd be as good tomorrow as it is today and would've been as good yesterday. That's what I was trying to make happen, because just to make another record at this point in my career... career, by the way, isn't how I look at what I do. *Career* is a French word. It means "carrier." It's something that takes you from one place to the other. I don't feel like what I do qualifies to be called a career. It's more of a calling.

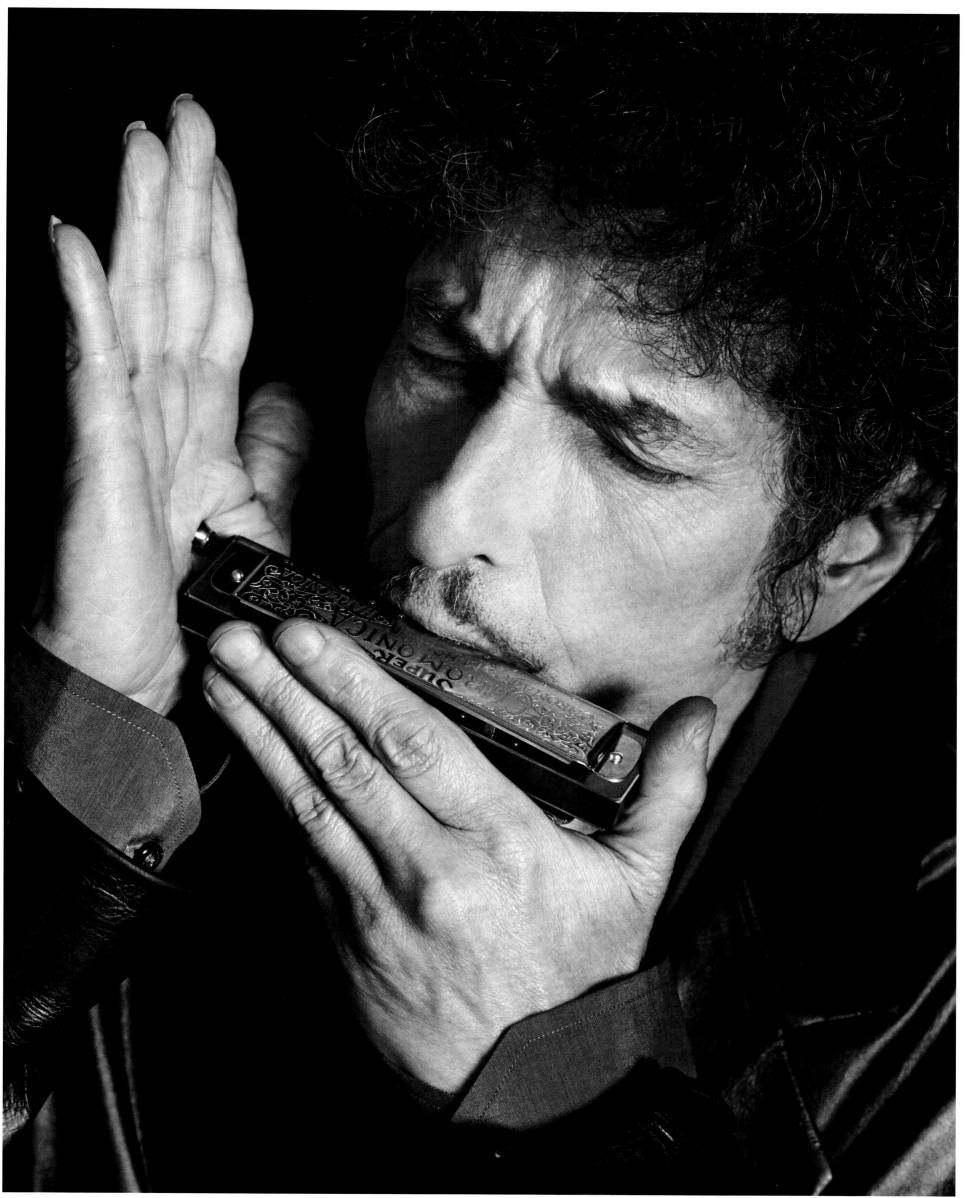

Bob Dylan in Los Angeles, September 2001.

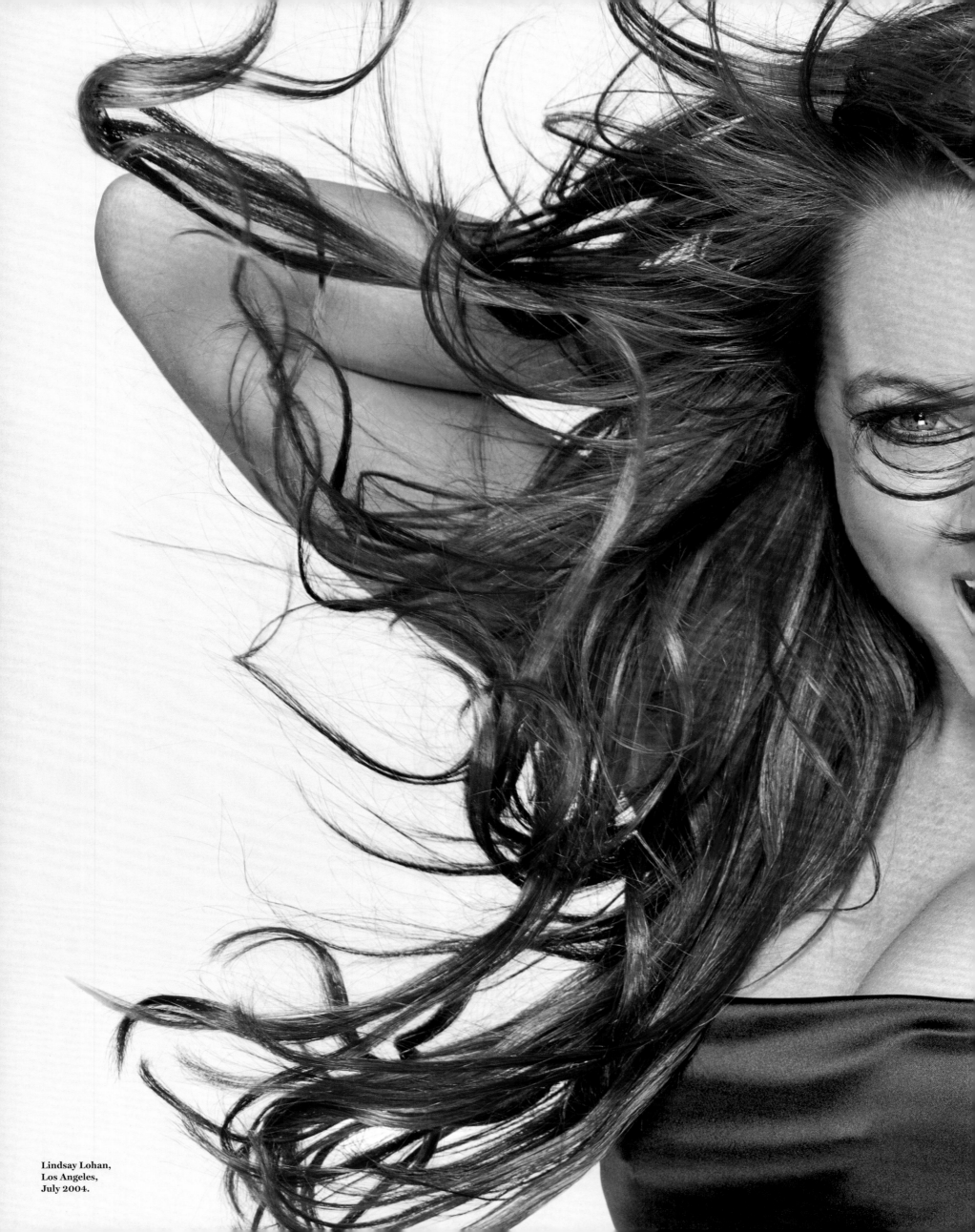

Lindsay Lohan,
Los Angeles,
July 2004.

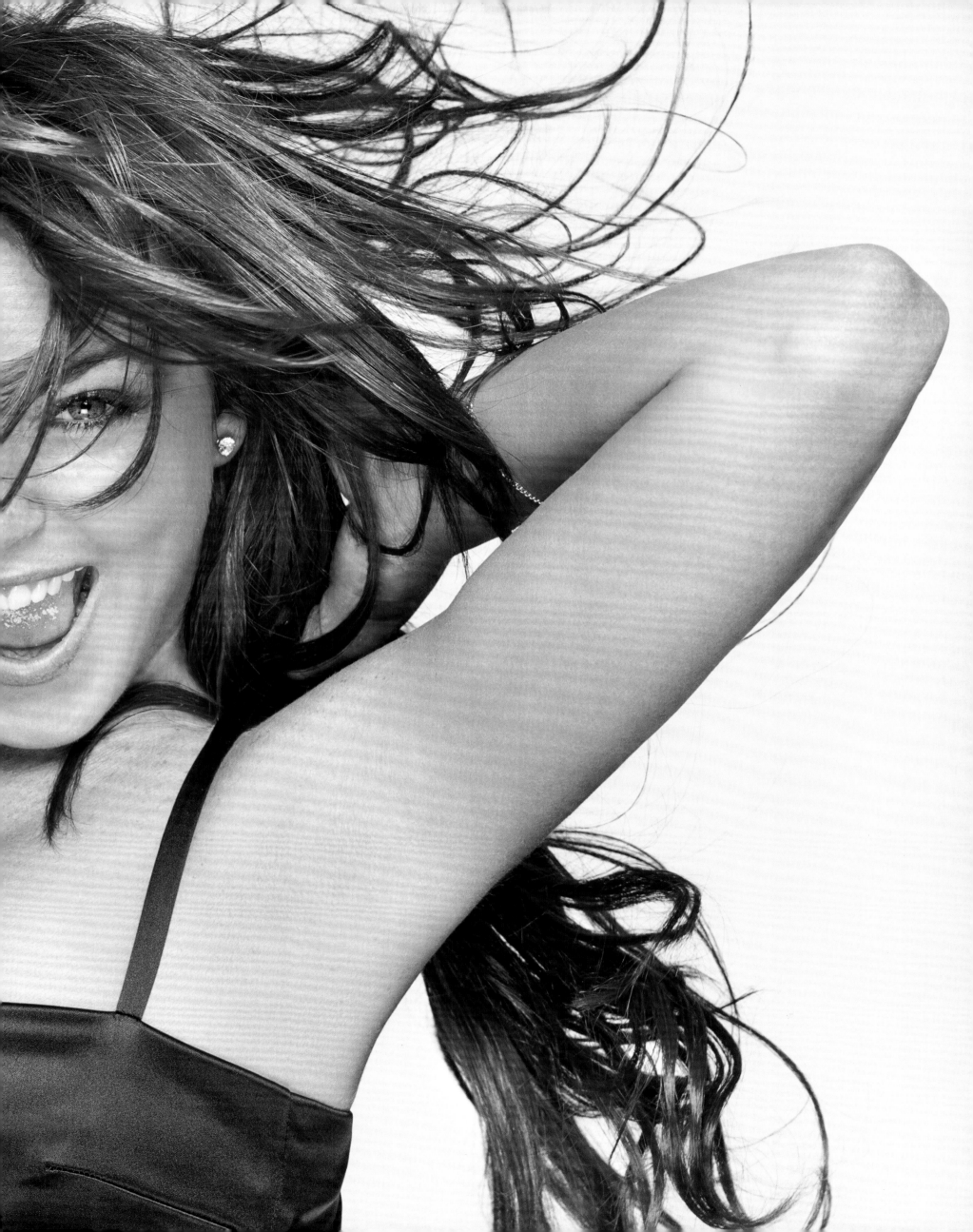

The Life and Death of David Foster Wallace

An intimate look at one of the greatest writers of his generation

RS 1064 • OCTOBER 30, 2008

On MARCH 5TH, 1996, *ROLLING STONE* CONTRIBUTING editor David Lipsky pulled up in front of a nondescript ranch house near the campus of Illinois State University in Normal, Illinois, to meet David Foster Wallace. The 34-year-old Wallace's second novel, *Infinite Jest,* had been published five weeks earlier. It was a discursive, demanding work, with interwoven narratives that looped through tennis, drugs, death and the collapse of society, and it ran 1,079 pages. A good beach book, Wallace joked when he turned in the manuscript to his editor, in the sense that people could use it for shade.

But it was an instant sensation, hailed on publication as a classic. Lipsky was about to publish his own novel, and, like Wallace, he helped support himself with magazine journalism. He pitched a profile of Wallace to ROLLING STONE for the magazine's annual Hot List, which would have run six months before *Infinite Jest* was published.

"Our assault on Mount Hot List failed," jokes Lipsky. But when the book was closer to publication, a piece on Wallace in *The New York Times* – with the bearded, longhaired and habitually bandanna'd Wallace looking like a cross between a mountain man and a Deadhead – sparked something in Jann Wenner. "He didn't look how writers tended to look," says Lipsky of Wallace. "Jann said, 'Ah, he's one of us. Send Lipsky.'"

Wallace was near the end of his cross-country book tour when Lipsky arrived in Normal, where Wallace taught creative writing at Illinois State. One of the first things Lipsky noticed entering the house was a huge Alanis Morissette poster. "The Alanis Morissette obsession followed the Melanie Griffith obsession – a six-year obsession," Wallace said. "It was preceded by something that I will tell you I got teased a lot for, which was a terrible Margaret Thatcher obsession. All through college: posters of Margaret Thatcher, and ruminations on Margaret Thatcher. Having her really enjoy something I said, leaning forward and covering my hand with hers." Wallace lived with two enormous mixed-breed dogs named Drone and Jeeves, who ran wild throughout the unkempt home. A Barney the dinosaur towel served as a makeshift curtain in the bathroom.

Lipsky spent five days with the novelist, accompanying him to a bookstore appearance in Minneapolis, a screening of the John Travolta movie *Broken Arrow* at the Mall of America and many long diner meals. He captured nine hours of their conversation. "I wanted to see what he saw, how quickly and thrillingly his brain worked," says Lipsky. "I figured the best way to get people excited about him and get them to pick up the book was to see what it was for him to live as David Foster Wallace."

But when Lipsky returned to New York, his story was put on hold. ROLLING STONE was preparing a news feature about the problem of heroin in the music industry. Lipsky was sent to Seattle, where he spent a month living with young addicts to produce a devastating look at the drug's impact on ordinary kids, "Junkie Town," for the May 30th, 1996, issue. By the time he was done, his editors told him it was simply too late for the Wallace piece.

He wouldn't return to it for 12 years, and then under the saddest of circumstances. Wallace had struggled with depression since high school. On September 12th, 2008, he hanged himself. Lipsky dug out his dusty cassette tapes of his interviews with Wallace and pored over the transcripts. He made them a starting point for something more far-reaching than an obituary. He spoke with Wallace's parents and sister; his friends Mark Costello and Jonathan Franzen, both novelists; his literary agent and editor. Wallace had explained his mission as writing "stuff about what it feels like to live. Instead of being a relief from what it feels like to live." Lipsky delivered what it felt like to live alongside him.

The story was rich with detail: As a teenager, Wallace decorated his bedroom with pictures of tennis players (he played competitively until smoking pot distracted him), but he'd also pinned an article about Kafka to the wall, with the headline THE DISEASE WAS LIFE ITSELF; he turned up for college at Amherst in 1980 looking out of place in what Costello described as a "kind of Sears suit"; six years later, he turned up in New York for a meeting with the editor of his first novel, looking once again out of place in a U2 T-shirt. And though he gathered friends like Costello and Franzen around him, and was deeply attached to his parents, he struggled with his depression. "He would talk about just being very sad and lonely," his mother told Lipsky. "It didn't have anything to do with being loved. He just was very lonely inside himself."

"The Lost Years and Last Days of David Foster Wallace" went on to win a National Magazine Award for profile writing in 2009. (Wallace himself was a ROLLING STONE contributor and had won a National Magazine Award for feature writing for a 2000 piece about John McCain on the campaign trail titled "The Weasel, Twelve Monkeys and the Shrub.") Lipsky expanded the piece into a book, *Although of Course You End Up Becoming Yourself: A Road Trip With David Foster Wallace,* which became the basis of the 2015 movie *The End of the Tour.*

A lot has come from those five days Lipsky spent with Wallace. "I want people to stop thinking of him as just this depressed writer who killed himself," Lipsky says. "I wanted to show people what it was like for him to be alive. I also think I met the parameters of the original assignment, which was to preserve a week of this man's life." More than a week, really. A life in full.

Wallace in 1995, in the Syracuse, New York, apartment where he wrote much of *Infinite Jest.* Fiction was a way to combat the loneliness that had haunted him.

The Secret Religion

The question was simple: How did Scientology work? Answering it wasn't

RS 995 • MARCH 9, 2006

'THE FADED LITTLE DOWNTOWN AREA OF CLEARWATER, Florida, has a beauty salon, a pizza parlor and one or two run-down bars, as well as a bunch of withered bungalows and some old storefronts that look as if they haven't seen customers in years," began "Inside Scientology," ROLLING STONE's investigation into the secretive religion founded in 1954 by the former sci-fi writer L. Ron Hubbard. "There are few cars and almost no pedestrians. There are, however, buses – a fleet of gleaming white-and-blue ones that slowly crawl through town, stopping at regular intervals to discharge a small army of tightly organized, young, almost exclusively white men and women, all clad in uniform preppy attire: khaki, black or navy-blue trousers and crisp white, blue or yellow dress shirts."

Those men and women – all of whom politely called each other "sir," even when the "sir" was a woman – were part of Scientology's elite, known as the Sea Organization, and Clearwater was the worldwide spiritual headquarters of the church itself. Janet Reitman had gone there for a firsthand look at what *The St. Petersburg Times* had dubbed "Scientology's Town," population 108,000, about 8,300 of them members of the church.

She was talking with one of them in a Starbucks when a mysterious woman approached her. "It's summer and 95 degrees, and this lady in a cape shows up and hands me a business card," Reitman says. "She was the PR person for the church." Somehow, Reitman says, "Scientology knew what I was doing and who I was meeting with, but I never knew how they knew – I suspected I was followed or spied upon by any one of a number of people connected to the church." (The Church of Scientology maintains that this was a "chance meeting" – a member overheard Reitman say she was doing an article and mentioned it to a local spokesperson.)

In 2005, when Reitman began her reporting, Scientology was better known for its celebrity members (including Tom Cruise, John Travolta and Beck) than for its beliefs. From the outside, it looked like a mix of science fiction and self-help. Most of Scientology's central teachings, however, were secret. The most crucial of these was its foundation myth – its Genesis – which Scientologists learned only after years of study. The gist of the story: 75 million years ago, an intergalactic warlord named Xenu disposed of portions of his overpopulated world by dumping them on Earth. The remnants of these souls, or "thetans," contaminated the planet, and only Hubbard's techniques, using devices like the E-meter (a sort of lie detector), could get rid of them. But even getting to the point of learning this story required immersion in "tech," as Hubbard named his techniques for enlightenment – the so-called science in Scientology. And the

more tech a member accessed, the more it cost, as Reitman found when she visited a church in New York and was offered a chance to spend $2,000 and then $4,000 for basic sessions. (The church maintains that Reitman donated $155 for some books and was not solicited for further funds.)

From the story's inception, both Reitman and her editors were intent on producing a balanced portrait of the controversial institution (which was infamous for guarding its secrecy by doing everything from bugging IRS offices to hounding members of the press who dared to cover it). To that end, the magazine immediately reached out to the church to interview its leaders and members. The church initially declined the magazine's requests, but sent a spokesperson to ROLLING STONE's offices to discuss the story as it was being reported. Managing editor Will Dana received weekly, sometimes daily, calls from one Scientology spokesperson.

The magazine proceeded undeterred, and Reitman wound up interviewing dozens of former Scientologists, who spoke openly about the organization. During the fact-checking process, the magazine's research department sent a list of questions to the church, and only then did officials get a sense of the depth of Reitman's reporting – and realize they needed to cooperate. Reitman was soon on a plane to California to interview Scientology executives and be given a tour of some of the institution's most notorious but rarely seen (and well-guarded) buildings, including its Gold Base compound, north of Los Angeles. "I would meet them at 8:00 in the morning and they kept me busy until 10:00 at night," she says. "Their MO was if they couldn't persuade me, they would exhaust me."

Nearly a year after Reitman began her work, the finished story, "Inside Scientology," more than lived up to its title. Long before other such journalistic investigations into the church, Reitman pulled back the curtain on its founder's controversial past and gave readers an intimate, detailed look at the rise of Scientology, its philosophy, its workings and the reasons some people took to it and others fled from it. The story was a finalist for a National Magazine Award and led to Reitman's acclaimed book, *Inside Scientology: The Story of America's Most Secretive Religion.*

Writing the piece presented a unique challenge for Reitman. "There are so many subtle aspects of Scientology that are just superbizarre," she says. "How do you avoid using words like 'bizarre'?" Although the church maintains the magazine had an agenda, Jann Wenner insisted that Reitman cut out any subjective terms and let the story, and the subjects, speak for themselves. "He felt I had the material to do that, and it was a great lesson as a writer. What makes a great magazine story is doing enough reporting so that the story can simply tell itself."

Scientology's Celebrity Centre in Los Angeles, part of a project launched in 1955 to recruit famous "prime" communicators, like Tom Cruise and John Travolta.

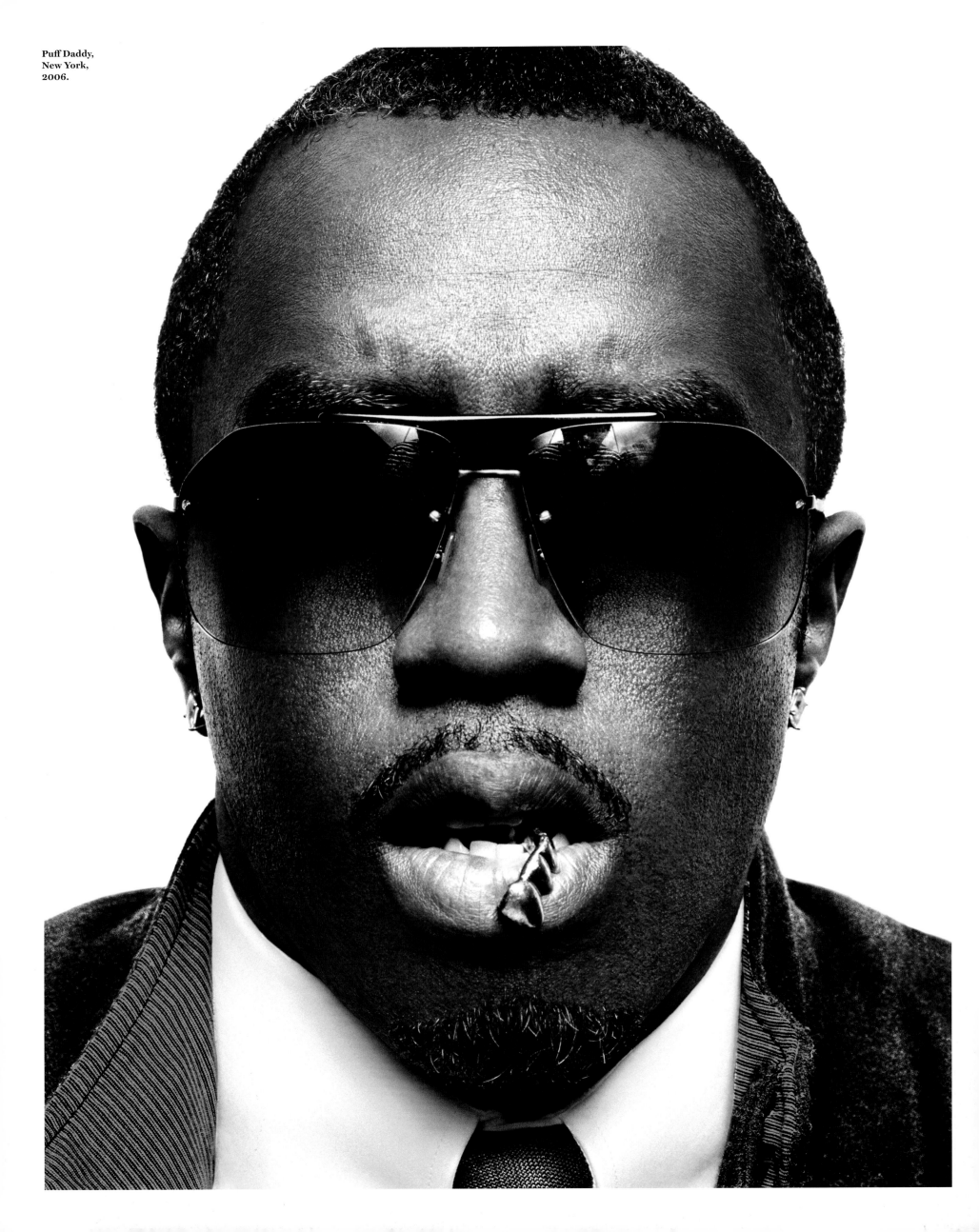

Puff Daddy,
New York,
2006.

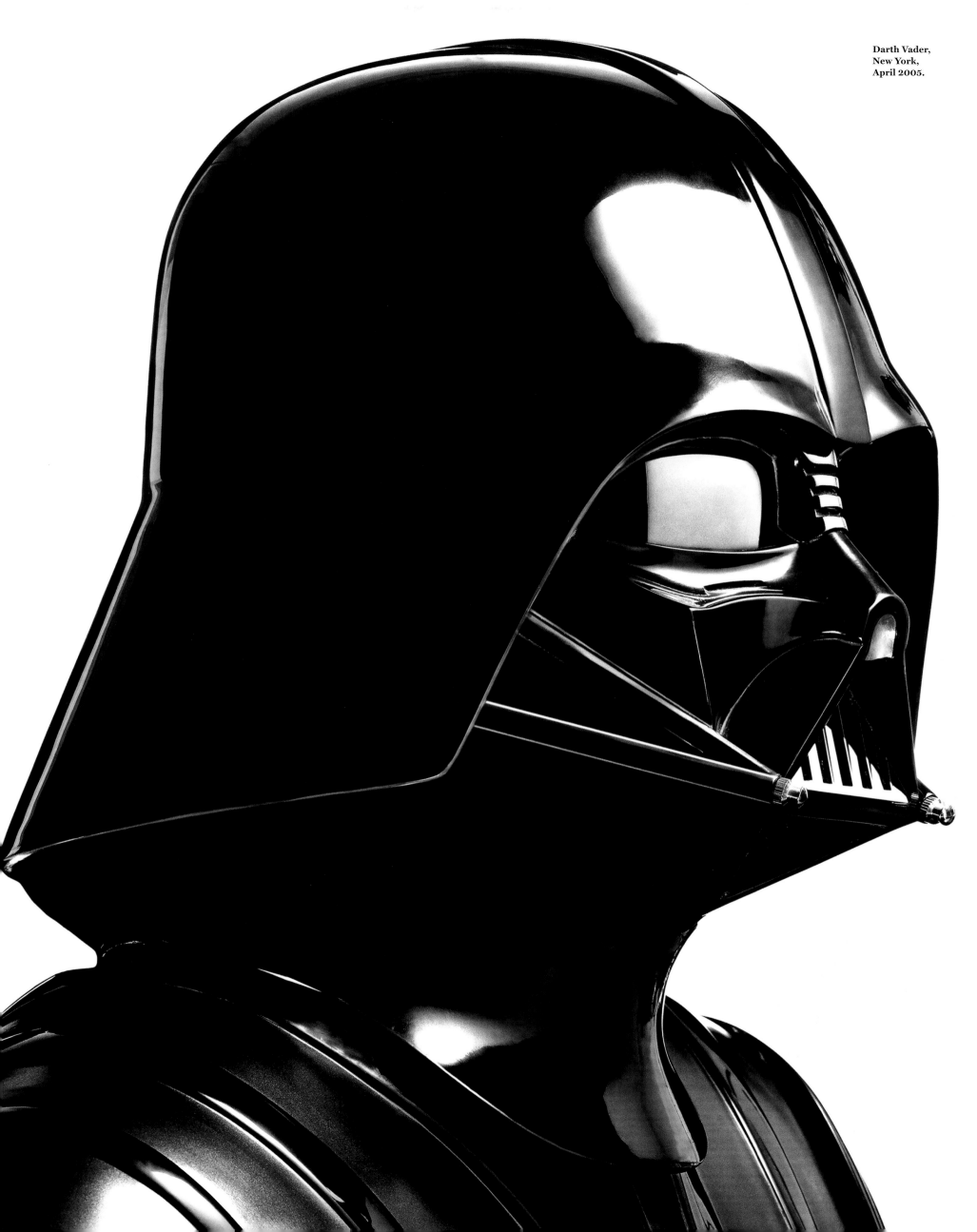

"I do suffer from depression, I suppose. Which isn't that unusual. You know, a lot of people do."

AMY WINEHOUSE, *"The Diva and Her Demons," RS 1028, June 14, 2007.*

Winehouse in Miami Beach, May 2007.

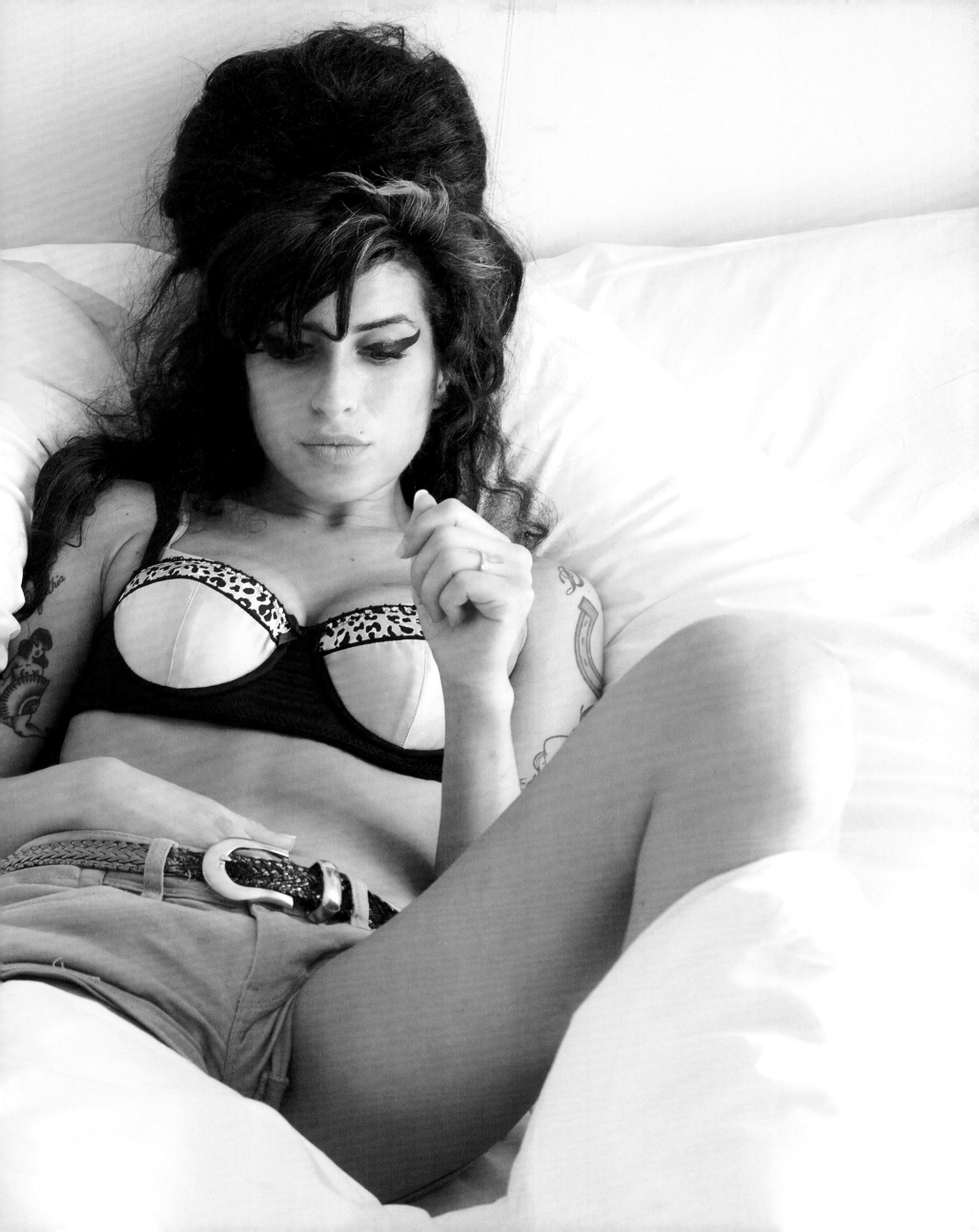

At the Dawn of Time

*In an eight-year project, photojournalist Sebastião Salgado sought
to capture the world before humanity altered it almost beyond recognition*

A MAN STANDS ON THE DECK OF A TWO-MASTED SHIP, FACing an iceberg so large it generates its own weather. He is on a quest to encounter the world as it was at the dawn of time – spending days on the wind-blasted seas surrounding Antarctica, or taking 50-day walks through the mountains of Ethiopia – and to deliver those visions to the viewer.

Sebastião Salgado's "Genesis" project – from which the pictures here are drawn – was an eight-year expedition to document nature as it was in the world before humans. From 2004 to 2011, Salgado, one of the world's greatest photojournalists, captured both the startling majesty of nature as well as the terrifying power of man to transform it. A photo of hundreds of thousands of penguins on the volcanic rock of Deception Island carries a story behind its beauty: "The number of penguins is so huge because

men have killed so many whales that came to feed in Antarctica," Salgado told ROLLING STONE in 2005. The whales eat plankton, or krill, as do the penguins. "With too much food, their population is really growing."

ROLLING STONE's collaboration with Salgado has spanned 19 photo essays across 17 years, with the magazine participating in two of Salgado's monumental projects – "Migrations," a seven-year effort that took him to more than 35 countries to record the displacement of people by war, natural disaster, environmental decay, population growth and economics; and "Genesis," for which he sought landscapes and people untouched by modernity, and discovered something unexpected: hope. "We have destroyed half the planet – but half the planet is just like it was the day it was created," he told ROLLING STONE in 2008. "I was shocked by this. We have to preserve these untouched, pristine areas. Half the planet is there yet."

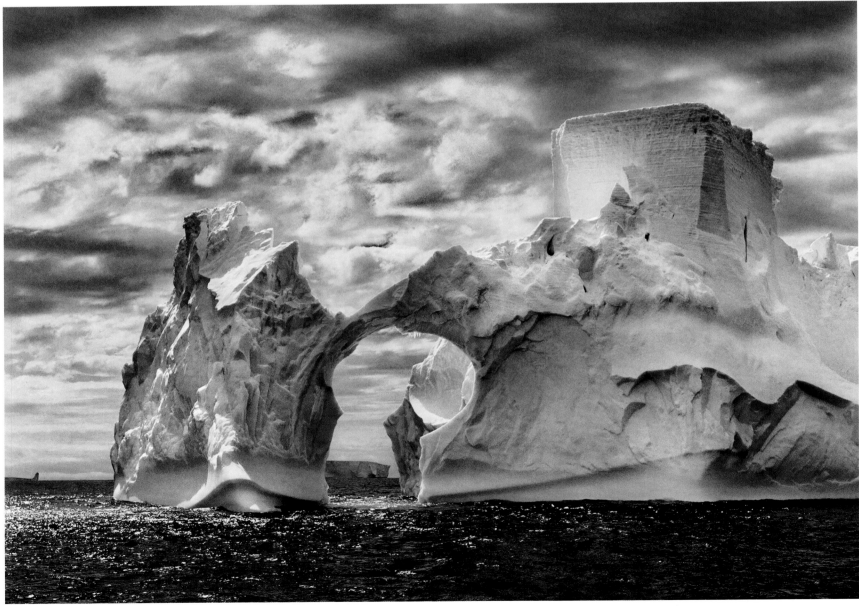

Sailing to Antarctica, Salgado encountered icebergs so huge they generated their own weather. "You have the impression of landing on another planet," he said.
Right: Hundreds of thousands of chinstrap penguins nest on Antarctica's Deception Island, a crescent-shape volcanic rock rising 1,890 feet out of the sea.

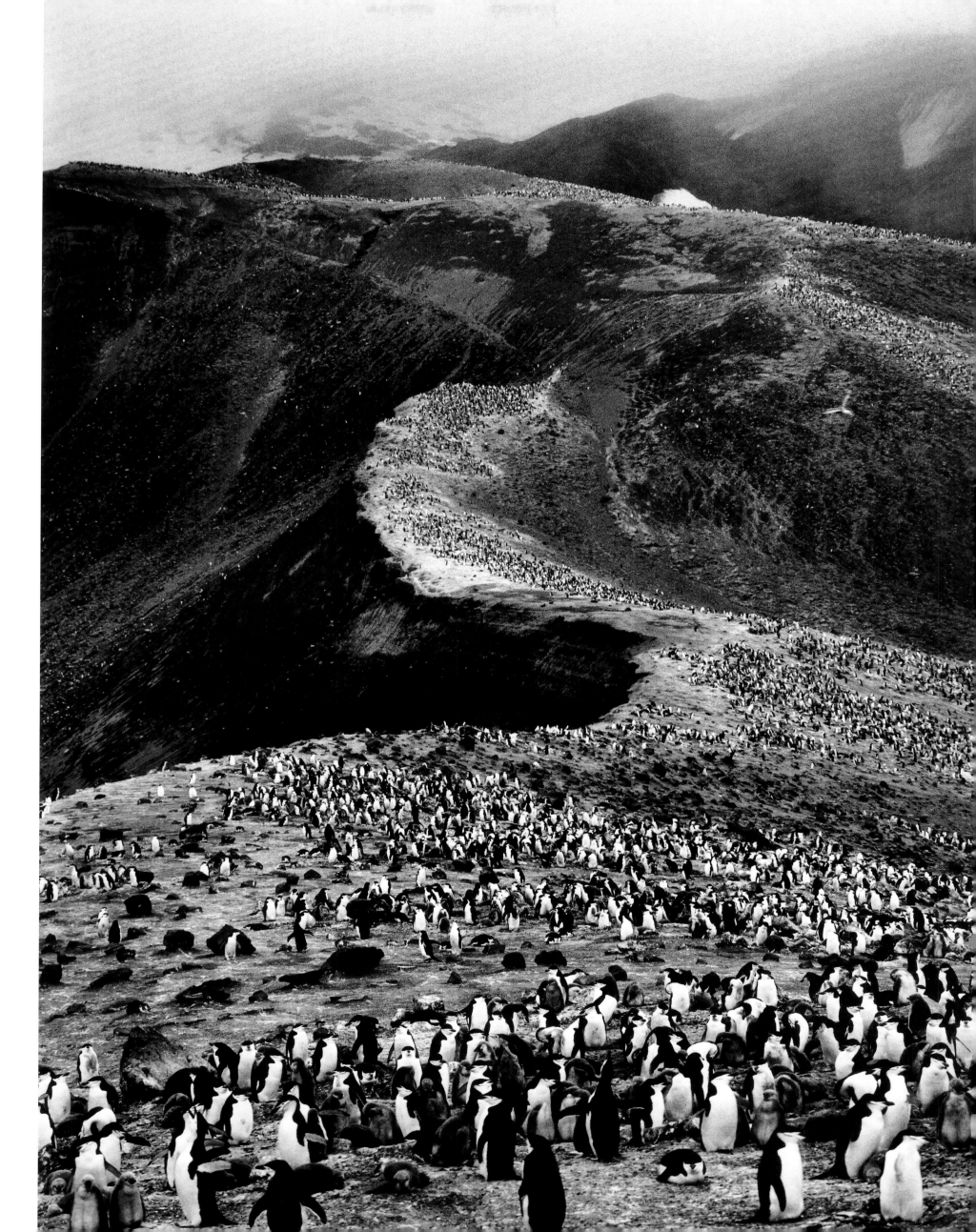

A young boy from the Dinka tribe in Sudan helps lead his clan's herd to a river. The Dinka live in camps of 300 people with more than 8,000 head of cattle.

Previous spread: Water drains off a right whale's tail, which can measure 20 feet wide and seven feet high. Salgado spent one and a half months in the waters off Patagonia photographing whales, which he called "the world's largest and most delicate creatures."

—

Right: A mass of marine iguanas – descendants of dinosaurs – in the Galápagos.

—

Left: In the Galápagos, a male giant tortoise greets a female during mating season. Driven almost to extinction by pirates, whalers and settlers in the 18th and 19th centuries, the tortoises can live for more than 150 years.

THE 2010s BROUGHT NEW URGENCY TO THE issue of climate change, which had long been part of ROLLING STONE's environmental coverage. An article on the vulnerability of Miami to sea-level rise shocked many when it began with a vision of an all-too-possible future that saw the city underwater, retaining its status as a vacation destination for those who wanted to snorkel through ruined hotels. "This is not a distant problem that we can keep putting off," President Barack Obama told the magazine in a cover story devoted to his crusade against climate change (the ninth time Obama had been on the cover). "This is something that we have to tackle right now." ¶ As ROLLING STONE closed in on its first half-century of publication, the mix of music, politics and popular culture that it pioneered in 1967 had come to define not just the world of magazines but the Internet as well. And yet ROLLING STONE's access and impact remained unparalleled. A profile of Gen. Stanley A. McChrystal found the top commander of the Afghanistan war unguarded and critical of the Obama administration, and immediately cost him his command. Lady Gaga brought the magazine into her backstage fortress of solitude, where she communed with pictures of Jimmy Page, Debbie Harry, the Sex Pistols, John Lennon and Elvis Presley before concerts. And in a profile of Taylor Swift, a ROLLING STONE reporter was in the passenger seat as the newly minted music icon got into not one but two fender benders. Just another day reporting – as the saying on the ROLLING STONE table-of-contents page puts it – "all the news that fits."

Previous spread: Adele, London, October 6, 2015.

"I don't freak out on the rock-star excess. When Nirvana got popular, I was renting a house with a friend. I had a futon, a lamp and a dresser for my clothes. Ten million records later, I was still in that back room with the futon, lamp and dresser."

DAVE GROHL, *"The Passion of Dave Grohl," RS 1223, December 4, 2014.*
—
Grohl in Malibu, 2014.

■

"I feel like watching my dating life has become a bit of a national pastime. And I'm just not comfortable providing that kind of entertainment anymore."

TAYLOR SWIFT, *"The Reinvention of Taylor Swift," RS 1218, September 25, 2014.*
—
Swift in Amagansett, New York, July 2014.

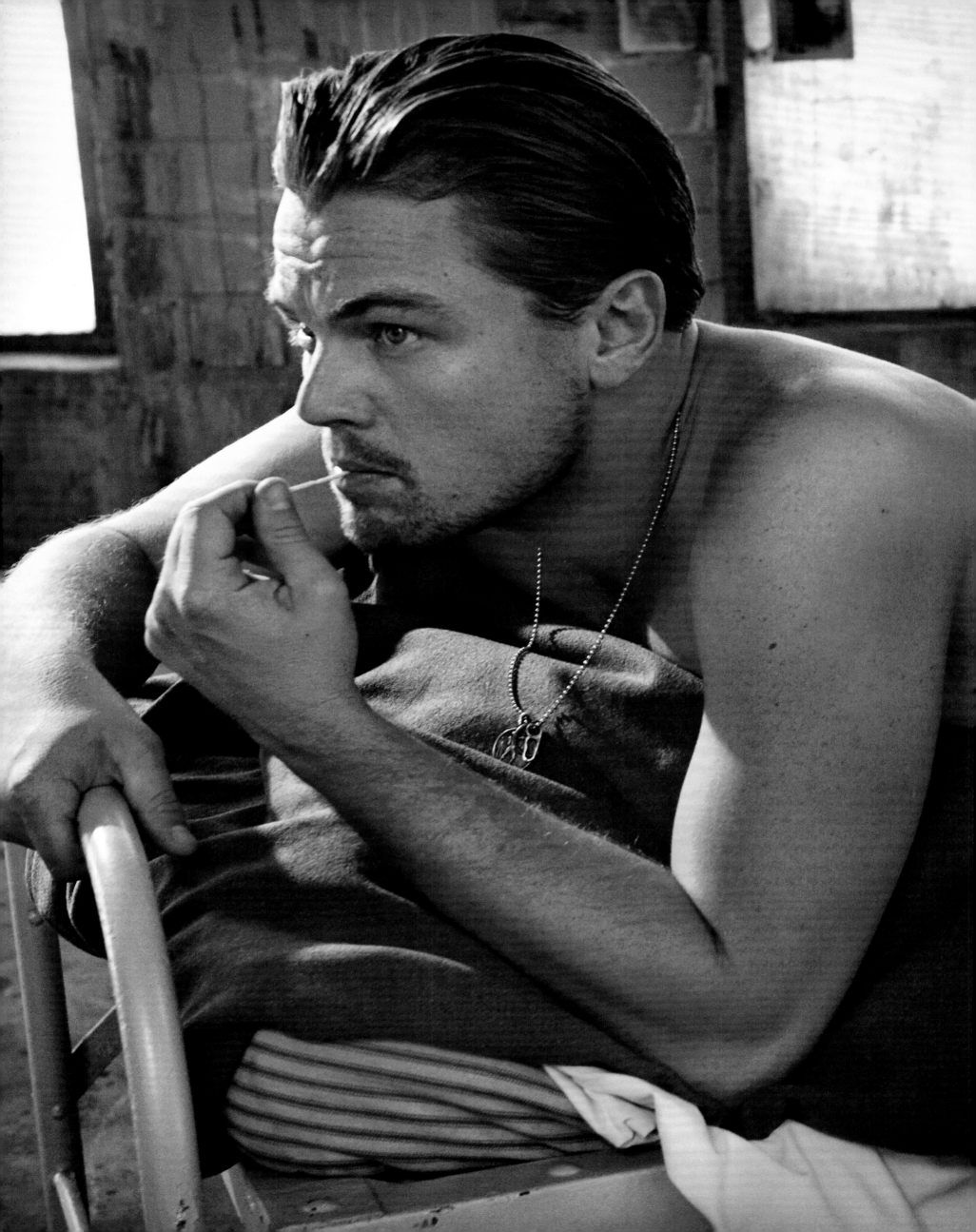

"I had a lot of fu
when I was you
It was pre-TMZ
I got to be wild
nuts, and I did
suffer as much
people do now
they have to p
so safe that th
their credibili

LEONARDO DICAPRIO, *"Le
Demons," RS 1110, August*
—
DiCaprio in Los Angeles

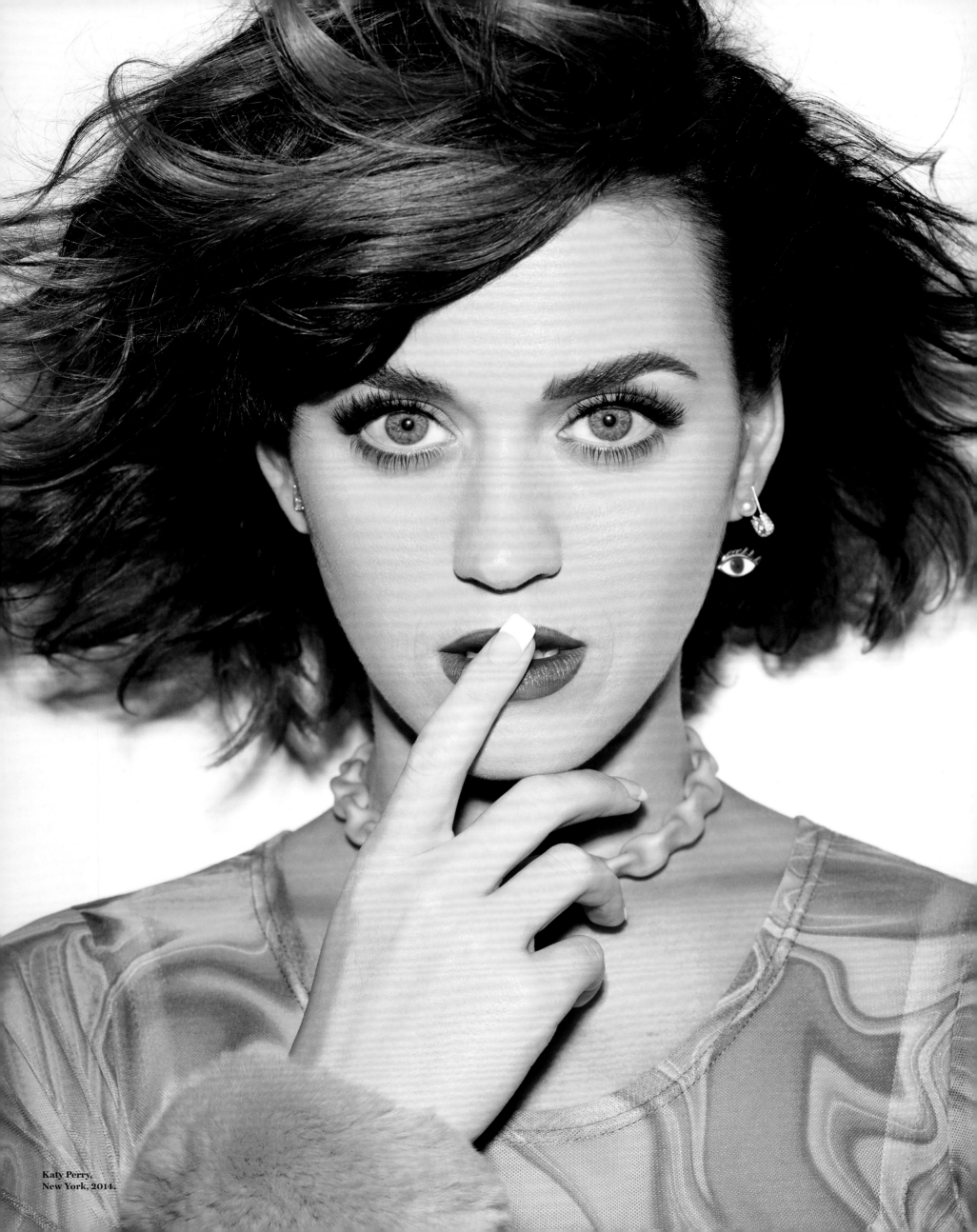

Katy Perry,
New York, 2014.

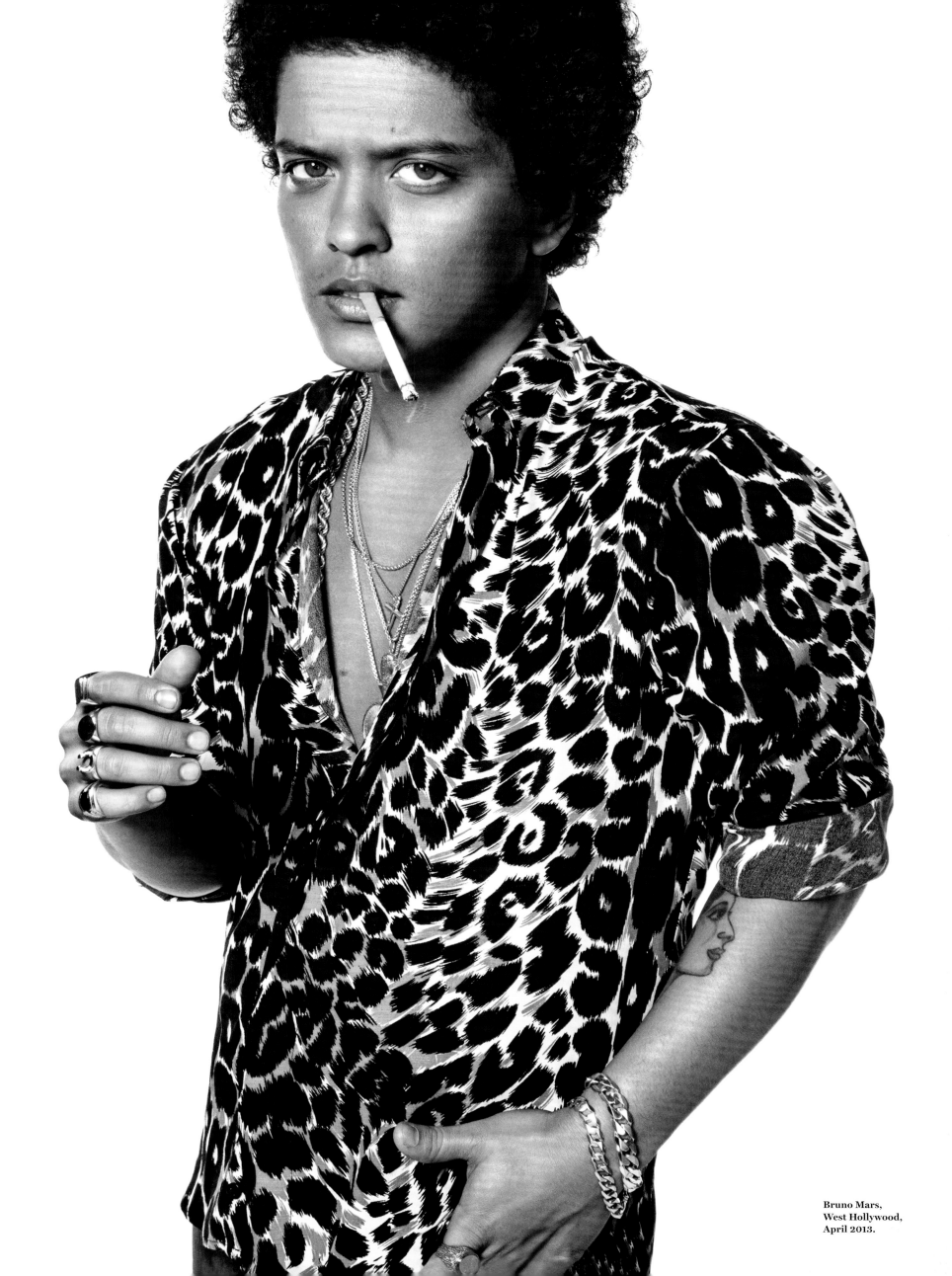

Bruno Mars,
West Hollywood,
April 2013.

The Trials of Kendrick Lamar

How the most exciting rapper in hip-hop became the voice of Black Lives Matter

RS 1231 • MARCH 26, 2015

When Josh Eells met Kendrick Lamar at a Compton burger stand in early 2015, Eells had heard only about half of the rapper's "To Pimp a Butterfly," but that was enough to know it would be a landmark release. It was set to arrive after a rash of deaths of young black men at the hands of police, and Eells probed deeply into both the album and Lamar's life: "The stuff about violence that he'd witnessed obviously came back, but it was of-the-moment and it didn't feel sensationalistic – 'Tell me about Compton! Tell me about the riots!' It very much informed the art he was making." By the end of 2015, "To Pimp a Butterfly" would become ROLLING STONE's album of the year, and something more: a soundtrack for the Black Lives Matter movement.

* * *

THERE'S A FAMOUS STORY from Tom Petty's childhood in which a 10-year-old Tom sees Elvis Presley shooting a movie near his hometown in Florida, takes one look at the white Cadillac and the girls, and decides on the spot to become a rock star. Kendrick Lamar has a similar story – but for him it's sitting on his dad's shoulders outside the Compton Swap Meet, age eight, watching Dr. Dre and Tupac shoot a video for "California Love." "I want to say they were in a white Bentley," Lamar says. "These motorcycle cops trying to conduct traffic, but one almost scraped the car, and Pac stood up on the passenger seat, like, 'Yo, what the fuck!'" Lamar laughs. "Yelling at the police, just like on his motherfucking songs. He gave us what we wanted."

Lamar, 27, has a lot of good memories of Compton as a kid: riding bikes, doing backflips off friends' roofs, sneaking into the living room during his parents' house parties. But being a rapper was far from pre-ordained. As late as middle school, he had a noticeable stutter. "Just certain words," he says. "It came when I was excited or in trouble." In seventh grade, an English teacher named Mr. Inge turned him on to poetry – rhymes, metaphors, double-entendres – and Lamar fell in love. "You could put all your feelings down on paper, and they'd make sense to you," he says. "I liked that."

Lamar flirted with the idea of going to college, but by the time he was in high school, he was running with a bad crowd. This is the crew he raps about on 2012's *good kid, m.A.A.d. City* – the ones doing robberies, home invasions, running from the cops.

Once, his mom found a bloody hospital gown, from a trip he took to the ER with "one of his little homeys who got smoked." Another time, she found him curled up in the front yard crying. She thought he was sad because his grandmother had just died: "I didn't know somebody had shot at him." One night, the police knocked on their door and said he was involved in an incident in their neighborhood, and his parents, in a bout of tough love, kicked him out for two days. "And that's a scary thing," Lamar says, "because you might not come back."

After a couple of hours in downtown Compton, the mood starts to shift. An ambulance roars by, sirens blaring. In the middle of the street, a homeless man is shouting at passing cars. Lamar starts to grow uneasy, his eyes glancing toward the corners. I ask if everything's OK. "It's the temperature," he says. "It's, uh, raising a little bit." A few minutes later, one of his friends calls out, "Rollers!" and two L.A. County sheriff cruisers round the corner. "There they go," Lamar says, as they hit their lights and take off.

As a teenager, "the majority of my interactions with police were not good," Lamar says. "There were a few good ones who were protecting the community. But then you have ones from the Valley. They never met me in their life, but since I'm a kid in basketball shorts and a white T-shirt, they wanna slam me on the hood of the car." He nods toward the street. "Right there by that bus stop. Even if he's not a good kid, that don't give you the right to slam a minor on the ground, or pull a pistol on him."

Lamar says he's had police pull guns on him on two occasions. The first was when he was 17, cruising around Compton with his friend Moose. He says a cop spotted their flashy green Camaro and pulled them over, and when Moose couldn't find his license fast enough, the cop pulled a gun. "He literally put the beam on my boy's head," Lamar recalls. "I remember driving off in silence, feeling violated, and him being so angry a tear dropped from his eye." The story of the second time is murkier: Lamar won't say what he and his friends were up to, only that a cop drew his gun and they ran. "We was in the wrong," he admits. "But we just kids. It's not worth pulling your gun out over."

Friends of his weren't so lucky. Just after midnight on June 13th, 2007, officers from the LAPD responded to a domestic-violence call five minutes from Lamar's house. There they found his good friend D.T. allegedly holding a knife. According to police, D.T. charged, and an officer opened fire, killing him. "It never really quite added up," Lamar says. "But here's the crazy thing. Normally when we find out somebody got killed, the first thing we say is 'Who did it? Where we gotta go?' It's a gang altercation. But this time it was the police – the biggest gang in California. You'll never win against them."

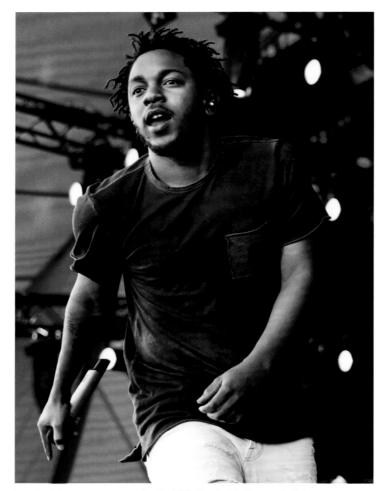

Kendrick Lamar onstage at the Roskilde Festival in Denmark, July 2015.

Taylor Swift Crashes the Party

She was on the verge of jumping from country to pop stardom – and wrecking her car

RS 1168 • OCTOBER 25, 2012

When *Taylor Swift crashed her SUV on a hot Nashville night in the summer of 2012 – with a* Rolling Stone *writer in the passenger seat – the singer had a lot on her mind. She was 22 and on the verge of releasing "Red," the album that would catapult her to pop stardom. "She was grappling with understanding that she had a rough road ahead," says senior writer Brian Hiatt. "This was someone who was holding on tight." For the first time in her career, Swift was the target of criticism – about her singing voice, her romantic life, her authenticity. "The whole car crash showed me she wasn't exactly who people believed she was," Hiatt says. "I don't think she's an evil Machiavellian schemer. She's just terrified of things slipping out of control."*

* * *

This is what it sounds like when Taylor Swift totally loses it: "Oh, my God. OH, MY GOD. OH, MY GOD. OH, MY GOD. OH, MY GOD. OH, MY GOD. OH, MY GOD. OH, MY GOD. OH, MY GOD. OH, MY GOD. OH, MY GOD."

Her summer tan is turning ashen; her very blue eyes are practically pinwheeling with panic. But she didn't do anything *that* bad just now, didn't start a nuclear war or curse on country radio or upload her new album to BitTorrent: We're on a bleak industrial road outside a Nashville rehearsal studio one stiflingly hot late-August evening, with Swift behind the wheel of her black Toyota SUV – which she just backed directly into a parked car.

She's never learned to use her SUV's built-in GPS, was messing with Yelp and Google Maps on her iPhone instead, realized she was going the wrong way, started to turn around, still clutching the phone, and…*crunch.*

"Oh, my God," she repeats, pausing for air. She takes another look at the car she hit. "Oh, is that my bass player?"

It totally is. "It's fine, it's my bass player!" She couldn't look more relieved if she had received a death-row pardon. Popping out of the SUV, she apologizes to her bemused employee, a Ben Stiller look-alike named Amos Heller, who had been walking toward his now slightly dented car. "I'm gonna pay for it, I promise! I'm good for it! Oh, my God, Amos, I'm so sorry. I freaked out 'cause I went the wrong way and he was gonna think I'm a bad driver and then I backed into another car. This is the worst interview he's ever had, already!"

The moment she crashed, she pictured herself being taken away

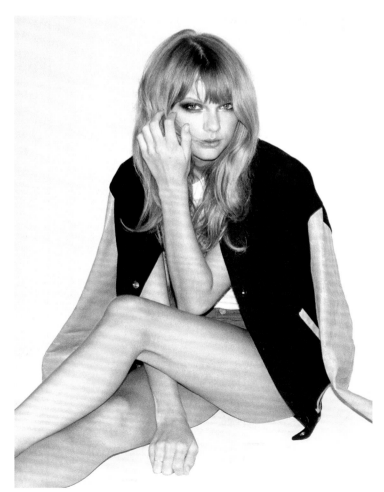

Taylor Swift in New York, August 2012.

in handcuffs, sitting in jail in her blue polka-dot shirtdress. "I have a lot of anxieties that end in me being put into a police car," she says, ponytail bopping as she shakes her head. "I am so, like, rules, and not getting into accidents. So this is perfect."

It's somehow not surprising to learn that Swift had her first drink ever on her 21st birthday. "I knew I couldn't get away with it until then," she says the night before, sipping a Diet Coke through a little red straw that matches her lipstick. We made it into the restaurant without fuss, except for a pigtailed little girl who gaped with I-just-saw-the-Easter-Bunny joy. "I didn't really care to know what I was missing, and I knew it was illegal, and that my luck would be that I'd get caught. And then you think about all the moms and little girls who would have thought less of me. I'm still not much of a drinker, but I'll have a glass of wine every once in a while." And has she gotten drunk? "I'm not gonna talk about that! No one wants to picture that!"

It can't be easy, living like this. Her buddy Selena Gomez recalls going out to dinner with Swift when she noticed another patron eavesdropping. "She got startled that they were listening," Gomez says, "and she got nervous, and then the person left and she felt awful. She was like, 'I hope he didn't leave because of me. I hope he doesn't think I'm mean. Do you think he's going to tell everyone I'm mean?' She cares so much."

Swift has recurring anxiety dreams, and, predictably enough, one of them involves being arrested for something she didn't do. "I keep trying to tell them that I didn't do anything," she says, "and they won't listen, or my voice doesn't work."

Another one is quite vivid. "I'll be in a room with piles of clothes all over the floor, and I can't clean it. It makes me wish I could clean it, 'cause I love cleaning. But the piles get bigger, or there's piles on the ceiling, and I don't even know how that's possible."

She knows what that one's about. "I think I have a big fear of things spiraling out of control," she says. "Out of control and dangerous and reckless and thoughtless scares me, because people get hurt. When you say 'control freak' and 'OCD' and 'organized,' that suggests someone who's cold in nature, and I'm just not. Like, I'm really open when it comes to letting people in. But I just like my house to be neat, and I don't like to make big messes."

At 22, Swift is always waiting for her luck to run out. "I'm terrified that, like, something's going to happen," she says, "and I'm not going to be able to do this anymore and it's gonna all end in one day. Part of the fear comes from loving this so much and not wanting to lose it."

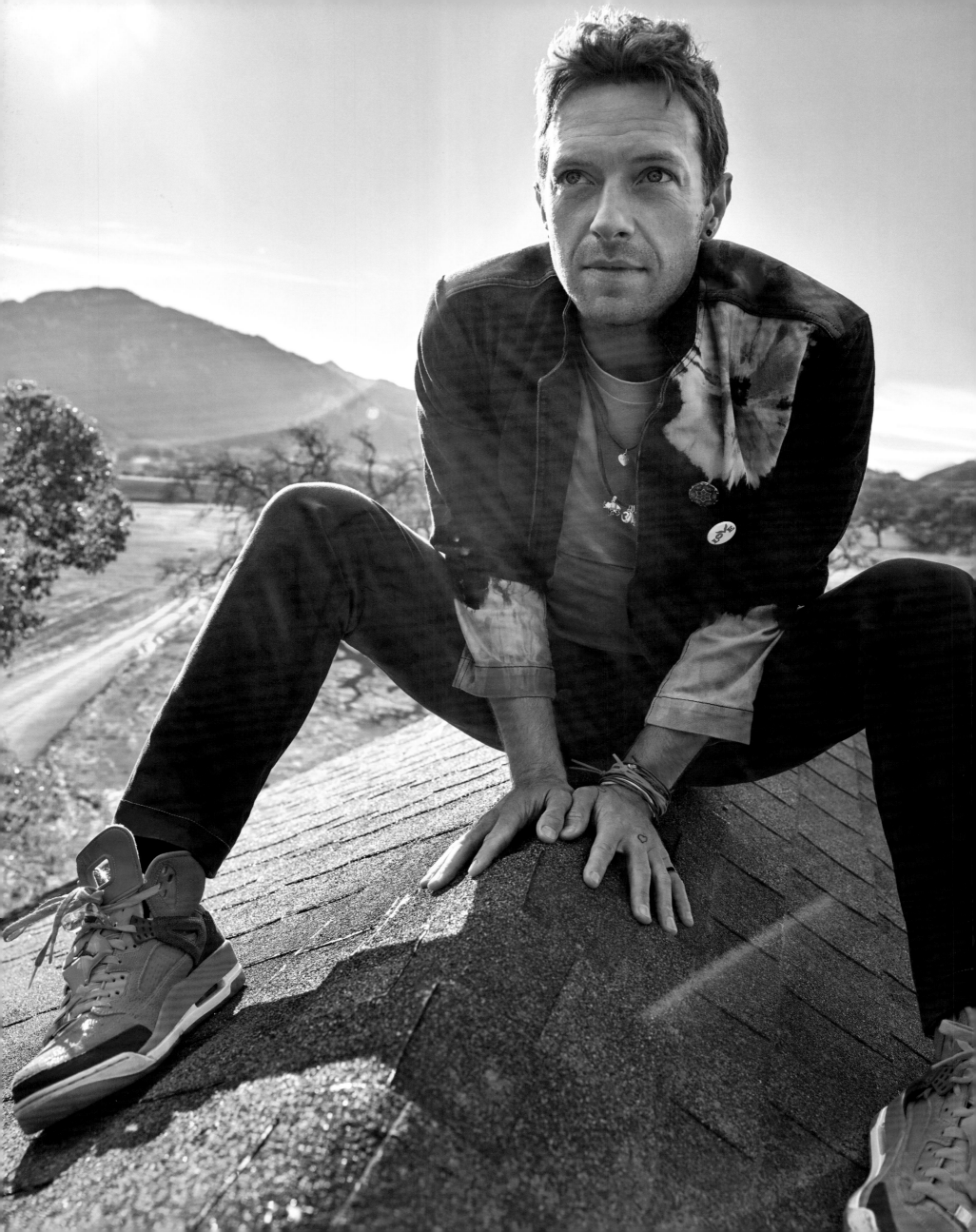

Chris Martin in
Westlake Village,
California,
January 2016.

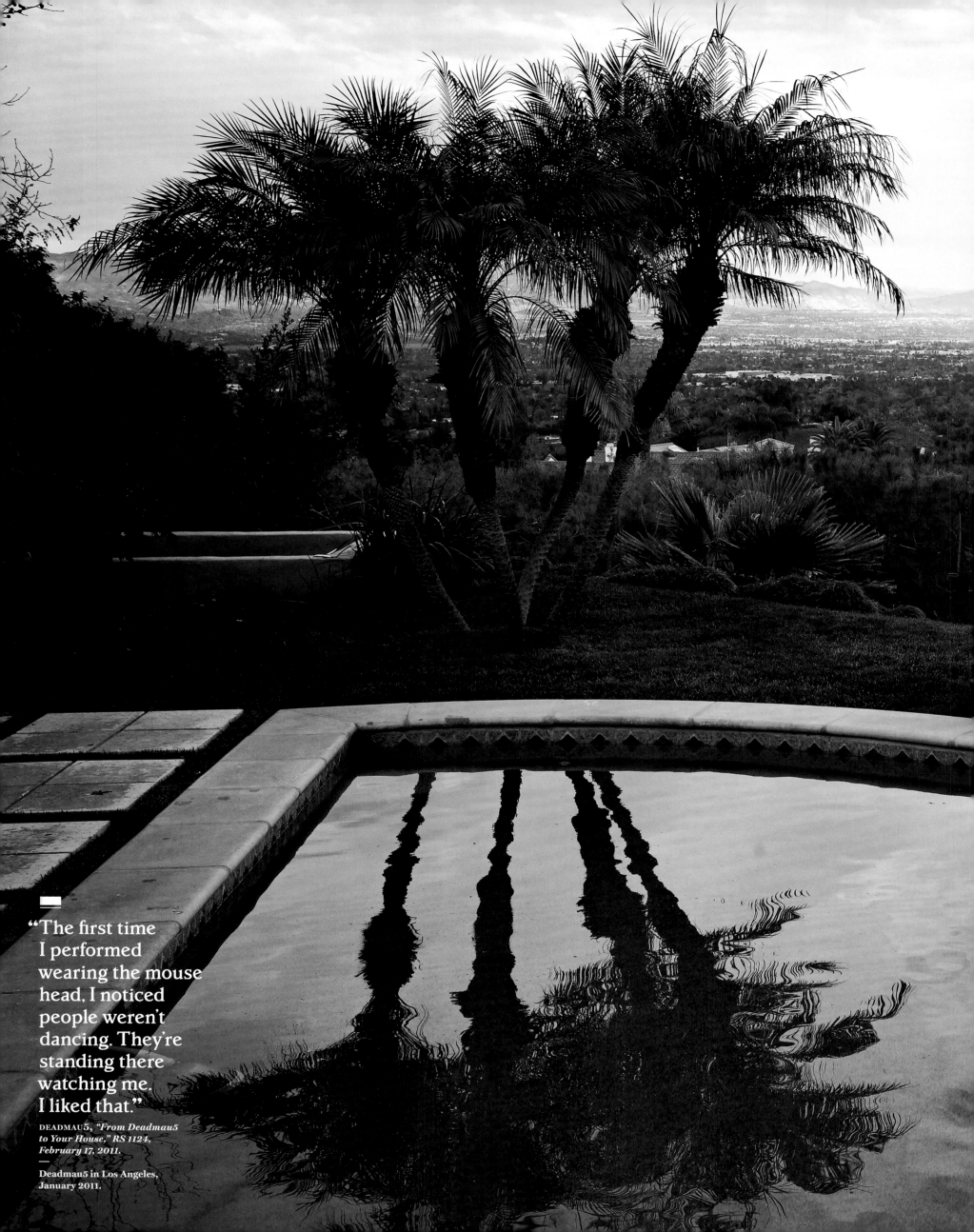

"The first time I performed wearing the mouse head, I noticed people weren't dancing. They're standing there watching me. I liked that."

DEADMAU5, *"From Deadmau5 to Your House," RS 1124, February 17, 2011.*
—
Deadmau5 in Los Angeles, January 2011.

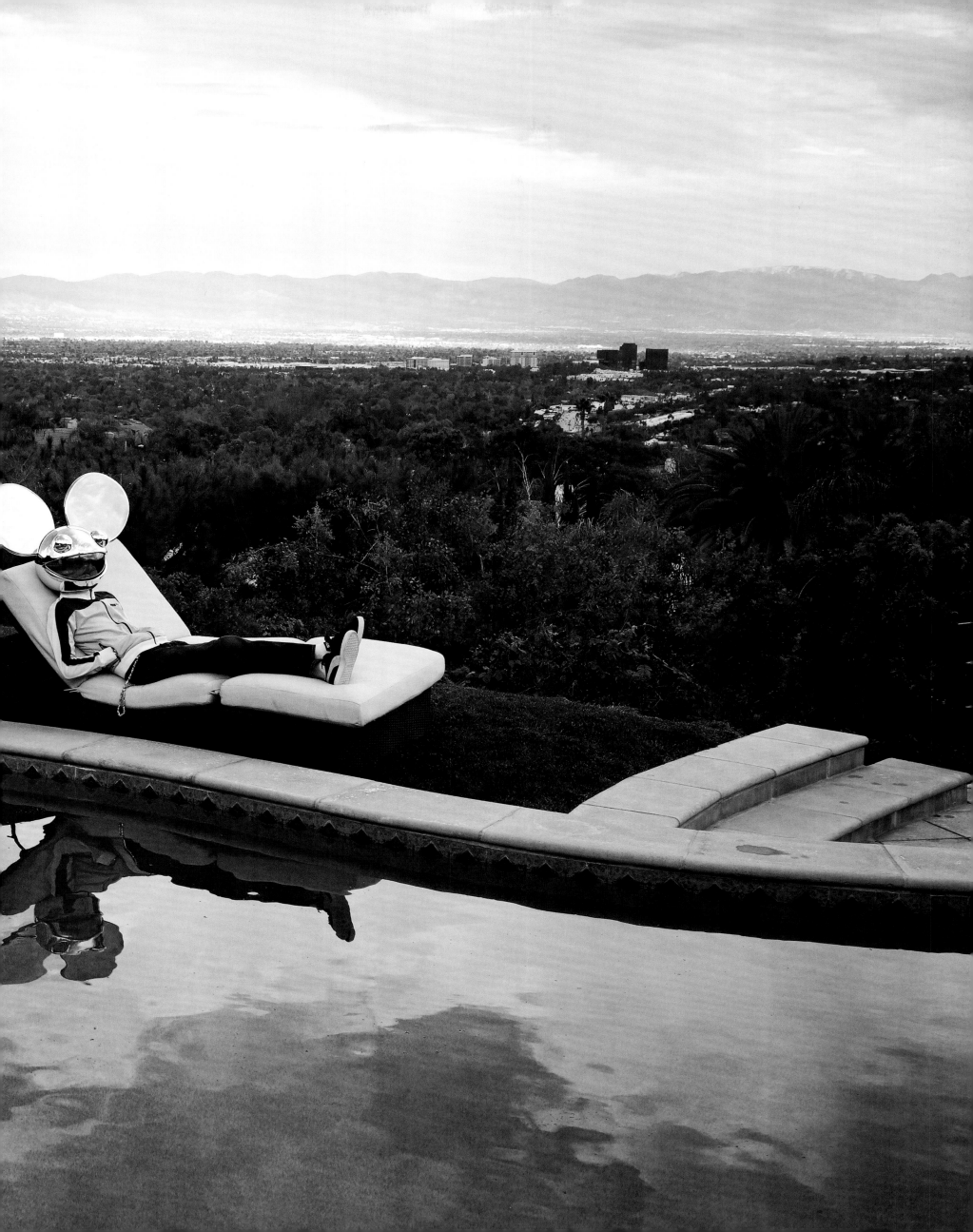

"I don't think of
myself as powerful.
If anything, my fans
are powerful. It's
all in their hands.
If they don't buy my
albums, I go away."

JUSTIN BIEBER, *"The Adventures
of Super Boy," RS 1125, March 3, 2011.*
—
Bieber in Los Angeles, January 2011.

Four-Star Loose Cannon

A profile of the commander of American forces in Afghanistan shook national policy

RS 1108/1109 • JULY 8-22, 2010

I T IS THE HOPE OF EVERY WRITER AND EDITOR THAT THEIR WORK will have an impact – uncover new truths, change opinion. But few articles have the kind of impact that "The Runaway General," by Michael Hastings, did. The story reached into the Oval Office and changed the course of national policy within 48 hours.

It was the first piece Hastings wrote for ROLLING STONE. He had a background as a war correspondent that ran deep, both professionally and personally. He had covered the war in Iraq for *Newsweek*, and his younger brother had served there. What's more, Hastings had suffered a devastating loss when his fiancee, while working for a nonprofit in Baghdad in 2007, was killed in a botched kidnapping.

When Hastings first met with the editors of ROLLING STONE in 2010, discussion turned to the war in Afghanistan, which had already taken the lives of more than 1,000 U.S. troops and cost billions, yet seemed on the verge of being forgotten. Gen. Stanley McChrystal was the top commander of American forces in Afghanistan. President Obama preferred a limited number of deployed troops, while McChrystal wanted more boots on the ground – and that tension was indicative of the muddled state of the war. "We saw the perfect way to say something about the war through a profile of the guy who was leading it," says then-executive editor Eric Bates, who worked with Hastings on the piece. "Most people didn't know anything about McChrystal."

Getting access to McChrystal proved to be strangely simple: Hastings e-mailed the general's PR contact and was soon on a plane heading to Paris for an interview. ("I always said they'd give us access because they'd want to recruit our readers," Bates says dryly.) That invitation was the first of many surprises. Almost immediately after he landed, Hastings was invited to McChrystal's wedding-anniversary party, where he witnessed soldiers and various advisers in a boozy setting. "It was a very powerful moment just to see the people who are really shaping the policy of this war in a setting that…at least, I had never seen them in such a setting before," Hastings recalled later. When a volcano eruption in Iceland grounded flights across Europe for nearly a week, Hastings had even more access than first anticipated and spent a month following McChrystal and his inner circle to Berlin, Kandahar and then back to Washington, D.C.

McChrystal was known as a loose cannon, and he didn't disappoint. Hastings captured scenes in which the general and his staff mocked Vice President Joe Biden. And though the general didn't speak critically of the commander in chief, sources told Hastings that McChrystal had felt Obama was "uncomfortable and intimidated" when the president first met with a dozen senior military officials a week after he'd taken office. The article was a blunt and damaging demonstration of the disconnect between the White House and the military leadership in Afghanistan.

Bates recalls, "Michael started calling and saying, 'You won't believe what I'm getting' and reading me some of the notes." Thanks to Hastings' access and old-fashioned reportorial legwork, "The Runaway General" gave readers an unprecedented look into the upper echelons of military power, a view of the war even many troops don't see. Hastings also traced McChrystal's reckless behavior back to his days at West Point and offered up a biting critique of counterinsurgency, a strategy championed by McChrystal that would, sadly, prove to be even more of a quagmire than Vietnam.

Then came publication day. "I knew I had very strong material, but I did not know what the impact was going to be," Hastings said later. "I figured it would…maybe give General McChrystal and his team a headache for a couple of days, and then it would be swept under the rug." That would prove to be an understatement. An early copy of the story was given by a media outlet to the Obama administration. What followed was, as McChrystal himself put it, "a firestorm."

McChrystal was immediately summoned to Washington to meet with Obama. As Jann S. Wenner and Bates quietly watched on a TV in Bates' office, Obama announced that McChrystal was resigning his command: "The conduct represented in the recently published article does not meet the standard that should be set by a commanding general," Obama said. McChrystal apologized for his remarks, saying his interviews were "a mistake reflecting poor judgment and should never have happened."

Some media outlets questioned whether Hastings' reporting was on the record. (It was, and both the magazine and Hastings stood by his reporting and his sources.) Without interviewing Hastings or McChrystal, the Department of Defense conducted an investigation that cleared McChrystal of wrongdoing and challenged the accuracy of the ROLLING STONE story. "The report by the Pentagon's inspector general offers no credible source – or indeed, any named source – contradicting the facts as reported in our story," the magazine responded. "Much of the report, in fact, confirms our reporting, noting only that the Pentagon was unable to find witnesses 'who acknowledged making or hearing the comments as reported.' This is not surprising, given that the civilian and military advisers questioned by the Pentagon knew that their careers were on the line if they admitted to making such comments."

"The Runaway General" received a George Polk Award for magazine reporting. Hastings became a ROLLING STONE contributing editor, writing about McChrystal's successor, Gen. David Petraeus, and interviewing Julian Assange, the founder of WikiLeaks. Tragically, Hastings died in a 2013 car accident in Los Angeles at age 33. His legacy – and that of "The Runaway General" – is lasting and historic. "It was a real reminder of the power and importance of journalism," says Bates, "and its place in civil society and in holding the powerful accountable."

McChrystal works aboard a C-130 between battlefield visits, March 2010.

The Water Next Time

Global warming meant rising sea levels – and a foreboding forecast for Miami

RS 1186/1187 · JULY 4-18, 2013

I T BEGAN WITH A CHANCE REMARK. JEFF GOODELL'S REPORTING on climate change had helped put ROLLING STONE in the forefront of environmental journalism, and in the wake of Hurricane Sandy, in 2012, Goodell began looking for a way to cover the disaster and its aftermath. He was talking with a climate scientist at Columbia University when an offhand comment gave rise to a story. "You know, this has been devastating," the scientist told him. "But thank God we're not Miami. Miami is completely fucked."

Goodell's earliest assignments for ROLLING STONE, in the Nineties, had focused on Silicon Valley – he'd done in-depth interviews with Steve Jobs and Barry Diller and written a powerful piece about homeless shelters in that dot-com-rich area. But a research trip to a coal mine in West Virginia for another publication in 2001 changed things. There, he made the connection between electrons in computer technology and burning coal, and afterward he began concentrating on environmental and climate issues for ROLLING STONE, including important features on fracking and the Keystone pipeline. "The environment is part of the consciousness of this generation," Goodell says of millennials. "You couldn't write about rock & roll and this generation without thinking about environmental issues."

The issue became more pressing as global warming spiraled out of control, but ROLLING STONE had a long history of serving as a watchdog on matters relating to the planet and its health. A 1969 report on "The Environmentalists" detailed the rise of new-wave thinkers like Stewart Brand and the influential *Whole Earth Catalog*, and a prescient 1975 report identified the depletion of the ozone layer as "the first order of the apocalypse." The magazine regularly addressed climate change, corporate polluters and other threats to the planet, with contributors including Vice President Al Gore and leading environmental journalist Bill McKibben.

"This is probably the most important story of our time – how the human race is going to respond to this threat that's going to impact life on the planet for generations," says former managing editor Will Dana, who oversaw many of these stories. "How could we not be writing about this and sounding the alarm? It would have been irresponsible not to give that subject as much space as we did."

For Goodell, the angle for a story on Miami's future was frighteningly clear: the potentially ruinous impact of rising sea levels on South Florida's mecca for sun and pleasure and the way it served as a warning bell for climate change and mankind's lack of preparedness for it. "Miami is the canary in the coal mine for a lot of what's happening, not just in the state but in the world," he says. "What is going to happen to a city like Miami when the sewers start flooding the streets and drinking water goes away? Who is going to fix the roads? How are we going to deal with this? You can't just build a wall. Miami is one of the first places where it's going to play out."

During several research trips to the state, Goodell saw for himself Miami's lack of vigilance. Driving across the Venetian Causeway to Miami Beach on his first visit, Goodell looked over Biscayne Bay and saw high-rises alongside the low-level road. "There was all this money perched on the water, sitting there defenselessly," he says. "You could imagine a couple of big storms and how vulnerable this whole place was." On the same trip, he encountered several feet of water on the streets of Miami Beach. "This was not from a hurricane or storm," he says. "It was just tide. It was stunning."

Miami Beach, Goodell wrote, had hired an engineering firm to come up with a $200 million storm-water plan to keep the city dry for the next 20 years. It planned for six inches of sea-level rise, though most scenarios called for more. Worse, a visit to North Miami showed how vulnerable the canals protecting Miami's drinking water were – and sea levels there had already risen nine inches in the 50 years since the canals had been built.

Florida Gov. Rick Scott was a climate-change denier. He had ordered the state's Department of Environmental Protection not to use the phrases "global warming" and "climate change." The developers building multimillion-dollar condominiums needed this denial to hold, or real estate would lose its value. "Miami is all about instant gratification and pleasure," Goodell says. "There are no cultural institutions that are thinking long-term."

Miami was the bellwether of the climate-change threat. "London, Boston, New York and Shanghai are all vulnerable, as are low-lying underdeveloped nations like Bangladesh," Goodell wrote. To bring home how destructive – and very possible – the danger was, Goodell came up with a new opening section at the last minute: the fictional depiction of Miami as a hurricane hits in 2030, after an all-too-plausible sea-level rise of one foot. "In South Beach, the old art-deco buildings were swept off their foundations," he wrote. "A 17-mile stretch of Highway A1A that ran along the famous beaches up to Fort Lauderdale disappeared into the Atlantic. The storm knocked out the wastewater-treatment plant on Virginia Key, forcing the city to dump hundreds of millions of gallons of raw sewage into

The Miami skyline, which faces submersion due to climate change.

Biscayne Bay. Tampons and condoms littered the beaches, and the stench of human excrement stoked fears of cholera." He imagined a future in which Miami was still a tourist attraction, but as "a popular snorkeling spot where people could swim with sharks and sea turtles and explore the wreckage of a great American city."

"Goodbye, Miami" received extensive media coverage and spawned many other articles about the city's waterlogged future. "There's something sexy about Miami that captures people's imagination," Goodell says. "I had written a big piece about the risks of climate change in Australia, but this one for some reason captured it all."

The reason, Goodell says, is as simple as it is potentially devastating: "Climate change has grown beyond environmental issues. It's now a civilization issue."

"All this strangeness? I wouldn't have a music career without it. But I am at odds with myself.... I have not had a woman appear in my dreams sexually without a paparazzi in the dream too."

JOHN MAYER, *"The Dirty Mind and Lonely Heart of John Mayer," RS 1097, February 4, 2010.*

Mayer in Los Angeles, January 2010.

"I'm very selfish. I make everything for me. I mean, every little thing, down to the guitar and the drums. It's just for me. I want to hear it, I want to drive to it, I want to swim in the ocean to it."

LANA DEL REY, *"Vamp of Constant Sorrow," RS 1214, July 31, 2014.*

—

Del Rey in Los Angeles, June 2014.

Florence Welch,
London, 2011.

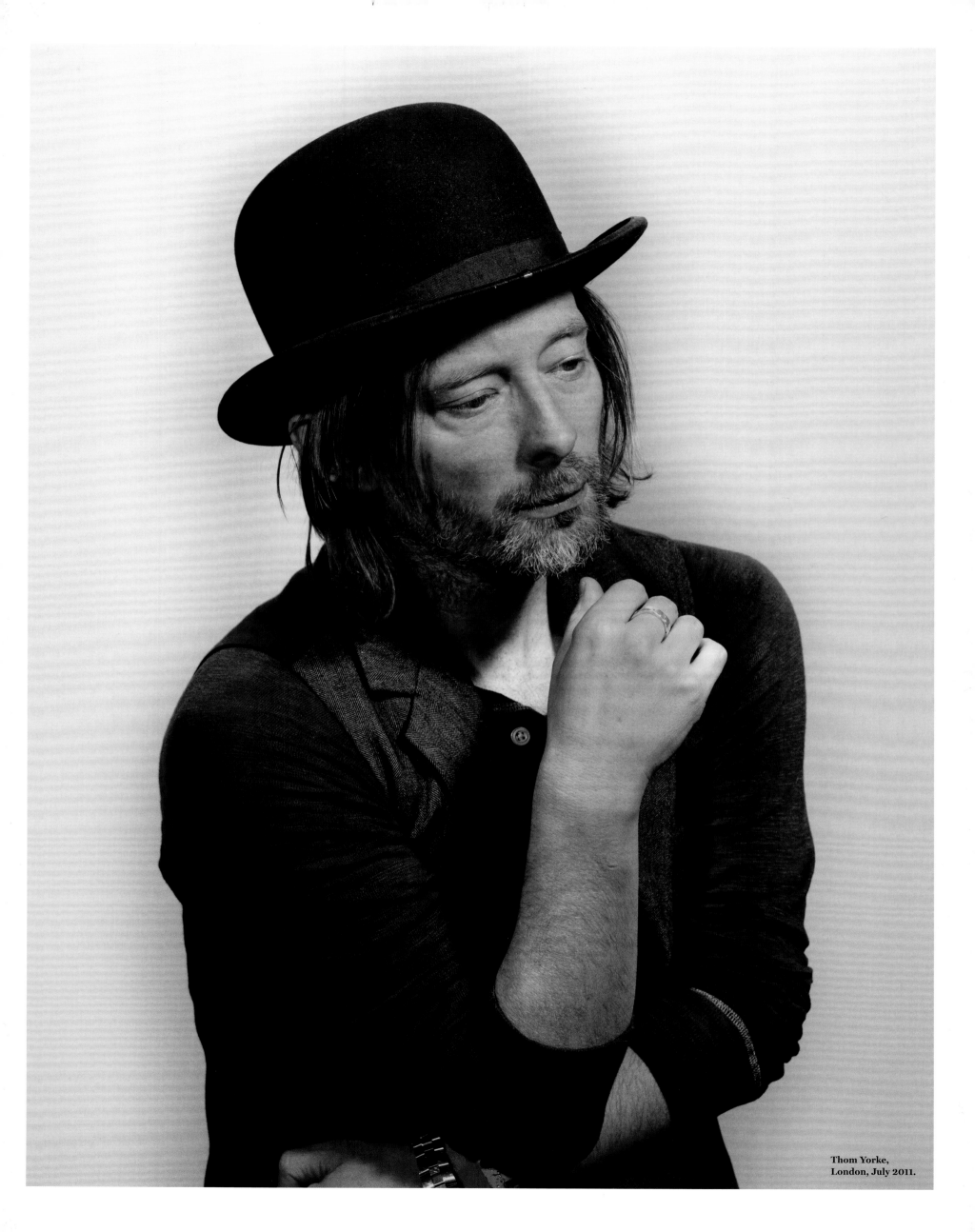

Thom Yorke,
London, July 2011.

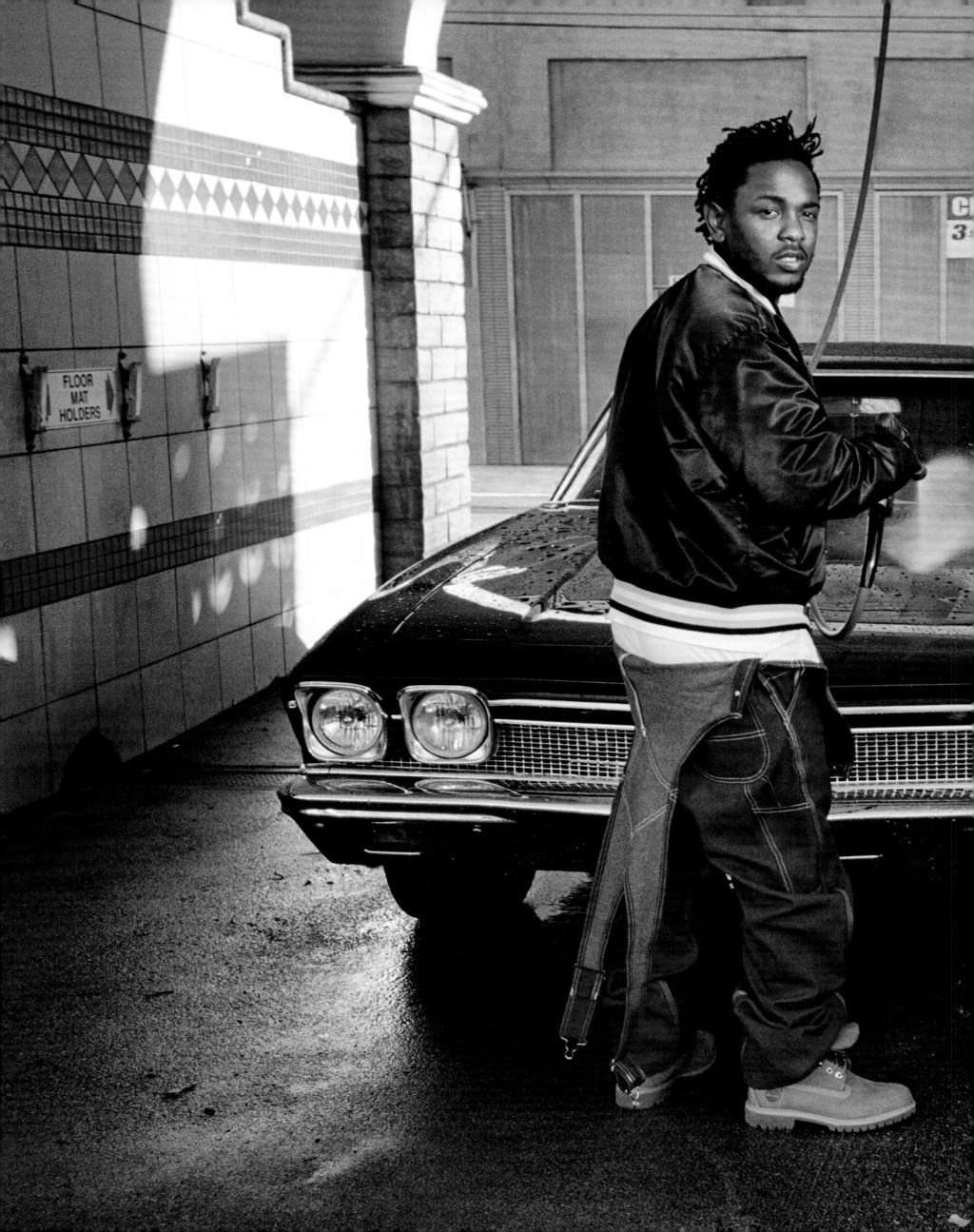

Storage
ONTH FREE
469-1402

"I've wo
the m
felt li
guilty
Feeli
a kid
you
succ
and
your

*KENDRI
of Ken*
March

— **Lamar**

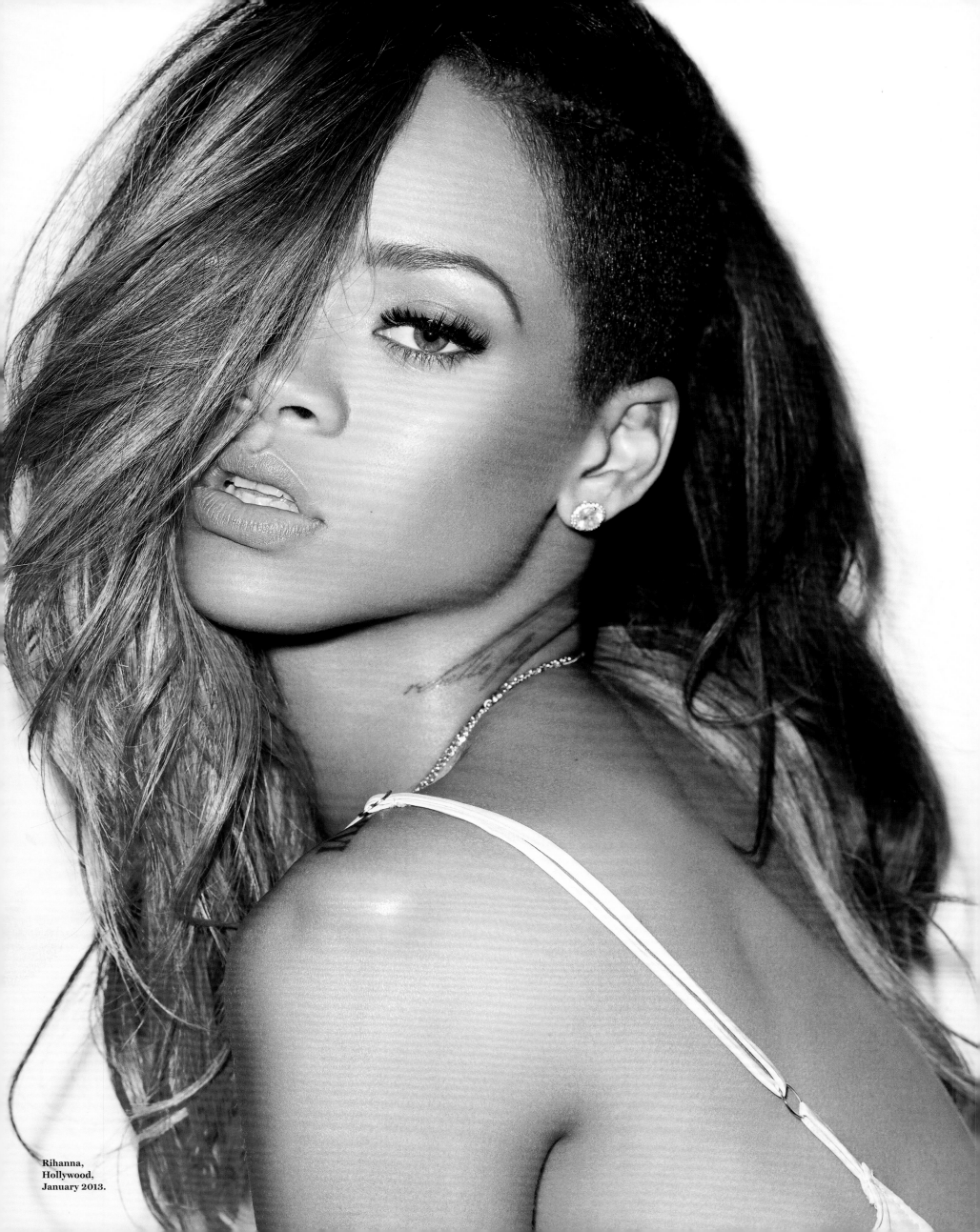

Rihanna,
Hollywood,
January 2013.

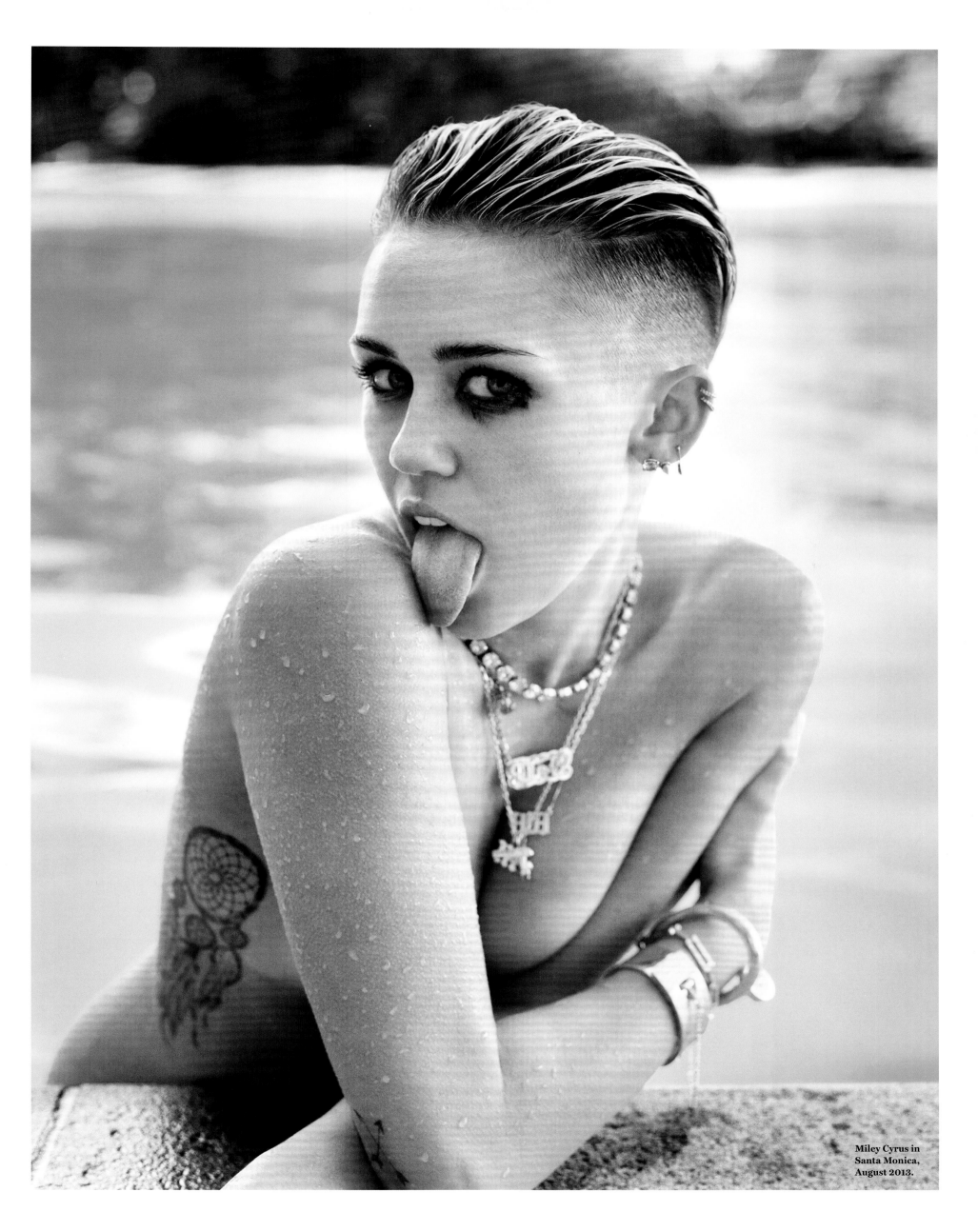

Miley Cyrus in
Santa Monica,
August 2013.

Dan Auerbach (left)
and Patrick Carney of
the Black Keys, Akron,
Ohio, April 7, 2010.

The Monster Goddess

As Lady Gaga put finishing touches on 'Born This Way,' she changed the formula that made her famous

RS 1132 · JUNE 9, 2011

When senior writer Brian Hiatt caught up with Lady Gaga in April 2011 for her third ROLLING STONE cover story, she was finishing her 203-date Monster Ball world tour and her new album, "Born This Way." The previous three years had been a whirlwind: 10 top singles; a parade of boundary-breaking outfits made of meat, feathers or plush toys; and a legion of fans known as "little monsters" who emulated her by finding strength in their own idiosyncrasies. Gaga was just 25, already an icon, and coping with tremendous pressure, external and internal. "I had written Gaga's first cover story, and we'd gotten along really well," says Hiatt. "So I ended up getting pretty incredible access to Gaga at a pivotal moment in her career."

* * *

IN A DARK, airless studio control room on the third floor of a downtown-Manhattan office building, Lady Gaga is clutching a toy unicorn and talking about *Rocky IV*. She's eight hours away from finishing vocals for her third album, *Born This Way*, which is supposed to be out in less than a month. But even with deadlines looming ("soon" is all anyone will say, ominously, about the final cutoff), even in the computer monitors' dim light, even while she sips from a can of Coke Zero through a bendy straw, she is resplendent in her Gaganess: Her blond hair extensions are in dual ponytails, rising up like her unicorn's horn; her bangs are a contrasting black; her dramatic cat-eye makeup extends well past the edges of her lids. She's wearing tights with a small rip in the left thigh, a bra top, knee-high "stripper boots" and a hugely oversize denim jacket with the cross-and-heart cover art of her current single, "Judas," painted on it – a present from a fan.

"Whenever I get sad, I think of little monsters and go like this," Gaga coos, making the unicorn's tiny horn light up. "Fight on, little pony, fight on!" Her admirers call themselves little monsters; in the oft-heartbreaking letters they pass up to the stage, they call her Mother Monster. In three years of fame, Gaga has amassed 34 million Facebook friends and 1 billion YouTube clicks; hip teens in China express surprise by saying, "Oh, my Lady Gaga." She's reshaped pop in her image, telling kids it's cool to be gay or freaky or unpopular, that they're born that way: a message that's largely been absent from the charts since Nineties alt-rock's outcast chic. Gaga may, on occasion, draw heavily from the music and iconography of her heroes, but her influence on her own peers is even more obvious: Miley Cyrus and Christina Aguilera practically

Lady Gaga in East Norwich, New York, April 2011.

destroyed their careers trying to copy her; Rihanna and Katy Perry keep getting weirder (see Perry's "E.T." video); Kesha is allowed to be famous. Not to mention the now-inescapable four-on-the-floor dance beats that Gaga reintroduced to pop radio – a sound she's now trying to reinvent. "Step away from the formula!" says Gaga, who's infused the new album with her passion for vintage rock. "If I could get those epic choruses on the dance floor, that for me is the triumph of the album."

But Gaga still feels like an underdog – so she's been watching the *Rocky* movies. Rocky is a lot like Gaga, minus the meat dress, giant egg and 10-and-counting hit singles: small, scrappy, Italian-American, always in competition with more flawless physical specimens. Last night, she saw the fourth film for the first time, crying when Rocky triumphed over the evil Soviet Ivan Drago. "My favorite part," Gaga says with rapt enthusiasm, "is when Apollo's ex-trainer says to Rocky, 'He is not a machine. He's a man. Cut him, and once he feels his own blood, he will fear you.'" (She actually invented at least half of this quote, but whatever.) "I know it sounds crazy, but I was thinking about the machine of the music industry," she continues. "I started to think about how I have to make the music industry bleed to remind it that it's human, it's not a machine. I kept saying to myself today, 'No pain, no pain, I feel nothing.'"

Lady Gaga has a fortress of solitude, of Gaga-tude, set up backstage at every stop of her Monster Ball Tour – a curtained, candlelit sanctuary. Two days earlier in a Nashville arena, she's curled up on a backstage couch in that room, beneath pictures of her heroes: Jimmy Page, Debbie Harry, the Sex Pistols, John Lennon and the Ramones, plus an Andy Warhol triptych of Elvis Presley. She's sipping coffee from a mug decorated with cartoons from *Alice in Wonderland*, which she makes a point of showing off – she went down the rabbit hole long ago, and has no intention of coming out.

After the show, there's a tornado warning in Nashville, but Gaga's private plane is going to take off anyway. The crew is jittery, and no one finds it particularly amusing that Gaga's makeup artist is wearing a Stevie Ray Vaughan T-shirt. But as she rides to the airport, Gaga is serene, cracking *Wizard of Oz* jokes: "New York City," she sighs, still splattered in stage blood underneath her leather jacket. "There's no place like home." The cosmos, she believes, simply won't allow a plane crash. "I have way too much at stake," she says, back in messiah mode. "God wants *Born This Way* to come out – that plane's going straight to New York." I can't help pointing out that even if the plane went down, the album would come out. She nods – point taken – and laughs, unafraid.

Jersey Boys

In 2012, Bruce Springsteen sat down with Jon Stewart for the ROLLING STONE *Interview*

RS 1153 • MARCH 29, 2012

They were both Jersey boys, and both fans of each other's work. "Jon Stewart is the first modern interpretive-media class on television," Bruce Springsteen told ROLLING STONE in 2007. "There was a sense that finally the veil is being pulled away. It was the way I felt about 'Highway 61.'" And when Stewart, who had counted himself a fan since seeing the "Darkness on the Edge of Town" tour in 1978, sat down with Springsteen to interview him for a ROLLING STONE cover story, he said, "The only band I've seen more than Bruce Springsteen is the Springsteen tribute band Backstreets. I try not to let him know how pathetic I truly am." For almost two hours, the two Garden State natives talked music, the recent death of Clarence Clemons and the fierce populism of the Occupy Wall Street movement.

* * *

Throughout "Wrecking Ball," you get a taste of many different Springsteen flavors. You have so many different constituencies that want so many different things from you. How do you deal with that?

Generally I do what I like at any given moment and let the people find out where they fit in. The only thing I do keep in mind is that I'm in the midst of a lifetime conversation with my audience, and I'm trying to keep track of that conversation. Martin Scorsese once said that "your job is to make your audience care about your obsessions." So if the artist loses track of the conversation he's having with his audience, he may lose us forever. So I try to keep track of that, while giving myself the musical freedom I need.

You don't want to shut people out.

No. I see the cops, the firefighters, the construction workers, the conservative guys, the Republicans, the Democrats. My family is filled with Republicans and Democrats, every Sunday night at the table, and so it's not hung there on anybody's political hat. Its independence means a lot, because I respect the audience that comes to see me. I want them to be able to hear it as clearly as they can. I don't want the horse to follow the cart.

Has that gotten harder as the times have gotten more divided? As you find that the partisan voices are getting more shrill, is it harder to put something out and feel like it lives beyond that conversation?

The conversation I want to have with the audience is just the one that I want to have. There's also the one they're having with themselves, the one they're having with their buddy, the one they're having with their wife. It's a wide-open playing field. We've been onstage and we've been booed by our own crowd.

A conversation can be an argument. That's the thing I don't understand. That's what Thanksgiving is

for – you sit and you and your family argue out all different points of view, but you still love each other.

Yeah. I'm proud of our band in that we've maintained an audience who want to listen to us, in the sense that they're interested in not just what you were saying in '85 or '80 but interested in what we're saying right now: What's the next step we're going to take together, what are we going to argue about, what are we going to debate the meaning of?

Do you have an idea for yourself where this conversation is going?

You're never going to hear anything called an E Street Band farewell tour. It just goes until it stops, and then it keeps going.

It doesn't stop even then?

No.

You can still get stimulated by things artistically. Do those things have to be greater and greater to break through to you, or is the muse still tuned as finely as it was?

You just have to be living and listening. You have to be open and see the value, hear what magic it holds, and somewhere down the line, maybe years later, suddenly there's a little spot in your song where you go, "I know what this needs," and it's there for you. Listening, paying attention, being open – that's supposed to be the natural development of adulthood.

What's the development of adulthood? I knew it was something.

It's supposed to be how we broaden and move into adulthood. We're supposed to be picking up as we go – a larger experience of our world. It's something I've tried to facilitate through what I've done – broaden people's perspective, broaden people's vision and assist people in seeing through to the inner reality of things. Your show is basically an interpretive-media class.

That may be the nicest thing anyone's ever said about our show.

That's one of the things it is. That did not exist, in that form, until you did it. You have to go back to some of the early stand-up, Mort Sahl . . .

It's funny – there have always been people who do this, we're just using the form and technology that exist now to express it.

This is what the guys at Bear Stearns and Lehman Brothers forgot, that they are a part of a continuum of history, and it's not about the fucking buck that you make today at whoever's fucking expense. If there's not a sense of continuity, a sense of some sort of communal obligation and responsibility, a sense of a future involved in what you're doing, and a sense of being beholden to the past, you end up being one shallow, greedy motherfucker, just trying to get all you can get.

Now that's a name for a song, "Shallow, Greedy Motherfuckers."

I had that one, but I left it off.

Bruce Springsteen, New York, February 2012.

Wavy Gravy at his
Berkeley home, 2010.

Julia Louis-Dreyfus,
Los Angeles,
March 2014.

Lin-Manuel
Miranda,
New York,
May 2016.

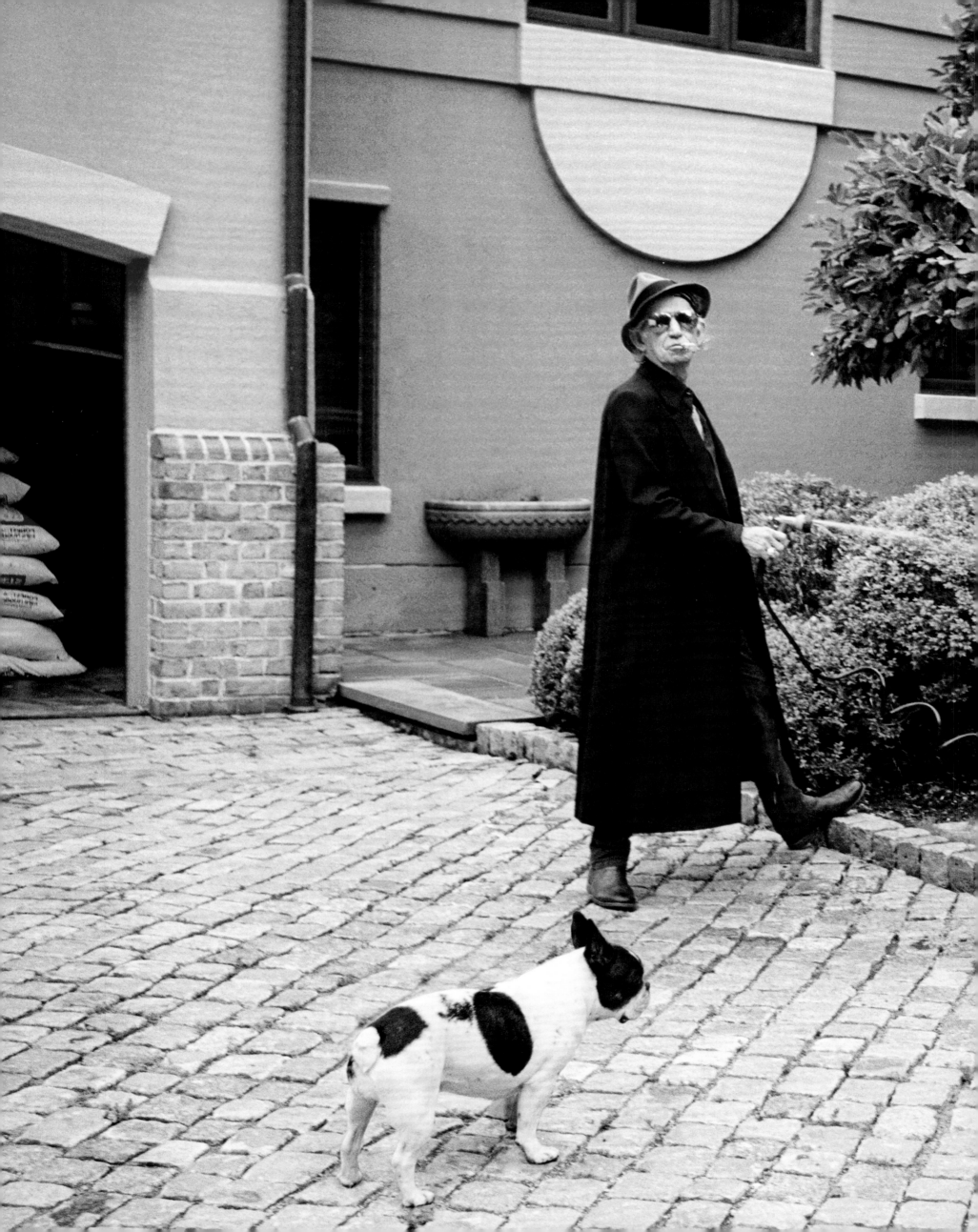

"I never thought I'd get this far. Now I have to think about this and wonder what to do with it.... It's my turn for growing old."

KEITH RICHARDS, *"It Ain't Easy Being Keith," RS 1246, October 22, 2015.*

Richards in Connecticut, August 2015.

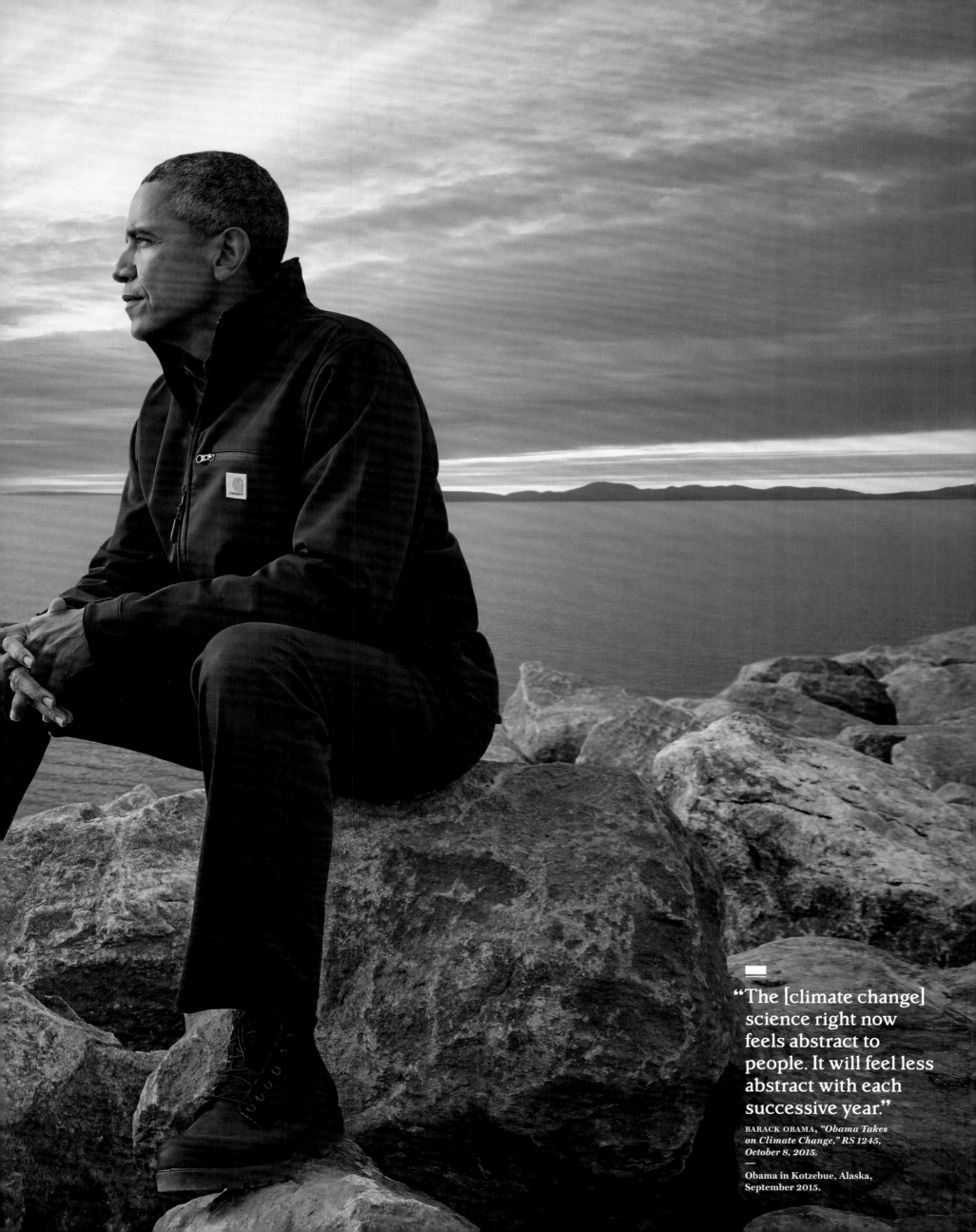

"The [climate change] science right now feels abstract to people. It will feel less abstract with each successive year."

BARACK OBAMA, *"Obama Takes on Climate Change," RS 1245, October 8, 2015.*

Obama in Kotzebue, Alaska, September 2015.

PHOTO CREDITS

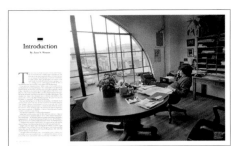

Page 2
JANN S. WENNER, *Baron Wolman/*
© *Iconic Images*, 1968

Pages 10-11
JANN S. WENNER, *Gene Anthony/*
Wolfgang's Vault, 1968

Pages 12-13
Clockwise from top left: Baron Wolman/© Iconic
Images (2); © Jim Marshall Photography LLC;
Annie Leibovitz; Jann Wenner Archive; Annie
Leibovitz; Jann Wenner Archive (2); Annie Leibovitz;
Jann Wenner Archive

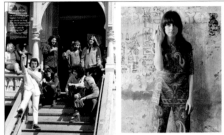

Page 14
FROM LEFT: WILLIAM GREIDER, P. J. O'ROURKE,
JANN S. WENNER, HUNTER S. THOMPSON,
BILL CLINTON, *Mark Seliger*, 1992

PAGE 17
MICK JAGGER, © *Ethan Russell*, 1969

Page 20
GRATEFUL DEAD, *Baron Wolman/*
© *Iconic Images*, 1967

Page 21
GRACE SLICK, *Herb Greene*, 1966

Pages 22-23
FRANK ZAPPA, *Baron Wolman/*
© *Iconic Images*, 1968

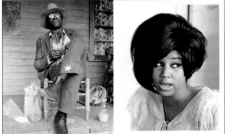

Page 25
PETE TOWNSHEND, *Baron Wolman/*
© *Iconic Images*, 1967

Page 26
TAJ MAHAL, *Baron Wolman/© Iconic Images*, 1968

Page 27
ARETHA FRANKLIN, *Linda McCartney/*
© *PML*, 1969

Pages 28-29
PHIL SPECTOR, *Baron Wolman/*
© *Iconic Images*, 1969

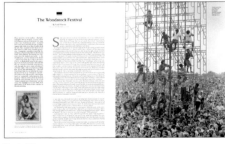

Page 31
WOODSTOCK, *Baron Wolman/*
© *Iconic Images*, 1969

Pages 32-33
WOODSTOCK, *Baron Wolman/*
© *Iconic Images*, 1969

Page 34
JONI MITCHELL, *Baron Wolman/*
© *Iconic Images*, 1968

Page 35
JIMI HENDRIX, © *Ed Caraeff/Morgan Media*, 1967

Page 36
GROUPIES, *Baron Wolman/© Iconic Images*, 1968

Page 37
STUDENT PROTEST, *Nacio Brown*, 1968

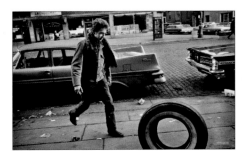
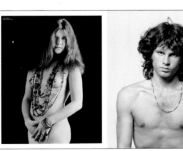

Pages 38-39
BOB DYLAN, © *Jim Marshall Photography LLC*, 1963

Page 40
JANIS JOPLIN, © *Bob Seidemann*, 1967

Page 41
JIM MORRISON, © *Joel Brodsky/*
Morrison Hotel Gallery, 1967

Page 43
BOB DYLAN, *Annie Leibovitz*, 1978

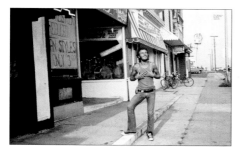

Pages 46-47
BRUCE SPRINGSTEEN,
© *Estate of David Gahr*, 1973

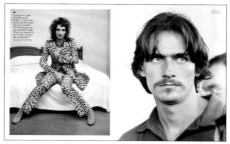

Page 48
ROD STEWART, © *Charles Gatewood/*
The Image Works, 1973

Page 49
JAMES TAYLOR, *Baron Wolman/*
© *Iconic Images*, 1969

Pages 50-51
JACKSON BROWNE, © *Rick Smolan/*
Against All Odds Productions, 1977

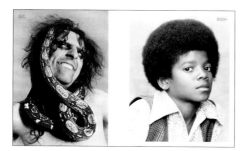

Page 52
ALICE COOPER, *Annie Leibovitz*, 1972

Page 53
MICHAEL JACKSON, © *Henry Diltz*, 1971

Page 54
PATTY HEARST, *Jamie Putnam*, 1975

Page 55
KAREN SILKWOOD, *AP Images*

Page 56
PATTI SMITH, *Annie Leibovitz*, 1978

Page 57
BOB MARLEY, *Annie Leibovitz*, 1976

Pages 58-59
DUANE AND GREGG ALLMAN, *Annie Leibovitz*, 1971

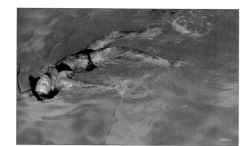

Pages 60-61
JONI MITCHELL, *Norman Seeff*, 1975

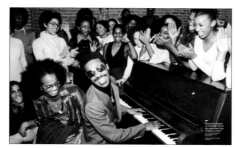

Pages 62-63
STEVIE WONDER, *Allen Tannenbaum/*
Polaris Images, 1975

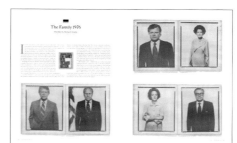

Pages 64-65
THE FAMILY, *Richard Avedon*, 1976

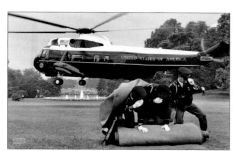

Pages 66-67
NIXON LEAVING THE WHITE HOUSE,
Annie Leibovitz, 1974

Page 68
BRIAN WILSON, *Annie Leibovitz*, 1976

Page 69
NORMAN MAILER, *Annie Leibovitz*, 1974

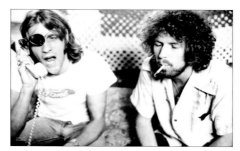

Pages 70-71
GLENN FREY AND DON HENLEY, *Barry Schultz/*
Sunshine/Zuma Press, 1975

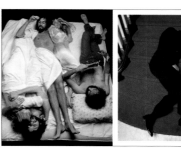

Page 72
FLEETWOOD MAC, *Annie Leibovitz*, 1977

Page 73
MUHAMMAD ALI, *Annie Leibovitz*, 1978

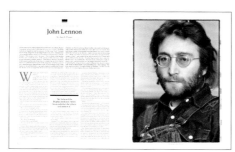

Page 75
JOHN LENNON, *Annie Leibovitz*, 1970

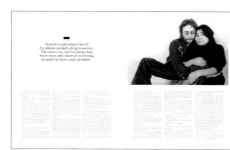

Page 77
JOHN LENNON AND YOKO ONO,
Annie Leibovitz, 1970

Pages 78-79
CROSBY, STILLS, NASH AND YOUNG,
© *Henry Diltz*, 1970

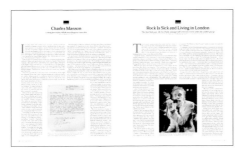 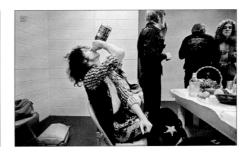

Page 80
CHARLES MANSON LETTER, 1970

Page 81
SEX PISTOLS, *© Dennis Morris*, 1977

Page 82
BETTE MIDLER, *Annie Leibovitz*, 1979

Page 83
LINDA RONSTADT, *Annie Leibovitz*, 1976

Pages 84-85
JIMMY PAGE, *© Neal Preston*, 1975

Page 86
THE RAMONES, *Ian Dickson/The Hell Gate*, 1977

Page 87
KEITH RICHARDS, *Annie Leibovitz*, 1972

Pages 88-89
ELTON JOHN, *Annie Leibovitz*, 1973

Page 90
HUNTER S. THOMPSON, *Ralph Steadman*, 1971

Page 91
HUNTER S. THOMPSON AND GEORGE MCGOVERN, *Annie Leibovitz*, 1972

Page 92
HUNTER S. THOMPSON, *Annie Leibovitz*, 1971

Page 93
HUNTER S. THOMPSON, *Annie Leibovitz*, 1972

 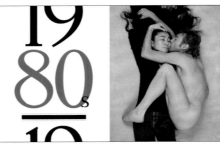

Pages 94-95
FEAR AND LOATHING, *Ralph Steadman*, 1972

Page 97
YOKO ONO AND JOHN LENNON, *Annie Leibovitz*, 1980

Page 100
MADONNA, *Herb Ritts/Trunk Archive*, 1987

Page 101
MICK JAGGER, *Herb Ritts/Trunk Archive*, 1987

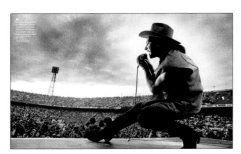 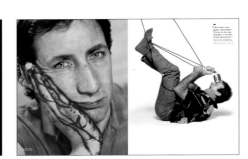

Pages 102-103
BONO, *Lex Van Rosen/Getty Images*, 1987

Page 104
AXL ROSE, *Timothy White/Trunk Archive*, 1988

Page 105
KEITH RICHARDS, *Larry Hulst/Michael Ochs Archives/Getty Images*, 1981

Page 106
DAVID BOWIE, *Herb Ritts/Trunk Archive*, 1987

Page 107
B.B. KING, *Albert Watson*, 1989

Page 108
PETE TOWNSHEND, *Annie Leibovitz*, 1980

Page 109
ROBIN WILLIAMS, *Bonnie Schiffman*, 1988

 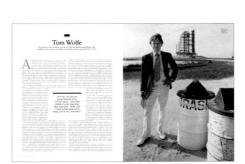

Pages 110-111
JOHN BELUSHI, *Bonnie Schiffman*, 1980

Page 112
PAUL MCCARTNEY, *Herb Ritts/Trunk Archive*, 1989

Page 113
TOM CRUISE, *Herb Ritts/Trunk Archive*, 1986

Page 115
TOM WOLFE, *Annie Leibovitz*, 1972

Page 117
TOM WOLFE, *Mark Seliger*, 2007

Page 118
PRINCE, *Richard Avedon/*
© The Richard Avedon Foundation, 1982

Page 119
EDDIE MURPHY, *Richard Avedon/*
© The Richard Avedon Foundation, 1983

Page 120
CYNDI LAUPER, *Richard Avedon/*
© The Richard Avedon Foundation, 1984

Page 121
BOY GEORGE, *Richard Avedon/*
© The Richard Avedon Foundation, 1984

Page 122
JOHN HOLMES, *Bettman/Getty Images*, 1982

Page 123
THE PLAGUE, *Matt Mahurin*, 1985

Page 124
BILLY IDOL, *EJ Camp*, 1984

Page 125
DAVID BYRNE, *© Deborah Feingold*, 1983

Page 126
MERYL STREEP, *Annie Leibovitz*, 1981

Page 127
TINA TURNER, *© Steven Meisel*, 1984

Page 129
JOHNNY CARSON, DAVID LETTERMAN & JAY LENO,
Robert Risko, 1988

Page 130
JACK NICHOLSON, *Herb Ritts/Trunk Archive*, 1986

Page 131
STEVE MARTIN, *Annie Leibovitz*, 1981

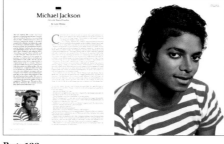
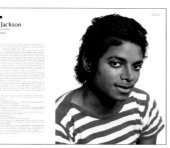

Page 133
MICHAEL JACKSON, *Bonnie Schiffman*, 1983

Page 135
NIRVANA, *Mark Seliger*, 1992

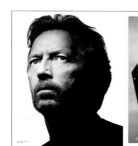

Page 138
ERIC CLAPTON, *Albert Watson*, 1991

Page 139
EDDIE VEDDER, *Mark Seliger*, 1993

Page 140
BEASTIE BOYS, *Mark Seliger*, 1998

Page 141
BRITNEY SPEARS,
© David LaChapelle Studio Inc., 1999

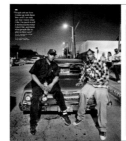

Page 142
DR. DRE AND SNOOP DOGG, *Mark Seliger*, 1993

Page 143
GREEN DAY, *Mark Seliger*, 1995

Page 144
EMINEM, *Catherine McGann/Getty Images*, 1999

Page 145
JERRY GARCIA, *Mark Seliger*, 1993

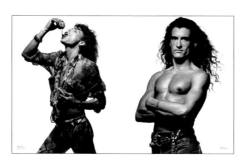

Page 146
STEVEN TYLER, *Albert Watson*, 1992

Page 147
JOE PERRY, *Albert Watson*, 1992

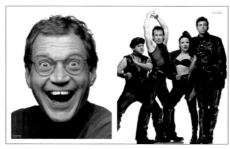

Page 148
DAVID LETTERMAN, *Mark Seliger*, 1993

Page 149
SEINFELD, *Mark Seliger*, 1993

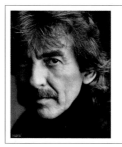

Page 150
GEORGE HARRISON, *Mark Seliger*, 1992

Page 151
BECK, *Anton Corbijn*, 1997

Page 152
DREW BARRYMORE, *Mark Seliger*, 1995

Page 153
SINÉAD O'CONNOR, *Herb Ritts/Trunk Archive*, 1991

Page 154
FIONA APPLE, *Mark Seliger*, 1997

Page 155
MARILYN MANSON, *Matt Mahurin*, 1996

Page 157
MICK JAGGER, © *Peter Lindbergh*, 1995

Page 159
KEITH RICHARDS AND MICK JAGGER,
© *Jim Marshall Photography LLC*, 1972

Page 160
TOM PETTY, *Mark Seliger*, 1991

Page 161
RED HOT CHILI PEPPERS, *Mark Seliger*, 1992

Page 162
WILLIE NELSON, *Mark Seliger*, 1996

Page 163
NEIL YOUNG, *Mark Seliger*, 1992

Page 164
LITTLE RICHARD, *Herb Ritts/Trunk Archive*, 1992

Page 165
MICHAEL STIPE, *Anton Corbijn*, 1996

Page 166
MANUREGATE, *Lane Smith*, 1990

Page 167
MARILYN MANSON, *Maureen Grey/Zuma Press*, 1997

Page 169
KURT COBAIN, *Mark Seliger*, 1993

Pages 170-171
EMINEM, © *David LaChapelle Studio Inc.*, 1999

Page 172
JANET JACKSON, © *Patrick Demarchelier*, 1993

Page 173
AXL ROSE, *Herb Ritts/Trunk Archive*, 1991

Page 174
BILLY JOEL, *Mark Seliger*, 1992

Page 175
RINGO STARR, *Mark Seliger*, 1992

Page 176
COURTNEY LOVE, *Mark Seliger*, 1994

Page 177
JERRY GARCIA, *Mark Seliger*, 1993

Page 178
BRAD PITT, *Mark Seliger*, 1994

Page 179
WINONA RYDER, *Herb Ritts/Trunk Archive*, 1994

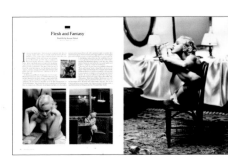

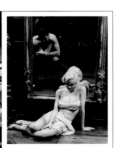

Pages 180-181
MADONNA, © *Steven Meisel*, 1991

Pages 182-183
MADONNA, © *Steven Meisel*, 1991

Page 184
WORKER, *Dan Winters*, 1998

Page 185
MANDATORY MINIMUMS, *Brian Cronin*, 1998

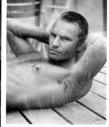

Page 186
SEAN PENN, *Mark Seliger*, 1995

Page 187
JOHNNY DEPP, *Herb Ritts/Trunk Archive*, 1990

Page 188
JAMES HETFIELD, *Mark Seliger*, 1993

Page 189
STING, *Herb Ritts/Trunk Archive*, 1990

Page 190
JAKOB DYLAN, *Mark Seliger*, 1997

Page 191
TUPAC, *Danny Clinch*, 1993

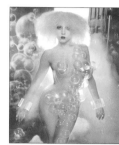

Page 193
KANYE WEST,
© *David LaChapelle Studio Inc.*, 2006

Page 196
BRITNEY SPEARS, *Peggy Sirota/*
Trunk Archive, 2008

Page 197
JUSTIN TIMBERLAKE, *Herb Ritts/*
Trunk Archive, 2002

Page 198
LADY GAGA,
© *David LaChapelle Studio Inc.*, 2009

Page 199
CHRIS ROCK,
© *David LaChapelle Studio Inc.*, 2008

Page 201
BONO, *Platon/Trunk Archive*, 2005

Page 203
BONO, © *Edward Keating/*
Contact Press Images, 2005

Page 204
STEPHEN COLBERT, *Robert Trachtenberg/*
Trunk Archive, 2006

Page 205
JON STEWART, *Robert Trachtenberg/*
Trunk Archive, 2006

Pages 206-207
BRUCE SPRINGSTEEN, *Max Vadukul*, August 2007

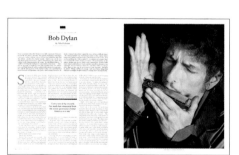

Page 208
THE GREAT AMERICAN BUBBLE MACHINE,
Victor Juhasz, 2009

Page 209
OZZY OSBOURNE, *Mark Seliger*, 2000

Page 210
JAY Z, *Albert Watson*, 2005

Page 211
ALICIA KEYS, *Mark Seliger*, 2001

Page 212
KID ROCK, *Mark Seliger*, 2000

Page 213
DAVE MATTHEWS, *Martin Schoeller*, August 2003

Page 215
BOB DYLAN, *Herb Ritts/Trunk Archive*, 2001

Pages 216-217
LINDSAY LOHAN, *Matthew Rolston*, 2004

Page 218
DAVID FOSTER WALLACE, *Bob Mahoney*, 1995

Page 219
CHURCH OF SCIENTOLOGY, *Phil McCarten/*
AP Images, 1995

Page 220
PUFF DADDY, *Platon/Trunk Archive*, 2006

Page 221
DARTH VADER, *Albert Watson*, 2005

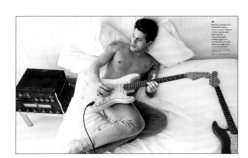

Pages 222-223
AMY WINEHOUSE, *Max Vadukul,* August 2007

Pages 224-225
© *Sebastião Salgado/Amazonas/*
Contact Press, 2005

Pages 226-227
© *Sebastião Salgado/Amazonas/Contact Press,* 2005

Pages 228-229
© *Sebastião Salgado/Amazonas/Contact Press,*
2004–2006

Page 231
ADELE, *Theo Wenner,* 2015

Pages 234-235
DAVE GROHL, *Sam Jones/Trunk Archive,* 2014

Pages 236-237
TAYLOR SWIFT, *Theo Wenner,* 2014

Pages 238-239
LEONARDO DICAPRIO, *Mark Seliger,* 2010

Page 240
KATY PERRY, *Peggy Sirota/Trunk Archive,* 2014

Page 241
BRUNO MARS, *Theo Wenner,* 2013

Page 242
KENDRICK LAMAR, *Gregers Tycho/Polfoto/*
AP Images, 2015

Page 243
TAYLOR SWIFT, *Theo Wenner,* 2012

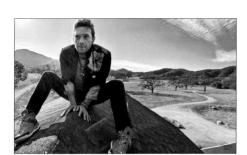

Pages 244-245
CHRIS MARTIN, *Peggy Sirota/Trunk Archive,* 2016

Pages 246-247
DEADMAU5, *Sam Jones/Trunk Archive,* 2011

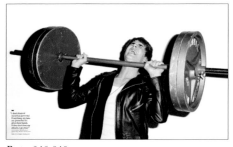

Pages 248-249
JUSTIN BIEBER, *Terry Richardson/Art Partner,* 2011

Page 250
GEN. STANLEY MCCHRYSTAL, *Mark O'Donald/*
NATO, 2010

Page 251
MIAMI, *Robert A. Sanchez/Getty Images,* 2013

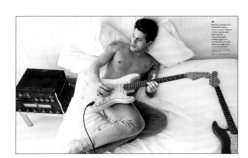

Pages 252-253
JOHN MAYER, *Mark Seliger,* 2010

Pages 254-255
LANA DEL REY, *Theo Wenner,* 2014

Page 256
FLORENCE WELCH, *Nadav Kander/*
Trunk Archive, 2011

Page 257
THOM YORKE, *Nadav Kander/Trunk Archive,* 2011

Pages 258-259
KENDRICK LAMAR, *Theo Wenner*, 2015

Page 260
RIHANNA, *Terry Richardson/Art Partner*, 2013

Page 261
MILEY CYRUS, *Theo Wenner*, 2013

Pages 262-263
THE BLACK KEYS, *Danny Clinch*, 2010

Page 264
LADY GAGA, *Ryan McGinley/Trunk Archive*, 2011

Page 265
BRUCE SPRINGSTEEN, *Mark Seliger*, 2012

Pages 266-267
WAVY GRAVY, *Peter Yang*, August 2010

Page 268
JULIA LOUIS-DREYFUS, *Mark Seliger*, 2014

Page 269
LIN-MANUEL MIRANDA, *Mark Seliger*, 2016

Pages 270-271
KEITH RICHARDS, *Theo Wenner*, 2015

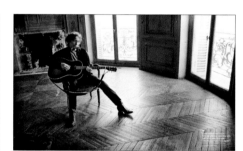

Pages 272-273
BARACK OBAMA, *Mark Seliger*, 2015

Page 274
MARK SELIGER, *Photo by Mark Seliger*

Pages 284-285
BOB DYLAN, *Sam Jones/Trunk Archive*, 2009

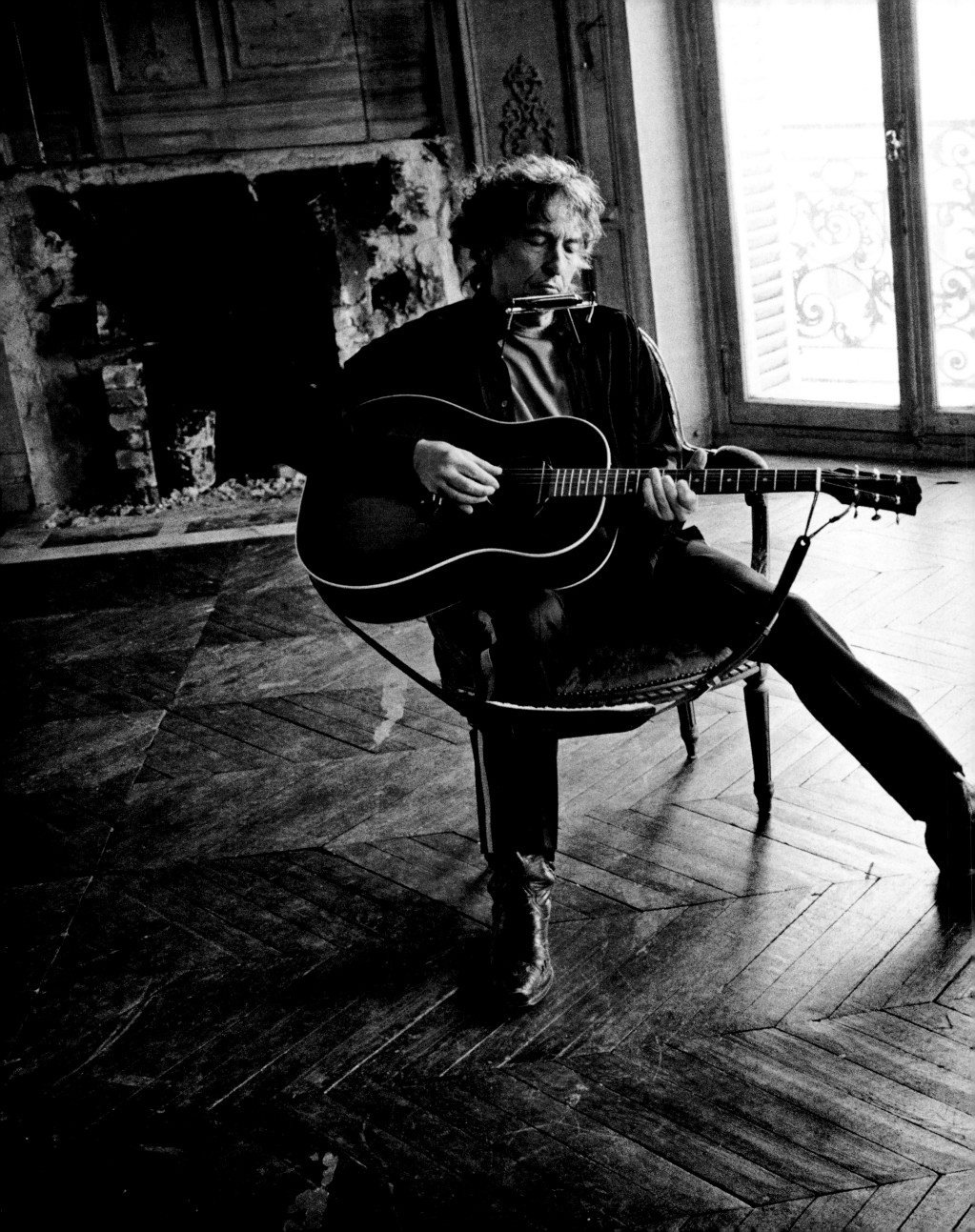

"Come writers and critics
Who prophesize with your pen,
And keep your eyes wide,
The chance won't come again."

BOB DYLAN, *"The Times They Are A-Changin'"*

Dylan in Paris, April 7, 2009.

EDITORS: *Jodi Peckman and Joe Levy*

DESIGN DIRECTOR: *Joseph Hutchinson*

MANAGING EDITOR: *Jason Fine*

PHOTO EDITOR: *Laurie Kratochvil*

DEPUTY MANAGING EDITORS: *Tara Cox, Alison Weinflash*

WRITERS: *David Browne, Patrick Doyle, Andy Greene, Kory Grow, David Swanson*

DESIGNERS: *Luke Hayman/Pentagram, Simon Blockley/ Pentagram, Mark Maltais, Nestor Clopatofsky, Toby Fox*

PHOTO DEPARTMENT: *Meghan Benson (Mgr.), Sandford Griffin, Sacha Lecca, Griffin Lotz*

COPY EDITORS: *Phoebe Neidl, Tom Brown, Jason Maxey, Thomas Walsh*

RESEARCHERS: *Hannah Murphy, Rick Carp, Jessica Corbett, Coco McPherson, Jordan Reed, Darren Reidy*

PRODUCTION: *Therese Hurter, John Lattarulo, Henry Groskinsky*

ARCHIVAL ART PHOTOGRAPHED BY: *Peter Riesett*

EXECUTIVE DIRECTOR, LICENSING: *Maureen Lamberti*

ABRAMS, NEW YORK
EDITOR: *Michael Sand*
PRODUCTION MANAGER: *Anet Sirna-Bruder*

EDITORIAL NOTE: In most cases, the date that accompanies a photograph, work of art, text excerpt, or magazine page or spread corresponds to the ROLLING STONE issue date in which it appeared. See "Picture Credits" for more information.

Library of Congress Control Number: 2016943558

ISBN: 978-1-4197-2446-6

ABRAMS The Art of Books
115 West 18th Street, New York, NY 10011
abramsbooks.com

"ALL THE NEWS THAT FITS"